Lyonel Feininger At the Edge of the World

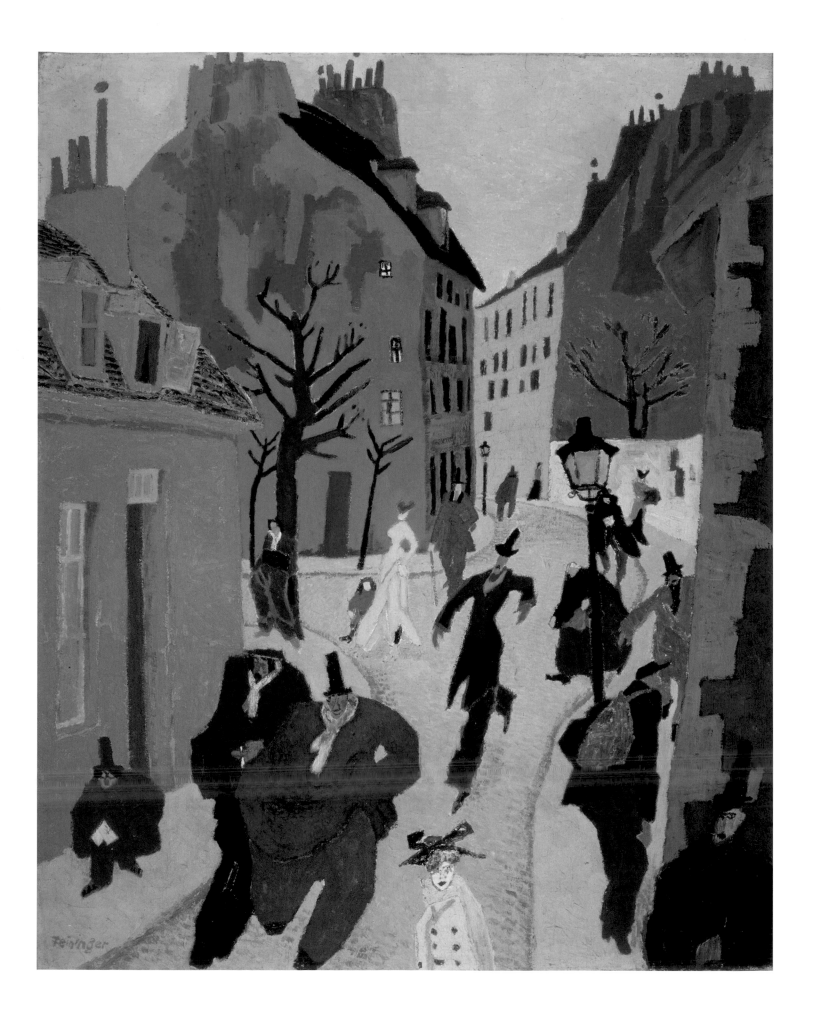

Lyonel Feininger

At the Edge of the World

Barbara Haskell

With essays by
John Carlin
Bryan Gilliam
Ulrich Luckhardt
Sasha Nicholas

Whitney Museum of American Art, New York

The Montreal Museum of Fine Arts

Yale University Press, New Haven and London

Lyonel Feininger: At the Edge of the World was organized by the Whitney Museum of American Art, New York in collaboration with the Montreal Museum of Fine Arts.

In New York, this exhibition and catalogue are made possible, in part, by generous grants from the Terra Foundation for American Art and the Henry Luce Foundation.

Major underwriting for this exhibition is provided by the Anna-Maria and Stephen Kellen Foundation, in memory of Stephen M. Kellen.

Additional support is provided by The Shen Family Foundation, the Karen and Kevin Kennedy Foundation, Susan R. Malloy, Déborah, André and Dan Mayer, Carol and Paul Miller, Joseph Edelman and Pamela Keld, Geraldine S. Kunstadter, the Karen and Paul Levy Family Foundation, Marica and Jan Vilcek, the Consulate General of the Federal Republic of Germany, and several anonymous donors.

Published with the support of the Dedalus Foundation, Inc., and Furthermore: a program of the J. M. Kaplan Fund.

In Montreal, the exhibition receives financial support from the Terra Foundation for American Art.

The international exhibition program of the Montreal Museum of Fine Arts benefits from the Exhibition Fund of the Montreal Museum of Fine Arts Foundation and the Paul G. Desmarais Fund.

The exhibition is funded in part by the Volunteer Association of the Montreal Museum of Fine Arts. The Museum wishes to thank the volunteer guides of the Montreal Museum of Fine Arts for their unflagging support. The Museum is also grateful to its Friends and the many corporations, foundations and individuals for their contributions, and, in particular, the Fondation Arte Musica, led by Pierre Bourgie.

The Montreal Museum of Fine Arts also wishes to express its gratitude to the Conseil des arts de Montréal as well as Quebec's Ministère de la Culture, des Communications et de la Condition féminine for their ongoing support. And finally, the Museum wishes to acknowledge the contributions of Air Canada as well as Astral Media, *La Presse* and *The Gazette*, its media partners.

Jacket illustrations: (front, ISBN 978-0-300-16846-4) *The Green Bridge II (Grüne Brücke II)*, 1916 (fig. 90), (front, ISBN 978-0-300-17730-5) *Yellow Street II*, 1918 (fig. 89); (back, ISBN 978-0-300-16846-4) *Gelmeroda XIII (Gelmeroda)*, 1936 (fig. 168)
Frontispiece: *In a Village Near Paris (Street in Paris, Pink Sky)*, 1909. Oil on canvas, 39¾ x 32 in. (101 x 81.3 cm). University of Iowa Museum of Art, Iowa City; gift of Owen and Leone Elliott 1968.15

Note to the reader: The titles of oil paintings reproduced in this volume are drawn from the catalogue raisonné of Feininger's work compiled by Julia Feininger and published in Hans Hess, *Lyonel Feininger* (New York: Harry N. Abrams, 1961). Instances where institutional titles differ from the catalogue raisonné are noted in parentheses.

Contents

Foreword

Today the notion of the global artist, one who works in multiple countries, is taken for granted, but when Lyonel Feininger arrived on the scene around 1900, the idea of an "inter-national" artist was still in formation. Although exceptional American artists—in both senses of the word—from John Singleton Copley and Benjamin West to Mary Cassatt and John Singer Sargent, as well as Canadian artists Marc-Aurèle de Foy Suzor-Coté and James Wilson Morrice, had gone to Europe to study, exhibit, and travel since the eighteenth century, it was not until the early twentieth century that vast waves of immigrants would profoundly complicate issues of American identity.

Feininger, born in Manhattan to a German father and German-American mother, spent his early years in New York, Connecticut, and New Jersey. At age sixteen, he was sent abroad to Hamburg to study. Thinking of himself as an American, he expected to return in a few short years. Instead, Feininger undertook further study in Berlin (on multiple occasions and in various schools), Liège, and Paris. As late as 1903, after spending more than fifteen years abroad, he still felt like "a typical American with 'American' oozing from every pore." However, his connection to his native country began to waver in the face of a successful marriage and burgeoning career in Germany. Despite his American roots, Feininger was treated as a German artist and was not included in the famous "Armory Show" in New York in 1913 because, as Barbara Haskell points out in her comprehensive and engaging essay in this volume, there was an apparent bias against German art at that time. As Ulrich Luckhardt documents in his text in this catalogue, Feininger was extensively exhibited and collected by prestigious German museums in the early part of the century, yet his work was rarely exhibited in America until the mid-1920s. It was not until he returned to the United States right before the outbreak of World War II that he was embraced as an American artist and his work shown by American museums. Within the first few years of Feininger's return, his work was presented at the Museum of Modern Art, New York; the Brooklyn Museum; and the San Francisco Museum of Modern Art (among many others). All of this points to the fluidity of cultural identity and the inadequacy of national labels. Suffice it to say, Feininger was among the first "American" artists of his generation who could be thought of as an international hybrid. This notion of cultural duality, a precedent unwittingly set by Feininger, has become the modus operandi for a vast number of contemporary artists across the world.

In addition to Feininger's relevance as an early global artist, his willingness to work with both fine and applied art and across a wide range of media resonates with many contemporary artists, making *Lyonel Feininger: At the Edge of the World* particularly timely. As mentioned above, his status as an international yet distinctly American artist mirrors that of many of today's artists, even though the intimate, modest, poetic quality of his work stands in stark contrast to the often brash, large-scale, spectacular art productions dominant today.

Feininger began his career as a caricaturist, illustrator, and cartoonist—a topic thoughtfully discussed in John Carlin's essay in this volume. Working for prestigious pub-

lications like the news magazine *Berliner Illustrierte Zeitung* and the comic journal *Ulk*, Feininger was one of the best known caricaturists in Germany at the turn of the twentieth century. In the comic strips he created for the *Chicago Sunday Tribune*—*Kin-der-Kids* and *Wee Willie Winkie's World*—we do not merely see the incipient style and subjects that would occupy him throughout his career, we also experience the work of an artist whose distinctive compositions, juxtapositions, use of scale, and wry sense of humor have led him to be considered one of the fathers of modern comic art. As Carlin writes, "Feininger participated in the birth of a new medium . . . at the precise moment newspaper comics transformed a popular medium into an art form." Despite producing a substantial body of work—more than 2,000 illustrations—by age thirty-five, Feininger abandoned the medium. While Feininger's comics are radically different in style and intent than the use of such material decades later by postwar artists such as Roy Lichtenstein, starting in the 1960s, and Raymond Pettibon, starting in the 1980s, Feininger's short but prolific career as an illustrator is significant and exemplary. Lichtenstein, for example, saw comics as a vital commercial art to be absorbed, modified, and repurposed, while an artist like Pettibon manifests the comic as the primary vehicle of his art. Although Feininger eventually abandoned comics in favor of oil painting, the seriousness of his commitment helped legitimize the form for subsequent artists. Presenting his comics in the context of his other work reconnects Feininger's paintings with his early career and also creates a bridge to contemporary practice.

Although Feininger privileged oil painting starting around 1907, works on paper are a distinct, extensive, and critical aspect of his oeuvre. Throughout his career, he did not treat them as preparatory tools but as independent works of art. Represented here are many of the watercolors he created throughout his life as well as a selection of the woodcuts he produced starting in 1918. Feininger also seriously experimented with photography, the results of which are almost completely unknown today. The manner in which Feininger moved between prints, watercolors, photographs, and oils reveals an appreciation for the modern concept of the intrinsic and unique characteristics of each medium and how those characteristics might be translated and exploited in oil. In his extraordinary woodcuts, Feininger had key realizations that inspired the geometric monumentality that characterized his Bauhaus work of the 1920s. As Haskell states, Feininger found woodcuts to be "a perfect medium with which to investigate planar composition." In addition, woodcuts informed his use of positive and negative space and confirmed his belief in "Form First!" Feininger produced dozens of watercolors when he vacationed in the Baltic village of Deep between 1924 and 1936. As Haskell notes, in these watercolors, his use of transparency and linearity "presented Feininger with a vision of atmosphere as space-architecture" that had profound relevance for his subsequent oils. Photography was also an important medium for Feininger, although he was deeply conflicted about its artistic merits during the early years of his career. As Sasha Nicholas discusses in her essay on this aspect of Feininger's work, photography, particularly the

images he shot at night and in damp weather, enabled him to extend his painterly interest in what he called "the magical and veiled world." In Feininger's photographs, the marriage of architectural subjects and a romantic fascination with light reinforces the mystical sensibility of his paintings.

An aspect of Feininger's art that has been conventionally thought of as more curiosity than serious endeavor is the toy sculptures he crafted. This exhibition repositions these toys as an integral part of the artist's practice. Around 1913, as Feininger was designing toys for commercial production, he began making a hand-carved and painted, diminutive, toy village for his children, which his son T. Lux later called "City at the End of the World." Feininger repeatedly used this title (which also inspired this exhibition's name) to describe his depictions of nineteenth-century German villages, in which unity and harmony start to become unhinged. He subsequently added to his "City" at each Christmas and for decades made dozens of toys for friends and their children. One cannot, of course, claim that these enchanting, miniscule creations were central to his art the way Alexander Calder's *Circus* (1926–31) was primary for that artist's oeuvre more than a decade later. Nevertheless, the large number of toys Feininger created over a protracted period and the way they mirror subjects of his paintings, suggest that they should be considered an essential component of his overall production. And, like the caricatures and comics, they tacitly acknowledge that humor, play, and usefulness can and should be seen as the rightful domain of the modern artist.

Beyond the many precedents set by Feininger and his work, the ultimate imperative for the exhibition is the art itself. Why did his work garner only scant attention in the United States for so long (even though he has been the subject of nearly annual exhibitions in Germany for decades)? Perhaps, as alluded to above, the calm, quiet, and unassuming character of his work has caused it to be missed or dismissed. Perhaps the hushed, spiritual qualities he prized in his work seem unfashionable today. Or could it be that unlike the work of better recognized colleagues from the Bauhaus such as Paul Klee and Wassily Kandinsky, he never sought to cut all ties with nature in his paintings and pursue non-objective abstraction? And, perhaps since he was not tied to a specific American school or style, he has become a sort of outsider in his own country. We suspect all of the above are pertinent and all are reasons to reconsider Feininger now. It is precisely the tranquility of his art, its coalescence of the spatial, the temporal, and the formal, as well as its subtle variety, that demands *and* rewards attention, focus, and repeated viewing. There need to be places to consider works that whisper; we believe this is the time.

We thank Barbara Haskell for recognizing that this is indeed the time for a fresh take on Feininger's art. Her persistence and thoroughness in undertaking new research and tracking down the finest examples of Feininger's work in all media, and her desire to reinterpret and re-present his work for a new generation are to be commended. Sasha Nicholas has painstakingly assisted Barbara with every aspect of the exhibition and catalogue, and we are ever so grateful for her commitment to this effort. At the Montreal

Museum of Fine Arts, we are very appreciative of Anne Grace's assistance with the presentation of the exhibition there.

This exhibition could not have happened in New York or Montreal without the support of those who recognize the importance of Feininger's work and his relevance today. At the Whitney, the Anna-Maria and Stephen Kellen Foundation thoughtfully honored the late Stephen M. Kellen, who had long hoped an exhibition such as this one would be realized in New York. The Terra Foundation for American Art and the Henry Luce Foundation provided significant support for both the exhibition and catalogue. Additional crucial funding for the presentation of the exhibition in New York came from the Shen Family Foundation; the Karen and Kevin Kennedy Foundation; Susan R. Malloy; Déborah, André and Dan Mayer; Carol and Paul Miller; Joseph Edelman and Pamela Keld; Geraldine S. Kunstadter; the Karen and Paul Levy Family Foundation, Marica and Jan Vilcek; and the Consulate General of the Federal Republic of Germany New York. The Dedalus Foundation, Inc., and Furthermore, a program of the J. M. Kaplan Fund, offered essential support for the publication of the English edition of the catalogue.

In Montreal, the exhibition received generous support from the Terra Foundation for American Art. The international exhibition program of the Montreal Museum of Fine Arts benefitted from the Exhibition Fund of the Montreal Museum of Fine Arts Foundation and the Paul G. Desmarais Fund. The exhibition is funded in part by the Volunteer Association of the Montreal Museum of Fine Arts. The Museum also thanks the volunteer guides of the Montreal Museum of Fine Arts for their unflagging support. In addition, the Museum is also grateful to its Friends and the many corporations, foundations and individuals for their contributions, and, in particular, Foundation Arte Musica, led by Pierre Bourgie. The Montreal Museum of Fine Arts also expresses its gratitude to the Conseil des arts de Montréal as well as Quebec's Ministère de la Culture, des Communications et de la Condition féminine for their ongoing support. And finally, the Museum acknowledges the contributions of Astral Media, La Presse, the Gazette, its media partners, as well as Air Canada.

We also owe a debt of gratitude to the lenders for their willingness to share prime examples of Feininger's work with viewers in two countries.

Adam D. Weinberg
Alice Pratt Brown Director, Whitney Museum of American Art

Nathalie Bondil
Director and Chief Curator, Montreal Museum of Fine Arts

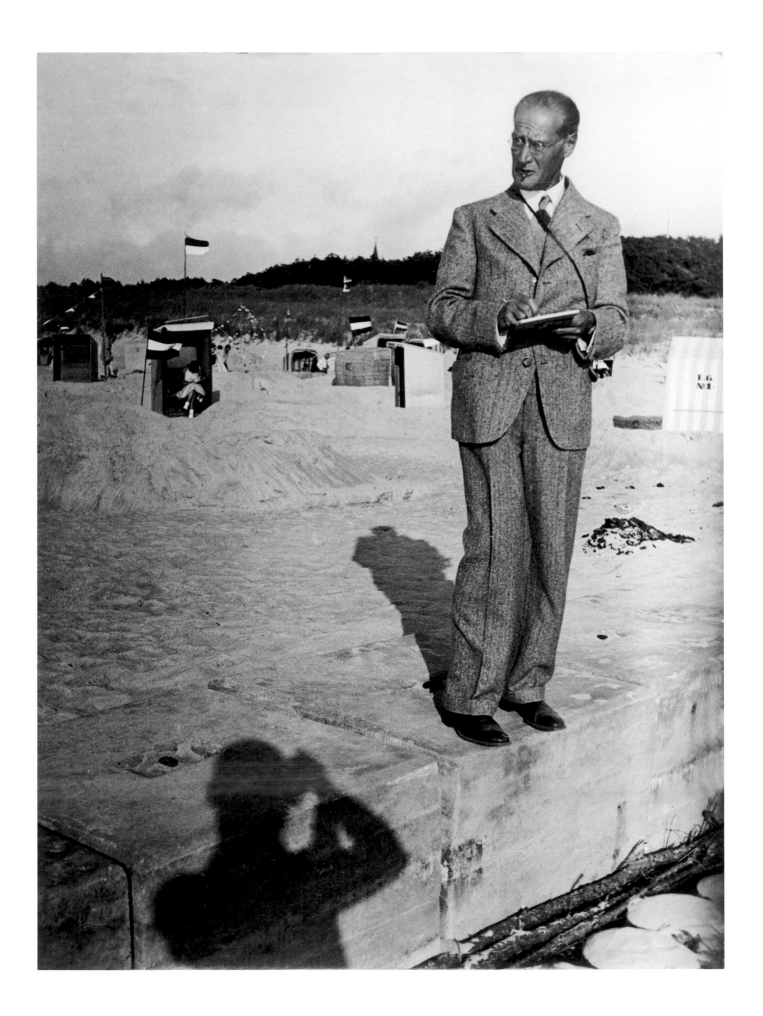

Redeeming the Sacred:

The Romantic Modernism

of Lyonel Feininger

Barbara Haskell

fig. 1. **Feininger sketching at the seaside, Deep,**
1932. Photograph by T. Lux Feininger

From America to Germany

Lyonel Feininger sailed at age sixteen from New York City, where he was born on July 17, 1871, to Germany. He remained an expatriate for almost fifty years, marrying, raising a family, and becoming a celebrated artist in Germany. Yet he never ceased viewing his adopted country through the eyes of an American; never once did he consider giving up his citizenship. At the same time, his valorization of German culture and his vision of the United States as inhospitable to art constrained his return home. When he did repatriate, in 1937, it was difficult; having spent two-thirds of his life in Germany, his deepest memories were of his experiences and friendships there. His complex and contradictory allegiances—to American ingenuity and lack of pretension on one hand, and to German respect for tradition and learning on the other—rendered him an outsider in both countries.[1] Always yearning for one world while living in the other, he never stopped longing for the "lost happiness" of his childhood, before his family splintered and his national identity became fractured.[2]

Feininger's opposing loyalties were rooted in the experiences of his father and paternal grandparents, who had fled Baden, in Germany, for Columbia, South Carolina, as a consequence of the family's involvement in the failed 1848 revolution.[3] Motivated to leave their homeland by politics rather than economics, the Feiningers embraced America as a nation of freedom and democracy while remaining wary of its materialism and disregard for the arts. Their economic success in South Carolina notwithstanding, they retained a romanticized view of German culture and German values that they transplanted onto American soil.[4] Feininger's father, Karl, had been nine when the family emigrated.[5] His parents sent him to a Catholic boarding school in Columbia and arranged for him to study music with a German-American violinist.[6] At age sixteen, he went to Leipzig to study violin at the conservatory with Ferdinand David, the distinguished disciple of the German composer and virtuoso Louis Spohr. There, Karl was introduced to the German Idealist philosophy of Immanuel Kant, Arthur Schopenhauer, and G. W. Hegel. In Hegel's published lectures on aesthetics, he found confirmation of his own instincts. According to Hegel, art is equal to religion and philosophy in communicating "the comprehensive truths of the spirit." By expressing "our highest spiritual experience objectively, thereby bringing it nearer to the senses, to feeling," art offers a way for people to experience the presence of the Ideal in the universe, without the mediation of reason.[7] Hegel's proposition that music is especially suited to this task by virtue of its dematerialization would become the cornerstone of Karl's worldview and later pedagogy. In his 1909 book *The Experimental Psychology of Music* he argues that music is a divine experience, effecting a "state of grace . . . in which man is enabled . . . to identify himself . . . with God as the origin of power."[8] Music not only induces awareness of God's majesty and "super-eminence," it offers irrefutable proof "of God's divine reason."[9]

Karl returned to the United States from Germany in time to participate in what turned out to be the final months of the Civil War as a member of New Hampshire's

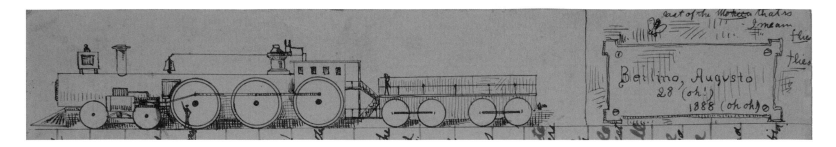

fig. 2. **Illustrations on postcards from Feininger to Frank Kortheuer,** August 28, 1888
Collection of the late Horace Richter

Second Brigade Band, stationed in Hilton Head, South Carolina.[10] He remained in the country after the war, significantly in the North, taking a job as head of the music department of Miss Kenyon's College for Girls in Plainfield, New Jersey—a position he retained for seventeen years. At the college, he met—and ultimately married—fellow teacher Elisabeth Lutz, a singer and pianist, whose childhood experiences as the daughter of German émigré parents from Lingenfeld were much like his own.[11] By the time Lyonel was born, the couple was living at 85 St. Marks Place in New York City and Karl was enjoying a successful international career as a violinist and composer, often performing with his wife as an accompanist.[12] The two shared an allegiance to German Romantic Catholicism, which opposed the dogma of Papal infallibility and the Catholic hierarchy. Elisabeth was less invested than her husband in the intersection between art and spirit, but she believed as ardently as he did in the omnipresence of the Divine. "Learn to know that you live and move and have your being in infinite Life—Truth—and Love and that life is not dependent on physical conditions," she would counsel her son. "We reflect the divine Mind. . . . It is omnipresent—all about us, in us spiritually and we in it spiritually. . . . You must understand your being in connection with the great All-in-All."[13] Guided by his parents' advocacy, Feininger grew up with what he called an "unbounded faith in the goodness of the Almighty" and in art's capacity to express it.[14]

Karl's belief in music as a spiritual experience giving life its meaning impressed itself on Feininger early in life. He remembered, as a boy of five to seven years of age, sitting enchanted in the dining room of the family's three-story townhouse on East Fifty-third Street, listening through an open grate in the ceiling to his parents playing music in the room upstairs: "Beethoven, Mendelssohn, Schumann, Schubert—a shudder ran through me. I think no one could have guessed what was taking place inside me."[15] By the time he was nine, Feininger was studying violin with his father; by age twelve, he was performing in public.[16] His childhood immersion in music produced a complicated response: on one hand, a lifelong fealty to music and the German musical tradition; on the other, resistance to music's overbearing presence in the household and the pressure on him to become a musician. Just as his loyalty to Germany and the United States remained divided all his life, so too would his devotion to music and fine art perpetually fight for his attention. Tellingly, three of his children became artists, one became a musicologist and choral conductor.

Owing to his parents' successful musical careers, Feininger's upbringing was

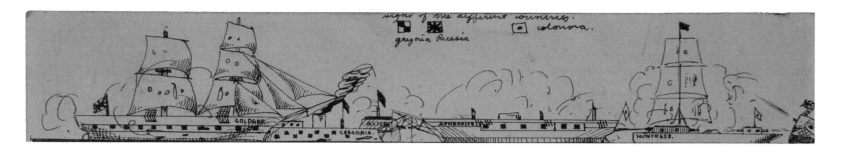

unconventional.[17] With his mother and father often on tour, he and his two younger sisters frequently boarded with strangers. One of his most vivid memories was of living with the Clapp family, who owned a farm in Sharon, Connecticut, near Helen Bartram, the godmother and namesake of Feininger's sister Helen Bartram Feininger.[18] Years later, Feininger recalled how happy he had been in the Clapps' company and how much closer he felt to them as a boy than to his celebrated but "almost hypothetical parents," who were so often away.[19] As an adult, he would find in the hamlets of rural Germany echoes of the "Connecticut hills against the Western sky, the wide valleys and solitary farms, barns, and the great old trees, amongst which the village church is nestled."[20] Feininger's other most precious childhood memories were associated with modernity. He would spend hours on the footbridge overlooking the tracks of the New York Central Railroad as trains entered Grand Central Station or sit entranced on the shores of the Hudson and East Rivers, observing the steamboats and sailing ships, standing side-by-side for hundreds of yards.[21] By the time Feininger was five, he could draw them from memory. He and his best childhood friend, Frank Kortheuer, spent much of their free time together drawing pictures of trains and masted ships for their fantasy kingdoms, Colonora and Columbia, and making models of locomotives and yachts, which they sailed on the pond in Central Park.[22] When apart, the boys exchanged lengthy letters filled with humorous caricatures, detailed lists and descriptions of the boats and trains in their respective kingdoms, and intimate reflections on their daily activities. As an adult, Feininger considered his memories of these childhood experiences "sanctuaries" in which he could "seek comfort, to forget about the day's grievances and disappointments."[23] As if to summon his recollections of them, he filled his later art with images of trains and ships.

The childhood contentment that Feininger associated with his early years in America came to an end in October 1887, a few months after his sixteenth birthday. Before leaving for Europe on tour that June, his parents arranged for him and his sisters to board with a friend in Plainfield. Nine months earlier, at the behest of his father, who was concerned that his son might not succeed as a professional musician, Feininger had started an entry-level job as a messenger in the Wall Street brokerage firm of one of his father's friends.[24] He commuted daily to Wall Street from Plainfield, relocating to the city only when his sisters departed for the Ursuline Convent School near Louvain, Belgium.[25] In October, quite unexpectedly, he received word from his father that he should sail for

Europe and enroll in the Leipzig Conservatory. The precise details of what happened after he landed in Hamburg on October 25 are unclear. Apparently, upon discovering that his intended violin teacher was away, Feininger elected to stay in Hamburg and apply to the Allgemeine Gewerbeschule, the city's vocational school, rather than go to Leipzig and find another music teacher. He submitted the portfolio of drawings he had brought with him from America to the school, which admitted him immediately.[26]

fig 3. **Cover illustration, *Fest-Zeitung,*** 1888
Archives of American Art, Smithsonian Institution, Washington, DC

Feininger had drawn incessantly since childhood, and he and Kortheuer had taken informal art lessons from Kortheuer's aunt, but he had never considered art as a career. Indeed, he had come to Germany as an aspiring musician. Yet his decision to transport his drawings across the ocean and to apply precipitously to art school suggests both his inherent love of drawing and his ambivalence about pursuing the musical career his father had chosen for him.[27] Whatever his motives for applying to Hamburg's art school, Feininger's success there was immediate. That spring, the school's director personally promoted him to the upper-level class and selected thirteen of his drawings—far more than any other student—for the school's Easter exhibition.[28] For Feininger, the joy of being in art school settled his career choice. "Will you be a painter and my comrade through life?" he entreated Kortheuer. "I love it and am so determined as to my future calling, that Life would seem not worth struggling through if I could not follow this calling."[29]

At the end of the school term, Feininger moved to Berlin to prepare for the entrance exam to Berlin's Königliche Akademie (Royal Academy), Prussia's most prestigious fine art school.[30] He passed the exam easily in October 1888, as he reported to Kortheuer: "I made a brilliant examination at the Academy and was accepted after the first week, while *all* the rest of the candidates had to work 5 weeks and then out of 90 only 9 came in."[31] A month later, one of his drawings was selected for the cover of the *Fest-Zeitung*, which was published in conjunction with the students' masked winter ball (fig. 3). Feininger remained at the Academy for the next two years, mastering the essentials of chiaroscuro and modeling under the tutelage of Ernst Hancke (1834–1914)—but without enthusiasm, as his characterization of himself as a "bad student" and Hancke's end-of-the-year report confirm.[32] Indeed, what most engaged him—and what he spent all his free time doing—was drawing caricatures (figs. 4–6). For his birthday in July 1888, his parents had given him several caricature books by Wilhelm Busch (1832–1908), whose combination of pictures and rhymed texts had made him the most famous caricaturist in nineteenth-century Germany. "I caricature almost all my spare

time and have many fine caricature books from which I learn very much," Feininger wrote to Kortheuer. "I have improved greatly haven't I. You look back at my earlier caricatures and you will see that it was sheer luck if any of the figures had fun or expression in them. Only since my birthday when I got these books, have I commenced to improve, but have studied the style and all, *not* copying of course, but learning and so in this last week alone I have made great improvement. It is a favorite amusement of mine now."[33]

Soon thereafter, caricature shifted roles in Feininger's life—from amusement to profession. The change owed to his fortuitous residence in the Pension Müller, a Berlin boardinghouse on Unter den Linden overwhelmingly populated by foreigners and illustrators. His mother had returned to Berlin in October 1888 following her extended Brazilian tour with Karl. The couple's relationship had always been difficult, and after their tour Elisabeth had refused to return with Karl to the United States, where a job as head of the music department of the Low and Heywood School for Girls in Stamford, Connecticut, awaited him.[34] Instead, she and Lyonel moved into the Pension Müller, followed a year and a half later by Helen and Elsa. Feininger's roommate at the Pension was Fred Werner, an Australian music student whom he credited with introducing him to the fugues of Johann Sebastian Bach. The Baroque composer's fugues would remain a lifelong passion, but of more immediate significance for Feininger's career was his contact with fellow boarders Johann Bahr (1859–?), Otto Marcus (1863–1952), and Ludwig Manzel (1858–1936). All were illustrators for Berlin's comic newspapers, whose satirical social criticism was hugely popular at the turn of the century. Feininger later recalled how "the air in Frau Müller's boarding house was charged with electric experiences . . . it was here that the first seeds fell into spiritual understanding and led me unfailingly towards 'illustration' and 'caricature.'"[35] At the beginning of Feininger's second year at the Academy, Bahr showed the young American's drawings to the editors of *Humoristische Blätter*, which published four of them in January 1890.[36] Three months later, Feininger was so busy illustrating stories for this and other Berlin comic papers that he boasted of having become a "regular carikaturist [*sic*]."[37] In April, he reported to Kortheuer: "I earn quite a sum of money every month and am gradually earning more and more money, besides working more all the time. Soon I will be able to

fig. 4. **Illustrations on a postcard from Feininger to Fred Werner,** July 8, 1889
Art Gallery of New South Wales, Sydney, Australia

earn my own living!" He accompanied this letter with a sketch of himself pulling a cart full of his drawings, depicting "how busy I will be in about a year from now, so that I will be compelled to hire a truck to take my sketches to the papers as soon as I make them."[38]

By July 1890, Feininger had been in Germany for almost three years. Never once during that period had he given up hope of returning to his native country or ceased being homesick "for New York and dear old America."[39] His friends in Berlin were exclusively English-speaking—Fred Werner, and the Americans Alfred Churchill and Fritz Strothmann, both students at the Academy. Their status as expatriates exacerbated rather than assuaged his almost desperate longing "after old friends and places."[40] "I would give anything to get back to America," he had lamented to Kortheuer in March.[41]

Decades later, Werner recalled the intensity of Feininger's patriotism during this period.[42] To return to America, he needed to be able to support himself, a requirement made all the more necessary by his parents' separation and his father's recent lack of success performing. Indeed, assessing the family's finances that June, Feininger concluded, "We are hardest up at present than we ever were."[43] Hoping that his success at illustrating for Berlin's comic newspapers would persuade his father that he could earn a living in New York drawing caricatures for the American humor magazines *Life* and *Judge*, Feininger proposed that he return to America and, if needed, once again work as a messenger on Wall Street until he was able to "earn a competence" from illustration.[44] He was jubilant when his father agreed to consider the proposal during his two-month visit to Berlin beginning the end of June. "I have a piece of grand news for you, that is, there is every chance of its happening: that is: I am coming to America in September!!!!" he jubilantly announced to Kortheuer. "I hope my father won't change his mind. He is in New York all alone I suppose you know, and told me I might come to live with him."[45] In retrospect, it seems likely that Karl's purpose in visiting Berlin was to persuade Elisabeth to accompany him back to America. His failure and subsequent return to America without his wife and family destroyed Feininger's immediate hope of repatriating and engendered conflicting familial allegiances, which would later complicate his decision about where to live.[46]

For the present, Feininger's lack of general education determined his place of residence. Following what he called his father's "grand consultation" with him that summer, it was decided that Feininger should attend the Jesuit Collège Saint-Servais in Liège, Belgium. Having been pulled out of school at age fourteen for health reasons, Feininger conceded that getting "what education I could, within the next two or three years" before launching a career was sensible.[47] Only in later years was this conclusion overshadowed by his memory of his father's harsh response later that summer to Feininger having pawned his watch:

I shudder to think of that date. . . . It was the most disastrous day I ever went through. I was judged, and condemned by my father for having pawned my watch for 3 Marks. Until I was finally deported to Liege on the 2nd of September my father didn't give me one good word, in fact didn't speak to me anymore. And [I] never saw him again as long as he lived. . . . Though maybe improvident and careless as a youngster, I was tenderhearted and sensitive, the soul searching for love and understanding, and trusting in a father's wisdom. . . . Though 19, I was still almost a child, with no experience, taking life subjectively. My friends were all and everything to me. I went with them through fire and water, to *them* I felt my life bound, more than to my parents. It was the most natural thing in the world to pawn a watch if one of these beloved beings was in a strait and one could help him by doing so.[48]

fig. 6. **Illustration in a letter from Feininger to Frank Kortheuer,** July 24, 1889
Collection of the late Horace Richter

At the time of this incident, Feininger did not know that he would never see his father again. Thus, he arrived at Saint-Servais in September 1890, enthusiastically anticipating that "these two years or so which I shall spend here will no doubt be of the greatest possible benefit to me."[49] The college he entered was theologically dominated by the post-Reformation Catholic embrace of Saint Augustine's writings, whose argument that faith and reason could mitigate the burden of original sin had shifted the church's focus to an awareness of God's love and the inherent goodness and beauty in all His creations. For Feininger, who had long sensed "the glory there is in Creation," this theology struck a chord.[50] "There is more pureness in this community of boys, owing to the good reverend fathers than I have ever enjoyed," he wrote of the Jesuit college. "This life removes darker cares and brings one back to a long unfelt simplicity and lack of self consciousness, which make life much better worth living; and one has again ambition for the future."[51] Feininger had entered Saint-Servais determined to lay what he called "a moral foundation for his future."[52] Applying the Jesuits' teachings about God's presence in the secular world to the school's thrice-weekly sketching expeditions in the Liège countryside clarified his view of art as capable of inducing awareness of God. Liberated from the Academy's "musty Hanckian temple" by the "taste of air and freedom" he experienced sketching out of doors, Feininger reexamined his goals as an artist, ultimately concluding that what was important in art was rendering the material world "human and yet, divine."[53] The corollary—that apprehending the divinity in everyday life required "true and humble work after Nature"—was an epiphany Feininger never forgot.[54]

At age nineteen, Feininger was significantly older than his classmates at Saint-Servais. His emotional estrangement from them by virtue of age, experience, and language gave rise to feelings of solidarity with the Jesuits, whose expulsion from France in 1762 he equated with his own involuntary expatriation from America. He later memorialized his identification with the Society in his 1906 *L'exode* (The Exodus) by depicting himself leading the Jesuits as they exited Paris (fig. 8). The sect's belief in humanity's potential for moral improvement and their comparatively benevolent attitude toward moral weakness appealed to Feininger. In his later work, he often portrayed the Jesuits in their black cassocks and birettas, walking alongside peasants and prostitutes through narrow streets bordered by houses with crooked walls and uneven windows,

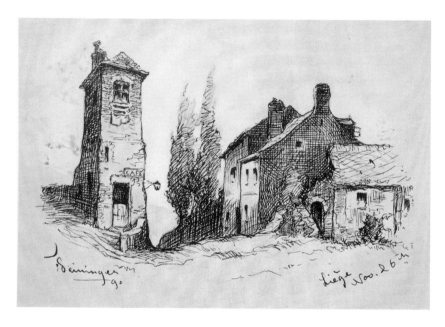

symbols of the hope that God's grace could gradually be achieved by discipline and reason. Feininger bequeathed his admiration of them to his middle son, Laurence, who became a Catholic priest researching Baroque liturgical music in the Vatican library.

While at Saint-Servais, Feininger had drawn continuously (fig. 7). As the school term came to a close and he approached his twentieth birthday, he appealed to his father to allow him to pursue an art career rather than be put "in business," as Karl had threatened.[55] After an exchange of letters, Karl relented and gave his son permission to return to Berlin and reenter the Academy. For the next six weeks, Feininger studied in the private art school run by Adolf Schlabitz (1854—1943) in Berlin, drawing portraits and masks in preparation for reapplying to the Academy in the fall.[56]

That September, Woldemar Friedrich (1846—1910), widely considered the Academy's best teacher, exempted Feininger from the examination process and admitted him into his upper-level drawing class.[57] Feininger's prestige rose even further after Friedrich gave him permission to work at home, making him a self-described "big name among the academicians."[58] But Feininger had returned to the Academy a changed student and the professors' disregard for art's spiritual dimension—what he called its "meaning and inwardness" and the "soul of the artist"—bothered him.[59] Convinced that the Academy's emphasis on drawing plaster statues rather than live models stifled art's essential spirituality, he resolved to go to Paris, which he imagined would be more hospitable to personal expression. "If my people won't hear of it, I'll *elope*," he announced to Churchill.[60] In order to earn enough money for the trip, he resigned from the Academy in March of 1891 and began illustrating stories for the *Berliner Illustrierte Zeitung* and drawing what would ultimately number more than 240 illustrated labels for cigar boxes.[61] Nine months later, he had financed his trip.

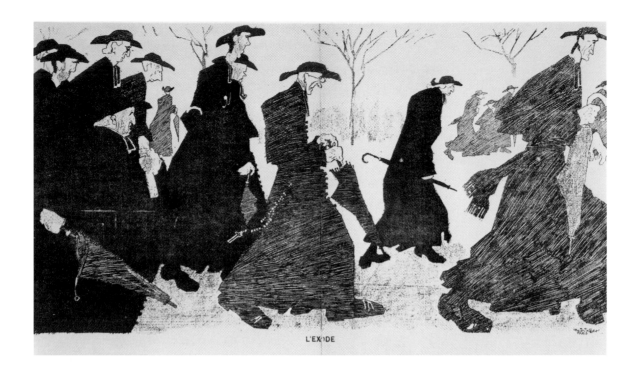

L'EXODE

fig. 8. **"L'exode" (The Exodus),** from *Le Témoin I,*
no. 11, 1906

Feininger arrived in Paris in November 1892. He spent the next seven months sketching figures on the street and drawing nudes at the Académie Colarossi, where, for a modest fee and no entrance exam, he could spend three hours in the evening drawing live models who changed poses every five minutes. Unlike the majority of artists who went to Paris, Feininger had no interest in participating in the city's art scene. He visited few art exhibitions during his stay, confessing later that he had failed to see even the work of Claude Monet; his only goal had been to perfect his skill at drawing. "It is the greatest value to me to acquire surety of hand and eye," he would later write of sketching. "To seize instantly the character of an object whether animate or otherwise—it is the surest method of gaining dexterity in one's fingers."[62] Even after he returned to Berlin, he continued sketching the figures he saw from his bedroom window or during walks in the street.

Illustrations and Comics

Feininger returned to Berlin in May of 1893, determined to "flood" the comic papers with his drawings.[63] Armed with the insight that the combination of humor and fantasy in children's books, nonsense stories, and fairy tales was perfectly suited to "call out my powers and make me happy in work,"[64] he methodically scoured museums and libraries for material with which to create historical-looking characters to situate "into quaint tales and legends."[65] With an eye toward returning home, he singled out the stereotypical ancestors of America's European immigrant population.[66] He sent drawings to Harper Brothers in New York, which began in January 1894 to regularly purchase them to accompany nonsense stories written by John Kendrick Bangs for *Harper's Young People* (fig. 9).[67]

fig. 9. **Illustration for "How Fritz Became a Wizard,"** by John Kendrick Bangs, from *Harper's Young People* XV, October 2, 1894

Having his work validated by an important American publishing house elated Feininger, who felt that his chances of earning a living in America—and, by extension, the possibility of his imminent return home—had increased dramatically.

All this changed in December 1894, when Manzel, staff cartoonist for *Ulk* (Joke) whom Feininger had known at the Pension Müller, recommended him for a job at the Berlin weekly humor magazine. Feininger wavered, cognizant that illustrating for *Ulk* would relieve his current poverty, but would also consume so much of his time that he would need to sever his ties with *Harper's Young People*, his pathway back to America. Financial considerations ultimately prevailed and Feininger began working for *Ulk* in January 1895. By the time he joined its ranks of illustrators, the magazine had become an eight-page comic supplement whose liberal slant echoed that of its parent newspaper, the *Berliner Tageblatt*, the highest-circulation paper in Germany. The humor of *Ulk*'s caricatures lay in the dynamic between the text, usually supplied by the editor, and the illustrator's drawing.[68] Feininger's tenure at *Ulk* was highly rewarding. In his first two years, the magazine published more than two hundred of his drawings, including seven it selected for covers. Employment as a regular artist on such a prominent satirical weekly was prestigious, and it was not long before *Lustige Blätter* (Funny Pages) and *Das Narrenschiff* (Ship of Fools), two other Berlin satirical magazines, began publishing his illustrations.[69] In contrast to *Ulk*, whose printing capabilities were limited to black, white, and occasionally red, these periodicals used four-color, half-tone screens. Feininger's skill at eliciting dramatic color effects from this process, combined with what he called his "rampaging fantasie" and inborn "love of the DRASTIC," gained him immediate popularity with the

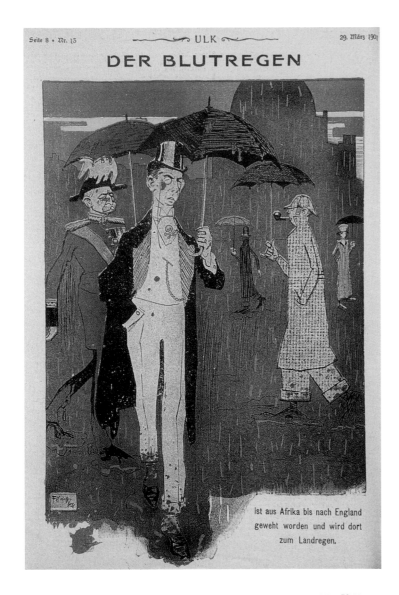

DER BLUTREGEN

ist aus Afrika bis nach England
geweht worden und wird dort
zum Landregen.

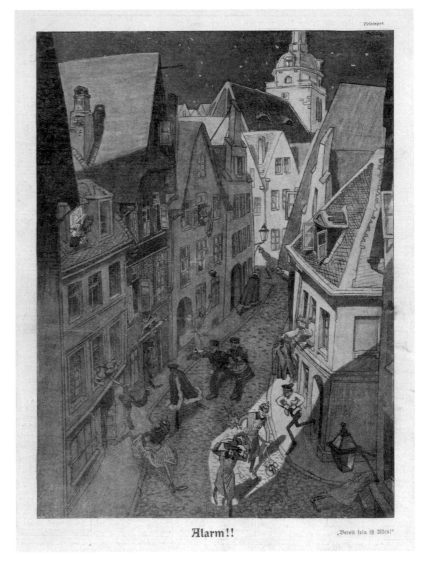

Alarm!! „Bereit sein ist Alles!"

fig. 10. **"The Bloodrain (has blown from Africa to England, and there it will last),"** from *Ulk* XXX, no. 13, 1901
Private collection

fig. 11. **"Alarm!! Being Ready Is What Counts!"** from *Lustige Blätter* XVIII, no. 52, 1903
Kunstbibliothek, Staatliche Museen, Berlin

public.[70] Boasting to Churchill that he was a "power in the land" and his name a household word among illustrators, he conceded that it was "a sweet sensation to know that one is in touch with so great a portion of humanity."[71]

The same penchant for exaggeration that made Feininger a successful illustrator had its dark side. "Morbidly lonesome" in Germany, he was often possessed by what he called the "leaden fiend of despondency."[72] By 1895 his parents' divorce, initiated in 1890 after Karl's unsuccessful attempt at reconciliation, was in its final stages; fiercely loyal to his father, with whom he had reconciled after their quarrel, Feininger felt a gulf between himself and his mother and sisters "too deep to be ever entirely bridged over."[73] The clouds that Feininger saw as hanging over his family became even darker in July 1897, when his sister Helen contracted tuberculosis.[74] Up until then, Feininger had regularly predicted his imminent return to the United States. In December, when it looked as if Helen would recover, he announced the coming year as "the last of my involuntary stay" in Germany, where he had been "dumped 10 years ago as a kid."[75] This hope dissolved when his youngest sister, Elsa, caught the disease and died in November 1898.[76] Three

months later, Helen died too, her earlier recovery having been an illusion. More alone than ever, and bound now to Germany by responsibility for his mother, whose income as a piano teacher barely kept her solvent, Feininger would feel for years to come that he had "lost the ability of feeling free from sadness."[77]

Feininger's longing for companionship seemed answered in 1900 when he met the pianist Clara Fürst, daughter of decorative mural painter and Berlin Secession member Gustav Fürst. Clara's connection to both music and fine art made her seem an ideal mate and the two married in early 1901. Their first child, Eleonora (Lore), was born that December; a second daughter, Marianne, followed eleven months later. By then, Feininger had been in Germany almost half his life, "still a typical American, with 'American' oozing from every pore, so that on the streets I continually am pointed out by passers-by as 'the true American.'"[78] But now his nostalgia for America vied with responsibility for his family and his dread of uncertainty.[79] "Here I sit," he wrote to Kortheuer in 1903, "a success in a way but just for that reason unable to leave the scene of my success since I should have to begin all over again."[80]

The marriage was unhappy almost from the start, its failure exacerbated by Feininger's growing discontent with his work. He remained exceedingly popular professionally, with drawings appearing regularly in *Ulk* and in almost every issue of *Lustige Blätter* and critics calling him "first among Berlin draftsmen" (figs. 13–15).[81] But with the increase in his abilities had come mounting dismay at the careless way his drawings were printed. "It breaks my heart to see my things printed like that!" he bemoaned to Churchill.[82] Even more dispiriting was the creative process, which was controlled by the editor, who typically determined the drawing's content and often its design, sometimes going so far as to create a sketch for the illustrator to follow.[83] As the editor of *Lustige Blätter* explained, "The editor designs the drawings, establishing the content; often he stipulates this right down to the details, and he expects the artist to follow these instructions. If an editor has a good inventive imagination as well as an ability to draw, he will send a black-and-white or colored sketch as a guide. This method puts a certain constraint on the artist, although it also prevents him from failing to produce what the editor needs."[84] Occasionally the comic magazines published drawings Feininger created independent of editorial demands. Under the guise of fantasy, works in which a malevolent steam engine races

fig. 12. **The Furious Locomotive,"** from *Der liebe Augustin* I, no. 15, 1904
Lyonel-Feininger-Galerie, Quedlinburg, Germany

off a viaduct in pursuit of a terrified fleeing man or people run helter-skelter through crooked alleyways at night from a nameless danger reflected Feininger's view of himself as "a fantastic dweller on the negative side of the sublime (figs. 11, 12)."[85] The exaggerated perspective and anthropomorphic treatment of mechanical gadgets and machines in these drawings attracted the attention of the Berlin Secession, an artist-run group formed in 1892 after the Academy closed that year's annual exhibition of the Verein Berliner Künstler (The Association of Berlin Artists) because it included works by the Norwegian Symbolist painter Edvard Munch (1863–1944). Under the leadership of German Impressionist painter Max Liebermann (1847–1935), the Secession had played a seminal role in transforming Berlin into the country's primary marketplace for modern art. Possibly at the instigation of his father-in-law, the group included Feininger's drawings in its annual exhibitions from 1901 to 1903 alongside the work of illustrators Thomas Theodor-Heine (1867–1948), Aubrey Beardsley (1872–1898), and Heinrich Zille (1858–1929).[86]

By 1904, however, Feininger had sunk into a numb, "lifeless stupor," as he described it.[87] Emotionally estranged from his wife and children and overcome by an "inner deadness," he failed to submit work to the 1904 and 1905 Berlin Secession exhibitions.[88] Escape came in August 1905 during a family vacation to the Baltic seaside town of Graal, when he met twenty-four-year-old Julia Berg, an aspiring artist and amateur musician who recently had left her doctor husband. The daughter of a prominent, highly assimilated German-Jewish family, Julia had all but converted to Christianity. Her father, Bernhard Lilienfeld, was a successful factory owner; his twin brother, Hermann, also a businessman, had started his career as a rabbi. On her mother's side, Julia was an heir to the prosperous coffee company Zuntz and counted among her cousins Albert Bing, the music conductor and early composition teacher of Kurt Weill.[89] In Julia, Feininger believed he had found the partner for whom he had been yearning for years, someone whose wishes and thoughts were so coincident with his own that he could surrender himself and his fate into her hands.[90] Immediately upon his return to Berlin, he separated from his wife and began an intense correspondence with Julia, who had meanwhile enrolled in Weimar's Kunstgewerbeschule (School of Applied Arts).[91] In the multiple love letters they exchanged daily, Julia fortified Feininger's resolve to create an independent art, free of restrictive commercial demands.[92]

fig. 13. **"The First Salutation (in New York Harbor): 'Check, Please,'"** from *Lustige Blätter* XIX, no. 26, 1904 Lyonel-Feininger-Galerie, Quedlinburg, Germany

Feininger's chance to liberate himself from his current employers came in February 1906, with a visit from *Chicago Tribune* editor James Keeley, who offered him a position as comic artist on the newspaper's Sunday supplement.[93] "I have to report a momentous event, something heavy, important—something I have been waiting for like for a calling—my future in America," he wrote to Julia.[94] By 1906, comics had become critical to circulation for American newspapers. Indeed, Keeley's trip to Germany to recruit humorists was part of a strategy to compete against the *Chicago American*, whose *Katzenjammer Kids* strip, created by German immigrant Rudolph Dirks (1877–1968), was causing the *Tribune*'s sales to plunge. By signing on well-known German caricaturists, the newspaper hoped to appeal to Chicago's large German community while simultaneously raising the level of American comics. For Feininger, the "call to freedom" from his native land seemed irresistible; but his decision about whether to accept the *Tribune*'s offer, which was contingent on his eventual relocation to America, was complicated by ongoing litigation over his and Julia's respective divorces.[95] "I won't accept. I cannot. . . . We first would have to be free," he wrote to her.[96] Over the next two weeks, they deliberated the offer in their letters. After traveling to Weimar to consult with Julia in person, Feininger signed a contract with the *Tribune* and began at once designing *The Kin-der-Kids*, hopeful that his wife would accept his alimony proposal and that he could return to America with Julia in November, right after her divorce.[97]

Feininger's American citizenship, coupled with his status as the "foremost comic artist in Europe," as the *Tribune* dubbed him, made him the paper's logical choice to launch its new comic supplement.[98] On April 29, 1906, the front page of the supplement carried the lanky figure of "your uncle Feininger" introducing the Kin-der-Kids— Daniel Webster, the voracious reader; constantly hungry Piemouth; and Strenuous Teddy, whose name was a play on President Theodore Roosevelt's "strenuous life" campaign—along with their evil pursuers, Aunt Jim-Jam and Cousin Gussie (figs. 19–21). Over the next nine months, *Tribune* readers watched the brothers narrowly escape from their aunt and cousin in an assortment of mechanical gadgets and flying machines and with the help of a character called Mysterious Pete. The strip was distinguished by Feininger's treatment of the page as an overall design, with clearly demarcated silhouettes, flat color planes, and abstract patterns that resem-

Besuch am Balkan.

Ferdinand: Donnerwetter, schwer ist aber Deine Krone, Bruder Peter!
Peter: Ja, das einzige Gute ist: Hierzuland braucht sie keiner lang auf dem Kopf zu tragen!

fig. 14. **"Visit to the Balkan (Ferdinand: Gosh! How heavy your crown is, brother Peter! Peter: Quite. The only good thing is that around here, no one needs to carry it for long!),"** from *Lustige Blätter* XIX, no. 44, 1904
Lyonel-Feininger-Galerie, Quedlinburg, Germany

bled Japanese woodblock prints. References to Japanese prints and Arts-and-Crafts design were even more pronounced in Feininger's second strip, *Wee Willie Winkie's World*, whose entire story line consisted of a young boy walking through the countryside observing the kindly, anthropomorphic actions of animate and inanimate forms: a sun yawning as it descended the horizon; trees running away from giant caterpillars; a rain cloud that metamorphosed into an old woman with a watering can (figs. 22–24). By allowing Feininger to experiment freely with abstract designs within the context of a benevolent and harmonious natural world, the strips alerted him to a new way of imagining his art. As he acknowledged later, "Only starting with Kin-der-Kids and Wee Willie Winkie did a part of my own creativity emerge!"[99]

Though constrained from returning to America by his and Julia's unresolved marital status, Feininger was at least freed by the *Tribune*'s salary from having to remain in Berlin to attend *Lustige Blätter*'s weekly editorial conferences. He joined Julia in Weimar, a small city in the state of Thuringia, using it as a base to explore the surrounding villages of Oberweimar, Vollersroda, Mellingen, and Gelmeroda, among others. Since his trip to Paris in 1892–93, he had been an inveterate sketcher, forever jotting down his impressions of people and architecture. He regarded these "nature notes" (*natur-notizen*) as he called them, the "greatest treasure you can build on."[100] Drawn with lead or colored pencil, sometimes with great precision, sometimes sketchily, these notes—which Feininger meticulously dated and filed—served as archives of memory, supplying him with motifs for his art, often years after the initial sketch was made. This working method mirrored his experience as an illustrator, which Feininger credited with teaching him to quickly sketch the essentials of his subject, afterward utilizing memory and imagination to transform his sketch into a final composition.[101]

fig. 15. **"The Pied Piper of England (Little Christian of Denmark: He plays so enticingly, should I follow?),"** from *Lustige Blätter* XX, no. 42, 1905
Lyonel-Feininger-Galerie, Quedlinburg, Germany

Feininger and Julia had been together in Weimar only five months when their "fairy-tale time" came to an end.[102] With their divorces still unresolved and Julia now pregnant, the couple felt they could not remain in Germany. Taking advantage of the freedom of mobility made possible by Feininger's *Tribune* salary, they went in late July to Paris, where they spent the summer and fall sketching and working quietly in their apartment during the day, and, in the evening, going for walks and playing music on rented

instruments, Julia on a reed organ and Feininger on a violin. It was not until several months after the birth of their first son, Andreas, on December 27, 1906, that Feininger ventured into the Parisian art world.

Feininger's entry point into the city's art world was the Café du Dôme, the meeting place for German-speaking artists in Paris. There, he came in contact with Hans Purrmann (1880–1966), Rudolf Grossmann (1882–1941), Oskar Moll (1875–1947), Rudolf Levy (1875–1943), Walter Bondy (1880–1940), Jules Pascin (1885–1930), and Richard Götz, all of whom were ardent disciples of Henri Matisse and Fauvism, which had debuted in the 1905 Salon d'Automne.[103] Matisse's influence within the café would grow even greater in January 1908 when he opened his art school to the public, thanks in part to Purrmann, whom Feininger considered the most "distinct character of them all."[104] Although Fauvism was the favored style of Dôme artists by the time Feininger began frequenting the café, Paul Cézanne's work was also attracting converts and sparking debate as a result of his memorial retrospective at the 1907 Salon d'Automne. Pablo Picasso's completion that year of *Les Demoiselles d'Avignon*, long considered the first Cubist painting, was less well known, but ideas that would lead to Cubism were already in the air. Feininger did not immediately embrace these vanguard styles, but his introduction to them through friends in the Dôme circle gave him a new way to think about art. "The paintings of the artists with whom I was acquainted in Paris (the Dôme group especially) began to acquire new meaning for me," he later wrote. "Also the postulate that the artist should be an experimenter, seek out logical and constructive solutions—create *synthetically pure* forms."[105]

Through the Dôme circle, Feininger also came to know individuals involved with *Le Témoin* (The Witness), a satirical journal edited by Paul Iribe. The journal's first issue appeared in October 1906, one month before the *Chicago Tribune* canceled Feininger's contract, purportedly because of his unwillingness to move to the United States until his divorce was finalized. In fact, the newspaper dropped all five of its German artists, even those who had moved to Chicago; they had been hired in an effort to increase circulation, but the

fig. 16. **"The Child-Murderess (She herself, oh God, has killed her child, the little Delcasse. Now he sits in formaldehyde, and whenever she sees him, she cries bitterly),"** from *Lustige Blätter* XXI, no. 2, 1906
Kunstbibliothek, Staatliche Museen, Berlin

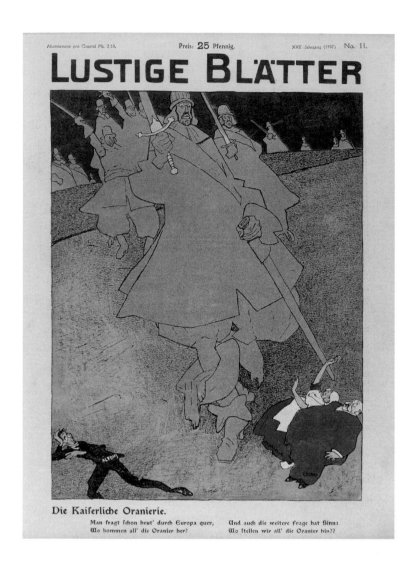

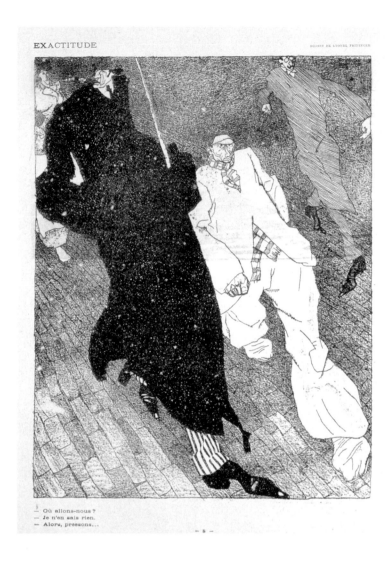

fig. 17. **"The Royal Dutch House of Orange (People are asking all over Europe: Where do all the Dutch sympathizers come from? What will we do with all of them?),"** from *Lustige Blätter* XXII, no. 11, 1907 Lyonel-Feininger-Galerie, Quedlinburg, Germany

fig. 18. **"Exactitude,"** from *Le Témoin* II, no. 43, 1907 Collection of Danilo Curti-Feininger

experiment had largely failed. Feininger's termination made his introduction to the newly launched *Le Témoin* immensely fortunate, allowing him to offset some of his lost income with work for a journal that was totally committed to artistic freedom and whose editor supplied captions *after* drawings were made, unlike the Berlin papers. Feininger took full advantage of this artistic autonomy by reducing his images to the flat, patterned shapes he had introduced in his comics and subverting the scale relationships of figures and objects by depicting them from different perspectives or vantage points (fig. 18). The resulting compositions, in which incongruously gigantic and diminutive figures occupy the same space or appear to be moving at such speed that they seem weightless, were at once comical and disquieting. The style became Feininger's trademark, even in the occasional drawings he submitted to *Lustige Blätter*, which periodically printed his work despite the publisher's objections that his "grotesque and extreme tone" was out of touch with German popular taste (figs. 16, 17).[106]

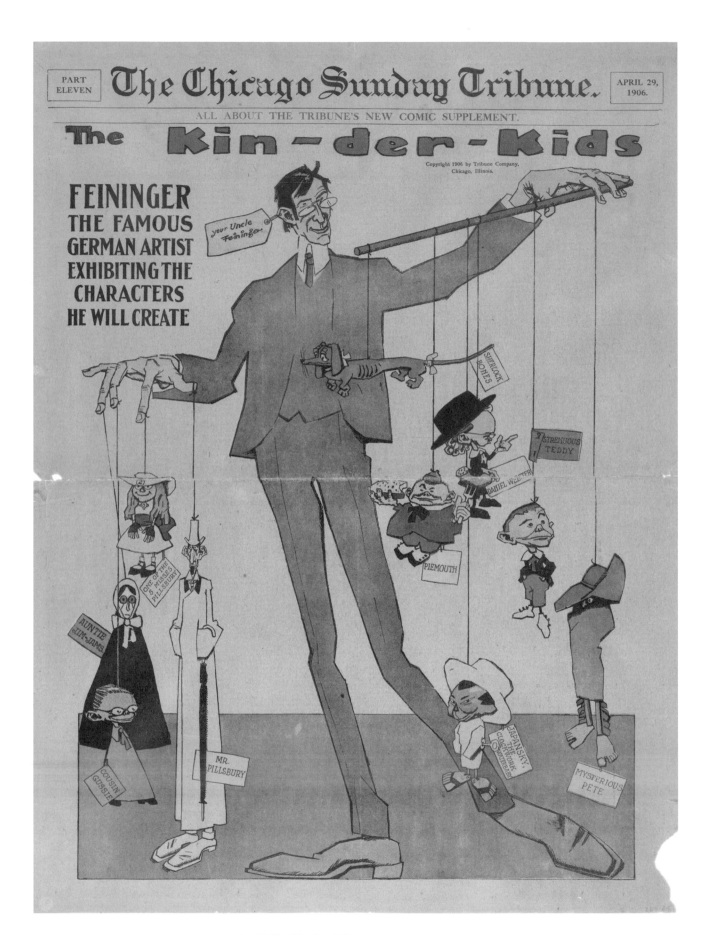

fig. 19. *The Kin-der-Kids*
From *The Chicago Sunday Tribune*, April 29, 1906
Commercial lithograph, 23⅜ x 17¹³⁄₁₆ in. (59.4 x 45.3 cm)
The Museum of Modern Art, New York; gift of the artist 260.1944.1

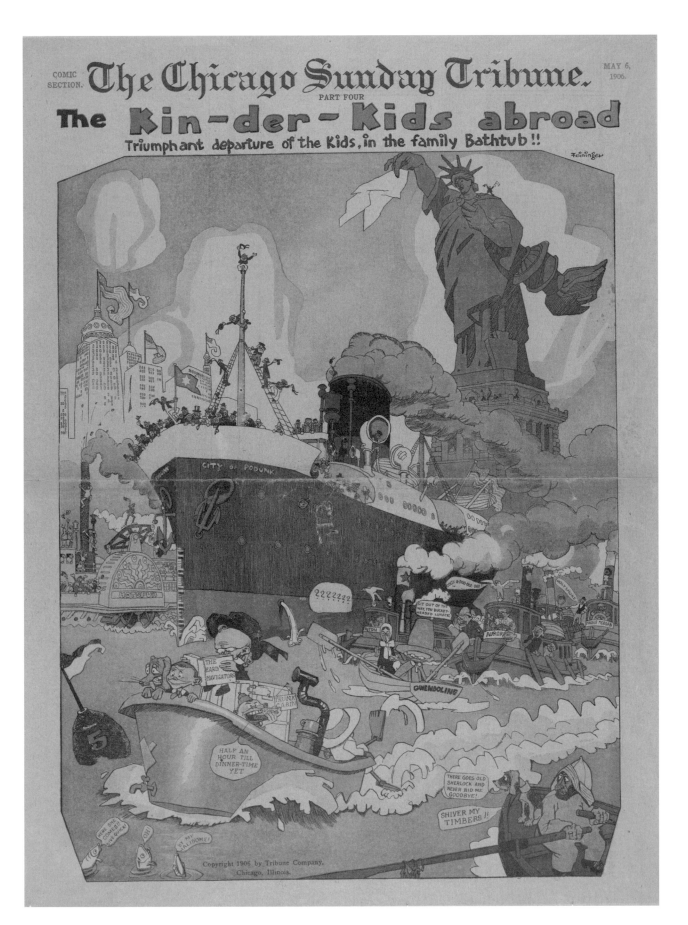

fig. 20. **_The Kin-der-Kids (Abroad)_, "Triumphant Departure of the Kids, in the Family Bathtub!!"**
From *The Chicago Sunday Tribune*, May 6, 1906
Commercial lithograph, 23⅜ x 17¹³⁄₁₆ in. (59.4 x 45.3 cm)
The Museum of Modern Art, New York; gift of the artist 260.1944.2

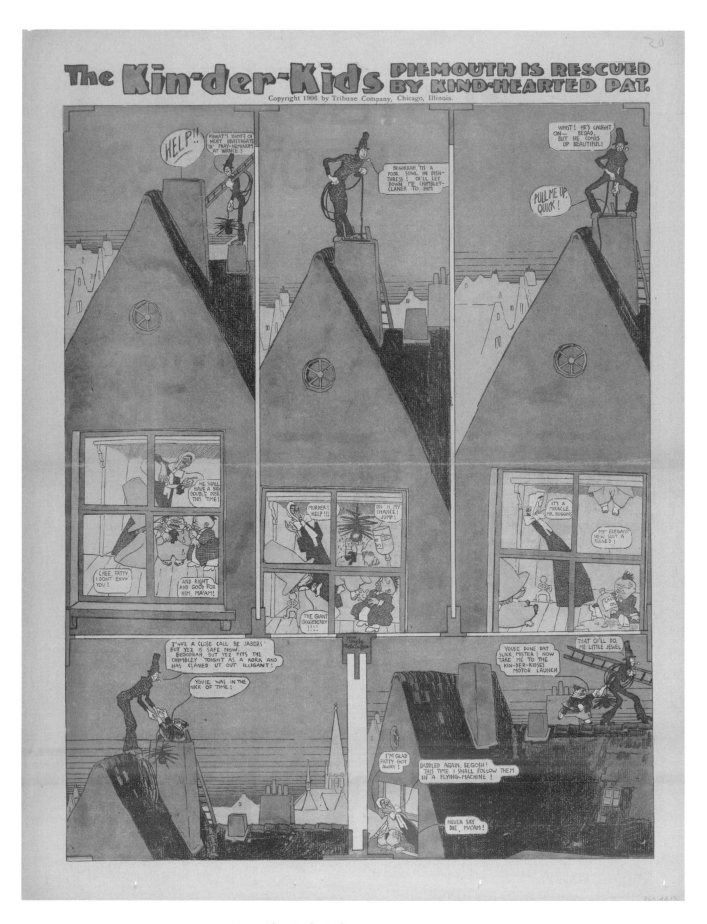

fig. 21. *The Kin-der-Kids,* **"Piemouth Is Rescued
by Kind-Hearted Pat"**

From *The Chicago Sunday Tribune*, September 9, 1906
Commercial lithograph, 23⅜ x 17¹³⁄₁₆ in. (59.4 x 45.2 cm)
The Museum of Modern Art, New York; gift of the artist 260.1944.19

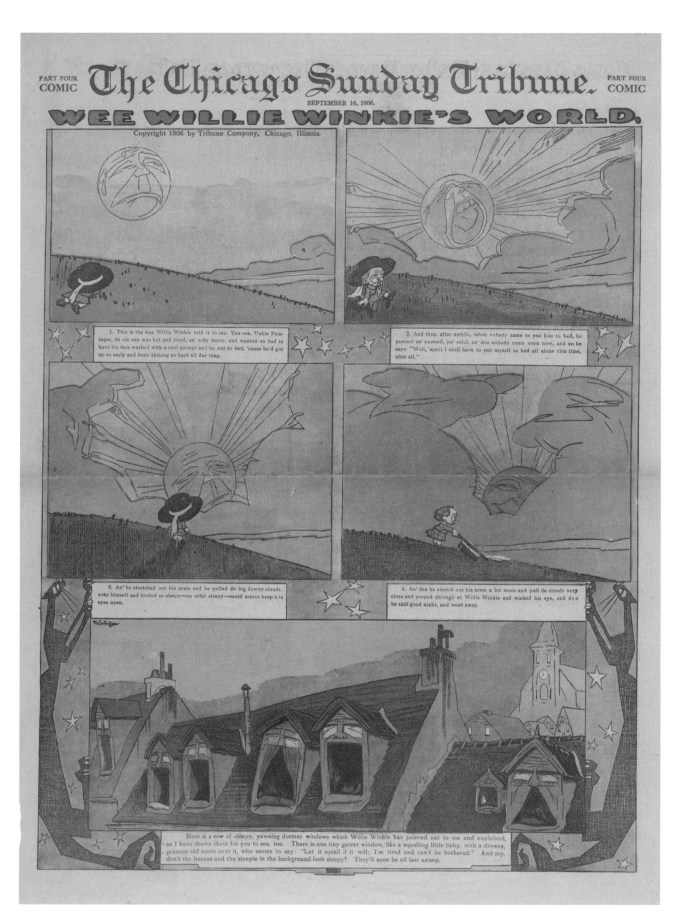

fig. 22. *Wee Willie Winkie's World*

From *The Chicago Sunday Tribune*, September 16, 1906
Commercial lithograph, 23½ x 17¹³⁄₁₆ in. (59.7 x 45.2 cm)
The Museum of Modern Art, New York; gift of the artist 61.1944.4

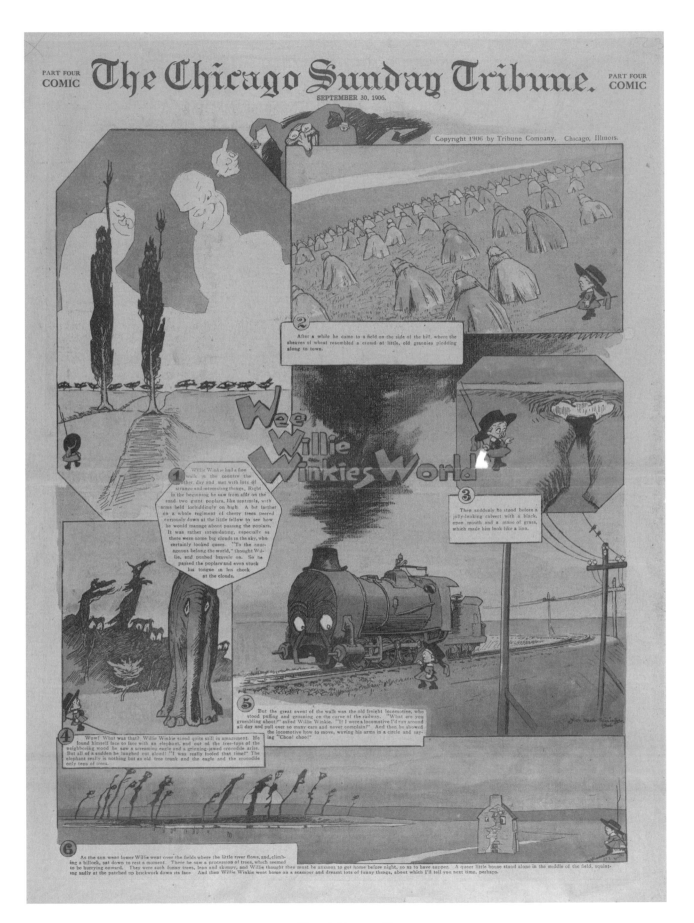

fig. 23. **Wee Willie Winkie's World**
From *The Chicago Sunday Tribune*, September 30, 1906
Commercial lithograph, 23½ x 17¹³⁄₁₆ in. (59.7 x 45.2 cm)
The Museum of Modern Art, New York; gift of the artist 261.1944.6

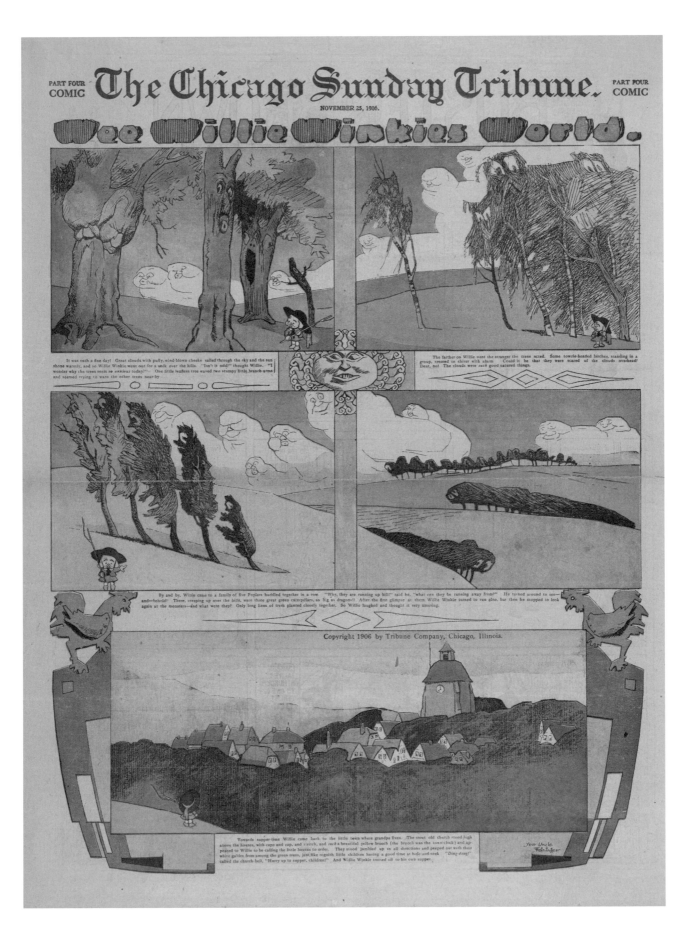

fig. 24. **Wee Willie Winkie's World**
From *The Chicago Sunday Tribune*, November 25, 1906
Commercial lithograph, 23½ x 17¹³⁄₁₆ in. (59.7 x 45.2 cm)
The Museum of Modern Art, New York; gift of the artist 261.1944.9

A Painting Career Begins

Despite the freedom Feininger enjoyed in his work for *Le Témoin*, his goal since entering art school had been to be a fine artist. "I crave after *serious* work," he had declared to Kortheuer in 1898, "and that is what I mean to turn to when I can properly study."[107] His immersion in a community of vanguard artists in Paris intensified his ambition. In the spring of 1907, as a thirty-five-year-old successful illustrator, he courageously quit illustration and determined to teach himself to paint. He began with small studies on board of still lifes and Parisian architectural subjects, painted in situ. That summer on a trip to the Black Forest and the Baltic island of Rügen, he expanded his repertoire to include images of haystacks and farmhouses (fig. 25). He considered the more than twenty small oils he produced in his six months of self-instruction "comfortless things," but the experi-

fig. 25. **Farmhouse (Gray Mood),** 1907
Oil on board, 14¾ x 19¼ in. (37.5 x 48.9 cm)
Private collection

ence of making them yielded a lifelong insight: what is observed in nature cannot simply be recorded, but must be internally crystallized and transformed.[108] "It is almost impossible to get away from *observed* reality," he acknowledged. "What one sees must undergo an *inner transformation*, must be reshaped and crystallized before even one brushstroke is made."[109] Rarely again would he paint directly from life. Instead, he would use his "nature notes" as triggers for paintings that amalgamated observed reality, memory, and imagination.

By the time Feininger returned to Paris in October 1907 from his six-month painting tutorial, he was ready to move into a more ambitious phase of his art. Cognizant that his whimsical distortion of reality had been key to the success of his caricatures, he took Julia's suggestion of adapting their subject matter to oil. His first two mature oils, *The White Man* and *The Proposal*, were direct transcriptions of illustrations he had created for *Le Témoin* (figs. 26, 27, 32, 33). In them and the paintings that followed, his aim was to compose images out of silhouettes similar to those in advertising placards and the cut-out tin figures in amusement park shooting galleries. That these planar silhouettes also resembled the paper cutouts Julia was making for their young son was not a coincidence: "I thought I would like to paint as clearly as these cutouts," he later attested.[110] Not surprisingly, given the enthusiasm for Matisse within the Dôme circle, Feininger's colors were high-key and non-descriptive. The tilted perspective, foreshortening, and scale distortions he had used in his caricatures became more exaggerated following his visits to the Galerie Bernheim-Jeune's January 1908 exhibition of Vincent van Gogh's work, which Feininger later cited as his dominant influence during this period.[111] His subject matter was a picaresque carnival world set in his "beloved romantic period" of the 1820s and 1830s.[112] With their saturated, rainbow colors, his depictions of Biedermeier-era inhabitants of small villages engaged in everyday activities—sitting on the shore, rushing hurriedly to and from work,

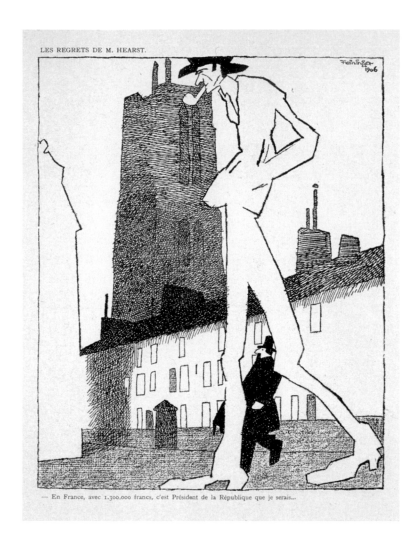

LES REGRETS DE M. HEARST.

— En France, avec 1.300.000 francs, c'est Président de la République que je serais...

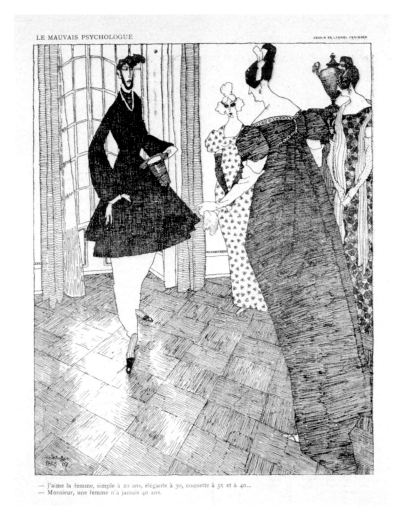

LE MAUVAIS PSYCHOLOGUE

— J'aime la femme, simple à 20 ans, élégante à 30, coquette à 35 et à 40...
— Monsieur, une femme n'a jamais 40 ans.

fig. 26. **"Les Regrets de M. Hearst" (The Regrets of M. Hearst),** from *Le Témoin* I, no. 6, 1906
Collection of Danilo Curti-Feininger

fig. 27. **"Le Mauvais Psychologue" (The Evil Psychologist),** from *Le Témoin* II, no. 27, 1907
Collection of Danilo Curti-Feininger

strolling at leisure through crooked village streets—exuded an air of romantic nostalgia similar to the mood that enchanted Feininger in Victor Hugo's *Les Misérables* (1862). "It is my favorite book," he wrote Julia. "It is deeply poetic, deeply romantic, but imbued with a noble spirit and it evokes our Paris of the twenties and thirties so enchantingly."[113] Feininger had inherited his idealized view of this period from his father, but he was not alone in viewing it with romantic nostalgia. By the turn of the century, the association of pre-1848 Europe with harmony, stability, and community had unleashed a widespread Biedermeier revival.

Feininger's courage to shift from illustration to fine art owed in part to Julia's unyielding belief in him and his art. "The actual existence of my 'self' commenced when we first met," he later testified. "I would still be nothing but a commercial worker at illustrated periodicals, without ever finding a way out, but for you! You recognized the spiritual potential within me. . . . I would never have achieved creative work but for you."[114] In addition to providing Feininger with unquestioning emotional support, Julia brought significant financial resources to the relationship. An only child, Julia received a monthly allowance of 950 marks, which paid for the couple's daily living expenses, including at least one maid and a baby nurse, as well as their summer vacations in the Baltic. In the

years after 1907, when Feininger was developing his art, the allowance from Julia's family allowed him the luxury of painting full time with only occasional distractions from commercial art assignments.

Feininger and Julia had obtained divorces from their respective spouses in 1907 after acrimonious negotiations, but they were prevented from marrying in both Germany and France by matrimonial laws against anyone involved in adultery. On September 25, 1908, after three years of waiting and one failed attempt, they were finally married in London. That fall, they moved as a married couple into a spacious rented villa in Zehlendorf, a suburb of Berlin. With the arrival of their second son, Laurence, on April 5, 1909, Feininger felt impelled to renew his career as an illustrator. But the preceding three years of unconditional aesthetic freedom made the full-time return to commercial work seem like prostitution.[115] He despaired at the indignity of having to grovel for commissions and the humiliation of being ignored by editors who passed him over in favor of younger, less expensive artists.[116] Just when he felt at the height of his powers as an artist, he was being told that his work was unacceptable.

The disappointment Feininger experienced in having his commercial work rejected was offset by the attention his fine art began to garner from the Berlin Secession. Earlier he had exhibited with the group as a guest, but he participated in the Secession's 1908 and 1909 exhibitions as a full-

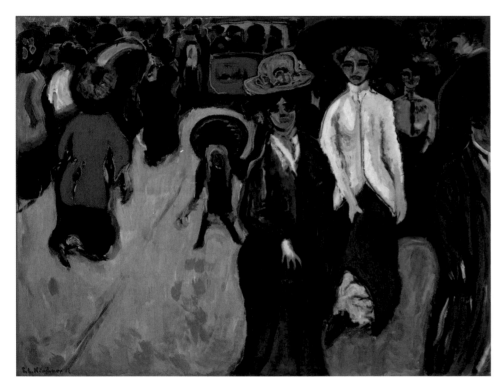

fig. 28. Ernst Ludwig Kirchner, **Street, Dresden,** 1908 (dated 1907 on work, reworked 1919) Oil on canvas, 59¼ x 66⅞ in. (150.5 x 200.4 cm) The Museum of Modern Art, New York; purchase 12.1951

fledged member. His real debut, however, came in 1910, when he presented a painting for the first time in the group's spring annual (fig. 41), and was represented by forty-three drawings in its winter show (figs. 45, 46). Most of these drawings dispensed with traditional, single-point perspective in favor of his new and "absolutely *personal perspective*" in which he depicted objects and figures from multiple vantage points as if he were observing them from different distances in space.[117] Karl Scheffler, one of Germany's most influential critics, found this violation of traditional perspective anathema and disparaged Feininger's contributions as "mere juggling with possibilities."[118]

In the context of avant-garde art, Feininger's exploitation of multiple perspectives was hardly at the forefront. At the Secession's 1910 spring annual in which Feininger had debuted an oil, the organization's newly elected executive committee had rejected the entries of twenty-seven artists, including Erick Heckel (1883–1970), Ernst Ludwig Kirchner (1880–1938), Max Pechstein (1881–1955), and Karl Schmidt-Rottluff (1884–1976) from the Dresden-based Expressionist group Die Brücke (The Bridge), founded

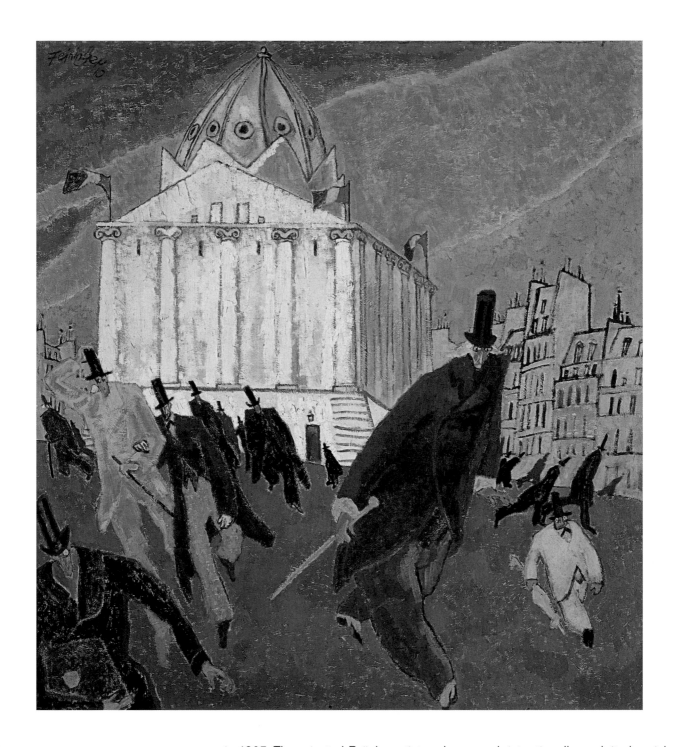

fig. 29. *Fin de Séance,* 1909
Oil on canvas, 37¼ x 33¾ in. (95 x 85.5 cm)
Location unknown

in 1905. The rejected Brücke artists, whose work intentionally exploited garish color schemes, expressive distortion, and bold outlines for the sake of emotional intensity (fig. 28), immediately organized a counter-exhibition under the auspices of the Neue Secession. By 1911, when the Brücke artists moved to Berlin, their work was already well known in the art community there through its frequent reproduction in *Der Sturm* (The Storm), the journal owned and edited by the influential Berlin art dealer Herwarth Walden. The Brücke's yearly participation in the Neue Secession marginalized the Berlin Secession, which was fast becoming irrelevant in an art world increasingly dominated by German Expressionism. Feininger would exhibit with the Berlin Secession only two more

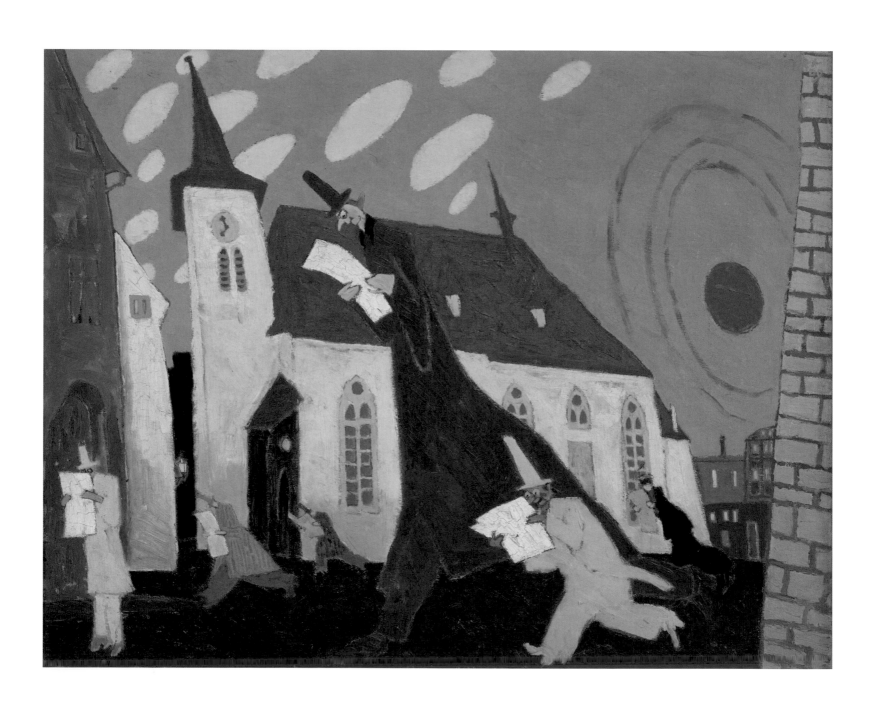

fig. 30. **Newspaper Readers (Zeitungsleser),** 1909
Oil on canvas, 19¾ x 24⅞ in. (50.3 x 63.2 cm)
Collection of Judy and John M. Angelo

times after 1910, resigning in 1913 following the conservative faction's victory in a battle over the group's leadership.

Die Brücke's sensational presence in the Neue Secession's 1910 inaugural show encouraged Feininger to replace elegance and refinement in his work with expressive immediacy. In contrast to his earlier, predominantly romantic depictions of the carnival of everyday life, he imbued his next set of canvases—*Uprising (Émeute)* and *Carnival in Arcueil* for example (figs. 47, 52)—with a mood of anarchy and anxiety. Using garish color, exaggerated cropping, and scale distortions, he evoked a nervous unpredictability and agitation, as if the world had lost its balance and was careening out of control. By the spring of 1911, Feininger was confident enough in the maturity and force of his art to take six paintings— including *Fin de Seánce*; *Longeuil, Normandy*; *Velocipedists (Draisenfahrer)*; and *Green Bridge (Grüne Brücke)* (figs. 29, 41, 44, 51)—to the French capital to exhibit in that year's jury-free Salon des Indépendants. The hanging committee assessed the paintings' non-associative, saturated color as being compatible with Fauvism and placed them in the room with Matisse's work. Fellow Salon participant Robert Delaunay (1885–1941) promulgated a story about Matisse being so overwrought by Feininger's *Green Bridge* that he removed his own picture hanging opposite it, explaining to his astonished coterie that he would have to rework it before letting it stand comparison with Feininger's.[119] However apocryphal the story, its frequent recounting by Feininger and circulation among his friends and promoters suggest the powerful impression his paintings made among the more than 1,500 entries in the show.

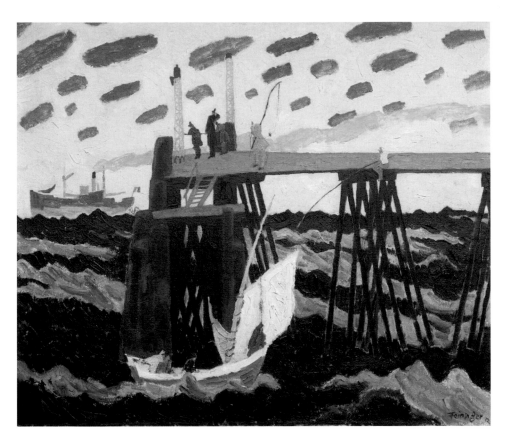

fig. 31. *Pier (Landungsbrücke),* 1912
Oil on canvas, 28½ x 32½ in. (72.4 x 82.6 cm)
Private collection

Analytic Cubism dominated the 1911 Salon, with every major Cubist artist represented except Pablo Picasso and Georges Braque, whose exclusive arrangement with dealer Daniel-Henry Kahnweiler precluded their participation. Having learned a lesson from the 1910 Indépendants show, when their work was scattered throughout the Grand Palais, the Cubists took control of the hanging committee in 1911 to ensure that their submissions would be concentrated in two rooms. The effect was electrifying. "People were packed into our room," Albert Gleizes recounted, "shouting, laughing, raging, protesting, giving vent to their feelings in all sorts of ways; there was jostling at the doors to force a way in, there were arguments going on between those who supported our position and those who condemned it."[120] Cubism had arrived on the art scene.

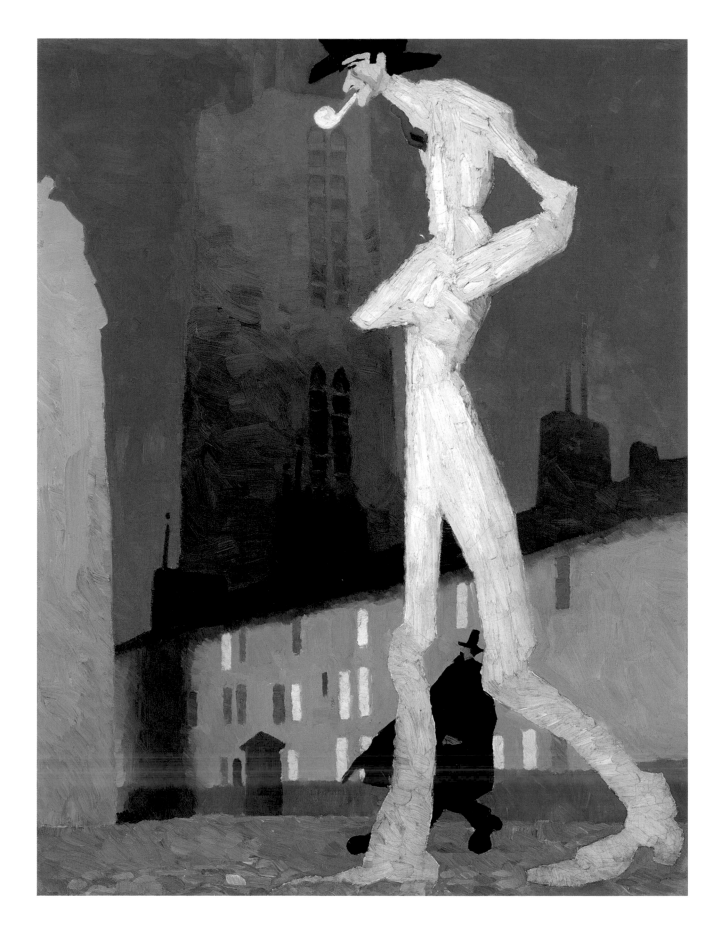

fig. 32. **The White Man,** 1907
Oil on canvas, 26⅞ x 20⅝ in. (68.3 x 52.3 cm)
Collection of Carmen Thyssen-Bornemisza

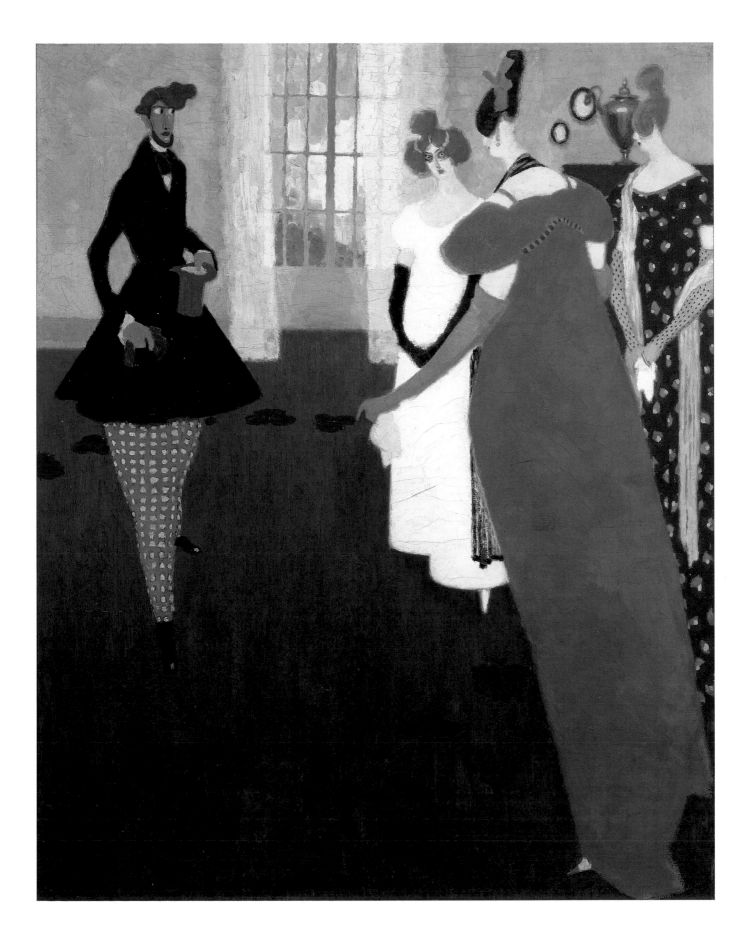

fig. 33. **The Proposal (Die Werbung),** 1907
Oil on canvas, 26¾ x 21 in. (67.8 x 53.3 cm)
Private collection

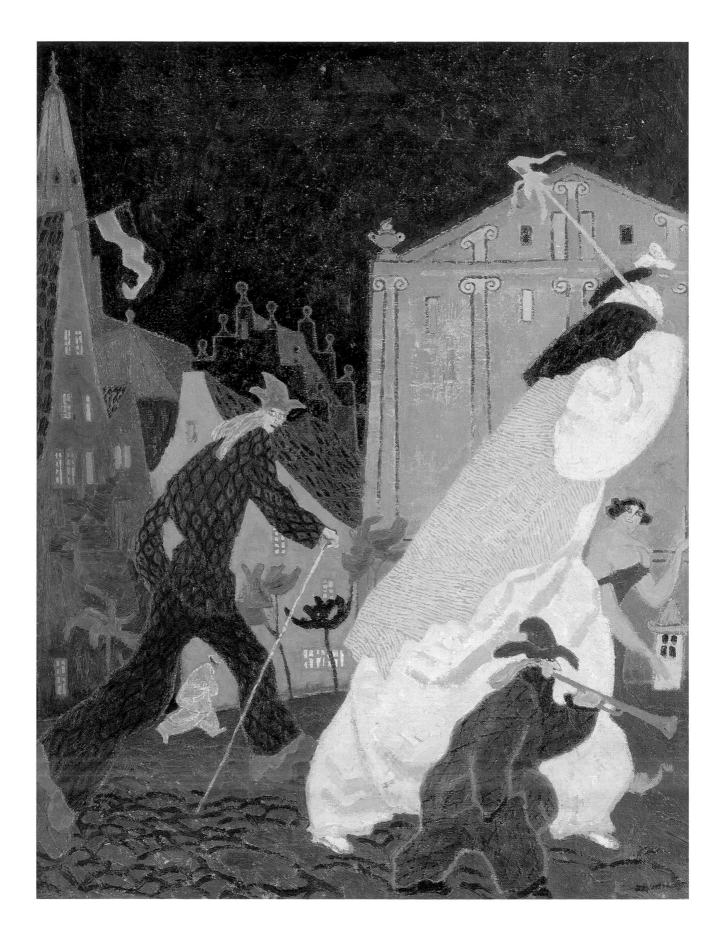

fig. 34. *Carnival,* 1908
Oil on canvas, 27 x 21¼ in. (68.5 x 54 cm)
Nationalgalerie, Staatliche Museen, Berlin

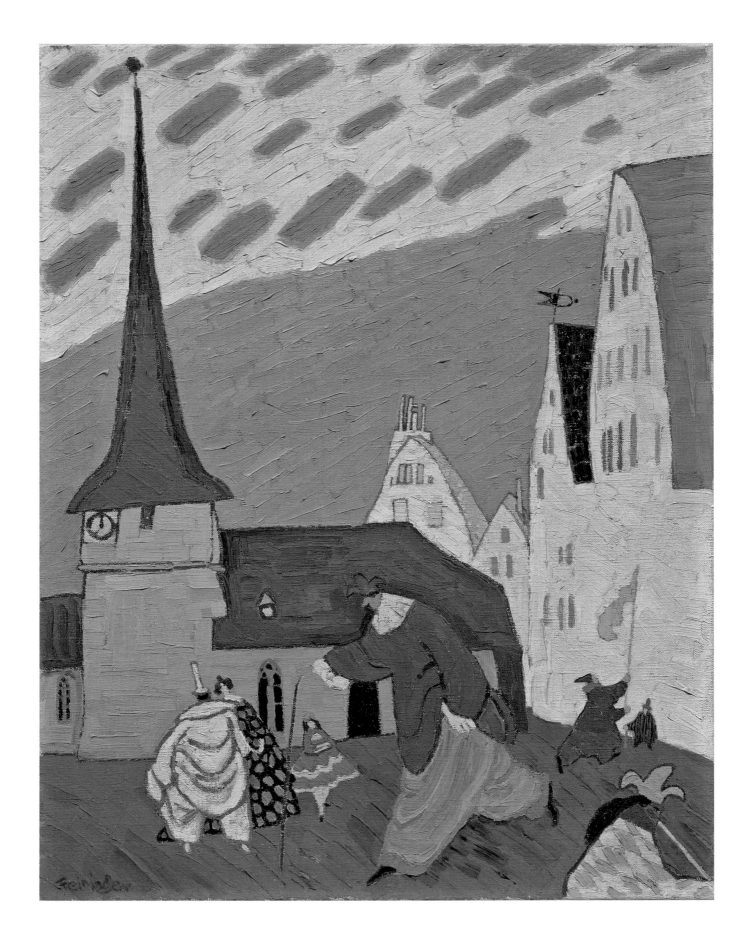

fig. 35. *Carnival in Gelmeroda II,* 1908
Oil on canvas, 27¼ x 21⅜ in. (69.2 x 54.3 cm)
Private collection

fig. 36. **Street Types II
(Strassentypen II),** 1908
Watercolor and ink on paper,
9⅞ x 7½ in. (25.1 x 19 cm)
Private collection

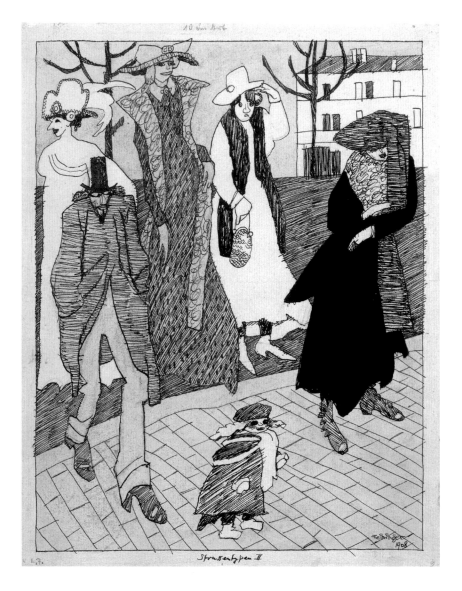

fig. 37. **The Head Inquisitor,** 1911
Ink on paper, 9⅜ x 12⅜ in.
(23.9 x 31.5 cm)
Private collection

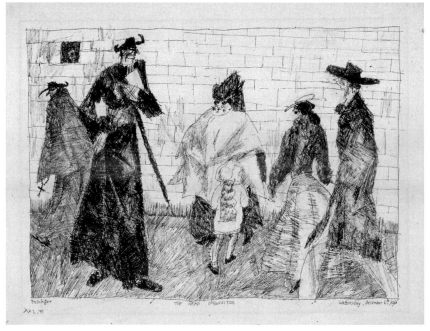

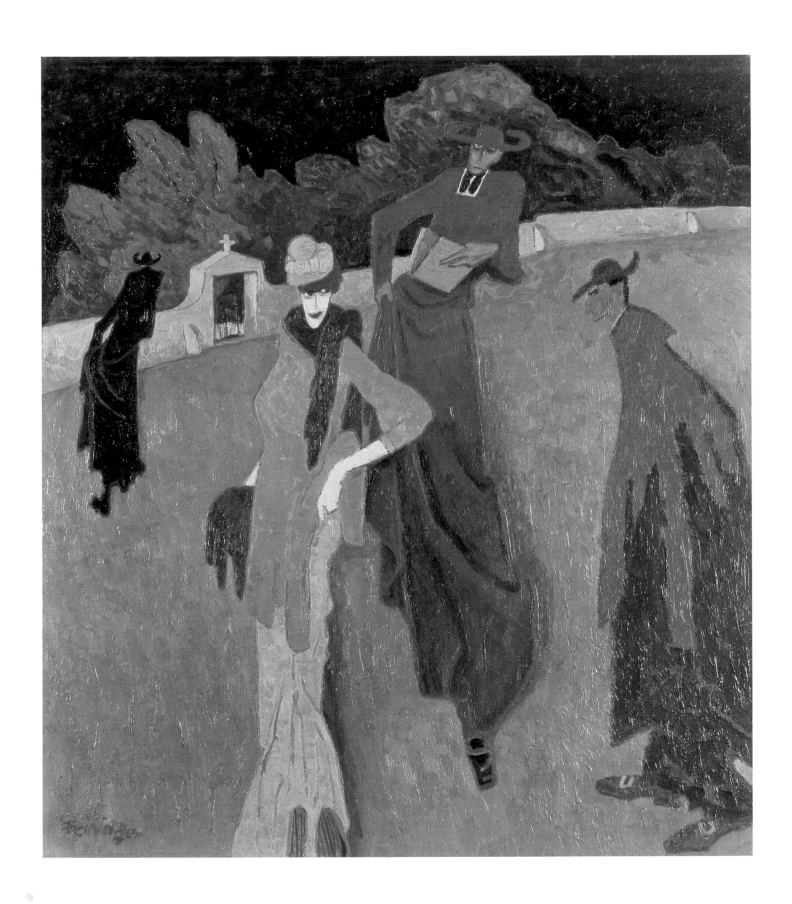

fig. 38. *Jesuits I,* 1908

Oil on canvas, 23¾ x 21½ in. (60.2 x 54.6 cm)

Private collection

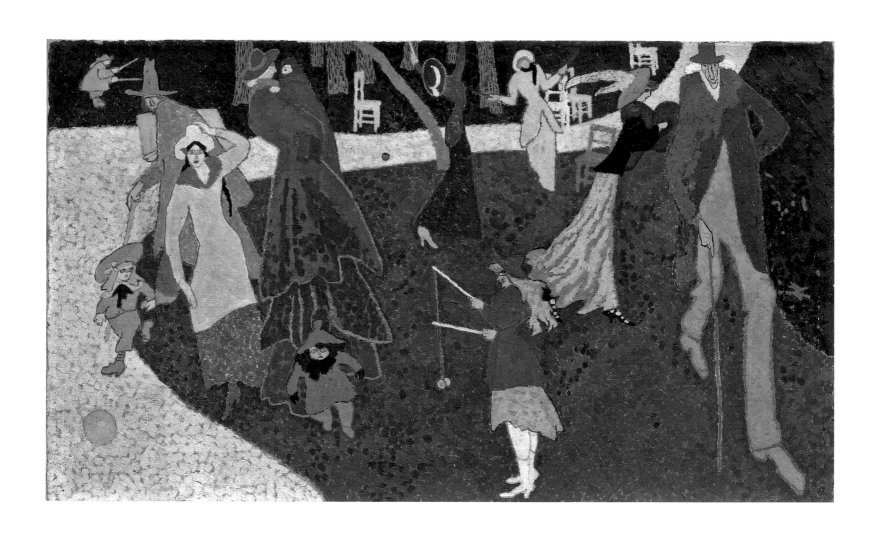

fig. 39. *Diabolo Players I,* 1909
Oil on canvas, 15½ x 26 in. (39 x 66.5 cm)
Private collection; courtesy Moeller Fine Art, New York and Berlin

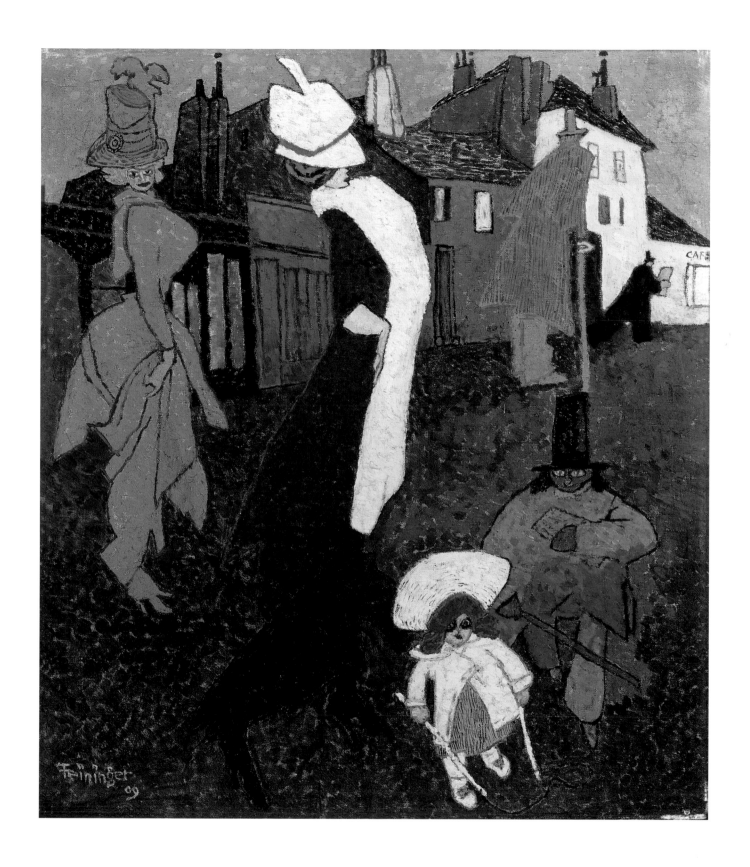

fig. 40. *Figures, Dusk,* 1909
Oil on canvas, 16⅜ x 14⅜ in. (41.4 x 36.3 cm)
Private collection

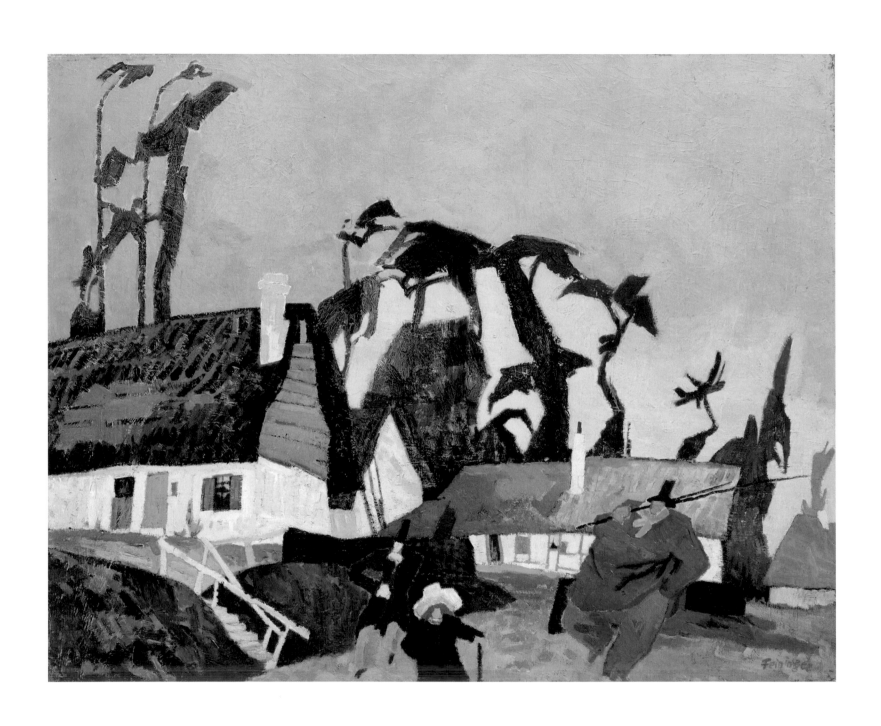

fig. 41. **Longeuil, Normandie,** 1909
Oil on canvas, 31¾ x 39¾ in. (80.6 x 101 cm)
The Art Institute of Chicago; gift of Clara Hoover Trust 1998.357

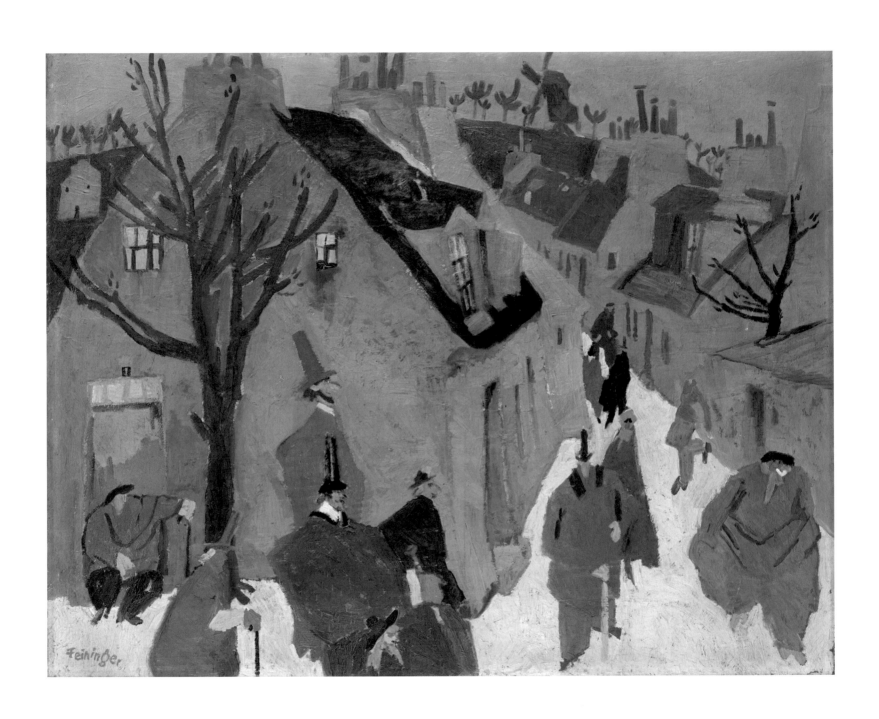

fig. 42. *Village, Dusk (Dämmerdorf),* 1909
Oil on canvas, 31½ x 39⅜ in. (80 x 100 cm)
Nationalgalerie, Staatliche Museen, Berlin

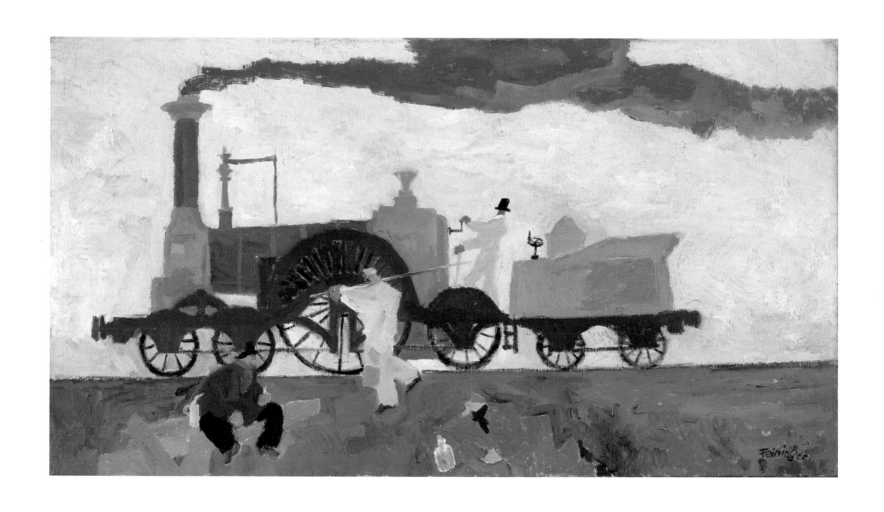

fig. 43. **Locomotive with the Big Wheel I,** 1910
Oil on canvas, 21¾ x 39½ in. (55.2 x 100.3 cm)
Albertina Museum, Vienna; Batliner Collection

fig. 44. **Velocipedists (Draisinenfahrer),** 1910
Oil on canvas, 37⅞ x 33¼ in. (96 x 84.6 cm)
Private collection; courtesy Eykyn Maclean LP

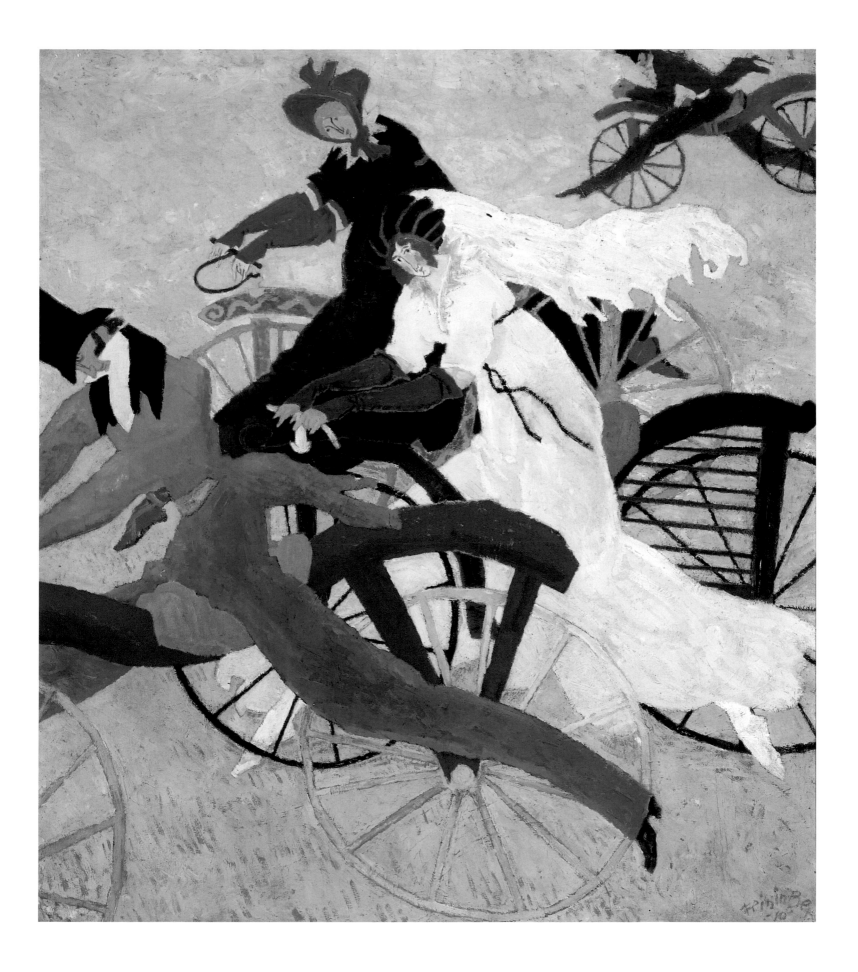

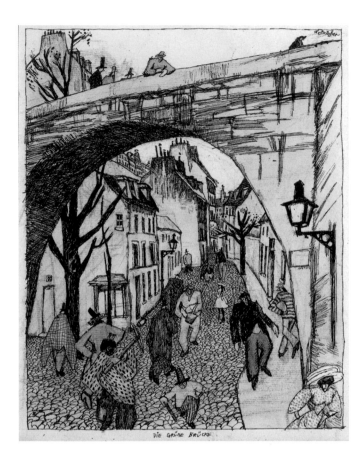

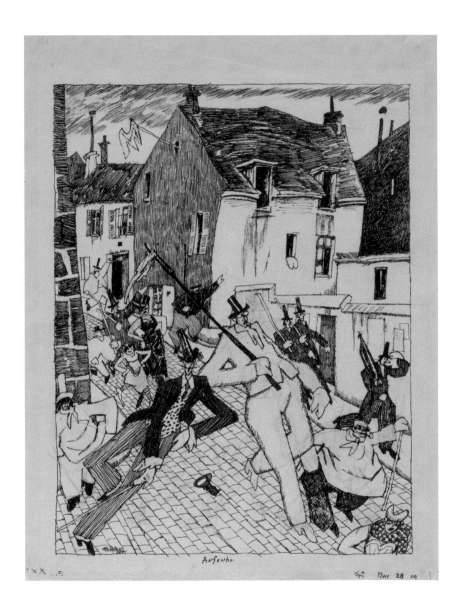

fig. 45. ***The Green Bridge (Die Grüne Brücke),*** 1909
Watercolor and ink over graphite on paper, 9⅞ x 7⅞ in.
(25 x 20 cm)
Private collection

fig. 46. ***Uprising (Aufruhr),*** 1909
Ink and charcoal on paper, 12½ x 9⅜ in. (31.8 x 23.8 cm)
The Museum of Modern Art; gift in memory of Reverend
Laurence Feininger 244.1976

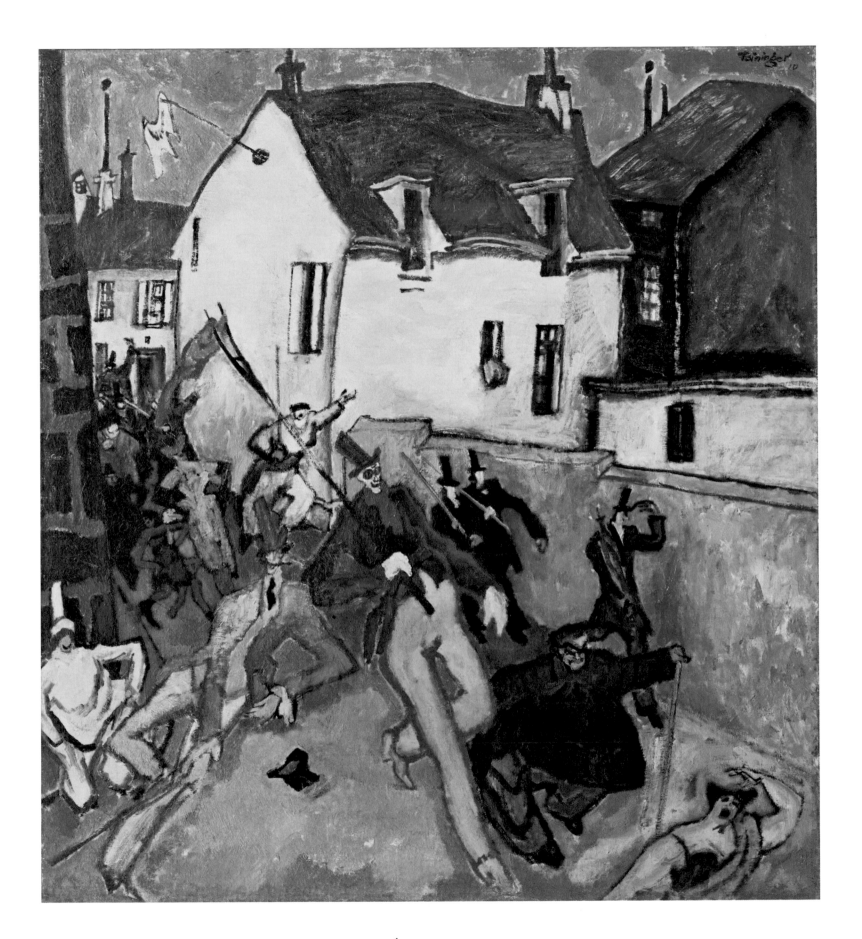

fig. 47. **Uprising (Émeute),** 1910
Oil on canvas, 41⅛ x 37⅝ in. (104.4 x 95.4 cm)
The Museum of Modern Art, New York; gift of Julia Feininger 257.1964

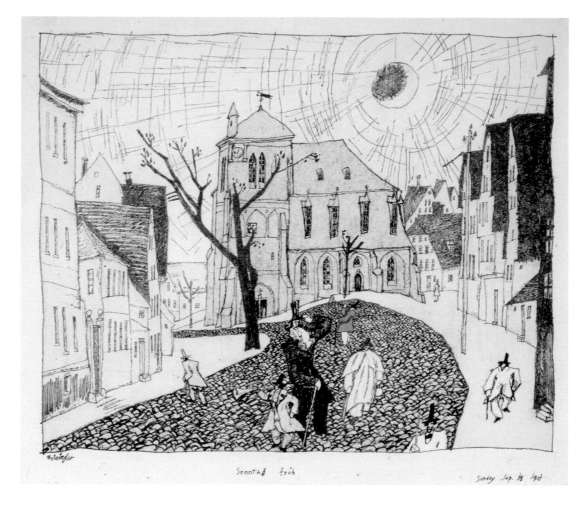

fig. 48. **Sunday Morning (Sonntag früh),** 1910
Watercolor and ink on paper, 9½ x 11⅛ in.
(24.1 x 28.3 cm)
Private collection

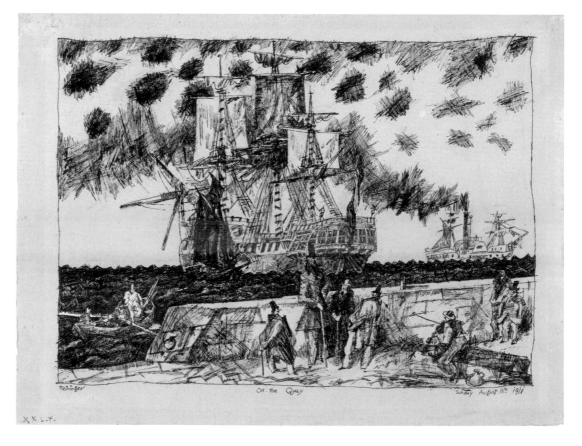

fig. 49. **On the Quay,** 1911
Ink and opaque watercolor on paper,
9½ x 12⅜ in. (24.1 x 31.4 cm)
The Museum of Modern Art, New York; gift
of Julia Feininger 271.1964

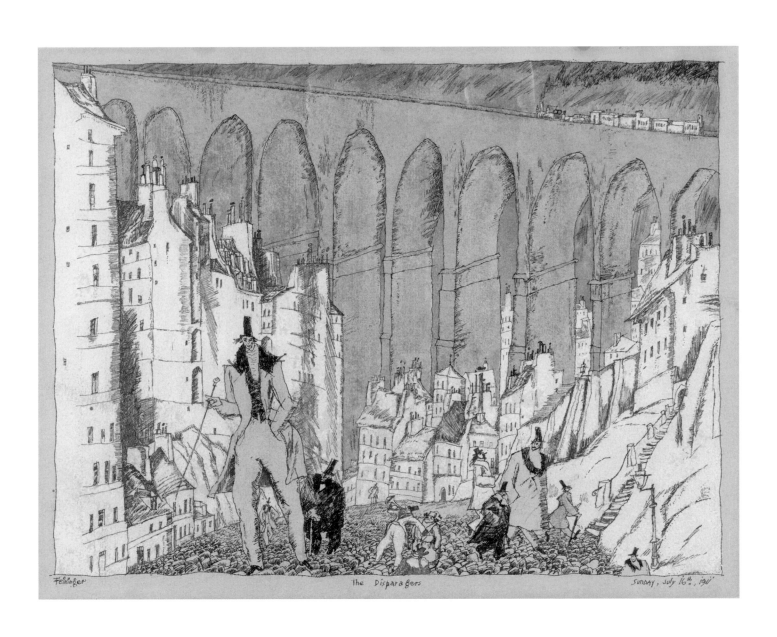

fig. 50. **The Disparagers,** 1911
Watercolor and ink on paper, 9⅜ x 12¼ in. (23.8 x 31.1 cm)
The Museum of Modern Art, New York; acquired through the
Lillie P. Bliss Bequest 477.1953

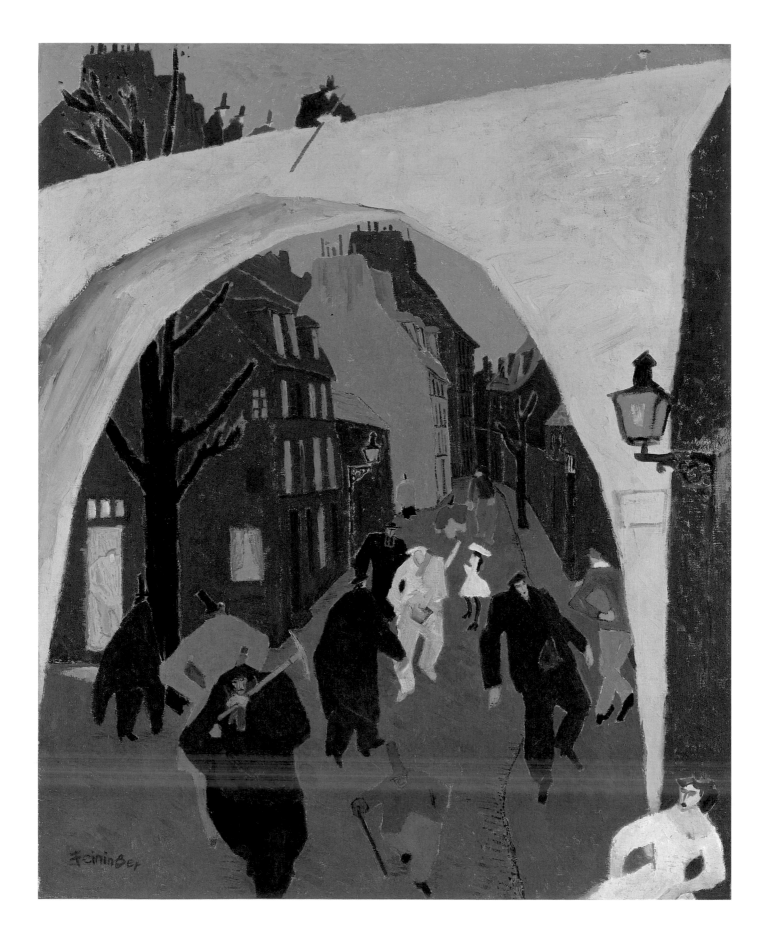

fig. 51. **Green Bridge,** 1909
Oil on canvas, 39⅞ x 31⅞ in. (101.1 x 81 cm)
Private collection

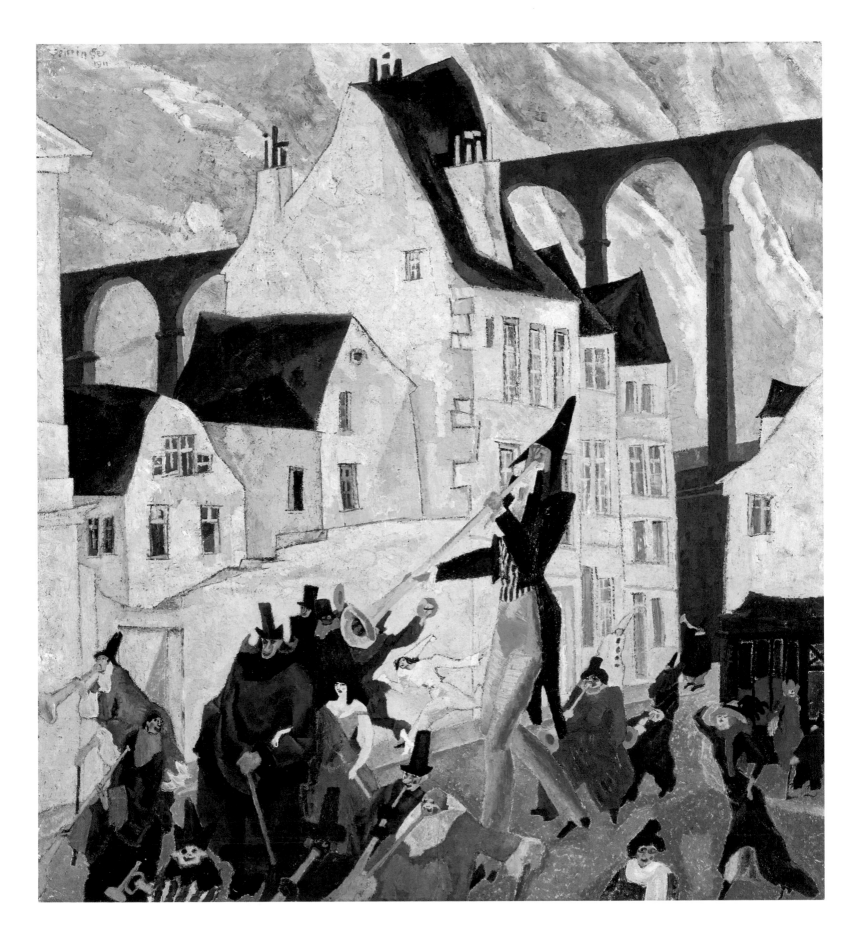

fig. 52. *Carnival in Arcueil,* 1911
Oil on canvas, 41¼ x 37¾ in. (104.8 x 95.9 cm)
The Art Institute of Chicago; Joseph Winterbotham Collection
1990.119

The Impact of Cubism

For Feininger, encountering Cubism was revelatory. Describing it later, he wrote: "In the spring I had gone to Paris and found the world agog with Cubism—a thing I had never heard even mentioned before."[121] "I saw the light. 'Cubism'—'Form' I should rather say—to which Cubism showed the way. Afterward it was amazing to find that for years I had been on the right road. . . . But only in Paris did I see and hear for the first time that such a thing existed."[122] During his three-week stay in Paris, Feininger had ample time

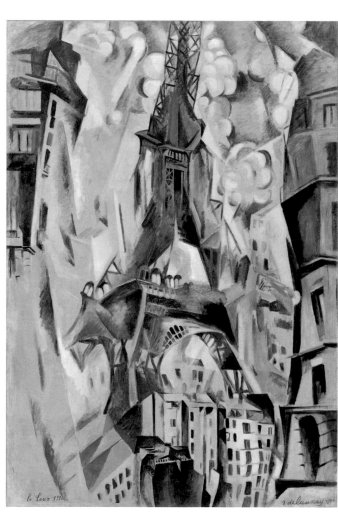

fig. 53. Robert Delaunay, **Eiffel Tower (Tour Eiffel),** 1911 (dated 1910 by the artist)
Oil on canvas, 79½ x 54½ in. (202 x 138.4 cm)
Solomon R. Guggenheim, New York; Solomon R. Guggenheim Founding Collection, by gift 37.463

to absorb the lessons of Cubism. While inherently opposed to the French Cubists' "chaotic dispersal of form," which he felt deteriorated into a "sort of neo-neo-impressionism," he understood immediately that their reduction of objects to angular, geometric shapes and their treatment of empty space and mass as virtually synonymous created the impression of volume without resorting to modeling.[123] It was initially unclear to Feininger how he could adapt that vocabulary to his own style. In May he described a dream in which he was a Cubist, "shad[ing] squares from above to below."[124] Two years later, he was still occasionally unable to sleep, his brain "tortured with cubist problems, always the same, it could drive you crazy!"[125]

Not until April 1912, a year after his introduction to Cubism, did Feininger begin to selectively incorporate into his work the style's geometric faceting of forms. Since his earlier paintings had consisted almost entirely of flat silhouettes, his only option for suggesting three-dimensional space had been to layer his forms. Now, in works such as *Angler with Blue Fish II* and *Bathers on the Beach I*, he broke his images into geometric planes seemingly tilted at varying angles to the picture surface (figs. 58, 59). The approach resembled that of the Cubists, particularly Delaunay, whose *Eiffel Tower* had been declared by the French critic Guillaume Apollinaire the most important entry in the 1911 Salon des Indépendants (fig. 53). Feininger's work differed from Delaunay's in rejecting fragmentation and simultaneity in favor of monumentality. In *Eiffel Tower*, Delaunay employed the shifting viewpoints of Cubism and the disruptive properties of light to create a shimmering, prismatic world in which everything seemed to be vibrating. Although Feininger likewise exploited gradations of color to enhance volume and gave equal weight to figure and ground, he never relinquished his loyalty to the material aspects of reality.[126] Rather than splintering forms into geometric crystals whose broken contours blurred the clear demarcation between figures and their surrounding space, as Delaunay had done, Feininger reduced his images to flat, geometric shapes whose contours remained closed.

That spring, just as Feininger began experimenting with these innovations, the Berlin art world exploded. The Munich-based group Der Blaue Reiter (The Blue Rider) debuted at Walden's Galerie Der Sturm in March; the following month, Der Sturm

debuted Italian Futurism and Galerie Fritz Gurlitt opened the first show in Berlin devoted exclusively to Die Brücke.[127] Acclaim for Feininger's art likewise proliferated. Three of his oils were included in the Salon des Indépendants in Paris, and critics called the two oils he submitted to the 1912 Berlin Secession the most forward looking of the show's vanguard contributions.[128] The attention led to what would become a close friendship with Heckel and Schmidt-Rottluff, who invited Feininger to exhibit with Die Brücke at their inaugural show at the Gurlitt gallery.[129] Up until then, Feininger had shunned publicity, preferring, as he described it, to "keep dark, lie low and wait 'or rather' work."[130]

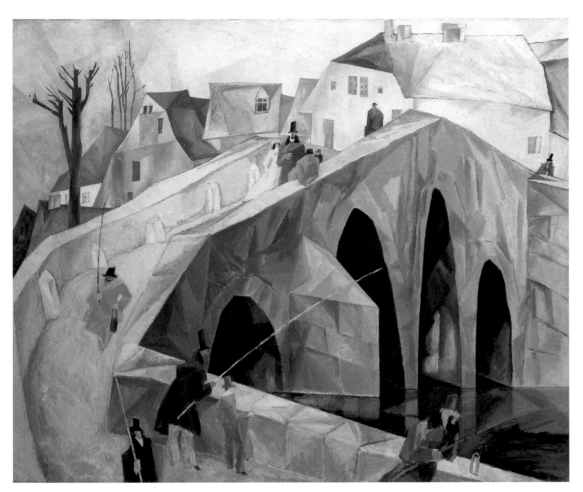

fig. 54. **Bridge O,** 1912
Oil on canvas, 35¾ x 43½ in. (90.8 x 110.5 cm)
Private collection

Therefore, although honored by the invitation to join such an esteemed group, he declined, fearful that unveiling his new direction before it was fully formed would impede its realization. As he explained it, he demurred precisely *because* he was progressing.[131] Nevertheless, his encounter with Die Brücke "opened up before me like a new world."[132] Shortly after meeting these artists, Feininger reported that he was "attracting the attention of the most gifted of the younger, ambitious artists + critics. Our quiet home . . . has suddenly become the favorite meeting place for a number of younger people . . . and every week, one or the other brings in a new man who has become curious to know my work."[133] By November 1912, Alfred Kubin (1877–1959), the visionary draftsman associated with Der Blaue Reiter, was asking Feininger if they might exchange drawings.

Feininger received offers to show his work in America as well. One such invitation came from Martin Birnbaum, proprietor of the Berlin-Photographic Gallery in New York, which included prints by Feininger in its survey of German graphics that fall; the other was from Edward Kramer, one of the twenty-five members of the artist committee formed to organize the "International Exhibition of Modern Art," or Armory Show, as it was later called. When Kramer first contacted Feininger, the committee was still envisioning the show as national in focus, with a handful of European artists included for publicity value. Kramer proposed the show as the venue for Feininger's American debut. "You must give the American public an opportunity of seeing some of your work," he wrote.[134]

Although Kramer was still discussing Feininger's inclusion in the show as late as mid-December 1912, his plans apparently fell victim to the bias against German Expressionism held by Arthur B. Davies (1863–1928) and Walt Kuhn (1877–1949), who selected all of the more than four hundred European works that appeared in the show.[135] When the Armory Show opened in New York on February 17, 1913, the only painters representing Germany were Kirchner and Wassily Kandinsky (1866–1944).

The Armory Show's disregard for German art had no impact on Feininger, who had spent the previous year assimilating Cubism. In April 1913, he announced that he was "ready to turn a new page" in his art.[136] To find the solitude he needed, he went alone to Weimar—"the promised land," as he and Julia called it—and began what he described as "the first mature period in my artistic life."[137] Working from a composition based on Parisian houses slated for demolition, which he had made in the summer of 1908 and then revisited in 1910, he created an image out of interpenetrating and overlapping planes of translucent color whose resulting diagonal lines and lucent triangular wedges created the sensation of looking through a prism. The overall luminosity he gained by replacing flat planes of opaque color with chromatically transparent ones endowed the work with an ethereal, crystalline radiance. Because figurative images seemed inappropriate for this new prismatic vocabulary—"prism-ism," he called it—he turned increasingly to architecture in his search for subjects.[138]

In the peace and quiet of Weimar and its surrounding Thuringian villages, untouched by modernity's psychic fragmentation and crisis of faith, Feininger found a subject matter that answered his lifelong yearning for harmony and oneness. Since childhood, churches, mills, bridges, and houses had evoked in him deep feelings of contentment, confirming his faith that everything in the universe was ordered, rational, and infused with Divinity.[139] "Even chaos is full of order," he insisted. "The fugitive shadow of a bird flying over the field is unalterable."[140] The laws of nature manifested in observable reality were "just as inescapable as any mathematical laws we humans are able to deduce."[141] To grasp them, one needed to begin with nature—"to get our bearing," as Feininger put it—but fixing one's sights exclusively on surface appearance was insufficient, since its beauty was ephemeral and its truths only partial.[142] The mysticism of objects, Feininger maintained, lay in the insights they offered into the universe's inherent order and beauty. These ideas formed a cornerstone of German Catholicism and Jesuit theology, but they appeared in Asian philosophy as well. Conscious of the parallels between her husband's and Lao-Tse's views, Julia sent Feininger an excerpt of the Chinese philosopher's writings on the symbiosis between the material and the immaterial: "Thirty spokes meet the hub, but the empty space between them makes for the essence of the wheel; pots are made of clay but the empty space within causes the essence of the pot; walls with windows and doors make up the house, but the empty space within cause the essence of the house. Fundamentally: the material elements contain usefulness; the immaterial causes the essence."[143]

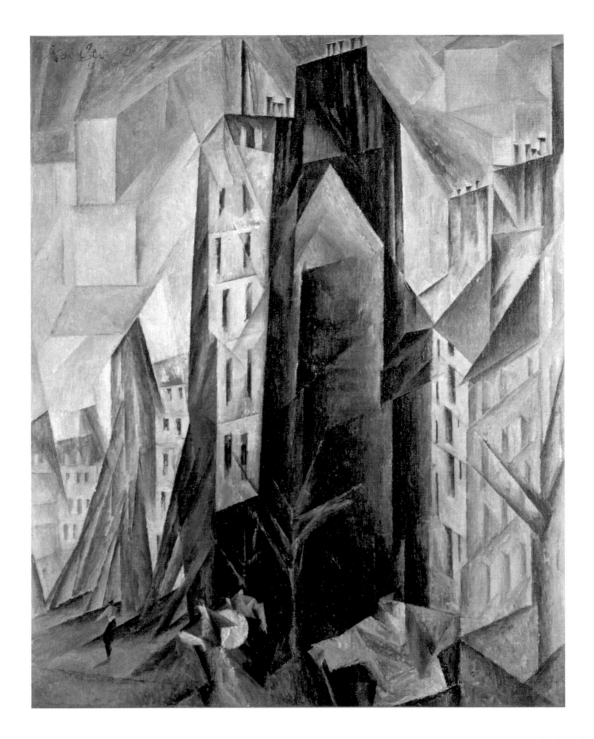

fig. 55. **High Houses II,** 1913
Oil on canvas, 39½ x 32 in. (100.3 x 81.3 cm)
Neuberger Museum of Art, Purchase College, State
University of New York; gift of Roy R. Neuberger
1974.22.09

The task of apprehending the "great forms, the great rhythms" of nature required concentration and a mind free of distraction and preoccupation.[144] Feininger experienced this "ecstatic . . . magnetic cohesion" between himself and his subject when he sketched; his whole being became "pure instinct and ability" as he stood in one spot and drew the same motif three or four times.[145] He wrote of being carried "to the border of existence" by close contact with the universe.[146] It was, he averred, "an ecstasy such as only love in youth can give, but an ecstasy which survives youth, takes its place and prevails to the end."[147] The formulation was uncannily reminiscent of another American who had been influenced by German Idealist philosophy, the Transcendentalist Ralph Waldo Emerson

(1803–1882). Almost a century earlier, Emerson had described an experience similar to Feininger's: "Standing on the bare ground . . . I become a transparent eye-ball; I am nothing; I see all; the currents of the Universal being circulate through me; I am part or parcel of God."[148] The process of translating this experience into oil was agonizing, however, requiring discipline and perseverance; moments of exhilaration were preceded and followed by long stretches of despair. Feininger recounted being driven "by a gradually increasing longing (which finally becomes unbearable) for a specific configuration," whose realization in oil he experienced "as a release from pain."[149] He wrote of painting as a Sisyphean battle involving the "deepest, most desperate human wrestling" toward a goal he acknowledged to "be out of reach forever."[150] But precisely because painting was "a path to the intangibly Divine," persevering was imperative.[151] "In the quiet of my studio I am fighting desperate battles; every morning I rise, inspired by new hope, to resume the struggle; every evening all courage is gone."[152] Art was not entertainment to Feininger: "The soul, having recognized its own infinite need, can never allow itself to be satisfied with anything less than the final, the highest, as well as the most profound meaning."[153]

Confirmation that Feininger was succeeding in expressing his vision of "ultimate reality" came on his forty-second birthday with an invitation from Blaue Reiter artist Franz Marc (1880–1916) to exhibit with the group in the upcoming Erster Deutscher Herbstsalon (First German Autumn Salon) being organized by Walden for September 1913. In his letter, Marc explained that the group had only recently heard about Feininger's work through Kubin—otherwise, they would have invited him to show with them earlier.[154] Feininger, for his part, had seen the art of the Blaue Reiter circle only in reproduction, but he knew of their commitment to spirituality and personal expression from having read their 1912 *Almanac*, edited by Marc and Kandinsky. The group's desire to express metaphysical truths through art appealed to Feininger; despite his reluctance to show his work before it was fully developed, he accepted the invitation, happy to exhibit "in the company of those with whom I am predestined to feel at home."[155]

The Herbstsalon had been the brainchild of the Berlin Secession, which had planned to hold an international "autumn show" in 1913 modeled after the juried Paris Salon d'Automne. When the Secession abandoned those plans following the leadership battle that summer that led to an exodus of members, Feininger included, Walden assumed organizational responsibility for the show, with the financial backing of collector Bernhard Koehler and the support of Der Blaue Reiter. The Herbstsalon was not the most extensive pre–World War I presentation of modern art in Germany—that distinction went to the 1912 Cologne Sonderbund, upon which New York's Armory Show was modeled. But Walden's more focused selections made the Herbstsalon more prestigious. The dealer's inclusion of five of Feininger's paintings catapulted the artist into the front ranks of the German avant-garde, along with fellow American artist Marsden Hartley (1877–1943), also represented by five paintings. The two met several years later on the occasion of Hartley's one-person show in Berlin. The war would cut short their friendship

fig. 56. **Untitled (Profile for Model Train Set, Two Engines),** 1914
Ink and watercolor on paper, 4¾ × 13 in. (12.1 × 33 cm)
Private collection; courtesy Moeller Fine Art, New York and Berlin

fig. 57. **Train,** 1913–14
Painted wood, overall dimensions variable
Bauhaus-Archiv, Berlin

by forcing Hartley to return to New York in December 1915, but not before he advised Feininger: "Let yourself loose would be what I would want to say—let the majesty of all beauty make you glad—let your mind rest from its terrible insistence and play with the little children who have the secrets of heaven in their eyes and in their souls. Give up to the creator . . . the problem of existence."[156]

Feininger sold three works out of the Herbstsalon, including *High House I* (1913) to Koehler and *Teltow I* (1912) to the French fashion designer Paul Poiret.[157] These sales mitigated but did not solve Feininger's financial problems. No longer able to obtain anything more than an occasional caricature commission, he was totally dependent for money on Julia's family. "My self confidence suffers from the condition of my finances. I cannot easily overcome my sense of being dependant as a result of not being gainfully employed," he confided to Julia.[158] "I suffer from it as if from a cancer of the soul, which humiliates me and consumes my *energy, my pride* as a man heading a family for whom I cannot provide financially."[159] Mortified by having to ask Julia for money, he described himself as "psychologically so overwrought that I cry often."[160] He put all his hopes for financial independence in the commission he received in the spring of 1913 from the Munich toy manufacturer Otto Löwenstein to design wooden toy trains for mass production. Feininger threw himself eagerly into the project, finding in it the same joy he had derived from making model trains and sailboats as a boy. Drawing nostalgically on childhood memories, he based his prototypes on old-fashioned American train designs, taking care to engrave historically accurate names of railway societies and dates on them (fig. 56). So pleased was he to have reduced manufacturing costs by introducing a "gliding block," whose painted wheels substituted for the movable wheels on most train sets, that he patented his invention. In May 1914, after submitting final production designs and meticulous coloring instructions for sixty-eight model trains, he received his first advance, happy that temporarily sacrificing his fine art had contributed to his family's finances. His joy evaporated suddenly on August 1, when Germany entered World War I and Kaiser Wilhelm II directed all manufacturing to be put in the service of the war effort.

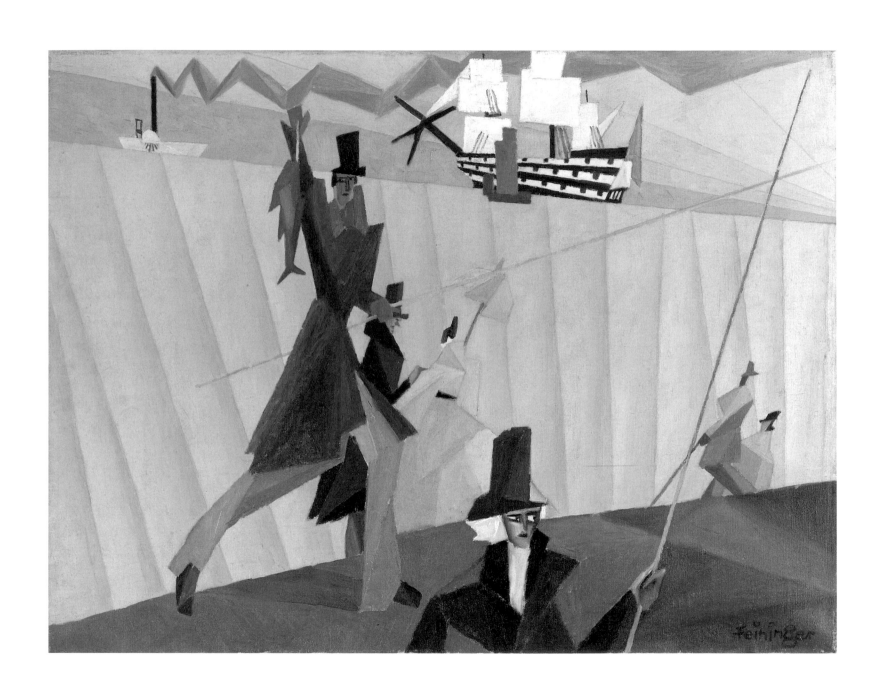

fig. 58. *Angler with Blue Fish II,* 1912
Oil on canvas, 22½ x 29½ in. (56.9 x 74.9 cm)
Private collection

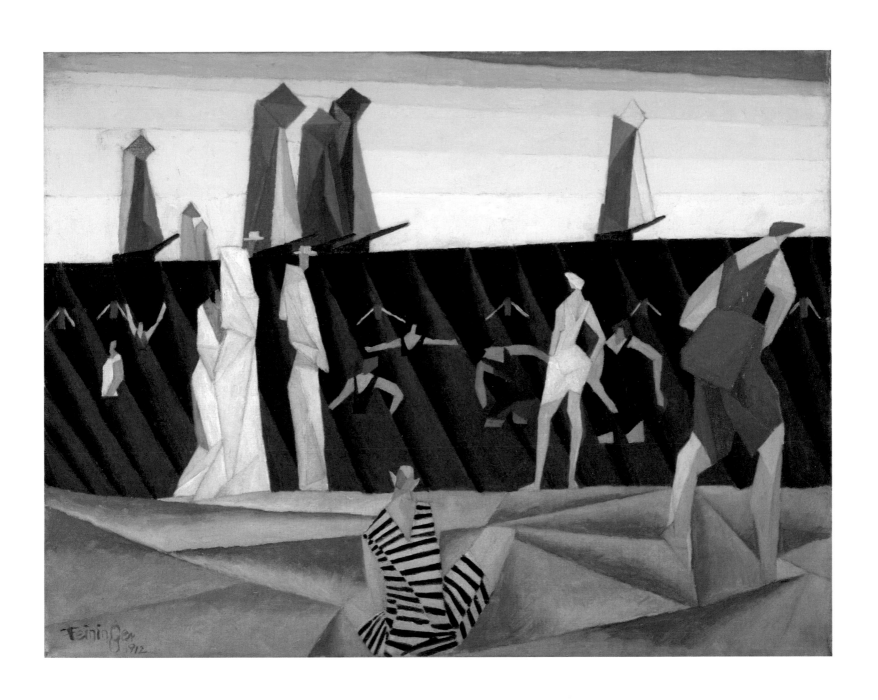

fig. 59. ***Bathers on the Beach I,*** 1912
Oil on canvas, 19⅞ x 25⅞ in. (50.5 x 65.7 cm)
Harvard Art Museums, Busch-Reisinger Museum,
Cambridge, Massachusetts; Association Fund BR54.7

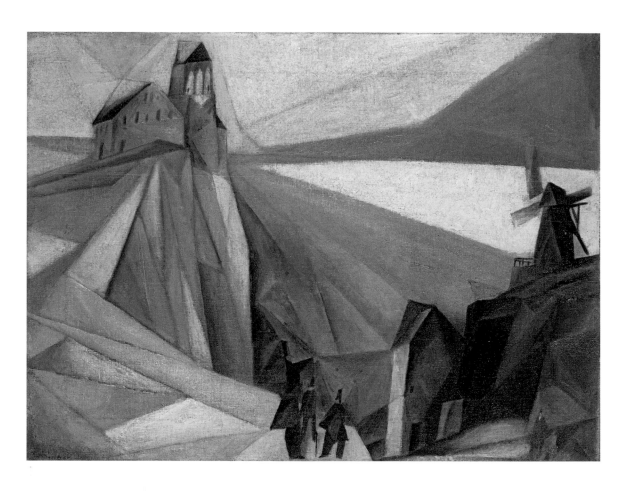

fig. 60. *Study, On the Cliffs (Early Attempt at Cubist Form),* 1912
Oil on canvas, 18 x 23¾ in. (45.7 x 60.2 cm)
Collection of A. Alfred Taubman

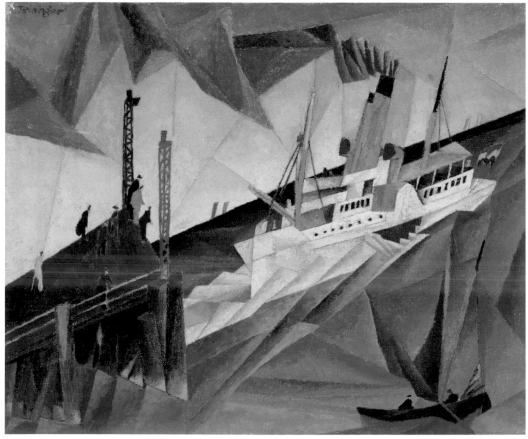

fig. 61. *Side-wheel Steamer at the Landing,* 1912
Oil on canvas, 15¾ x 18⅞ in. (40 x 48 cm)
Private collection

fig. 62. *Fisherfleet in Swell,* 1912
Oil on canvas, 16⅜ x 19 in. (41.5 x 48.3 cm)
Sprengel Museum, Hannover

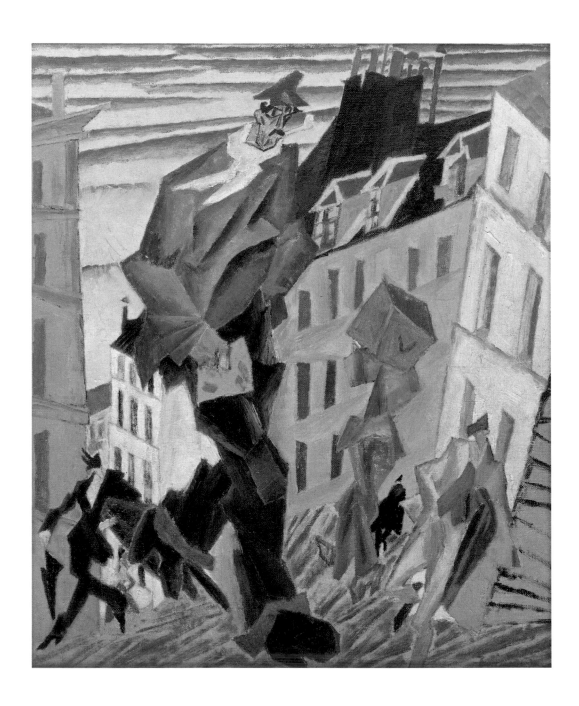

fig. 63. *The Messenger (Der Bote)*, 1912
Oil on canvas, 19 x 15¾ in. (48.3 x 40 cm)
The Caroline and Stephen Adler Family

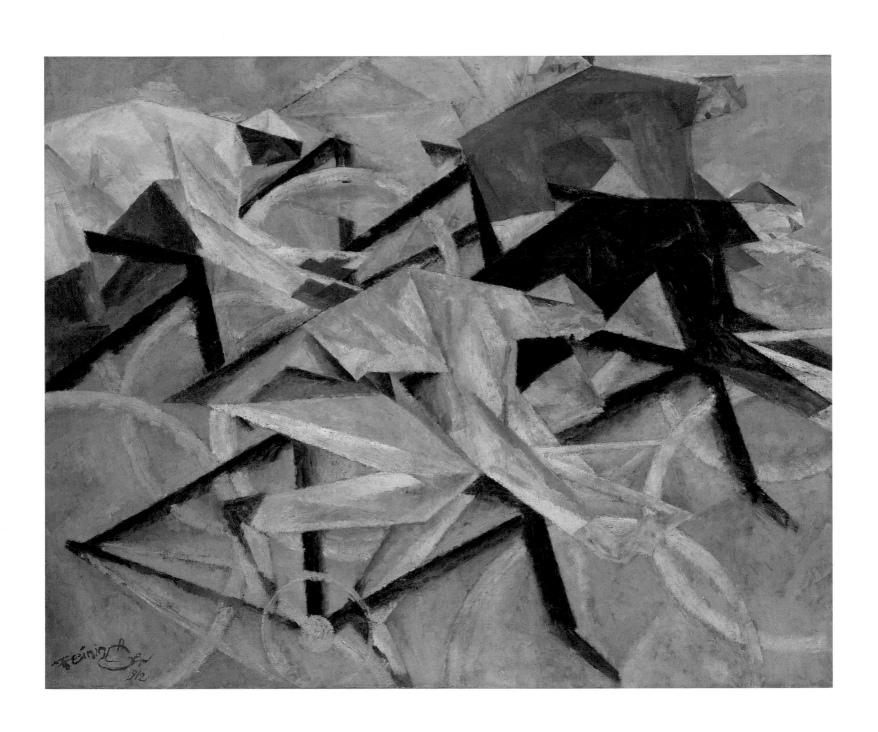

fig. 64. *Bicycle Race (Die Radfahrer),* 1912
Oil on canvas, 31⅝ x 39½ in. (80.3 x 100.3 cm)
National Gallery of Art, Washington, DC; Collection of Mr. and
Mrs. Paul Mellon 1985.64.17

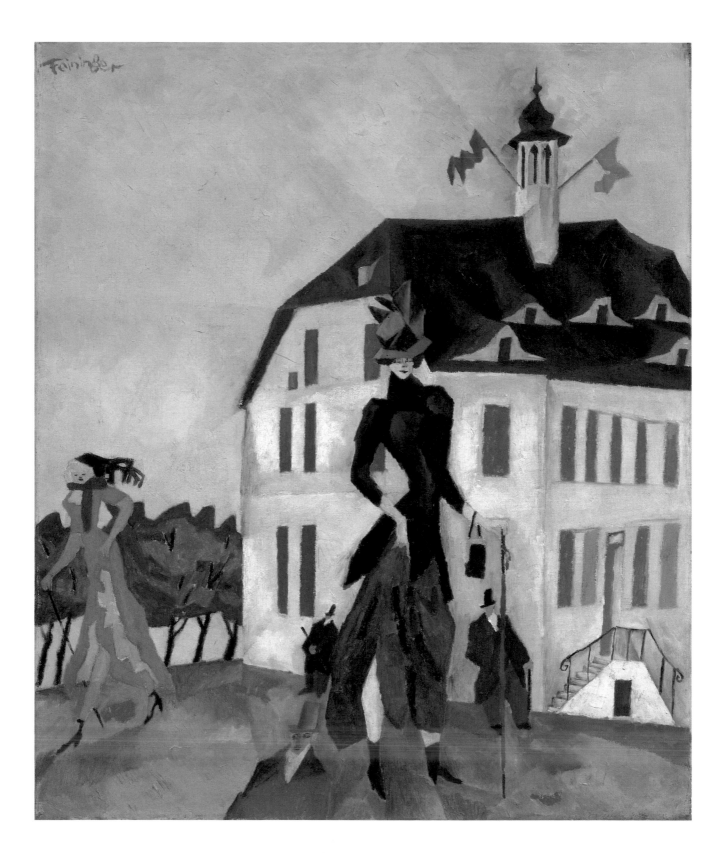

fig. 65. *Town Hall, Swinemünde (Rathaus von Swinemünde),* 1912
Oil on canvas, 28 x 23⅛ in. (71.1 x 58.9 cm)
Private collection

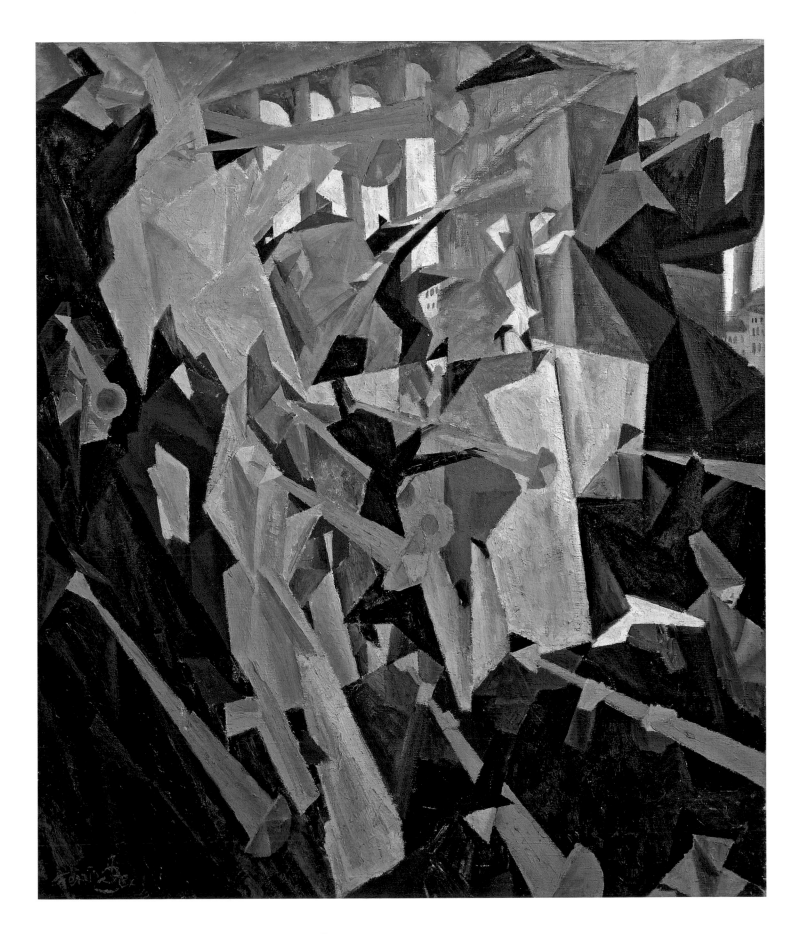

fig. 66. *Trumpeters,* 1912
Oil on canvas, 37 x 31½ in. (94.4 x 80.3 cm)
Private collection

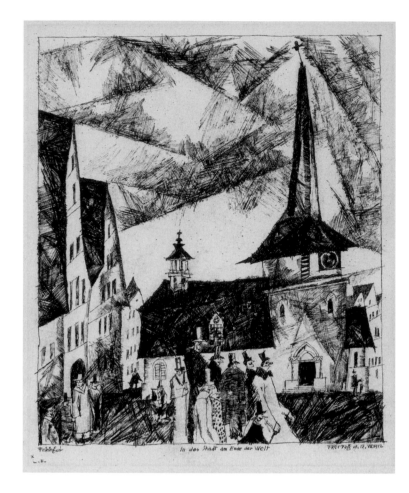

fig. 67. **Untitled (Church),** 1906
Graphite on paper, 11 x 8⅝ in. (27.9 x 21.8 cm)
Harvard Art Museums, Busch-Reisinger Museum,
Cambridge, Massachusetts; gift of Julia Feininger BR63.355

fig. 68. **The City at the Edge of the World (In der Stadt am Ende der Welt),** 1912
Ink and charcoal on paper, 12½ x 9½ in. (31.8 x 24.1 cm)
The Museum of Modern Art, New York; gift of Julia
Feininger 125.1966

fig. 69. **Church at Gelmeroda,** c. 1920
Painted wood, 12¾ x 10⅛ x 3⅛ in. (32.3 x 25.5 x 7.8 cm)
The Museum of Modern Art, New York; Julia Feininger
Bequest SC209.1972

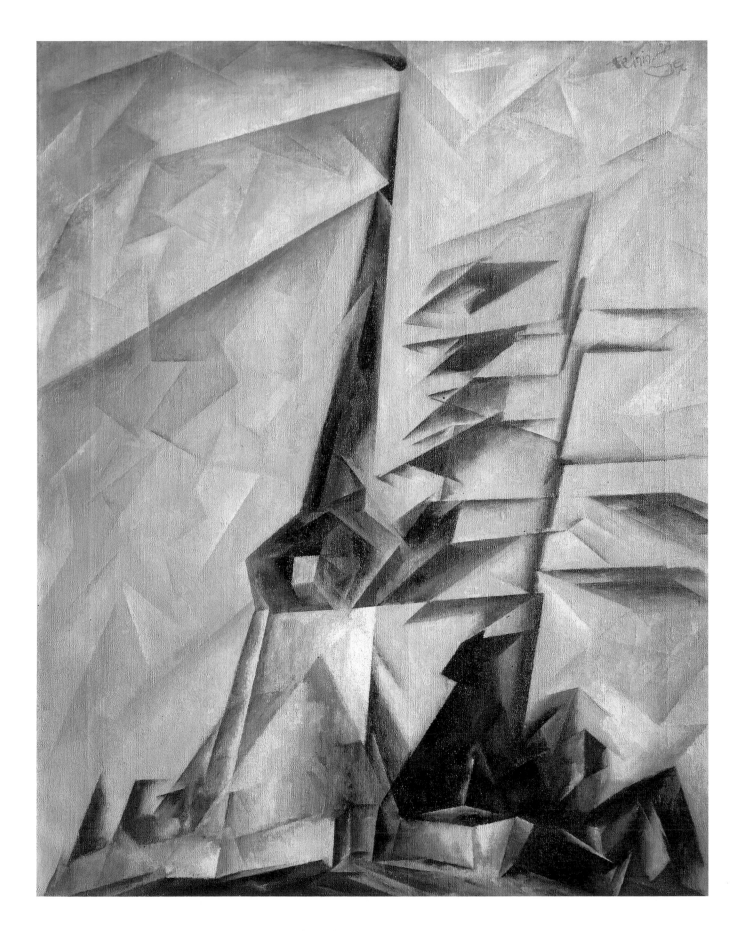

fig. 70. *Gelmeroda II,* 1913
Oil on canvas, 39½ x 31⅝ in. (100.3 x 80.3 cm)
Private collection; courtesy Neue Galerie, New York

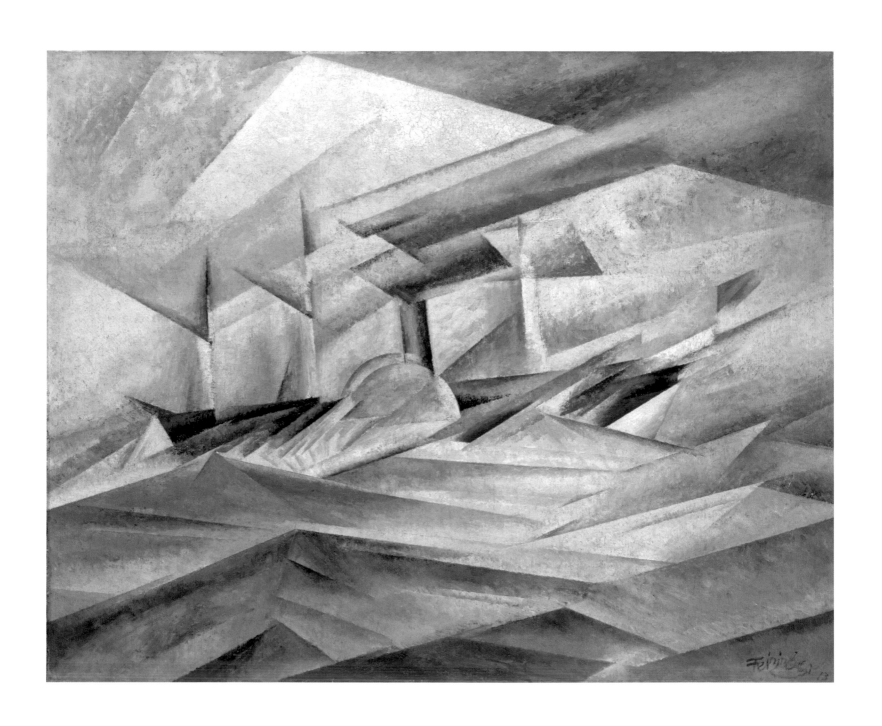

fig. 71. **The Side-wheeler II (Raddampfer II),** 1913
Oil on canvas, 31¾ x 39⅝ in. (80.6 x 100.6 cm)
Detroit Institute of Arts; City of Detroit Purchase 21.208

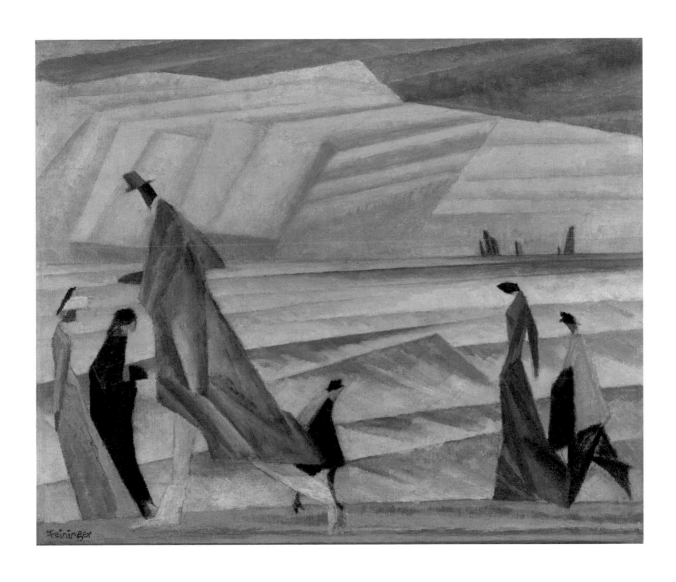

fig. 72. *On the Beach (Am Strande),* 1913
Oil on canvas, 15¾ x 19⅛ in. (40 x 48.5 cm)
Musée National d'Art Moderne, Centre Georges Pompidou, Paris

Art During Wartime

Most Germans initially saw World War I as an opportunity to realize the country's dreams of imperial grandeur, and they applauded it with patriotic fervor. At first, Feininger too fully supported the German war effort, defending the country's actions in letters to his father and in political cartoons satirizing the British and American governments that *Wieland* published in 1914 and 1915 (fig. 73).[161] A year into the conflict, however, his attitude darkened and he wrote of the "eternally anguishing thought of war," which he likened to a "monstrous, man-eating machine."[162] As an American—and thus immune from the draft—Feininger was far luckier than most other artists. Blaue Reiter artist August Macke (1887–1914) died at the front in the second month of the war; Kirchner suffered a nervous breakdown and entered a sanatorium after his discharge in December 1915; and Marc, who had welcomed the war as a purifying apocalypse that would cleanse and redeem the world, was killed on March 4, 1916. The deaths of people he knew and the letters he exchanged with friends on the front, particularly Schmidt-Rottluff and the poet Adolf Knoblauch, kept the conflict alive for Feininger. Caught between loyalty to Germany and his increasingly uncomfortable status as an American, he fell into a "psychotic state, like an overpowering, totally paralyzing self-hypnosis. . . . I wanted to suffer, have suffered, did not want to avoid my part in the general constraint of minds out of a putative obligation toward the great suffering."[163] In his paintings, even those such as *Jesuits III* and *Newspaper Readers II* (figs. 78, 92) that recapitulated earlier subjects, he replaced all suggestion of carefree gaiety with a somber restraint and immobile severity. "Where I formerly radiated movement and unrest," he reported, "I have now tried to sense and to express the total and brazen stillness of objects, even of the circumambient air—the world that is the farthest removed from the one that exists."[164] Decades later, he detected "an aloofness in the work of those dreadful years, not to be obtained through any conscious effort of aspiring for an ideal—it was suffering and horror of the Soul that made my visions so 'final.'"[165]

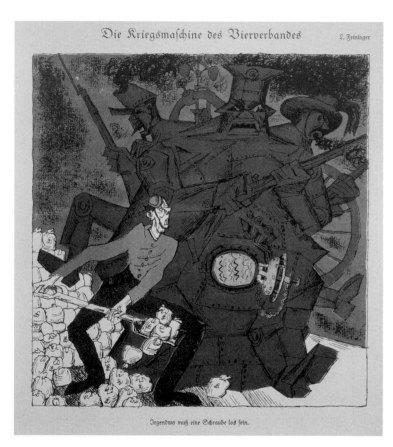

fig. 73. **"Gang-of-Four War Machine (A screw must be loose somewhere),"** from *Wieland* I, no. 25, 1915
Collection of Danilo Curti-Feininger

Externally, apart from rationing and the limitations the German government put on his freedom of mobility, the war had very little impact on Feininger's daily life. His wife and three boys—Andreas, Laurence, and Theodore Lux, known as T. Lux (born in 1910)—were healthy, and the threats to his father-in-law's fortune were not serious enough to cause worry about household expenses. At Knoblauch's urging, he deepened his contact with Walden, whose inclusion of Feininger's paintings in a three-person exhibition at Der Sturm in June 1916 signaled the dealer's growing interest in his work.[166] With the opening of Feininger's one-person show at the gallery on September 2, 1917,

and the simultaneous publication of excerpts of his correspondence with Knoblauch in Walden's *Der Sturm* journal, Feininger's position as a leading member of Berlin's art community was secured. He had spent ten years building an aesthetic foundation that could withstand the perils he associated with external success. Convinced of the aesthetic leap he had made in the previous two years, Feininger felt ready to "have his paintings work for him."[167]

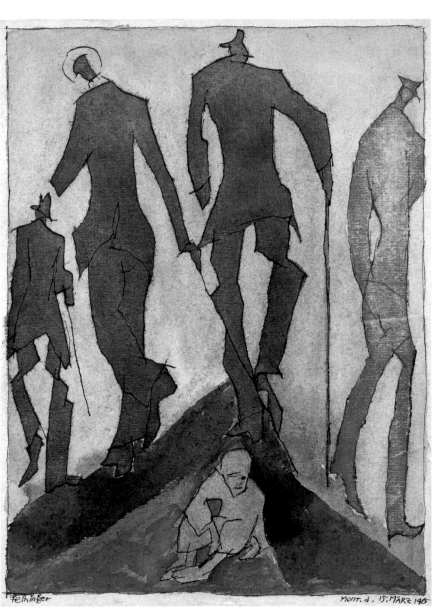

fig. 74. **Untitled (Deserted Child),** 1915
Watercolor and ink on paper, 12⅜ x 9¼ in. (31.5 x 23.5 cm)
Private collection; courtesy Moeller Fine Art, New York and Berlin

By the time Feininger's 1917 show opened, the United States was at war with Germany. Earlier, in August 1916, Feininger had petitioned the U.S. embassy to allow him to remain in Germany as an American citizen, arguing that returning to America without his art, whose transport across the ocean had been rendered unsafe by submarine warfare, he would not be able support his family.[168] Five months later, his status as an American became more precarious when the British decoded a telegram sent by the German foreign secretary, Arthur Zimmermann, to the German ambassador in Mexico instructing him to offer the Mexican government a military alliance should the United States enter the war. As hopes dimmed for American neutrality, most of the two to three thousand Americans still living in Germany left the country. Feininger remained, publicly proclaiming himself a "loyal German" who despised American politics.[169] On April 6, 1917, when America declared war, Feininger's plans for a summer vacation with his family in Braunlage in the Harz Mountains were already fixed. But when he returned to Berlin that August to prepare for his Der Sturm show, he was required to report daily to his local police station as an enemy alien. He took pride in never missing a day, reassuring his family that the political situation justified it. The shift in Feininger's national allegiance had occurred gradually. He had spent his first fifteen years in Germany desperately homesick. Even after meeting Julia, his initial instinct had been to return home. Each time, something had intervened. By 1917, he had been with Julia for more than ten years, during which time he had become a father of three boys, with a burgeoning art career and an aging father-in-law toward whom he felt increasing affection and emotional responsibility. He remained "Der Amerikaner" to strangers on the street, but his ties to Germany had strengthened. At the same time, his view of the country as bureaucratic and pretentious, and his suspicion that it lacked an intuitive appreciation for beauty despite its great cultural heritage, kept him from fully embracing what had become his adopted home.[170]

Feininger's citizenship had little impact on the reception of his Der Sturm show. Walden's prediction that it would be a watershed for the artist proved true. Critical response was universally favorable, with Paul Westheim calling Feininger "a Romantic, full of lyrical sentimentality," and Theodor Daubler dubbing him a "crystalline Cubist."[171] In characterizing Feininger's work as crystalline, Daubler invoked the prevailing valorization of the crystal as a symbol of dematerialized spirituality, an idea that originated with the German Romantics. "The spiritual within the material" was how German Romantic poet Friedrich Wilhelm Schelling had defined the crystal.[172] Wilhelm Worringer expanded the concept in his 1908 book *Abstraction and Empathy* by equating the crystal with abstraction and, by extension, with the desire for the eternal. By means of inorganic, crystalline forms, he argued, artists translate the transient, conditional aspects of reality into absolute, timeless, and eternal forms.

fig. 75. **Railroad Viaduct,** 1919
Woodcut, 15 x 19½ in. (38.1 x 49.5 cm)
Private collection; courtesy Moeller Fine Art, New York and Berlin

Critical affirmation of his work notwithstanding, with the country in its fourth year of war, Feininger had braced himself for tepid sales. In fact, few works sold, but Walden's purchase of *Marine* (1914) meant that Feininger's art was now part of the Der Sturm collection that toured to several German cities before being put on public display at the gallery two days a week. Seven months after the show, Feininger modestly had to agree that he had "become more of a public figure in the past year."[173]

As Feininger had feared, however, the public presentation of his work paralyzed him, and it took six months before he regained his equanimity and could paint again. When he did, he found that quality materials were unavailable. Wisely, he had stockpiled eighteen tubes of white paint, but even by painting thinly, he quickly exhausted his supply. Most likely at Schmidt-Rottluff's suggestion, he turned to woodcuts, a medium popular among Die Brücke artists. By the time he returned that summer to Braunlage—a vacation made possible by Walden having convinced the authorities that mountain air was necessary for Feininger's health—he had already "crashed into this technique with a passion to compensate for its belatedness in my career."[174] By year's end, he had completed 117 woodcuts.

Feininger found woodcuts a perfect medium with which to investigate planar composition. In contrast to etching and lithography, with which he had experimented since 1906, the balance demanded in woodcuts between figures and the spaces around them was essential; each had to hold the surface with equal intensity. Restriction to positive and negative space placed the emphasis on form, which is where Feininger felt it belonged. "Form first!" he later counseled his son Lux. "Form above Color."[175] The fact that woodcuts could be made from inexpensive and readily available materials—thin wood

blocks (including the covers of Feininger's cigar boxes), paper, and ink—made it the perfect medium for a wartime economy. In contrast to his laborious and agonizing painting process, Feininger could make woodcuts relatively quickly and effortlessly. Once he had selected a motif from among his treasury of sketches, he worked improvisationally, freely cutting the image into the wood block, then manually printing it on various papers. Often he printed multiple versions of a single image to test how different papers held the ink. His numbering system was precise but idiosyncratic: he inscribed each sheet with the last two digits of the year the woodcut was made, followed by its number within the year's production. Thus, the fifteenth print completed in 1918 was recorded as 1815.

The ease with which Feininger could produce woodcuts encouraged the expression of his playful side. In his painting, he often followed "a devout, deeply religious work" with a whimsical composition.[176] His woodcuts mirrored this pendulum by alternating between monumental architectural images and droll, figurative compositions populated by the same men in Biedermeier coats, workmen in baggy pants, prostitutes, and Jesuits who had inhabited his carnivalesque paintings. This "childlike joyous and fantastic-bizarre Feininger world," as the artist called it, also found expression in the small, hand-carved, hand-painted toys he made, initially for his sons, and later for friends and their children.[177] The first toy was a model train set, similar to the wood prototype he was designing for Löwenstein, that he carved as a Christmas present for his sons in 1913; toy boats, houses, and people soon followed (figs. 76, 93, 95–99). Each Christmas thereafter, he added more objects to the ensemble, which Lux later called "City at the Edge of the World," after his father's 1910 gouache of that title (fig. 94). Situated in a middle ground between sculpture and toys, these carved objects functioned as actors and props in a constantly changing performance. Their slapstick absurdity and guileless whimsy were doors through which Feininger entered "into Golden childhood again."[178] So too with his figurative watercolors of the 1920s, with their scraggly, vibrating outlines and implied narratives (fig. 114) and his depictions in the 1940s and 1950s of mischievous sprites, or "ghosties," as he called them (figs. 164–66). As Feininger attested, "Certain longings can only be experienced this way."[179]

fig. 76. **Figures and houses,** 1920s–40s
Painted wood, overall dimensions variable
The Cleveland Museum of Art; in memory of Leona E. Prasse, gift of Ada Prasse Bittel 1985.170

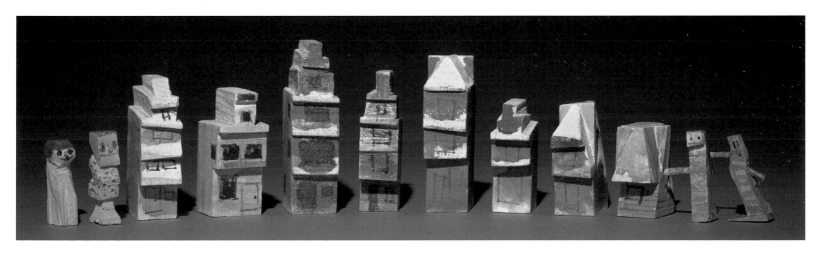

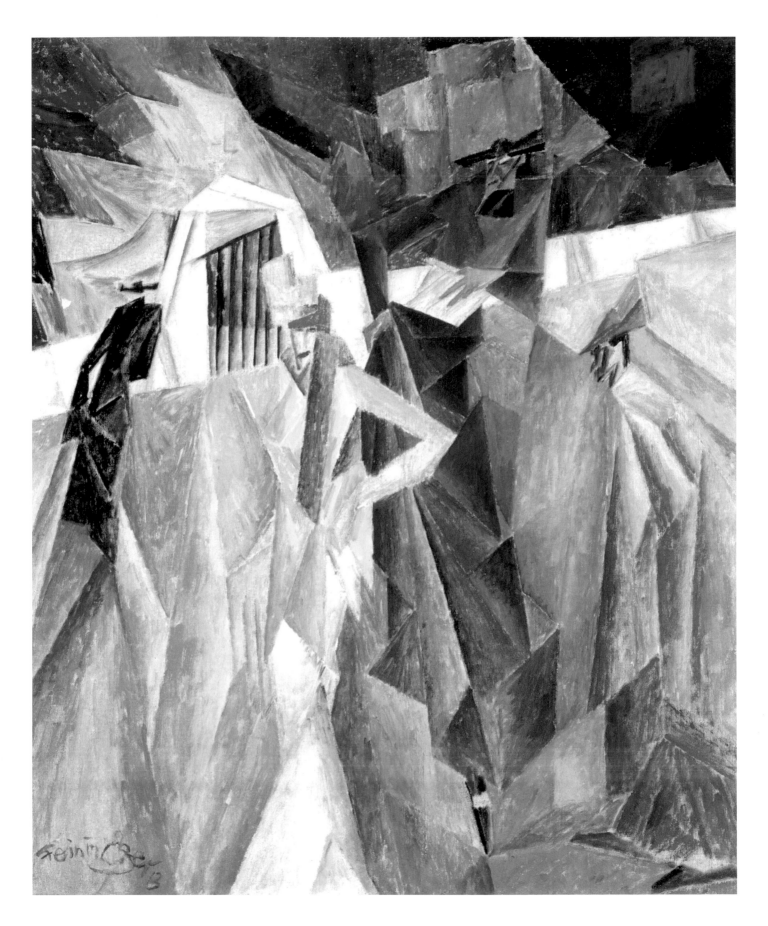

fig. 77. *Jesuits II,* 1913
Oil on canvas, 28¾ x 23⅝ in. (73 x 60 cm)
Saint Louis Art Museum; bequest of Morton D. May 886:1983

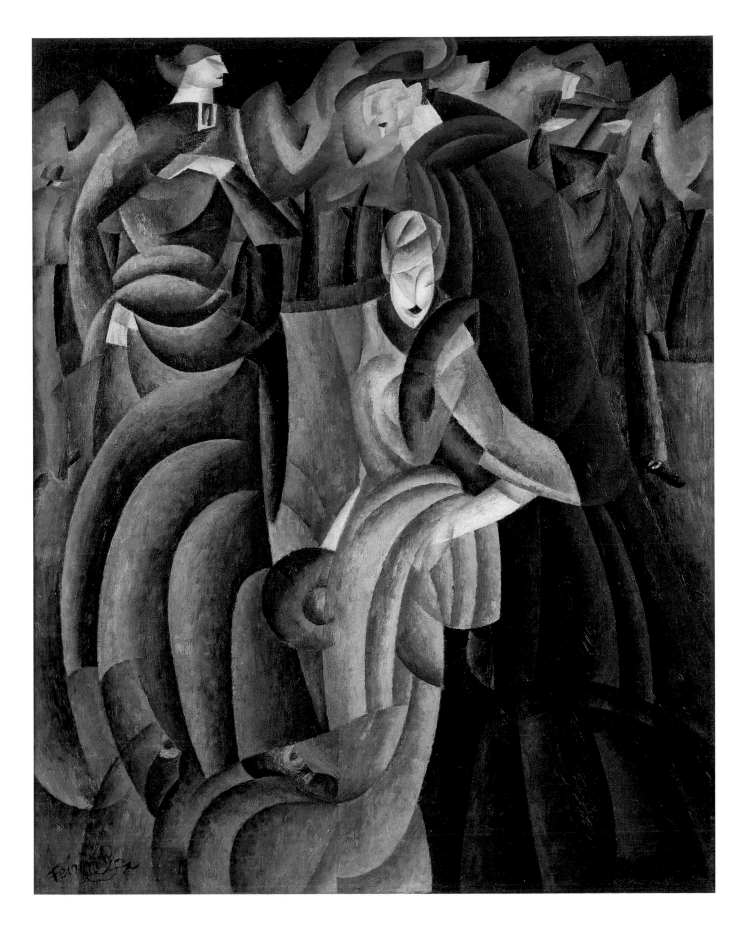

fig. 78. *Jesuits III,* 1915

Oil on canvas, 29½ x 23⅝ in. (74.9 x 60 cm)

Private collection

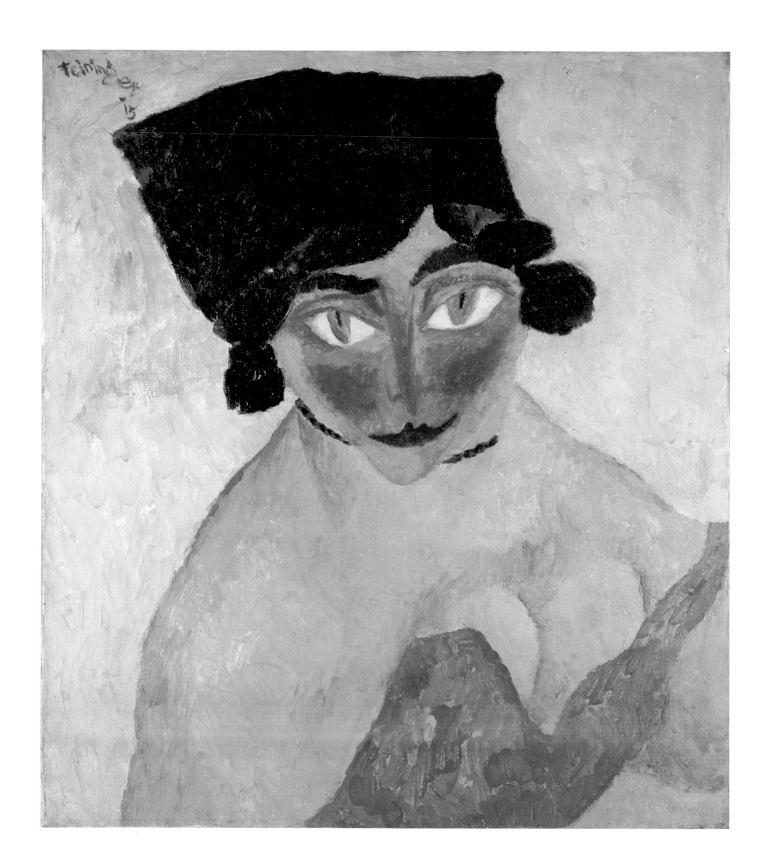

fig. 79. **Woman's Head with Green Eyes (Frauenkopf mit grünen Augen),** 1915
Oil on canvas, 28 x 24½ in. (71.1 x 62.2 cm)
Saint Louis Art Museum; bequest of Morton D. May 887:1983

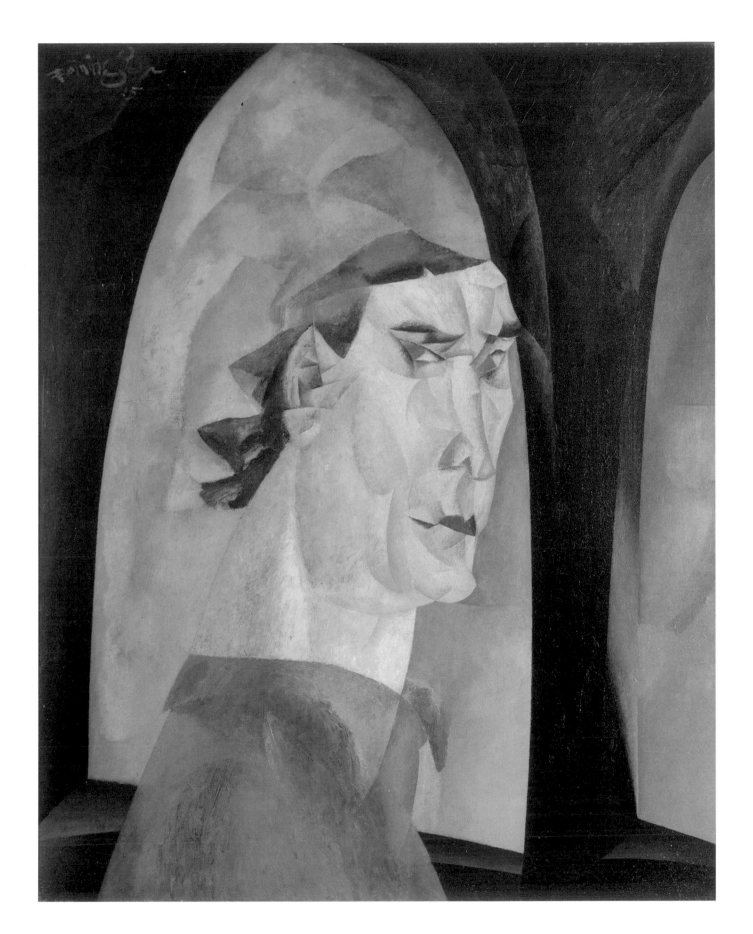

fig. 80. *Self-Portrait (Selbstbildnis),* 1915
Oil on canvas, 39½ x 31½ in. (100.3 x 80 cm)
Sarah Campbell Blaffer Foundation, Houston BF.1979.15

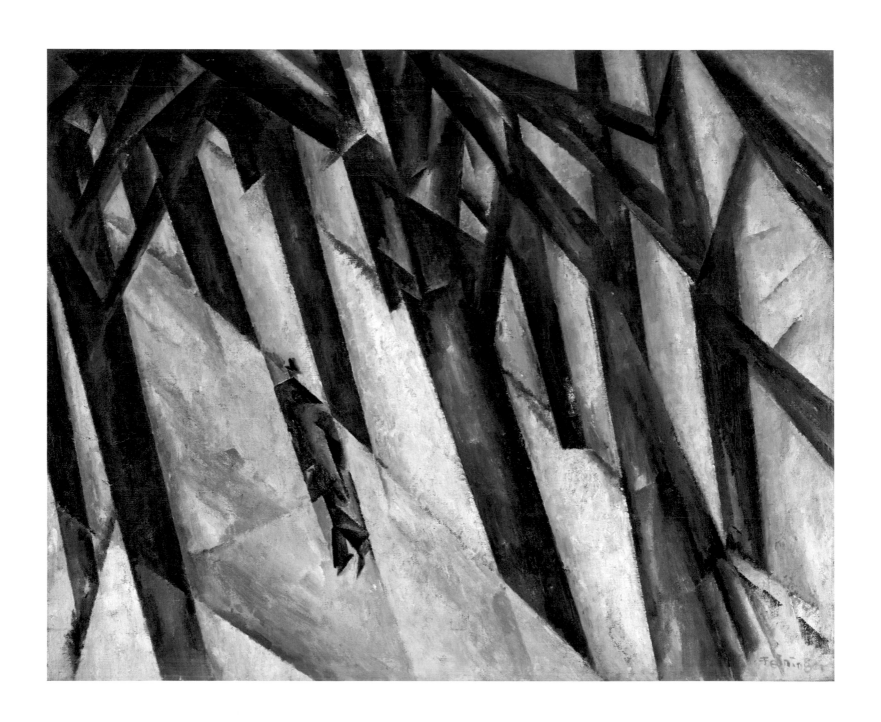

fig. 81. **Avenue of Trees (Allée),** 1915
Oil on canvas, 31 11/16 x 39 9/16 in. (80.5 x 100.5 cm)
Harvard Art Museums, Busch-Reisinger Museum, Cambridge,
Massachusetts; bequest of William S. Lieberman BR2007.17

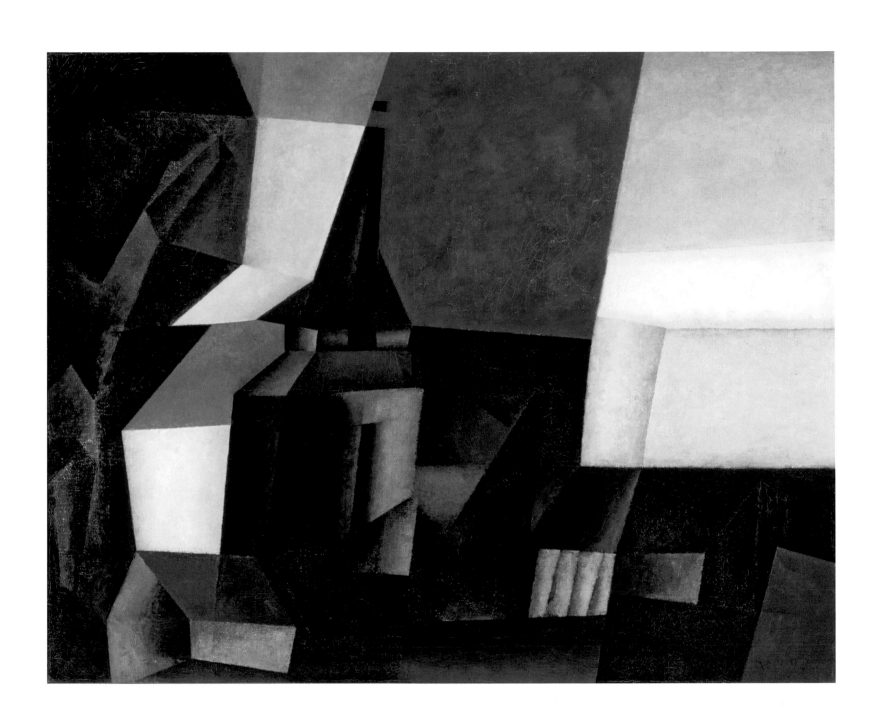

fig. 82. *Zirchow V,* 1916
Oil on canvas, 31⅞ x 39⅝ in. (81 x 100.6 cm)
The Brooklyn Museum; J. B. Woodward Memorial Fund and
Mr. and Mrs. Otto Spaeth 54.62

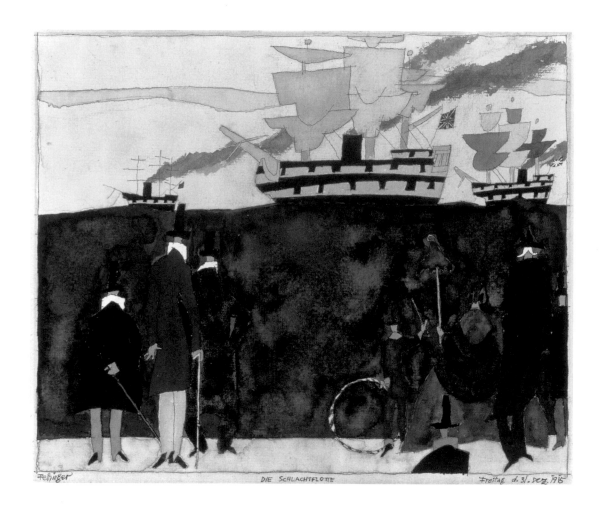

DIE SCHLACHTFLOTTE

fig. 83. **The Fleet (Schlachtflotte),** 1915
Ink and watercolor on paper, 8⁵⁄₁₆ x 10 in. (21.1 x 25.4 cm)
Private collection

fig. 84. **Rainy Day,** 1915
Oil on canvas, 39⅜ x 31½ in. (100 x 80 cm)
Private collection; courtesy Moeller Fine Art, New York and Berlin

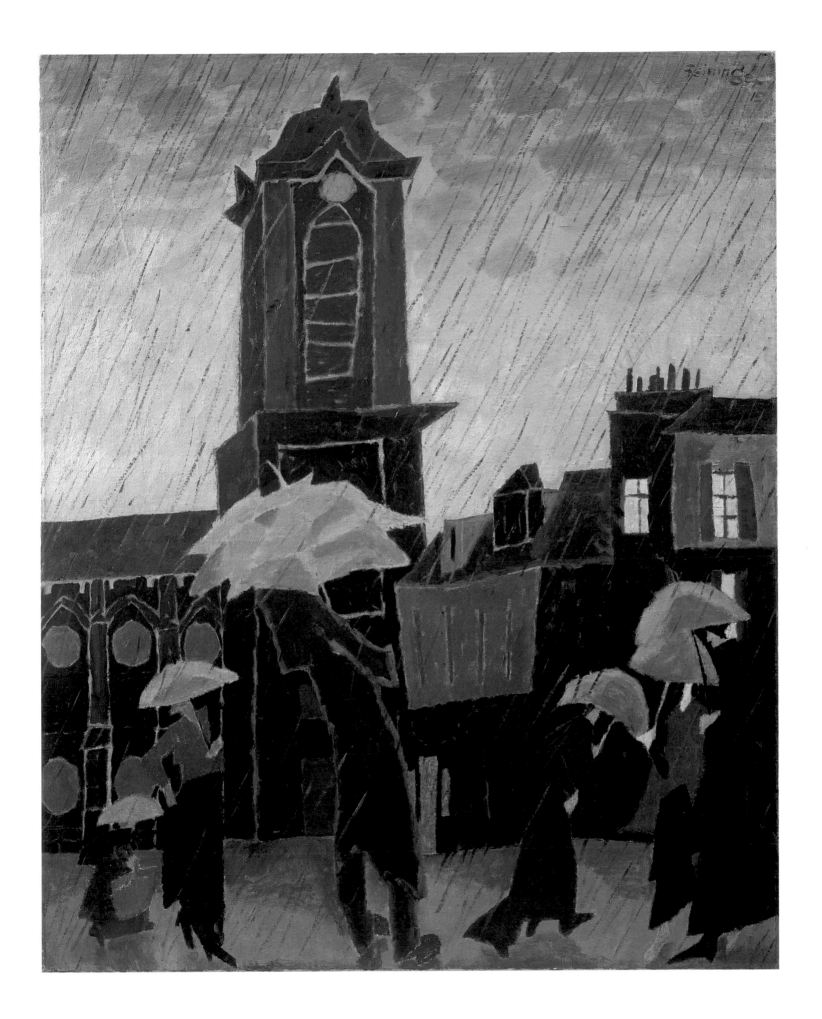

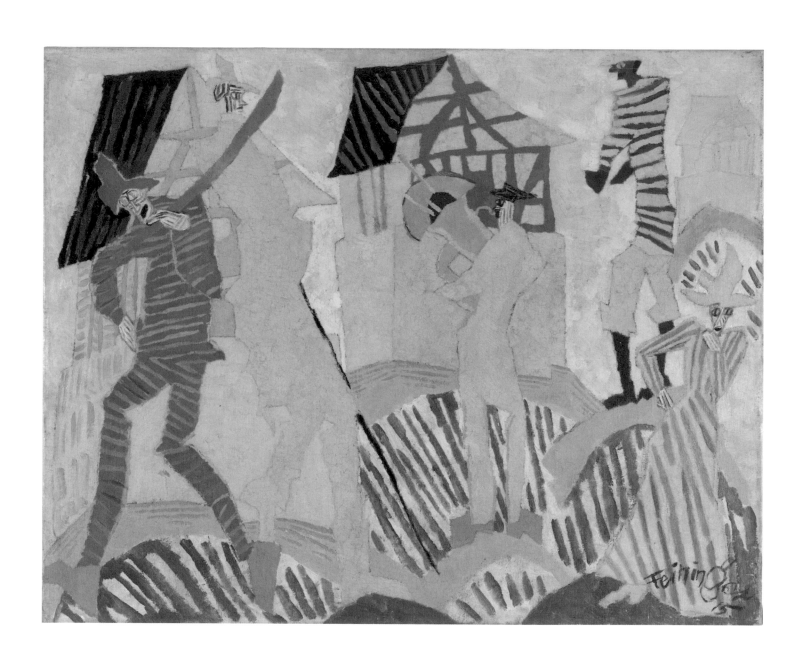

fig. 85. *Trumpeter in the Village,* 1915
Oil on canvas, 25¾ x 29½ in. (65.4 x 74.9 cm)
Private collection

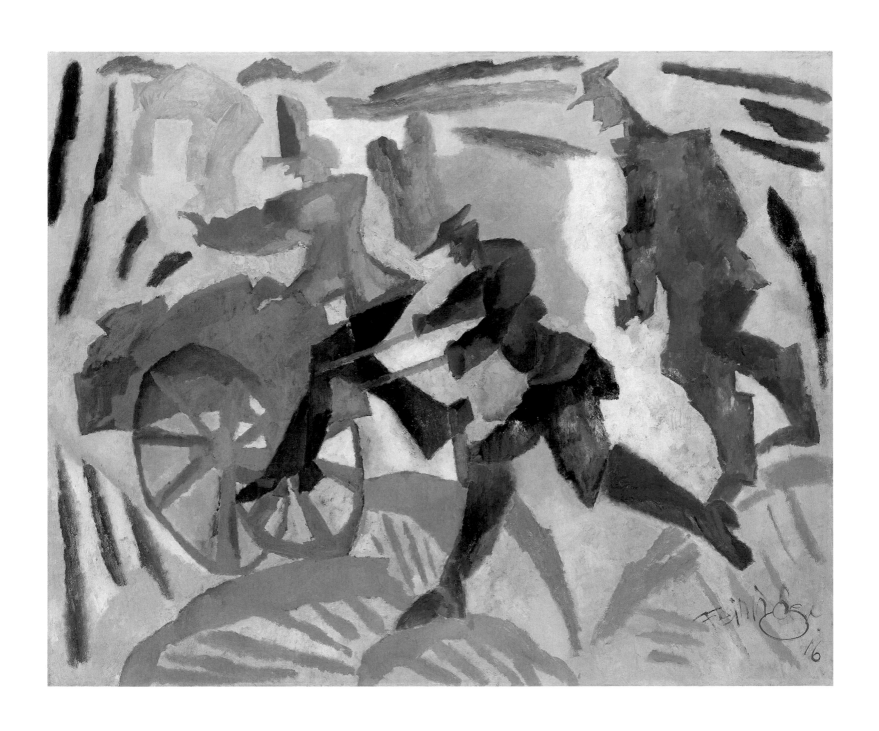

fig. 86. *Streetcleaners,* 1916
Oil on canvas, 47⅝ x 59⅛ in. (120.8 x 150 cm)
Private collection

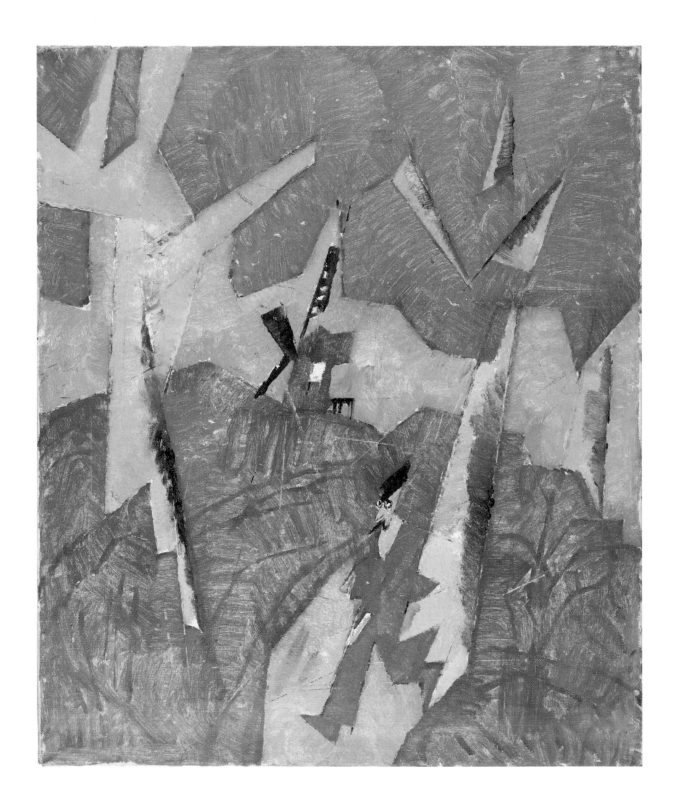

fig. 87. **Mill with Red Man,** c. 1917
Oil on canvas, 19⅛ x 15⅞ in. (48.6 x 40.3 cm)
Private collection

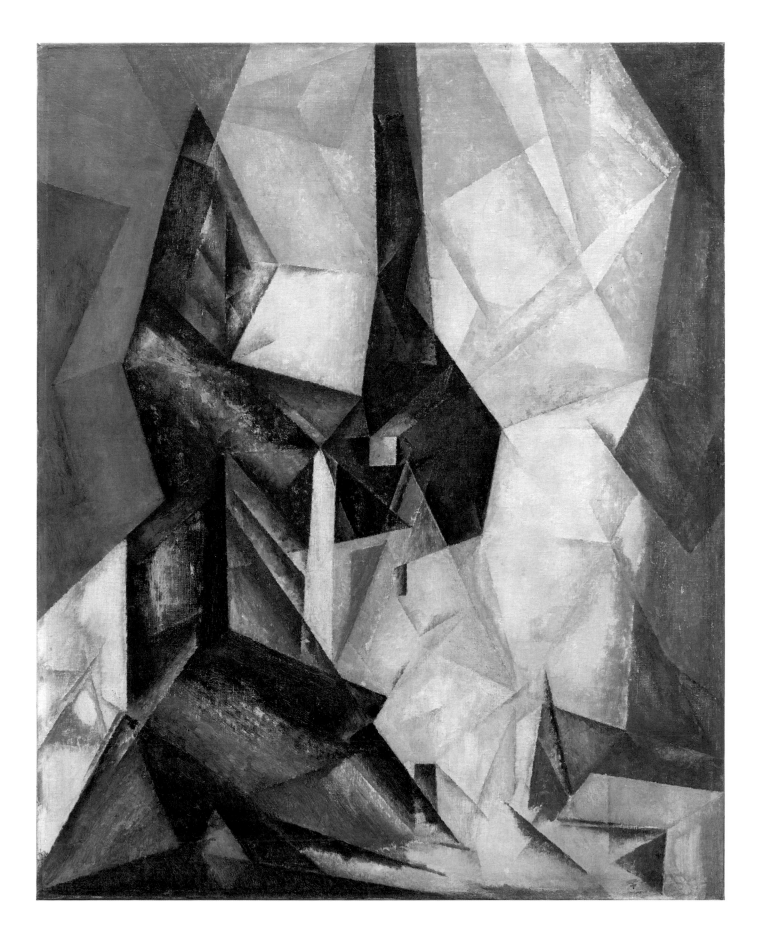

fig. 88. *Gelmeroda IV,* 1915
Oil on canvas, 39½ x 31⅜ in. (100 x 79.7 cm)
Solomon R. Guggenheim Museum, New York 54.1410

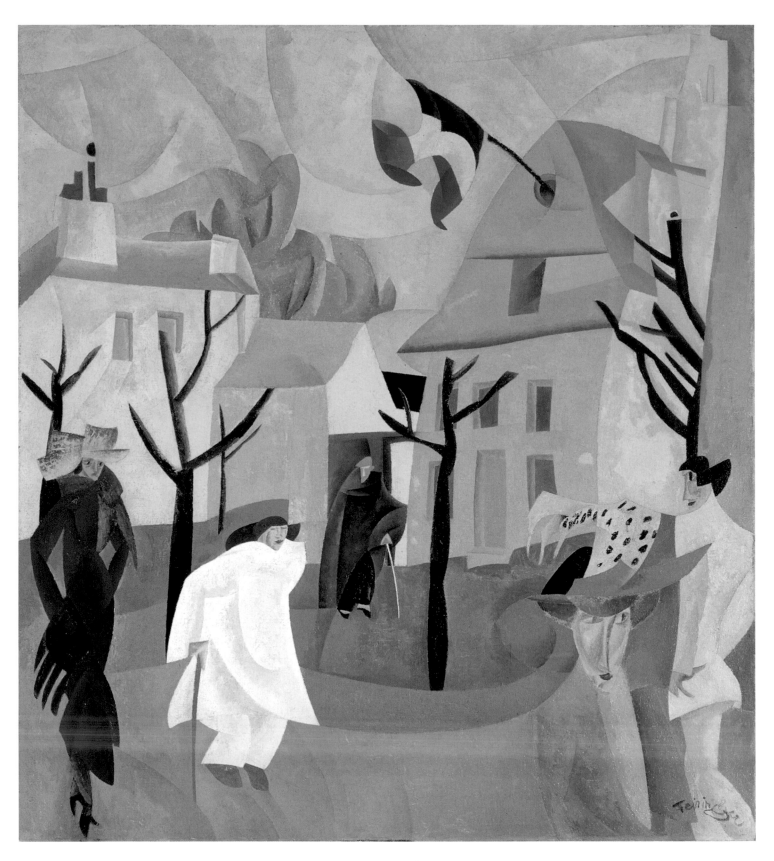

fig. 89. *Yellow Street II,* 1918
Oil on canvas, 37½ x 33⅞ in. (95 x 86.1 cm)
Montreal Museum of Fine Arts; purchase, gift of The Maxwell Cummings
Family Foundation, The Montreal Museum of Fine Arts' Volunteer
Association, John G. McConnell, C.B.E., Mr. and Mrs. A. Murray Vaughan,
Harold Lawson Bequest, and Horsley and Annie Townsend Bequest

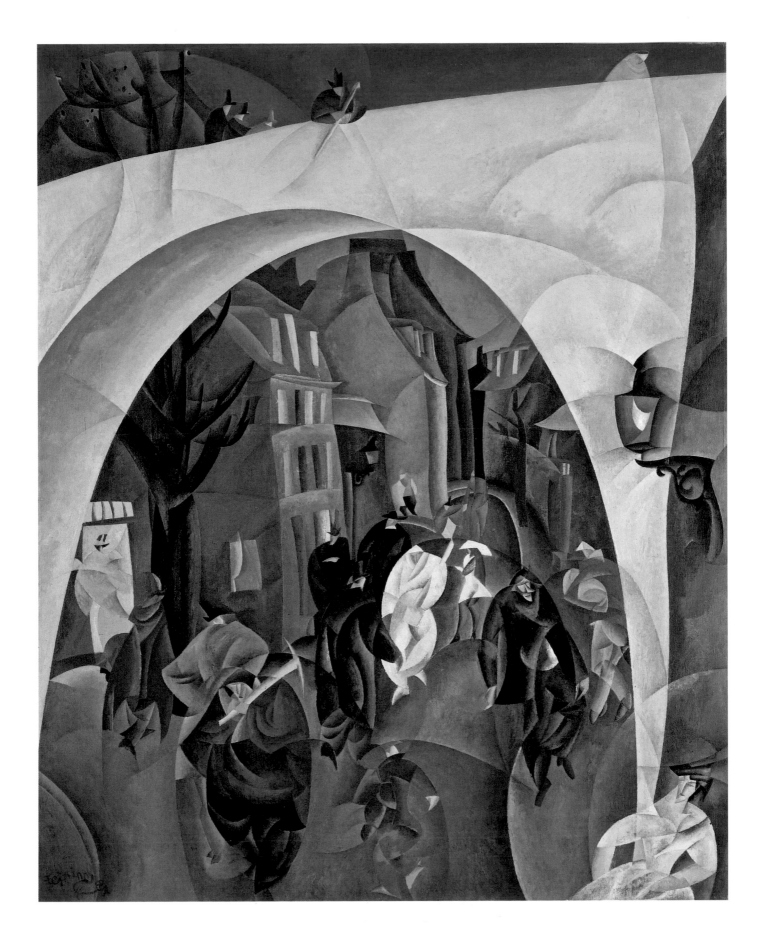

fig. 90. *The Green Bridge II (Grüne Brücke II),* 1916
Oil on canvas, 49⅜ x 39½ in. (125.4 x 100.3 cm)
North Carolina Museum of Art, Raleigh; gift of Mrs. Ferdinand Möller

Lyonel Feininger Promenade

18102

fig. 91. ***Promenaders (Spaziergänger),*** 1918
Woodcut, 14⁹⁄₁₆ x 11½ in. (37 x 29.5 cm)
The Brooklyn Museum; Dick S. Ramsay Fund 62.59.3

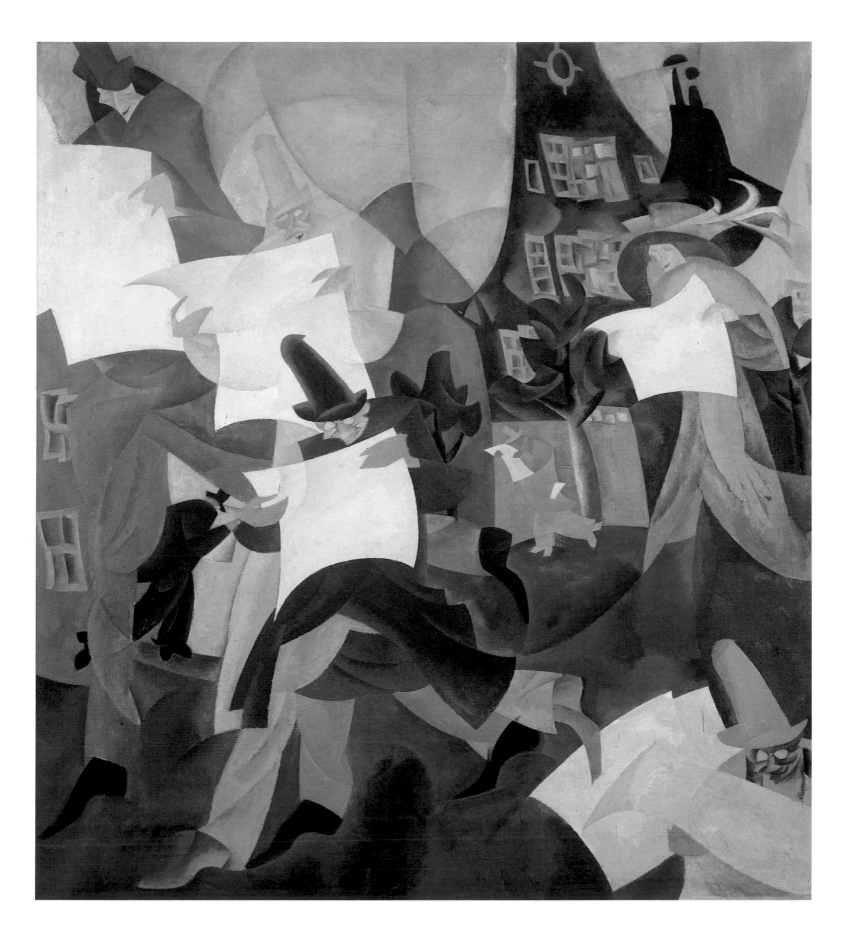

fig. 92. **Newspaper Readers II (Zeitungsleser II),** 1916
Oil on canvas, 40⅞ x 36¾ in. (103.8 x 93.3 cm)
Private collection

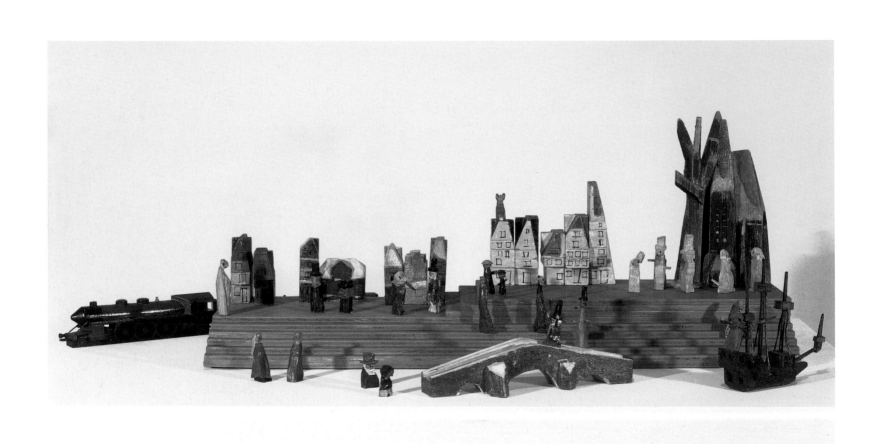

fig. 93. **Bridge, figures, houses, train, and tree,** c. 1916—45
Painted wood, overall diimensions variable
Private collection

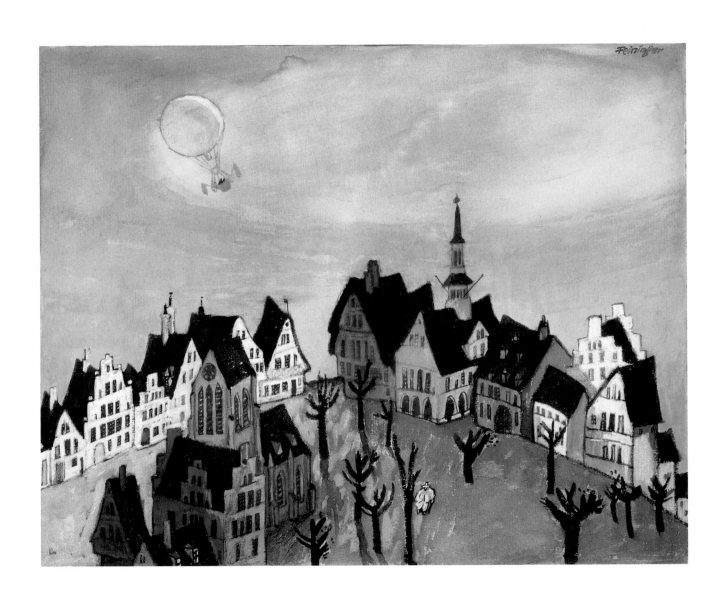

fig. 94. **City at the Edge of the World (Die Stadt am Ende der Welt),** 1910
Ink and gouache on paper, 9¼ x 11⅝ in. (23.5 x 29.5 cm)
Private collection

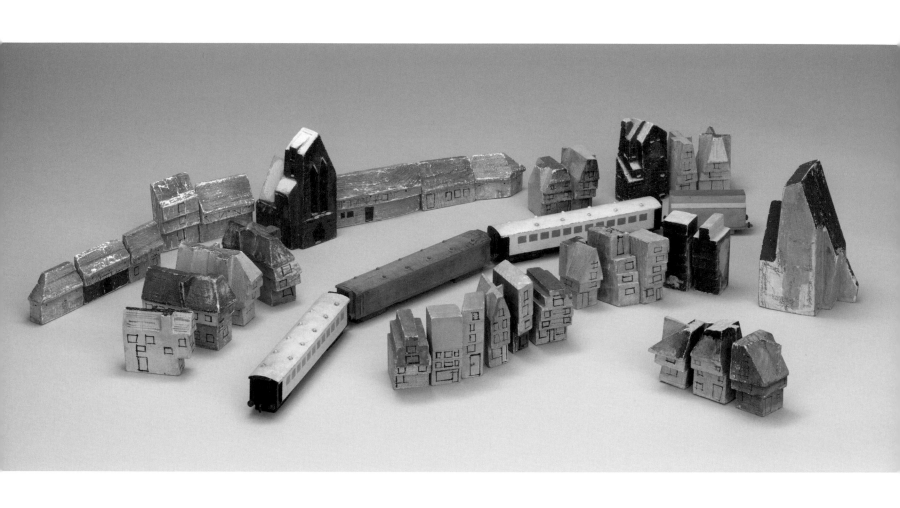

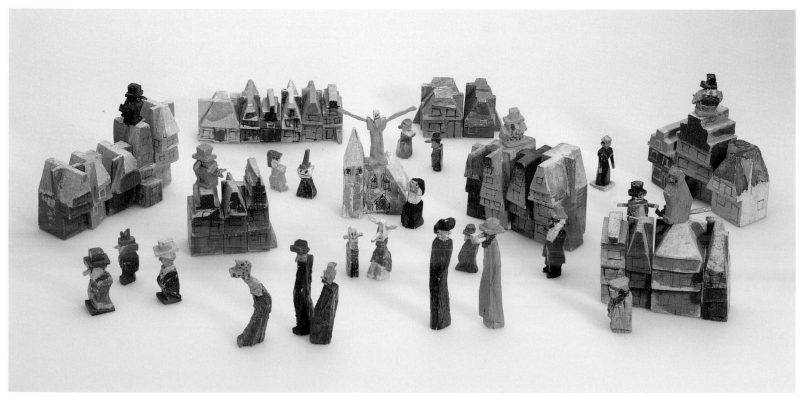

88 HASKELL

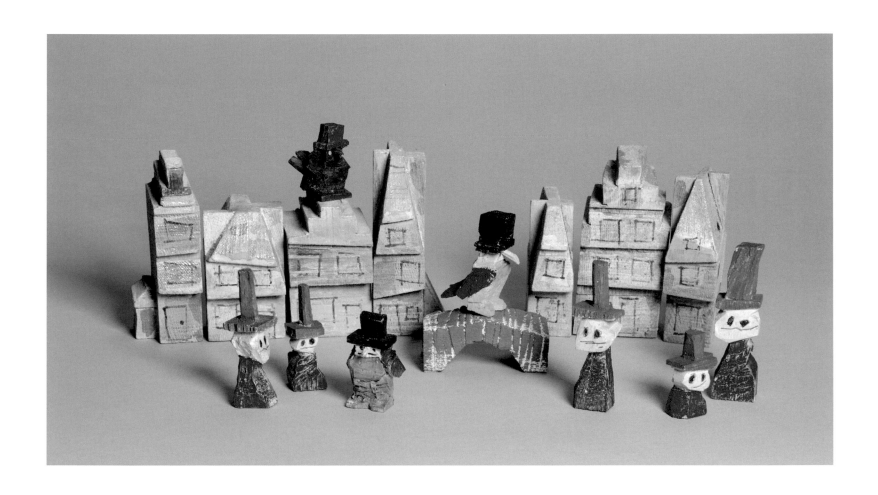

fig. 95. **Train cars,** c. 1913–14; **buildings,**
c. 1925–55
Painted wood, overall dimensions variable
The Museum of Modern Art, New York; Julia Feininger
Bequest SC704.1971.1–37

fig. 96. **Figures and houses,** 1919–50
Painted wood, overall dimensions variable
Museum für Kunst und Gewerbe, Hamburg

fig. 97. **Figures and houses,** c. 1949
Painted wood, overall dimensions variable
The Art Institute of Chicago; bequest of Maxine Kunstadter
1978.411

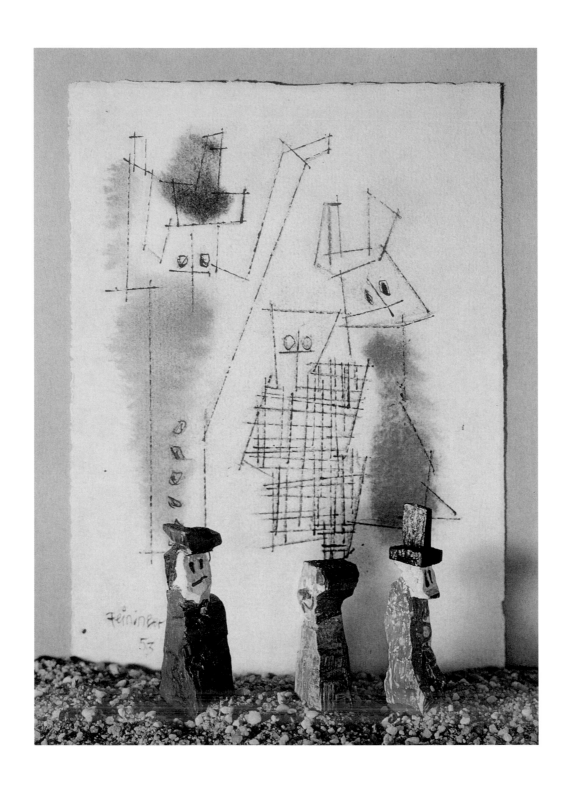

fig. 98. **Feininger's wood toy figures posed in front of his 1953 untitled watercolor.** Photograph by Andreas Feininger

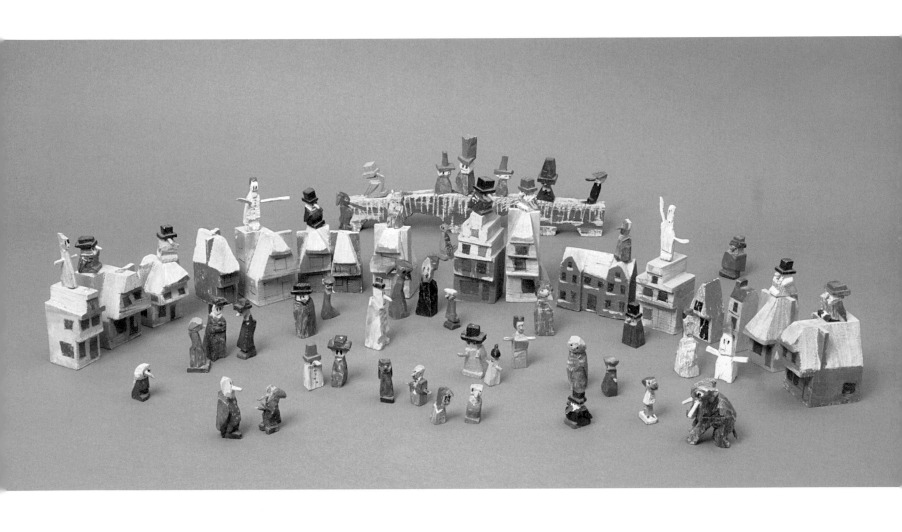

fig. 99. **Bridge, figures, and houses,** 1920s–40s
Painted wood, overall dimensions variable
Moeller Fine Art, New York and Berlin

The Bauhaus Years

By the fall of 1918, Germany had been at war for four years, the nation's hopes for a quick, heroic victory having long since fallen victim to disillusionment and the deaths of five million countrymen. On November 11, following the German sailors' mutiny and Kaiser Wilhelm II's abdication, an armistice was signed, formally ending the war. With the proclamation of a republic, a new era of peace and internationalism seemed possible.[180] Visions of a socialist utopia permeated the art community, as artists rushed to help build a new Germany in which art would be an integral part of daily life rather than a luxury commodity for the privileged elite. Two groups with overlapping memberships formed in Berlin that December, each dedicated to uniting artists and the working class.[181] Members of the Novembergruppe, taking their name from the November 1918 revolution in Germany, supported the new republic by designing posters for the provisional government's publicity office, while spreading the group's socialist agenda through exhibitions, catalogues, periodicals, and a collection of radical writings titled *An alle Künstler!* (To All Artists!), whose lead essay, "Call to Socialism," was a tacit mission statement. Feininger's involvement with the Novembergruppe was limited to the reproduction of his woodcut *Marine* in this publication and his one-time exhibition with the group in 1924. Invited officially to join it in December 1918 by the Expressionist painter Georg Tappert (1880–1957), a co-founder of the group, he declined, citing his need to refrain from political action for the sake of his art.[182]

fig. 100. **Title page, *Yes! Voices of the Workers Council for the Arts in Berlin (Ja! Stimmen des Arbeitsrates für Kunst in Berlin),*** with Feininger's woodcut ***Town Hall (Rathaus),*** 1919
Collection of Danilo Curti-Feininger

The Arbeitsrat für Kunst (Workers Council for the Arts) similarly advocated bringing art to the people, but because its leadership was dominated by architects— Walter Gropius (1883–1969), Bruno Taut (1880–1938), and Adolf Behne (1885–1948)— it proposed doing so as part of a new architecture that would amalgamate all the plastic arts into "Buildings of the People." Taut called upon artists and architects to create modern equivalents of Gothic cathedrals—"crystalline expressions [of] the noblest thoughts of humanity," as he called them.[183] Feininger did not sign the Workers Council's inaugural manifesto published in December 1918, but he was friends with a number of steering committee members, including Pechstein, Heckel, Schmidt-Rottluff, Gerhard Marcks (1889–1981), and Wilhelm Valentiner (1880–1958).[184] At their urging, he joined the council in March 1919, becoming one of the nineteen members of its "working group of artists and art writers living in Berlin."[185] A month later, he contributed the woodcut *Gelmeroda*[186] to a deluxe portfolio published by the dealer J. B. Neumann in conjunction with the Arbeitsrat-sponsored *Ausstellung für unbekannte Architekten* (Exhibition for Unknown

Architects) at Neumann's Graphisches Kabinett in Berlin.[187] His woodcut *Rathaus* (Town Hall) followed in November as the frontispiece of the group's book *Ja! Stimmen des Arbeitsrates für Kunst in Berlin* (Yes! Voices of the Workers Council for Arts in Berlin) (fig. 100), a compilation of twenty-eight members' responses to questions about art education, the reform of art institutions, and state support for art and artists. To help the group raise funds, Feininger made fifty-five prints of the image for the publication's deluxe edition. By depicting the early nineteenth-century town hall of Swinemünde, Feininger evoked the myth of harmony and community that was identified with the Biedermeier Period and, by extension, art's role in what the Arbeitsrat artists saw as society's modern, utopian equivalent.

The initial optimism of the November revolution was soon dampened by the violence that broke out between Social Democrats and Communists over control of the fledgling republic. As social unrest escalated along with the cost of living, Feininger yearned to escape Berlin. "Of course I am thinking first and foremost of Weimar," he wrote to Kubin in March 1919.[188] The opportunity came in April, when Gropius, whom Feininger had met through the Workers Council, asked him to join the faculty of the Staatliches Bauhaus (State Bauhaus), created a month earlier by merging Weimar's Hochschule für bildende Kunst (Academy of Fine Arts) with its Kunstgewerbeschule (School of Applied Arts).[189] Modeled on the aspirations of the Workers Council, the newly constituted school aimed to be a modern version of the medieval guild (Bauhütte), in which fine artists worked alongside artisans to create what Taut called the "visible vestments" of the new state.[190] Only three faculty vacancies had occurred at the two schools during the war; to fill them, Gropius selected Feininger, Marcks, and Johannes Itten (1888–1967), giving each artist the title of Meister (Master) rather than professor to reinforce the school's workshop-based approach.[191] To recruit students, Gropius wrote a four-page manifesto containing the school's mission statement and a précis of its program and pedagogical organization. He asked Feininger, still living in Berlin, to create a woodcut for the brochure's cover.

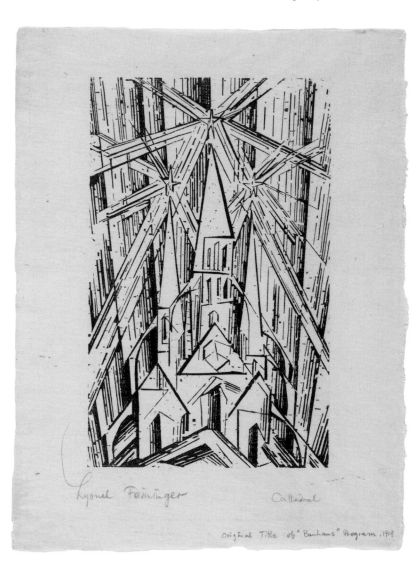

fig. 101. **Cathedral (Kathedrale),** 1919
Woodcut, 16⅛ x 12³⁄₁₆ in. (41 x 31 cm)
The Museum of Modern Art, New York; gift of Abby Aldrich Rockefeller 156.1945

In creating the brochure's cover image, Feininger was guided by the closing lines of Gropius's manifesto: "Let us collectively desire, conceive and create the new structure of the future, which will unify architecture and sculpture and painting in one entity and will one day rise from the hands of a million workmen as the crystalline symbol of a new-coming faith."[192] Taut's earlier text for the Arbeitsrat, upon which Gropius's was based, had proposed Gothic cathedrals as the model for unifying all the arts within

a great architecture. The association of Gothic cathedrals with the unity of art and spirit in the Middle Ages struck a chord with Feininger. Building on the metaphor, he designed the image of three overlapping Gothic spires surrounded by shooting stars and ascendant rays of light to evoke the Bauhaus synthesis of the three disciplines—sculpture, painting, and architecture—under the aegis of a new, spiritual architecture (fig. 101).[193]

Feininger and Gropius traveled to Weimar together on May 18, 1919, the architect's thirty-sixth birthday. Looking back, Feininger called that trip "the beginning of the finest adventure in my artistic career . . . the decisive turning point of my . . . artistic life."[194] The only Masters at the Bauhaus in its first few weeks, Feininger and Gropius were alone in facing threats of governmental budget vetoes, and attacks from conservative members of the art community and trade unions who feared competition from Bauhaus products. The name change in itself provoked bitterness. The anti-Bauhaus "cabal" accused the school of promoting Bolshevik art, citing Feininger's standing as a Cubist as evidence. Facing this "wasp's nest" together made allies out of Feininger and Gropius; the two ate lunch together every day, and Gropius often visited Feininger in his studio to discuss issues and ask his opinion.[195] Gropius relied on Feininger's calming influence over the faculty members the school had inherited from the former academy, and he publicly trumpeted Feininger's positive reviews and the purchase and exhibition of his paintings by major German museums as proof of the Bauhaus's legitimacy.[196] As part of Gropius's program to introduce faculty members to the community, Feininger mounted an exhibition that June of several hundred of his nature notes, drawings, watercolors, and woodcuts, along with twenty photographs of paintings that related to them, hoping that by demonstrating how his art derived from observed reality he could reassure the frightened student body and the anti-Bauhaus contingent within the town.[197]

Feininger's early experiences at the Bauhaus rejuvenated him. "The depressed, war-sick man and ruminator has become a refreshed and resilient man of action," he declared.[198] "I am truly alive again, experience again! Every moment of the day . . . all my eager senses absorb the thousands of visual experiences . . . again I see the way leading upwards and forwards! As I never hoped to see it again."[199] Nevertheless, living in Weimar while the constitution of the new republic was being written made Feininger acutely aware of the difficulties facing the new state. Hopeful that "the world's decency will prevail towards the ignominious injustice against a conquered, defenseless people," he prayed that the vindictive reparations' clause in the Treaty of Versailles would be amended, writing prophetically that "a beaten down Germany, in a state of paralysis and disease in economic terms, will impoverish all of Europe."[200]

At the end of Feininger's first month at the Bauhaus, he was joined by Itten, who for two years would share responsibility with him for teaching painting and drawing. Guided by his conviction that true art was essentially spiritual and thus could not be taught, Feininger approached his position as Master more like a counselor and "soul doctor" than a formal instructor.[201] In an effort to avoid imposing his own aesthetic style

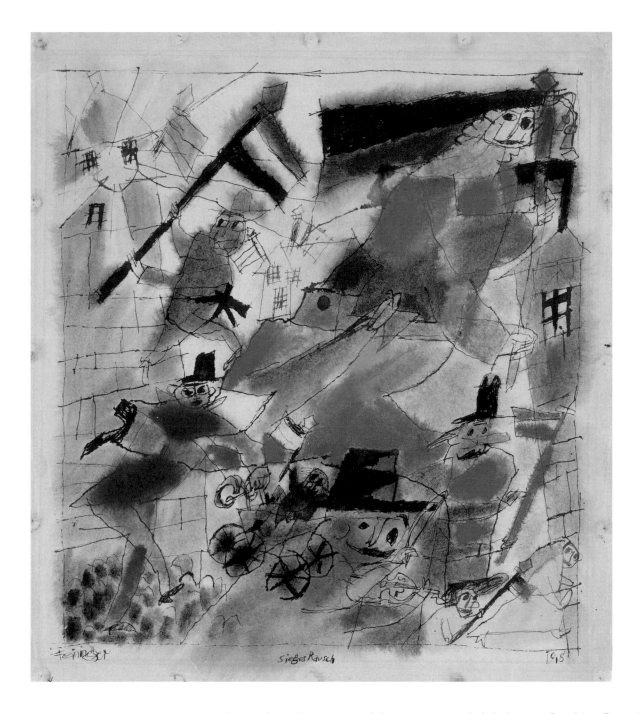

fig. 102. **Euphoric Victory (Siegesrausch),** 1918
Watercolor and ink on paper, 13⅝ x 12⅛ in. (34.6 x 30.6 cm)
The Museum of Modern Art, New York; gift of Julia
Feininger 130.1966

on his students, he instructed them in practical skills but confined his Saturday critiques of their work to mild avuncular judgments.[202] "What can the best teacher in art give but the direction, confirmation, and development of a talent already existing in a student?" he asked rhetorically in a letter to Julia.[203] His role, he said on another occasion, was "to guide them and help them, talk with them quite openly, and exchange thoughts and ideas with them."[204] Years later, Gropius recalled "the extraordinary impression upon the Bauhaus students, which stemmed from Lyonel Feininger's human qualities. . . . The modesty of his demeanor before even moderately talented students and his loving empathy for the existential quandaries of young men worked on them magnetically. His humbleness gave them pluck and respect. Thus stimulated and optimistically tuned,

they set their own creative forces in motion. That is the highest aim of education."[205] Fellow Bauhaus Master Georg Muche (1895–1987) echoed the assessment: "In the Bauhaus, Feininger was an example of the mysterious workings of a man who creates quietly from the depths, of an artist who is at peace with himself and radiates. No one was able to evade this unobtrusive effect which challenged no one to contradiction and evoked goodness. . . . He taught unintentionally through his own example as a person."[206]

Feininger's relationship to the Bauhaus shifted in 1921. That January, Gropius introduced a new curriculum into the school that reinforced the symbiosis between aesthetic invention and technical proficiency by mandating that workshops were to be run by a two-member team consisting of a Formmeister (Form Master), who provided formal and theoretical training, and a Werkmeister (Work Master), or craftsman. But the new curriculum likewise emphasized the teaching of abstraction over nature-based study by making attendance in Itten's preliminary course on abstract principles compulsory. This emphasis on abstraction codified attitudes that had bothered Feininger from the beginning, namely Gropius's implicit lack of appreciation for art's spirituality and his view that conventional artistic training was without benefit to students.[207] The architect's disregard for traditional art making led a group of faculty members to resign that April and begin plans to reestablish the former Academy of Fine Arts. Among them was Walter Klemm (1883–1957), who had headed the graphics workshop at the Bauhaus in its first two years. During that period, Feininger had been an almost constant presence at the workshop, printing his own woodcuts on stationery and producing a portfolio of his small-format, pre-Bauhaus woodcuts. Several months after Klemm's departure, Gropius asked Feininger to head the workshop, a reassignment the artist welcomed as a respite from teaching, which had become sufficiently deadening to him that he had considered leaving the Bauhaus. "Weimar is fateful—I'll never be myself until I leave" he had written to Julia earlier that spring. "I increasingly realize how the Bauhaus has a crippling effect on me—I have to free myself of it as soon as it is possible and we are financially independent. I'd be happy to remain but without obligation . . . not feel guilty if I don't teach courses and don't sound into the 'promotional-horn.'"[208] Heading the graphics workshop offered a perfect solution. That fall, when the rest of the school was bracing for an inspection by federal officials, Feininger voiced relief that he was responsible only for the print workshop: "My area however, is clearly the printing workshop—there they can gawk as much as they want and I'll be happy to be available for questions, for Gropius' sake—but for anything else, I'll make myself scarce."[209]

fig. 103. Feininger-designed title page, **Bauhaus prints. New European Graphics. Third portfolio: German Artists (Bauhaus Drucke. Neue Europäische Graphik. 3te Mappe: Deutsche Künstler),** 1921
Lithograph on folder, 22⅜ x 18⅜ in. (57.6 x 46.5 cm)
Bauhaus-Archiv, Berlin

Under Feininger's leadership, the graphics workshop became a pulse point of activity. In October, the workshop launched an ambitious program to publish a series of print portfolios under the rubric Neue Europäische Graphik (New European Graphics). In addition to raising funds, the series aimed to demonstrate "how the generation of artists of our time are taking part in the ideas of the Bauhaus and making a sacrifice by donating the use of their own works," as Gropius put it.[210] The first portfolio—prints by Bauhaus faculty members titled *Meistermappe des Staatlichen Bauhauses* (State Bauhaus Masters' Portfolio)—was followed by individual portfolios of prints by Bauhaus Masters Marcks, Kandinsky, Muche, and Oskar Schlemmer (1888–1943). Gropius's

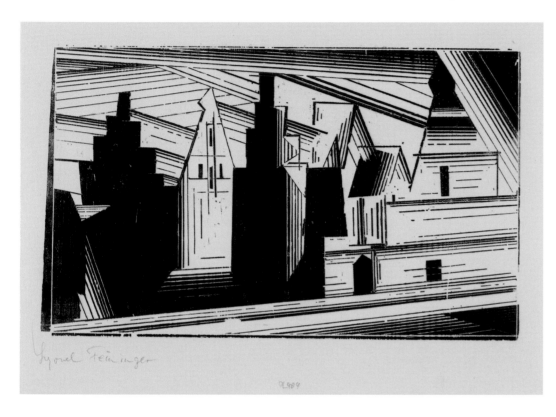

appeals for contributions from artists outside the Bauhaus community led to portfolios of German, Italian, and Russian prints, each in an edition of at least 110. Feininger oversaw all aspects of production, including covers, title pages, tables of contents, and colophons (fig. 103). So integral was he to everything printed at the Bauhaus—including invitations, announcements, and promotional advertisements—that he refused to enter the November 1921 competition to design a Bauhaus stamp on the basis that "there should be *one thing not made by me.*"[211]

Feininger's assumption of responsibility for the graphics workshop coincided with his involvement in musical composition. Music was not taught at the Bauhaus as a discipline, but it played a key part in the school's social life, especially for Feininger and his Bauhaus colleagues, Kandinsky and Klee (1879–1940). Klee, like Feininger, was an accomplished violinist from a musical family and Kandinsky, a close friend of the Austrian composer Arnold Schoenberg, had written four "color-tone dramas" between 1909 and 1914, the most influential of which was *Der gelbe Klang* (The Yellow Sound). In the evening and at his Sunday afternoon open houses Feininger often played violin duets with Klee and piano with his adolescent son Laurence and Hans Brönner, a Weimar composer and Laurence's piano teacher.[212] For Feininger's fiftieth birthday, on July 17, 1921, Brönner presented him with an organ fugue he had composed. The gift inspired the artist, who spent the next thirteen days composing a fugue of his own. Over the next six years, Feininger completed eleven more fugues, mostly for organ, with two others remaining unfinished.[213] The fugues were performed multiple times between 1924 and 1926, some to noteworthy acclaim, and Paul Westheim published a facsimile of

fig. 104. **Old Gables in Lüneburg (Die Giebel in Lüneburg),** 1924
Woodcut, 9¾ x 16 in. (24.8 x 40.7 cm)
The Museum of Modern Art, New York; gift of Julia Feininger 172.1966

Fugue VI in his almanac of European art.[214] But the fugues were difficult to play, and most performances of them disappointed Feininger. In Erfurt in 1923, the organist backed out at the last minute, citing the composition's difficulty and his inadequate preparation time. At the concert in Halle in 1925, the organist took so many liberties with his composition that Feininger became ill: "After a short while the whole thing was only a soft soap of sound! Entirely different modulations were played into it—the man even improvised! He arbitrarily switched pedal and manual voices, plucked apart the whole sturdy construction of my work and then suddenly—I could hardly believe my ears—without any coherence or preparation, came the conclusion, a sauce of filthy 'euphony!'"[215] The musical success or failure of Feininger's fugues notwithstanding, their primary importance lay in the insights into the structure of polyphonic counterpart that he gained in composing them.

Beginning with James McNeill Whistler (1834–1903) in the late nineteenth century, visual artists had looked to instrumental music as a model for an emotionally expressive art free of narrative and naturalistic imitation. By the twentieth century, the proposition that painting should aspire to the condition of music was widely embraced by vanguard artists in both Europe and America. Kandinsky and Klee were among the proposition's fiercest advocates. For them, as for most painters who sought direct comparisons between abstraction and music, the key pairing was color. Kandinsky likened color to the musical keyboard in his 1911 book *On the Spiritual in Art*, and Klee created color charts for his Bauhaus courses that established analogies between color gradations and musical counterpoint. The presence of these colleagues at the Bauhaus nurtured Feininger's long-held attachment to music as a carrier of emotions and moods that were inexpressible in words. "Music is the language of my innermost self which stirs me like no other form of expression" he declared in a 1929 letter to Julia.[216] Earlier, he had written: "The thirst for sound is powerful in me. . . . It is necessary for my very sustenance."[217] But rather than attempt to emulate the emotional power of music, Feininger sought to decode its structure, particularly that of polyphony. In polyphonic counterpoint, the initial thematic vocal statement is followed by overlapping voices harmonically echoing, modulating, or inverting the original theme to produce a vertical column of opulent sound. The possibility of translating this thematic repetition and variation into oil "intoxicated" Feininger "with joy . . . and hope for [his] work."[218] For years, he had described his paintings as "sound contained" and as "nearing closer to the synthesis of the fugue," but it was only after he began composing that he fully understood how he could translate the clarity and simplicity of fugal structure into his art.[219] "It now begins to get restive within me," he announced. "Something new is preparing—a new form."[220] Taking his cue from the "insurmountably concise" artistry of Bach, he replaced the complex, faceted forms in his prismatic work with expansive planes of transparent color, which he overlapped to create a chromatic equivalent of what he called the Baroque composer's lucid, sumptuous "closed chords."[221] Just as Bach's fugues began with a single musical line, so too did Feininger begin with an unprepossessing subject, often a village church. By echo-

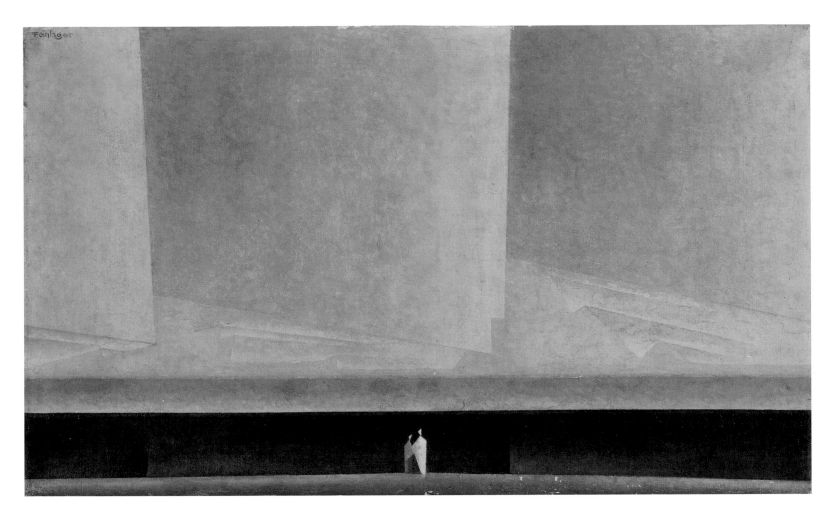

fig. 105. **Clouds Above the Sea I (Wolken am Meer I),** 1923
Oil on canvas, 14¼ x 24 in. (36.2 x 61 cm)
Private collection

ing and modulating its image in multiple, harmonically interconnected planes of diaphanous color, he transformed a modest structure into an edifice as "monumental and eternally alive" as Bach's music.[222] By 1923, he was reporting that "Bach's essence has found expression in my paintings."[223] Years later, he credited the composer with having "been my master in painting. The architectonic side of Bach whereby a germinal idea is developed into a huge polyphonic form."[224]

Not surprisingly, during the years he was directing the graphics workshop and composing music, Feininger's painting production declined. In the few paintings he produced between 1921 and 1924, his successful adaptation of multipart musical harmonies led to crystalline works that seemed illuminated by an inner radiance and infused with air.[225] The breakthrough to this new style came during his two-week vacation to the Baltic Sea town of Timmendorf in August 1922 with Gropius and Kandinsky. Ever since his childhood in New York, Feininger had always loved anything connected with water, often saying that "the most beautiful landscape cannot hold my fascinated attention as much as nature by the seaside and all that is connected with water."[226] That summer, experiencing the sky, clouds, and ocean for the first time in years, he was filled with happiness and "visions of longing."[227] Sitting on the beach one day in the warmth of the sun, he felt "how some hours are already as if predestined to be imprinted in memory as precious

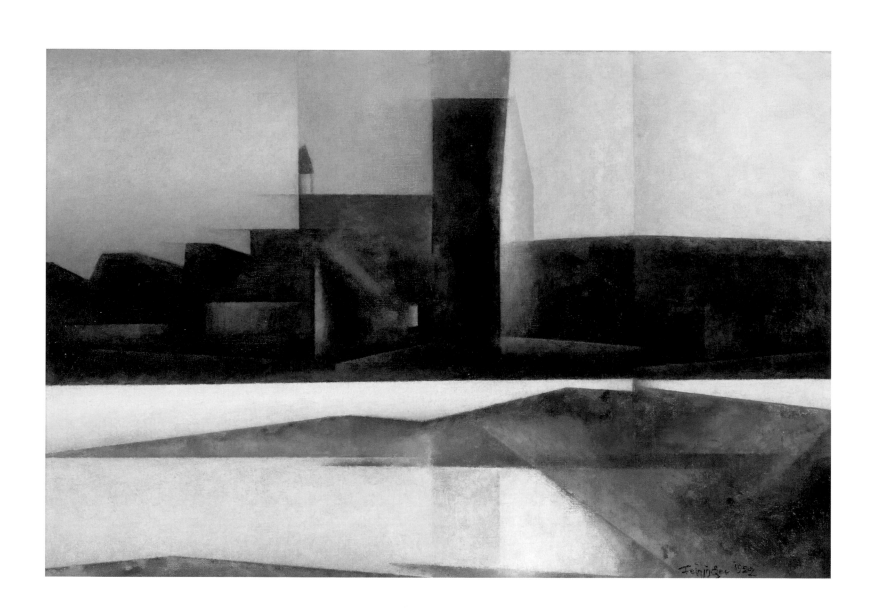

fig. 106. ***Church of Heiligenhafen,*** 1922
Oil on canvas, 15¾ x 23¾ in. (40 x 60.3 cm)
Reynolda House Museum of American Art, Winston-Salem,
North Carolina 1966.2.12

remembrance. . . . The 'connection' to the present minute was there . . . a sense of well being approaching from outside, which ran though my mind and body. . . . I knew right away that this half hour would persist, would remain memory and longing at the same time, because the feeling of happiness was so immediate and alive."[228] A year later, in a series of cloud paintings made from Timmendorf nature notes, he began to replicate his impression of what he called the seaside's "colorful air" and evoke the rapture he had felt in the presence of its silent grandeur. By applying his pigments in thin layers, which he washed with turpentine to reveal under-layers of paint, he endowed his canvases with a chromatically modulated, radiant softness. His light-infused seascapes, with their images

of diminutive figures on the beach looking out to an infinite sea and sky, recall Caspar David Friedrich's (1774–1840) iconic painting *Monk by the Sea*, in which an individual is similarly confronted by the overwhelming and incomprehensible immensity of the universe (fig. 107). Feininger's relationship to the German Romantic painter was complicated. When asked about Friedrich by Alfred H. Barr, Jr., in 1944, Feininger claimed not to have known the artist's work when he painted his first cloud paintings. This may have been true; he was in Weimar with Julia when the *Jahrhundertaustellung deutscher*

fig. 107. Caspar David Friedrich, **Monk by the Sea,** 1809
Oil on canvas, 43⅜ x 67½ in. (110 x 171.5 cm)
Nationalgalerie, Staatliche Museen, Berlin

Kunst (Centenary Exhibition of German Art), which reintroduced Germans to Freidrich's art, opened at the Nationalgalerie Berlin in April 1906. His first recorded mention of the German Romantic painter was in December 1923, *after* he had completed his first cloud paintings, in a letter in which he described Willi Wolfradt's monograph on Friedrich. During the next ten years, however, his Baltic Coast paintings would come to echo Friedrich's more closely. Both artists shared the desire to relocate the experience of divinity within a secular world—an affinity Feininger acknowledged in 1936 in quoting Friedrich's admonition to his students at Mills College in California to "close your bodily eye, that you may see your picture first with the eye of the spirit. Then bring to light what you have seen in the darkness, that its effect may work back on others from without to within."[229] But in 1944, with World War II still raging and the Nazi's embrace of Friedrich dampening American enthusiasm for the German's work, Feininger may have resisted calling attention to their shared aesthetics.

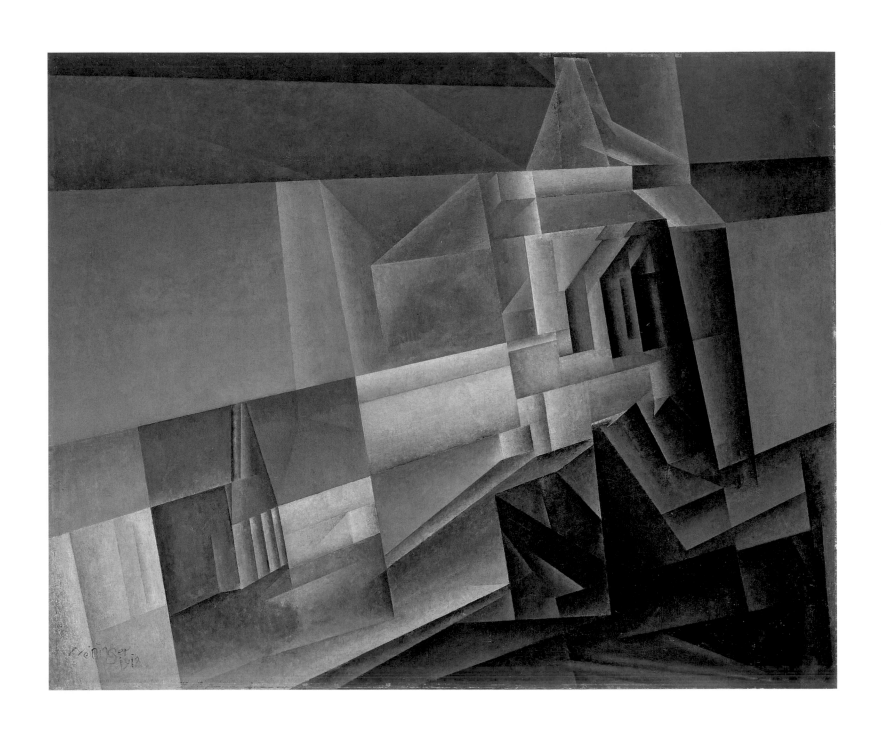

fig. 108. *Zirchow VII,* 1918
Oil on canvas, 31¾ x 39⅜ in. (80.7 x 100 cm)
National Gallery of Art, Washington, DC; gift of Julia Feininger
1966.3.1

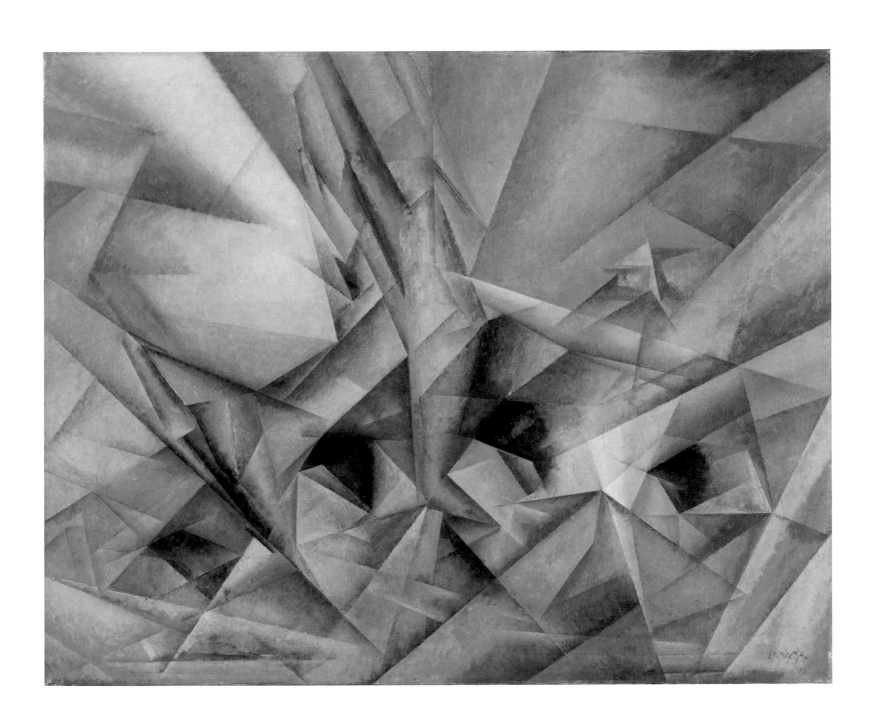

fig. 109. *Bridge V (Brücke V),* 1919
Oil on canvas, 31⅝ x 39½ in. (80.3 x 100.3 cm)
Philadelphia Museum of Art; purchased with the Bloomfield
Moore Fund, 1951

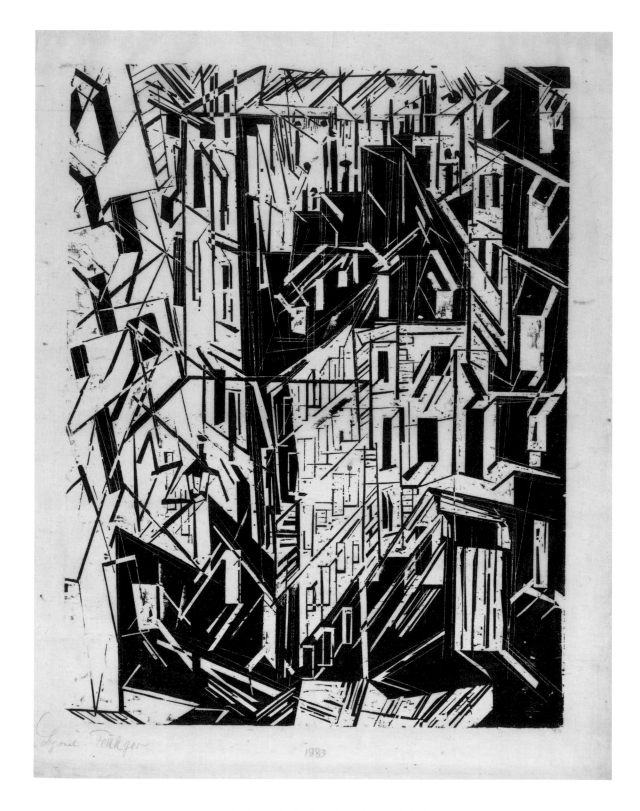

fig. 110. **Houses in Paris (Häuser in Paris),** 1918
Woodcut, 24¾ x 19⁷⁄₁₆ in. (62.9 x 49.3 cm)
The Brooklyn Museum; Dick S. Ramsay Fund 62.59.2

fig. 111. **High Houses IV,** 1919
Oil on canvas, 39⁷⁄₈ x 31⁷⁄₈ in. (101.1 x 81 cm)
Collection of Joseph Edelman and Pamela Keld

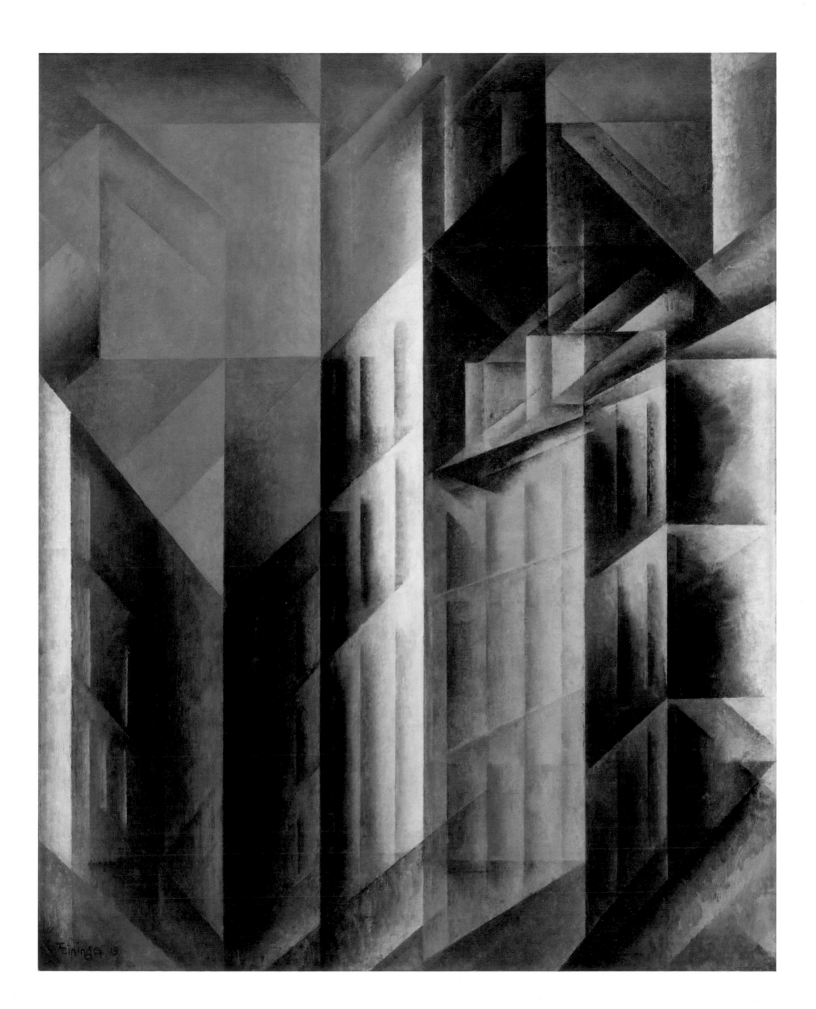

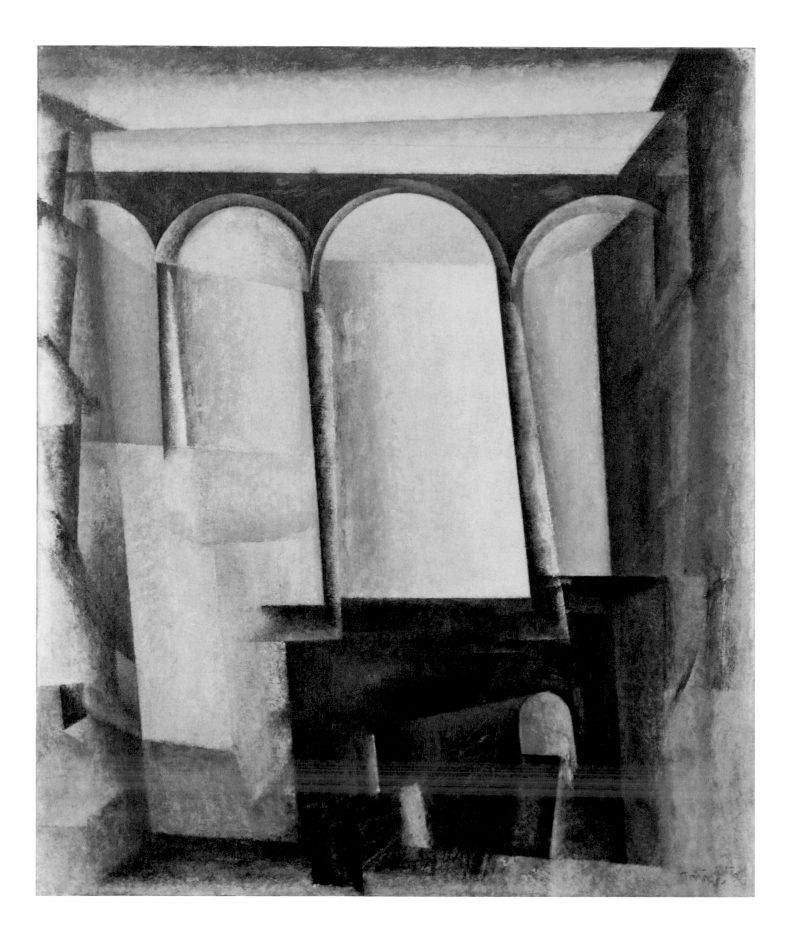

fig. 112. *Viaduct,* 1920
Oil on canvas, 39¾ x 33¾ in. (100.9 x 85.7 cm)
The Museum of Modern Art, New York; acquired through the Lillie P. Bliss
Bequest 259.1944

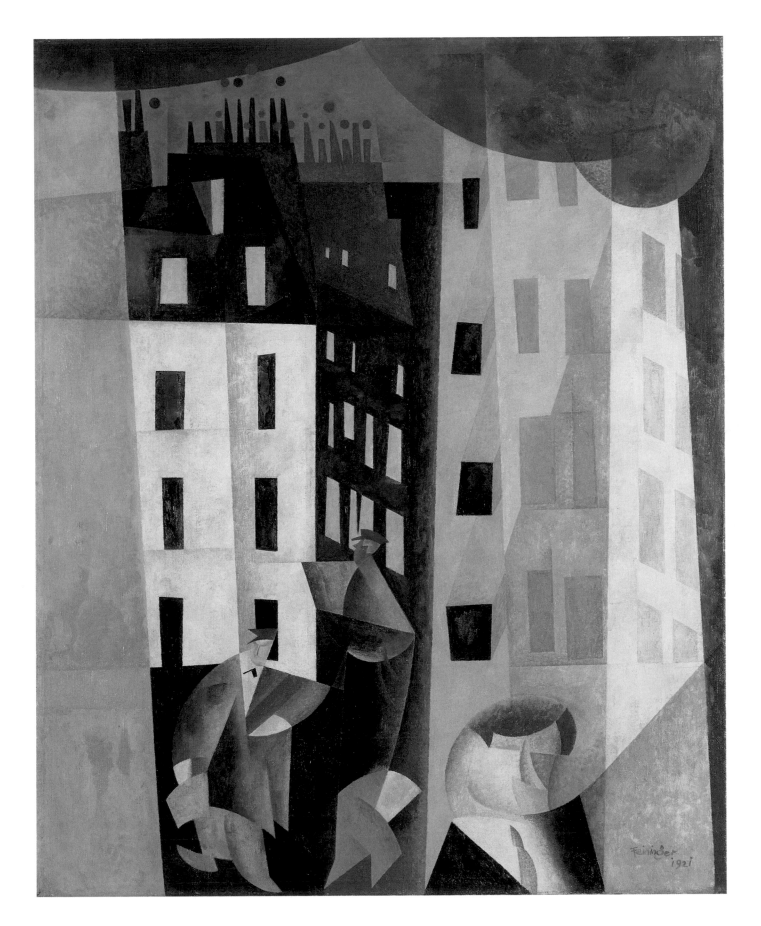

fig. 113. *Architecture II (The Man from Potin)*
(Architektur II), 1921
Oil on canvas, 39¾ x 31¾ in. (101 x 80.5 cm)
Museo Thyssen-Bornemisza, Madrid

fig. 114. *Departing Skiff (Ausfahrende Barke),* 1921
Watercolor and ink on paper, 10¾ x 13⅞ in. (27.3 x 35 cm)
Sprengel Museum, Hannover

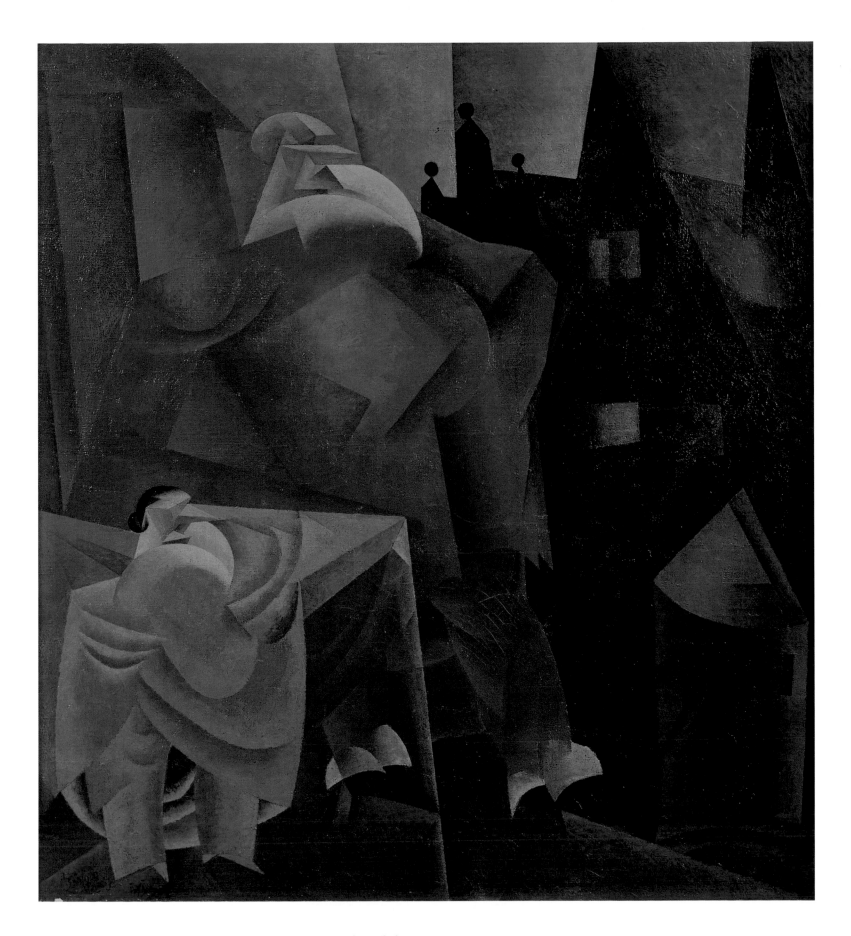

fig. 115. *The Red Clown,* 1919
Oil on canvas, 28½ x 24½ in. (72.4 x 62.2 cm)
Private collection

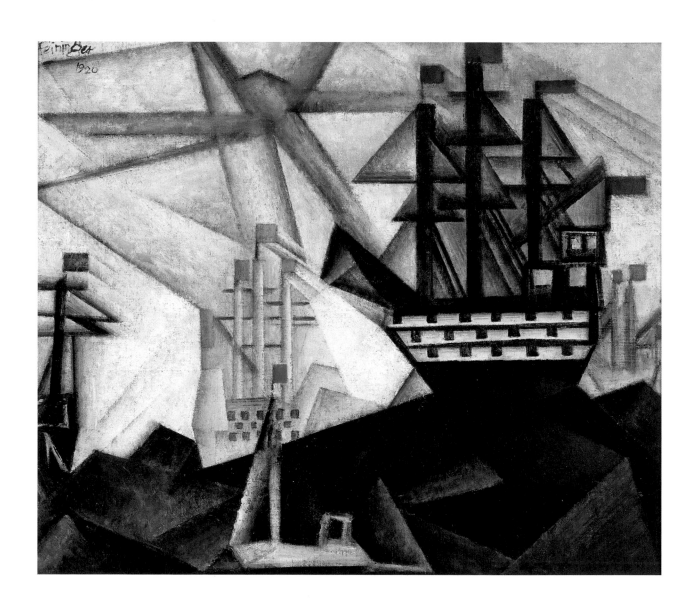

fig. 116. **Battle Fleet,** 1920
Oil on canvas, 16 x 19 in. (40.6 x 48.3 cm)
Private collection

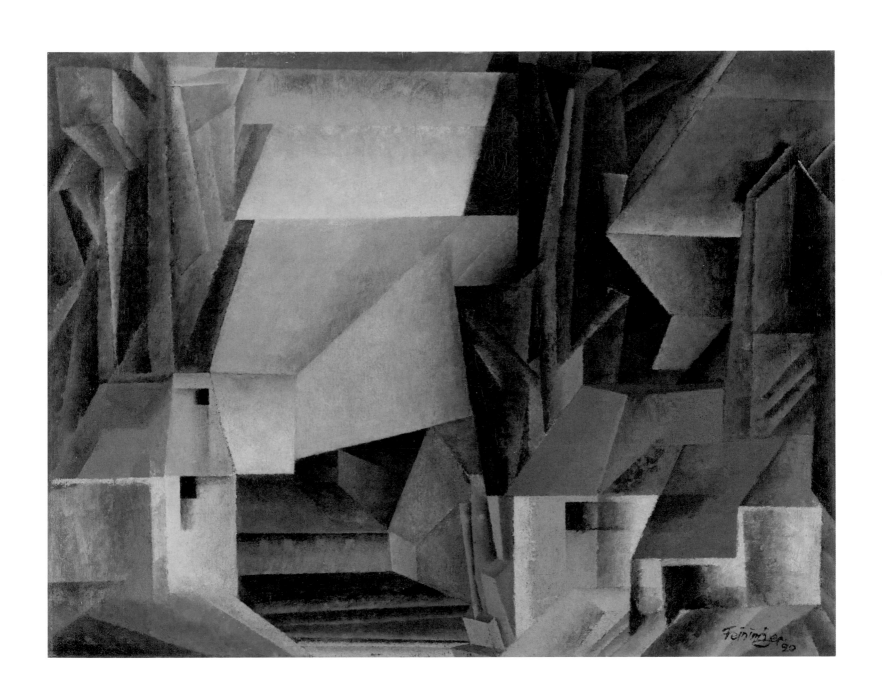

fig. 117. *Hopfgarten,* 1920
Oil on canvas, 25 x 32¼ in. (63.5 x 81.9 cm)
Minneapolis Institute of Arts; given in memory of Catharine Roberts
Seybold by her family and friends 55.2

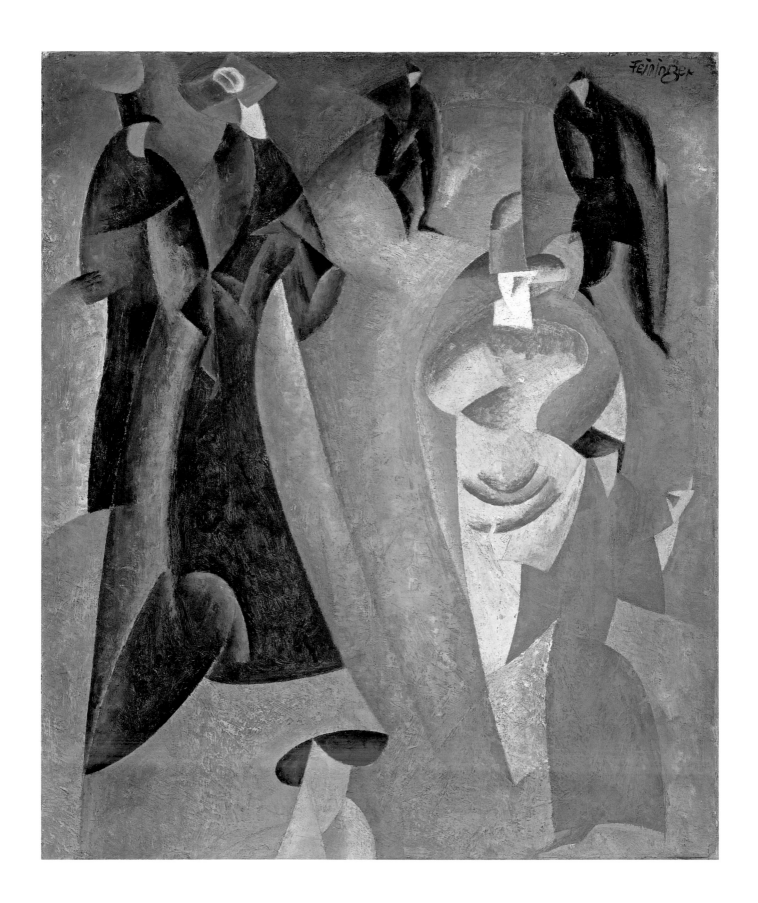

fig. 118. *Nighthawks (Nachtvögel),* 1921
Oil on canvas, 23⅝ x 19¾ in. (60 x 50 cm)
Collection of Charles K. Williams II

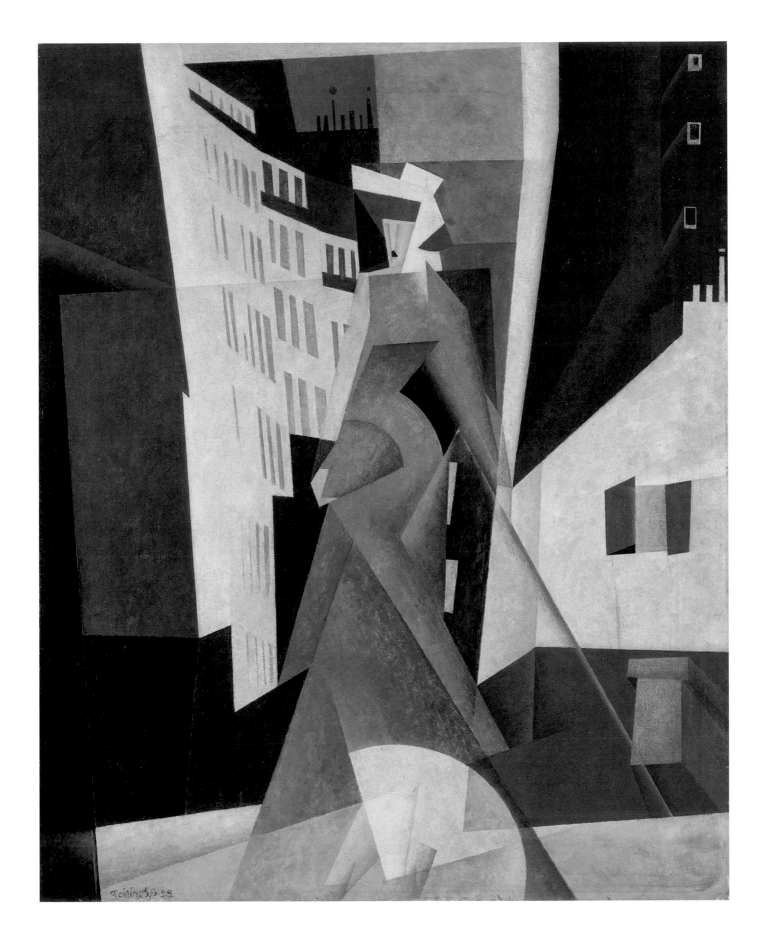

fig. 119. *Lady in Mauve,* 1922

Oil on canvas, 39⅝ x 31½ in. (100.7 x 80 cm)

Museo Thyssen-Bornemisza, Madrid

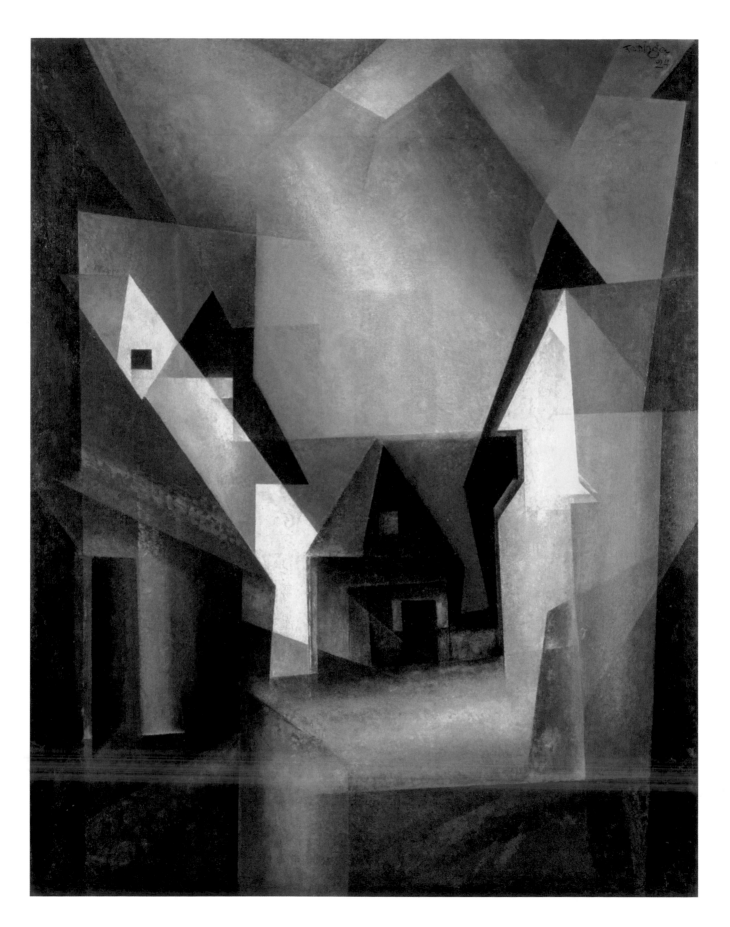

fig. 120. *Gaberndorf II,* 1924
Oil on canvas mounted on board, 39⅛ x 30½ in. (99.4 x 77.5 cm)
The Nelson-Atkins Museum of Art, Kansas City; gift of a group of
the Friends of Art 46-10

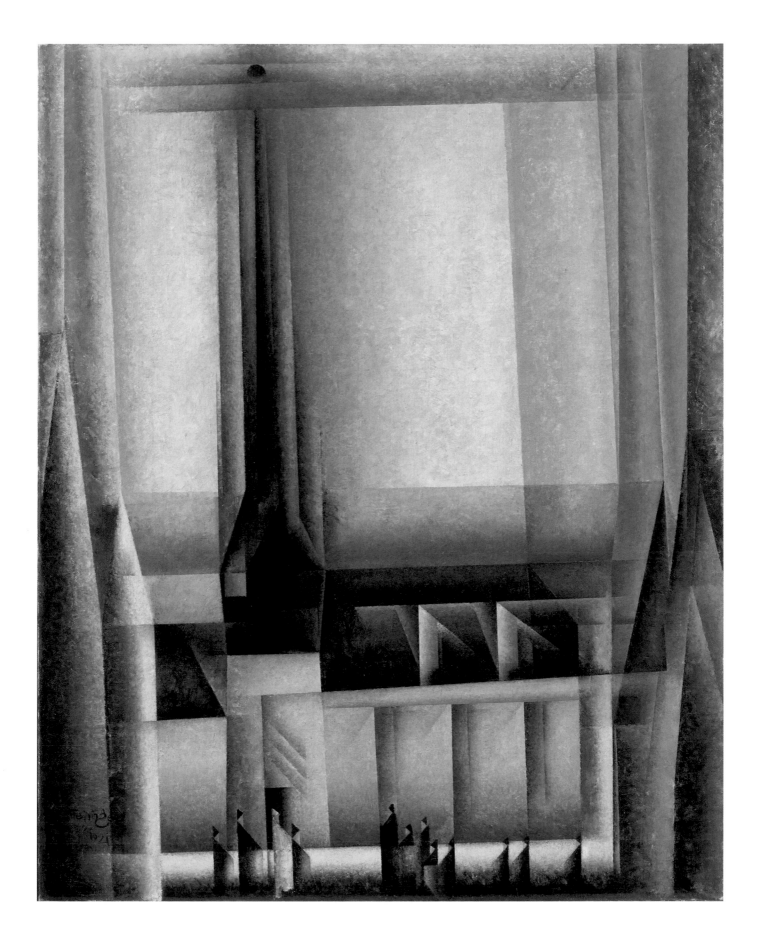

fig. 121. *Gelmeroda VIII,* 1921
Oil on canvas, 39¼ x 31¼ in. (99.7 x 79.4 cm)
Whitney Museum of American Art, New York; purchase 53.38

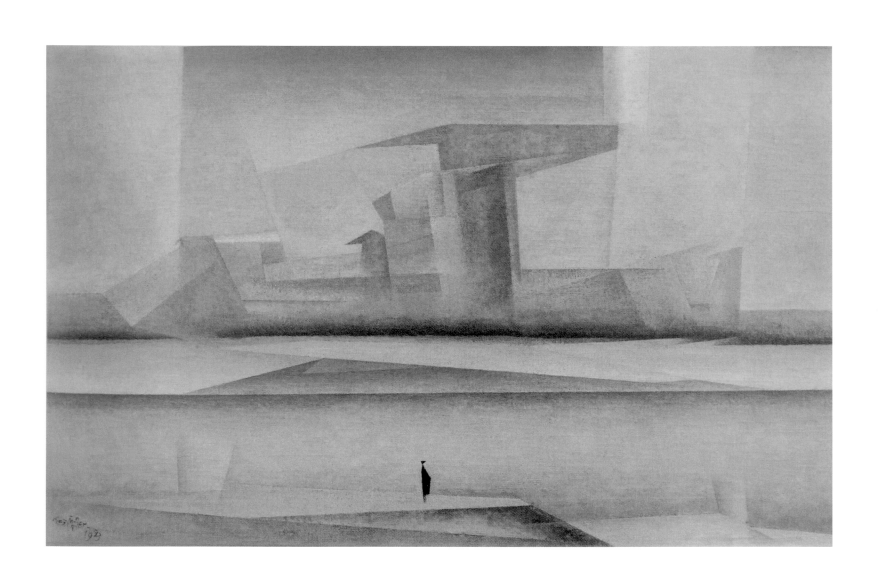

fig. 122. **The Island (Die Insel),** 1923
Oil on canvas, 18⅛ x 29⅛ in. (46 x 74 cm)
Private collection; courtesy Moeller Fine Art, New York and Berlin

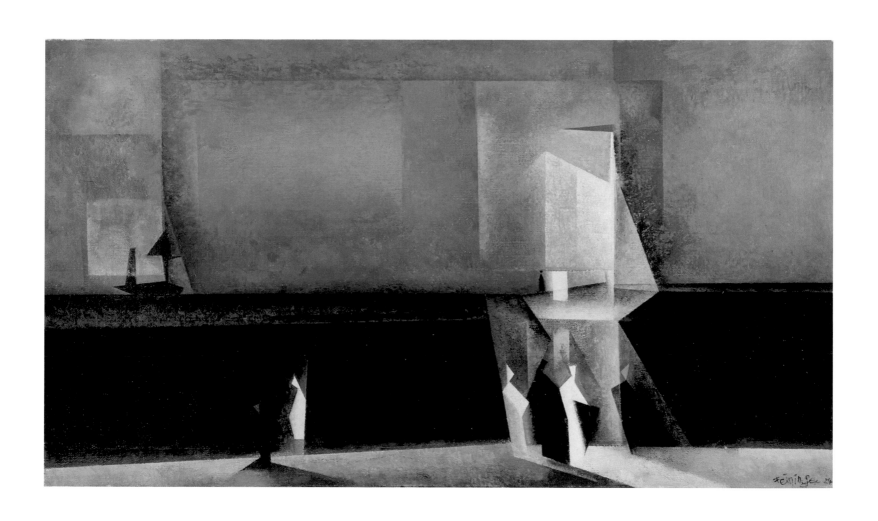

fig. 123. *Blue Marine (Blaue Marine),* 1924
Oil on canvas, 18¹⁵⁄₁₆ x 33³⁄₁₆ in. (48.1 x 84.3 cm)
Museum of Art, Munson-Williams-Proctor Institute, Utica, New York 52.35

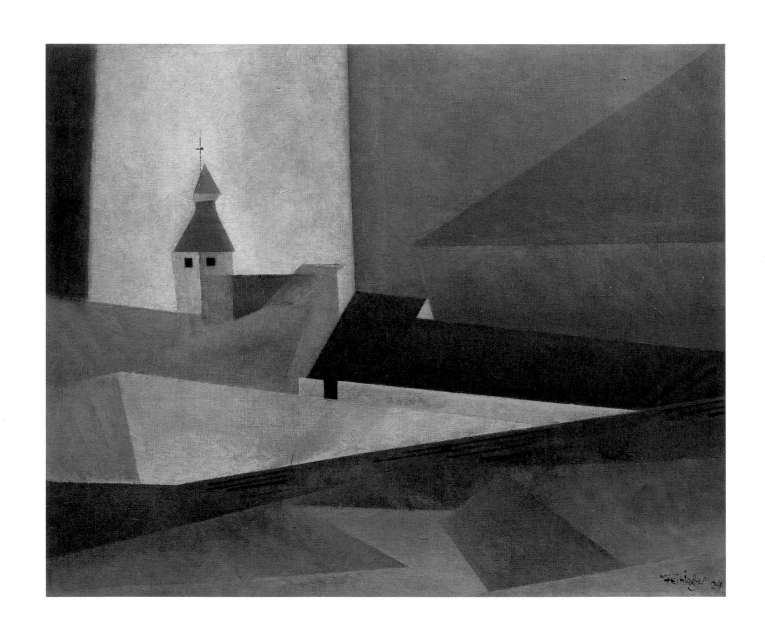

fig. 124. *Benz,* 1924
Oil on canvas, 15 x 18¾ in. (38 x 47.5 cm)
Private collection; courtesy Moeller Fine Art, New York
and Berlin

fig. 125. *Town Gate–Tower I (Torturm I),* 1923–26
Oil on canvas, 24½ x 18½ in. (61 x 47.5 cm)
Kunstmuseum Basel; bequest of Richard Doetsch-
Benziger, Basel G1960.18

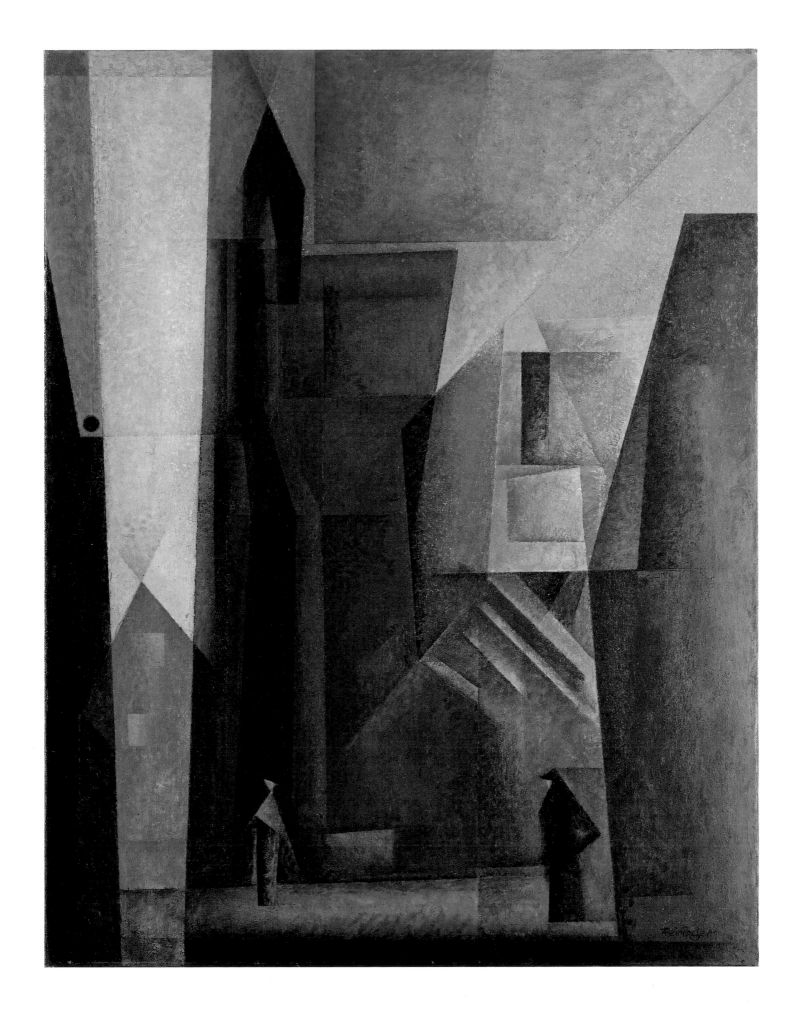

The Bauhaus Reconfigured

During the Bauhaus's early years, the faculty's dominant artists were those who earlier had been associated with Der Sturm—Itten, Klee, Feininger, Kandinsky, Muche, Lothar Schreyer (1886–1966), and Schlemmer. Girded by the euphoric possibility of renewing society through the unity of arts and crafts, the school had withstood Germany's economic and political instability. But by the fall of 1922, immunity was no longer possible. The Treaty of Versailles, which had mandated that Germany pay egregiously punitive war reparations while ceding its industrial, economically profitable areas in Upper Silesia to Poland, had given rise to hyperinflation. This resulted in workers' strikes that brought Germany to a near standstill. Worried about whether the Thuringian government would continue to finance the Bauhaus, Gropius resolved to raise funds by creating marketable products in partnership with industry. The ensuing discord within the faculty—evident in Itten's resignation and replacement by László Moholy-Nagy (1895–1946)—transformed the once bucolic school into a "volcano, ready to erupt."[230] Despite the faculty's growing disillusionment with Gropius, he obtained their approval for an industrial fair of Bauhaus products to open in the summer of 1923. Feininger despaired that the show went against all Bauhaus principles and would be dangerously rushed, but he conceded that "if we don't show 'results' in public and don't manage to win over the industrialists, then the prognosis for the future of the Bauhaus is very worrisome. It must be directed toward earnings *production, reproduction*! . . . The air is charged here. I see a new Gropius and he is not much to my taste. . . . He wants the best in terms of good artisanry, but the individual has to stand back and is less important in his view. 'Whoever cannot show *now* what he is capable of may go to hell with his art' he said in a meeting. . . . But he does have a clear vision of the *realities* and we others don't have that—or we understand something more profound as realities, something which needs time to thrive."[231] Committed to the community and to the "honor of the cause," Feininger threw himself into promoting the show by printing twenty advertisements for it designed by students and faculty, each in an edition of one hundred, including two based on his own woodcuts.[232]

Gropius's slide lecture "Art and Technology: A New Unity," given at the opening of the Bauhaus exhibition on August 15, 1923, formally announced the school's ideological shift away from Expressionism. Already "paralyzed" by the change the school had undergone since the arrival of Moholy-Nagy, Feininger found the motto hateful.[233] "I oppose with complete conviction the slogan 'Art and Technology: the new unity!' . . . Even the greatest technical perfection can never replace the divine spark of art! . . . One must not believe that we are in a position to advocate art and technology as *one* item! They are *two*, fundamentally *different* things."[234] The show's economic failure, not surprising given its occurrence at the apex of the country's inflation, paled in comparison to what lay ahead for the Bauhaus. In November 1923, the national army marched into Weimar and dissolved the coalition government; a month later, the newly elected Thuringian parliament reduced its funding of the Bauhaus by half.

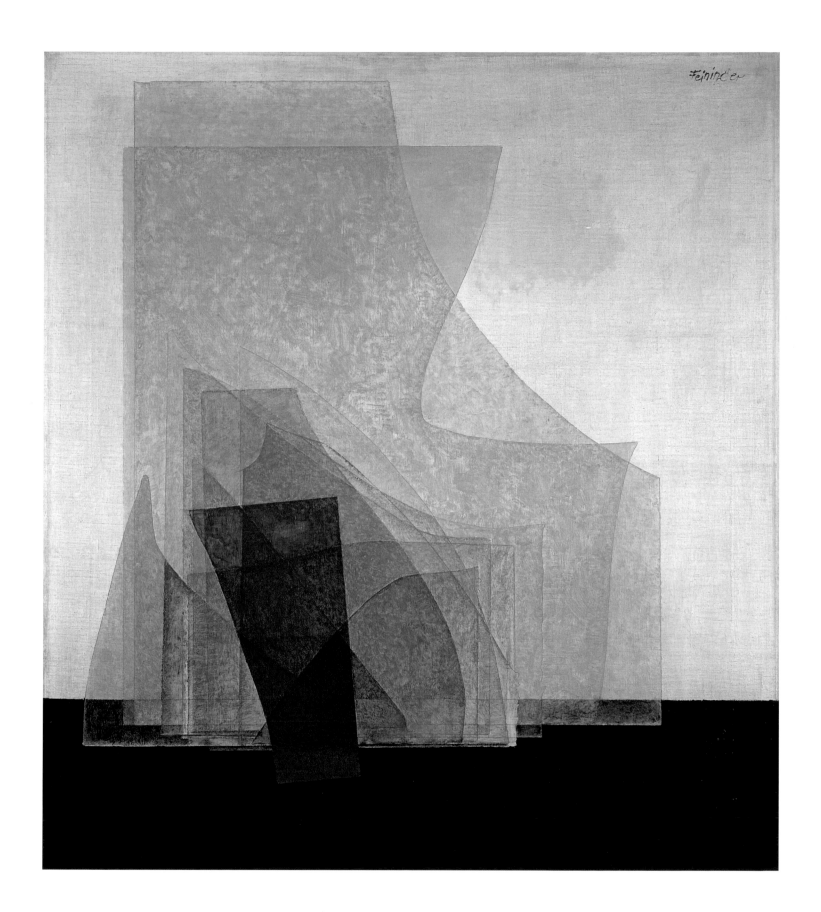

fig. 126. **Broken Glass (Glasscherbenbild),** 1927
Oil on canvas, 28½ x 27½ in. (72 x 70 cm)
Private collection; courtesy Moeller Fine Art, New York and Berlin

The threat to the Bauhaus from outside forces splintered rather than coalesced the faculty. By July 1924, Julia was likening the school to a "den of winding poisonous snakes."[235] Feininger earlier had accepted the constant interruption of his own work out of solidarity with the Bauhaus's mission; he now equated the school with "the worst poison," and wondered whether his years there had been "too unfavorable for a quiet unfolding of all powers."[236] Temperamentally disinclined to involve himself in the "maelstrom of passions and party-opinions that made Weimar a nest of birds of prey," he nevertheless felt helpless "to resist the cloak-and-dagger atmosphere that enshrouds us."[237] With moments of optimism increasingly replaced by the feeling of being "living-dead," he determined in December 1924 to leave the Bauhaus quietly and go "private."[238]

Feininger's discontent with the Bauhaus took place against a backdrop of German politics hurtling toward catastrophe. With the collapse of the German economy in 1922, the country had entered into a general depression in which "no one knows joy for its own sake any more," as Feininger put it.[239] The terrible poverty, which made all past troubles seem like "child's play," gave rise to "incredibly nauseating" politics.[240] Adolf Hitler had taken control of the German Workers Party in 1920, renaming it the Nationalsozialistische Deutsche Arbeiterpartei (National Socialist German Workers Party), known as the Nazi Party. Two years later, on November 8, 1923, he led the unsuccessful Beer Hall Putsch in Munich. By 1924, the "'fraternization' of the Folk and the National Socialists" in Weimar was horrifying Feininger.[241] "Hitler and his comrades have been glorified as heroes and they passed resolutions which make one doubt the accountability of their entire circle; I believe it will not be a good winter for free-thinking men under this regime."[242] At the onset of Germany's economic crash, Feininger had flirted with returning to America, but had ultimately concluded that his native country had "lost its life"

fig. 127. **Gables I, Lüneburg,** 1925
Oil on canvas, 37¾ x 28½ in. (95.9 x 72.4 cm)
Smith College Museum of Art, Northampton, Massachusetts;
gift of Nanette Harrison Meech (Mrs. Charles B. Meech),
class of 1939, in honor of Julia Meech, class of 1963

for him after his father's death in February 1922.[243] As the political and economic crisis in Germany escalated, the thought recurred. Watching an American Western film in January 1924, he was reminded "that I also was once a 'free American' and the land over there was still 'my' land . . . truly *my* world, *our* world, and the world of our boys.'"[244]

The thought of returning to America was fueled by what Feininger called his "rather awful" finances during this period.[245] Between 1922 and 1924, his non-salary income had derived primarily from sale of graphics, the only art Germans seemed to be able to afford during those years. But with sales even of graphics almost nonexistent by

1924, and Julia's father having severely reduced his monthly subsidy as a result of losing his fortune to the inflation of 1922–23, Feininger was unable to support his mother and was sued by his ex-wife for missed alimony payments.[246] That August, Julia wrote of being in New York within the year.[247] Still, Feininger hesitated, worried by reports that collectors in the United States were unresponsive to German art, and that he would have no way of earning a living if he returned home. Muche's conclusion, after a two-week trip to the States, that "there is simply no room in America for our European art and affairs . . . people there find modern painting, architecture, and the newest arts and crafts repulsive," was reinforced by reports that Alexander Archipenko (1887–1964)—a "celebrated *king* in all of Europe," as Feininger called him—had been so completely overlooked and pushed aside in the United States that he wanted nothing more than to return to Europe.[248] Feininger's own experience in the 1923 show of German art arranged for New York's Anderson Galleries by Berlin gallerist Ferdinand Möller and German émigré Wilhelm Valentiner, a former Workers Council colleague, had confirmed these reports: prices had been so low that he netted only thirty dollars from the sale of six prints.[249] Rumors that the New York art market was "so over-saturated that German dealers go there in order to buy very important works by German artists most cheaply" convinced Feininger not to abandon Germany for America "for all the money in the world!"[250]

At the very moment Feininger was concluding that he had no future in the United States, the art collector Emmy (Galka) Scheyer (1889–1945) was initiating efforts to bring his work and that of three other European artists to the attention of the American public. In 1924 Scheyer, a former art student turned prophet of contemporary German art, obtained the consent of Feininger, Klee, Kandinsky, and Alexei Jawlensky (1864–1941) to promote and sell their work in America under the rubric of the "Blue Four."[251] By May 1925, she had settled on the West Coast, where her efforts to "sow the seeds of love of art" assumed the aura of messianic destiny.[252] For the next twenty years Scheyer would successfully organize exhibitions and lecture widely on the art of the "Blue Brothers," with few sales to show for her efforts. Money was not her motive, as she would remind the group in 1936: "no art dealer would devote 12 years to representing 4 artists who year after year yield nothing in return; a lover of arts, on the other hand, would rather eat a raw carrot and live for art."[253] Nevertheless, Scheyer's lack of financial success was a constant reminder to Feininger of the insurmountable obstacles he would face as an artist in America. "What I should do there, I could not say," he wrote to a friend in November 1925, "because there are no ways of making a living. My art would be impossible there. . . . A friend of ours [Galka Scheyer] has been working hard for the 'Blaue Vier' without any financial success—in California, after New York and the East had failed, dozens of exhibitions, hundreds of lectures and articles—some enthusiasm, more curiosity but no material success. . . . I have great hesitations about my home country—I cherish no illusions."[254]

In the summer of 1924, as Feininger weighed the prospect of returning to the United States, he found new subject matter that gave him another reason to remain in

Germany. Ever since his 1922 vacation in Timmendorf with Gropius and Kandinsky, he had longed to return to the Baltic. Preparations for the Bauhaus's 1923 exhibition had been so all-consuming that he had only escaped Weimar for two weeks that fall to work in a studio in Erfurt's Anger Museum, made available to him after the Bauhaus graphics studio was commandeered temporarily for exhibition space.[255] In 1924, however, he discovered the Baltic fishing village of Deep on the Pomeranian coast, at the mouth of the Rega River. The sweeping vistas and silent beauty of Deep's unpeopled beaches and deserted, storm-blown dunes suited his desire for what he called "transcendental space."[256] Entranced by the village's expansive landscape and the way light reflected on the water, especially at sunset, when "the glory from above" suspended the separateness

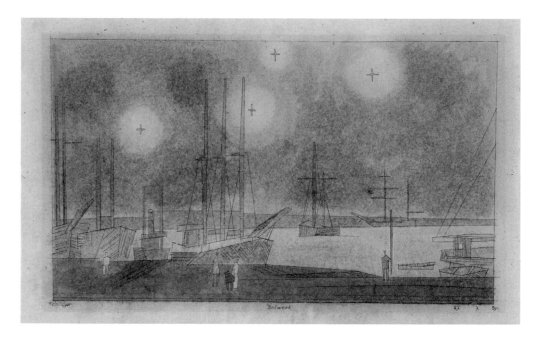

fig. 128. **Bulwark (Bollwerk),** 1929
Ink and watercolor on paper, 11¼ x 15¹⁵⁄₁₆ in. (28.5 x 40.5 cm)
Fine Arts Museums of San Francisco; bequest of Ruth Haas
Lilienthal 1975.2.8

of sky and water in multitudinous reflections of shimmering dots, he would return there every summer through 1936.[257] The combination of Deep's ghostlike, layered clouds and its soft air, colored "as if one were looking through rose-tinted smoked glass," presented Feininger with a vision of atmosphere as space-architecture.[258] He spent his time there making nature studies, watercolors, and preliminary compositions in charcoal, producing in that first summer alone some 450 nature studies, a host of compositional studies in charcoal, and about 50 watercolors. In these and the later watercolors he would make in Deep, he achieved a mixture of delicacy and monumentality by interrupting the pressure of his hand in the act of drawing, thereby giving his ruled lines a pulsing vibrancy.

For the next twelve years, the experience of the sea air and beach in Deep each summer would renew his sense of the "universe flowing through" him.[259] Back in his studio each fall, away from a "too-close proximity" to the subject, Feininger would transform the charcoal compositions he made in Deep into visions of the sublime.[260] Having found in 1925 a French white paint that did not gray his colors or coarsen his canvas, as had the "terrible 'Weimar' white," he felt "the curse of the last years" lifted.[261] He painted "alla prima," applying layers of wet paint to his canvas before the previous coat had dried in order to keep the "paste" alive and pliable until the last stage of completion.[262] To achieve as smooth a paint surface as possible and avoid gestural accents that might reveal traces of labor, he switched to flat brushes. By stippling short strokes of paint onto his canvas, one atop the other, he created chords of color that gave the impression of looking through multiple layers of light and atmosphere. The result was a sense of otherworldly joy, as if Feininger had given concrete form to his innermost experiences of "lost

happiness," which he lifted from the past in the act of painting.[263] He took pride in having designed what he called "sacred spaces" that communicated an inner meaning beyond their outer form, thus activating viewers' understanding of the mysteries of divinity.[264]

In December 1924, a few months after Feininger returned to Weimar from his first summer in Deep, the newly elected Thuringian parliament bowed to pressure from unions and its conservative majority by announcing it would terminate the Bauhaus Masters' contracts as of June. Gropius immediately began to investigate alternatives to Weimar; in February 1925, the faculty voted to move the school to Dessau. Feininger wavered about whether to relocate with them, caught between his conviction that teaching posed inherent dangers to artists and his affection for his colleagues. "Why do all of us lose over time the carefree approach that graced us in earlier times when we were free?" he asked rhetorically. "Somehow the tenure at an institution is filled with unavoidable obligations which impairs our sense of being carefree, even in the best of circum-

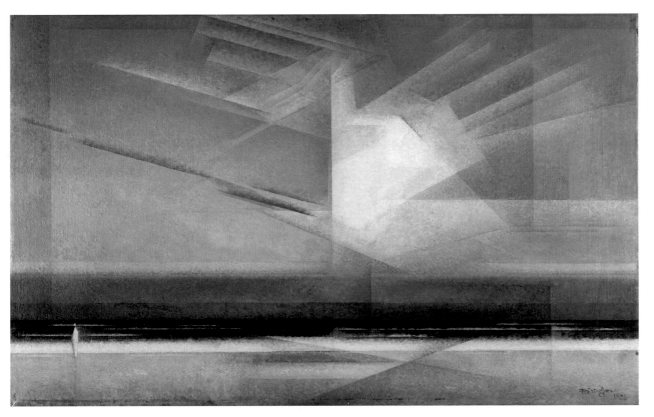

fig. 129. **Bird Cloud (Vogelwolke [Wolke nach dem Sturm]),** 1926
Oil on canvas, 17¼ x 28 in. (43.8 x 71.1 cm)
Harvard Art Museums, Busch-Reisinger Museum, Cambridge, Massachusetts; purchase in memory of Eda K. Loeb BR50.414

stances—we absorb certain methodical ways."[265] The publication that month of Moholy-Nagy's *Malerei Photographie Film*, which cast static painting as antiquated and lauded technological art as the only legitimate form, offered poignant evidence of how much the Bauhaus had changed since its early years. "This essay weighs down on my heart!" Feininger confided to his wife. "My self confidence is turning against being merely 'tolerated' at an institute which considers panel painting as over and done with."[266] Despite his reluctance to teach and his feeling of being marginalized at the Bauhaus, Feininger's certainty that Weimar would be hopelessly lonely without his Bauhaus colleagues convinced him to remain part of the school. He proposed a compromise, which Gropius and the mayor of Dessau accepted: he would join the faculty in Dessau and live in one of the Gropius-designed Master Houses rent-free, but be absolved from teaching in exchange for not receiving a salary. Feininger was happy to be spared teaching, but forgoing a salary turned out to be a courageous move given the decline in foreign credit to Germany

that followed Hindenburg's election as president in April 1925.[267] Indeed, selling art in Germany would become such a rarity that year Feininger even offered to work for *Ulk* and *Lustige Blätter* again. Julia, who once had complained of the impossibility of surviving without two maids, recognized the need to economize: "We are poor painter people, who should live most modestly, without much expenditure. We live, however, as if we belonged to a very different income class."[268] For Feininger, the benefits of not having to "waste [his] *best* energies" by becoming enmeshed in the Bauhaus's "powder keg" far outweighed the blandishments of a salary.[269] Though anxious about his own economic situation and the terrible poverty ravishing Germany, he remained hopeful that in Dessau "a thriving creativity will start up and we start living after having been liberated from the nightmare of Weimar."[270]

fig 130 **Untitled (Feininger's photograph of his *The Bölbergasse Halle (Die Bölbergasse)*, (destroyed in World War II) next to its charcoal study in Feininger's studio in the Moritzburg Museum),** c. 1931
Stiftung Moritzburg, Kunstmuseum des Landes Sachsen-Anhalt

Feininger and his family remained in Weimar for over a year after the rest of the Bauhaus faculty moved into temporary quarters in Dessau while awaiting completion of Gropius's Master Houses.[271] With workers' strikes impeding construction, it was not until July 30, 1926, that the Feiningers relocated to the duplex Master House in Dessau that they would share with the Moholy-Nagys. The house, with its red staircase and cobalt-blue stair-strings, delighted Feininger, as did the "feeling of community with the friends in others houses—not too close, not too far."[272] By the time he moved to Dessau, the government's introduction of the rentenmark had stabilized Germany's currency enough that the art market had rebounded. Feininger's stature as an artist likewise had risen substantially, with three solo museum shows in 1926 alone and demand for his watercolors so great he could not produce them fast enough. By 1928, he had adequate disposable income from sales to buy a car for his son Andreas and a good-quality camera for himself. Confirmation of his position as one of Germany's most renowned modern artists came that year with the installation of an entire room of his paintings, borrowed from private collectors, at the Kronprinzenpalais (Crown Prince's Palace), the Nationalgalerie's showplace for modern art. Of the eleven other artists included in the show, only Kandinsky and Marc were similarly honored with individual rooms of their work. When the installation came down, the museum's director, Ludwig Justi, extended enough loans from private collectors to keep a "Feininger wall" on permanent view. In 1929, the artist received a prestigious gold medal and prize money from the city of Düsseldorf, and a commission from the Halle Town Council to paint a large picture of the city as a present to the governor of the provincial capital of Saxony in Magdeburg. Alois Schardt, who had instigated the commission as director of Halle's Staatliche Galerie Moritzburg, gave Feininger use of the hexagonal studio on the top floor of the museum's tower, with its sixteen-foot ceilings and windows on five sides. Leaving Julia in Dessau, Feininger relocated there in early May 1929

with his son Andreas and began exploring the historical city. After only a few weeks, he determined to paint an entire cycle of pictures of Halle.

Feininger's zeal for creating this cycle owed in part to his engagement with photography, which had long been embraced at the Bauhaus as a result of Moholy-Nagy's advocacy.[273] In 1925, Feininger had vigorously rejected the Hungarian artist's claims for the superiority of technological art over painting. But in 1928, two years after Feininger's sons Andreas and Lux built a darkroom in the family's basement in Dessau to develop their photographs, Feininger too took up his camera as a tool for making fine art. Once he did, he was converted, especially to the blurred and veiled effects created by fog, mist, snow, and artificial light at night (figs. 141, 142). Excited by how the camera focused his attention, he made as many as fifty negatives a day, some intentionally unfocused, which he enlarged in what he called "a kind of dark-room orgy."[274] He continued the process in Halle, using an enlarger and darkroom that Schardt put at his disposal. As before, he was particularly entranced by the refractions of light on windows and water, and by the flattened space and crisp angles created by late-afternoon sunlight. Confident that taking pictures of these effects intensified his already sharply focused observation of external reality, he anticipated easily making a cycle of compositions from his photographs. To give himself time to fully absorb the motifs, however, he spent his first month in Halle painting variations on subjects he had depicted previously: *Calm at Sea III* (fig. 136) and *Mellingen*. Not until June of 1929 did he begin to paint the city.

That spring, oblivious to the looming international economic crisis, Feininger had only one worry: whether to leave the Bauhaus and settle permanently in Halle, where he had been offered a job at the city's art school. His initial hopes that his release from teaching duties at the Dessau Bauhaus would spare him involvement in the school's distracting politics had proved illusory. With Muche's departure in 1927 and Gropius's and Moholy-Nagy's in 1928, emphasis on functionalism and the applied arts had nearly obliterated the school's earlier utopian marriage of arts and crafts. What had kept Feininger in Dessau was his attachment to Klee and Kandinsky. But in 1929, convinced of the importance of "get[ting] out of the threatening paralysis caused by the air in Dessau" and unwilling to accept the Halle teaching job, he again considered returning to the United States.[275] Between 1917 and 1926, he and his family had been "stateless," without valid passports from either Germany or the United States. In attempting to register his new address with the American embassy after moving to Dessau, he had discovered that being stateless was not a legally recognized status. During the course of petitioning to be reinstated as an American citizen, he had found the people at the embassy so helpful

fig. 131. **Untitled (The Bölbergasse from the West),** c. 1930
Gelatin silver print
Stiftung Moritzburg, Kunstmuseum des Landes Sachsen-Anhalt

that he began seriously to consider returning permanently to the United States within a year or two.[276] In Germany, he had always been considered an outsider by virtue of his mannerisms and appearance. Even his face, he acknowledged, differed from "all other simple good German faces" in being "somehow 'strange' and I think uncanny for young people."[277] Yet he had stayed in Germany for over forty years, bound to the country by habit, by his success as an artist, and, conversely, by his view of America as materialistic and unreceptive to art. The vitriolic response to his work in the Museum of Modern Art's 1929 exhibition *Paintings by 19 Living Americans* reinforced his assessment. The museum's director, Alfred Barr, had met Feininger in Dessau in 1927 and become an immediate champion. His decision to present Feininger as one of America's best artists backfired; critics, unfamiliar with even his name, repeatedly questioned his inclusion, asking "Who is he?" and "How did he make the grade that excluded George Luks, Childe Hassam, Joseph Stella, Florine Stettheimer, Alexander Brooks & co?"[278] Given the press's hostility to Feininger's designation as an American artist, Barr decided to abandon his earlier plan to include the artist's work in an upcoming survey of modern German art for fear the confusion would be distracting; instead, he proposed organizing a one-person exhibition for Feininger in two or three years. [279]

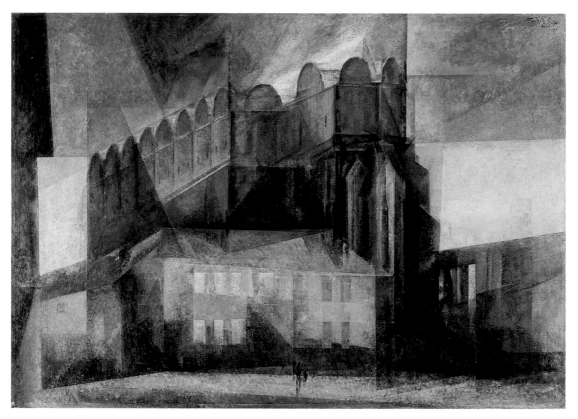

fig. 132. **The Cathedral, Halle (Der Dom in Halle),** 1931
Oil on canvas, 34 x 49 in. (86.4 x 124.5 cm)
Stiftung Moritzburg, Kunstmuseum des Landes
Sachsen-Anhalt

Feininger's disappointment with the reception given to his work in his native country evaporated with news in June 1930 that the mayor of Halle had agreed to purchase all nine completed Halle paintings and to consider compositions still underway. "I am so happy that the money worries have ended!" Feininger exulted. "It sounds like a fairytale, that all debts have been paid."[200] The purchase was all the more miraculous given the devastating impact on Germany's economy of the recall of loans by American banks following the 1929 stock market crash. With one in five Germans thrown into the ranks of the unemployed, art had become a luxury few could afford.

For the entire next year, pressure to complete the Halle paintings caused Feininger enormous anxiety. Finishing the last two canvases of the cycle was a torturous process. He worked and reworked them, sometimes wiping out the entire composition and starting fresh three times within a single day. He considered *The Cathedral, Halle*

(*Der Dom in Halle*), the most difficult picture he had ever attempted (fig. 132). In one day alone, he scraped and scrubbed the picture for seven hours, digging through roughly seven layers of paint to get to the original design. As was his habit, he had made preliminary charcoal drawings for each of the Halle paintings. Rather than precede these charcoals with nature notes, as he usually did, he worked primarily from photographs, using only a minimum of nature notes.[281] Although he vowed in desperation, while painting *Cathedral*, never again to work from photographs, he found those he took of in-progress paintings immensely useful. Seeing a photograph of an early version of *Cathedral*, for example, inspired him to wash layers of paint off the surface and "finish the painting after the photograph."[282] Working with black-and-white photography reinforced his emphasis on structure over color. "I cannot find color, so I must content myself with preparing the form," he wrote of his work that year. "I am too 'melancholy' to take pleasure in color; but to see form gives me spiritual support."[283]

The lack of transparency and luminosity that characterizes most of Feininger's Halle pictures—their physical density or "overcompletion" as he would call it—suggests his struggle to realize a commission under pressure of a deadline.[284] As the day drew nearer when the city council would formally view the works, Feininger became increasingly uneasy as he labored to finish them. "These last pictures don't make me happy," he confessed. "I am not cut out for such serial work."[285] In the end, however, the cycle was a victory: the Halle city council voted in May 1931 to purchase all eleven paintings and twenty-eight charcoals for 36,000 marks, to be paid in five annual installments from an escrow account that earned six percent interest. "We can be content to have payments from it for years to come," Feininger assured his wife. "Next year, every year, we can travel, and enrich our lives in all the things we have been doing without for so long! The money from Halle will serve for this."[286]

Feininger's success in Halle was followed several months later, in September 1931, by his greatest triumph to date: a retrospective in honor of his sixtieth birthday at the Nationalgalerie in Berlin's Kronprinzenpalais.[287] Four months earlier, the Museum Folkwang in Essen had expanded an exhibition of Feininger's watercolors at Dresden's Neue Kunst Fides gallery into a comprehensive survey of more than one hundred paintings and fifty watercolors from all periods of the artist's career, including his work at Halle. Justi, the Kronprinzenpalais's director, saw the show in Essen and immediately arranged for it to open at his museum in September, where it filled eight rooms, all but one of which he lined with white paper to showcase Feininger's work.[288] Response was enthusiastic. Feininger was lauded as one of the era's leading artists, whose presence in the country's most important museum symbolized the cordial relationship that existed between the United States and his adopted land.[289] The irony of Feininger being accepted in Germany as an American artist while being denied that designation in his native land went unnoticed. At the show's close, Justi installed an entire room in the museum's upper-floor permanent collection galleries with the artist's work.

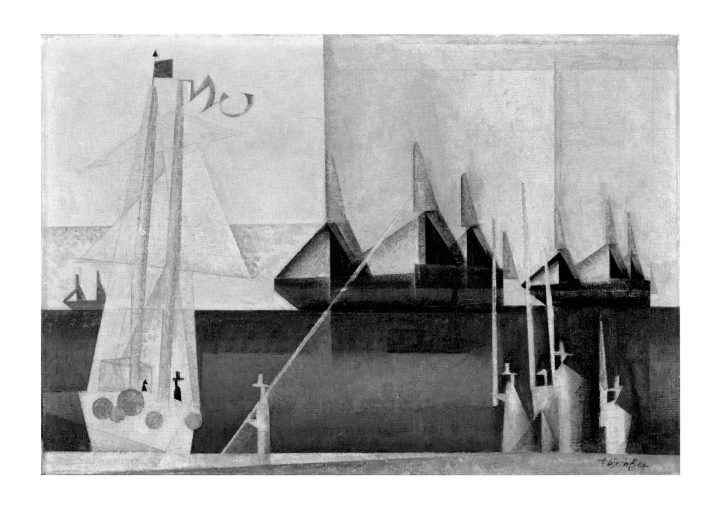

fig. 133. *Marine, Harbor of Peppermint (Marine [Hafen von Peppermint])*, 1929
Oil on canvas, 11 ¼ x 16 ⅜ in. (28.5 x 41.5 cm)
Kunstmuseum Bern, Switzerland; gift of Livia Klee, 2001

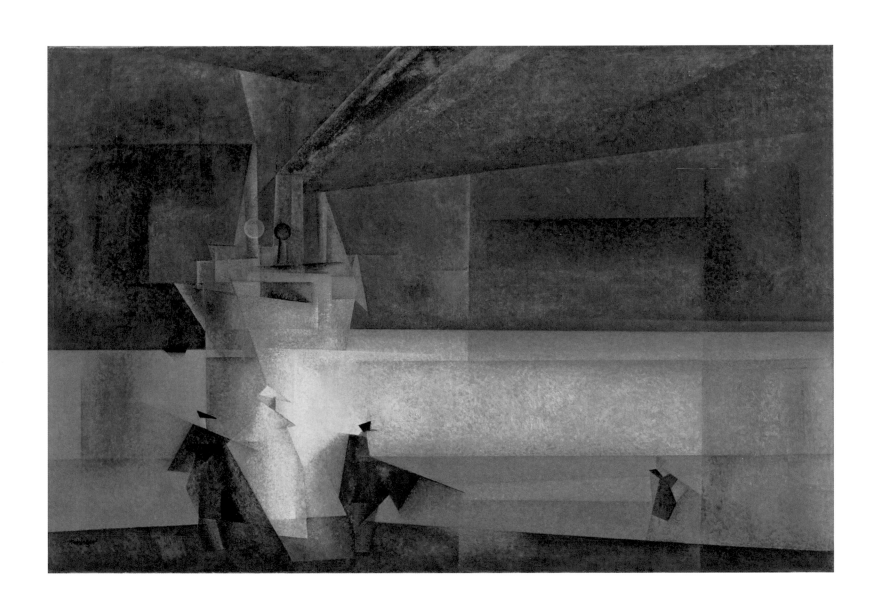

fig. 134. ***The Steamer Odin, II,*** 1927
Oil on canvas, 26½ x 39½ in. (67.3 x 100.3 cm)
The Museum of Modern Art, New York; acquired through
the Lillie P. Bliss Bequest 751.1943

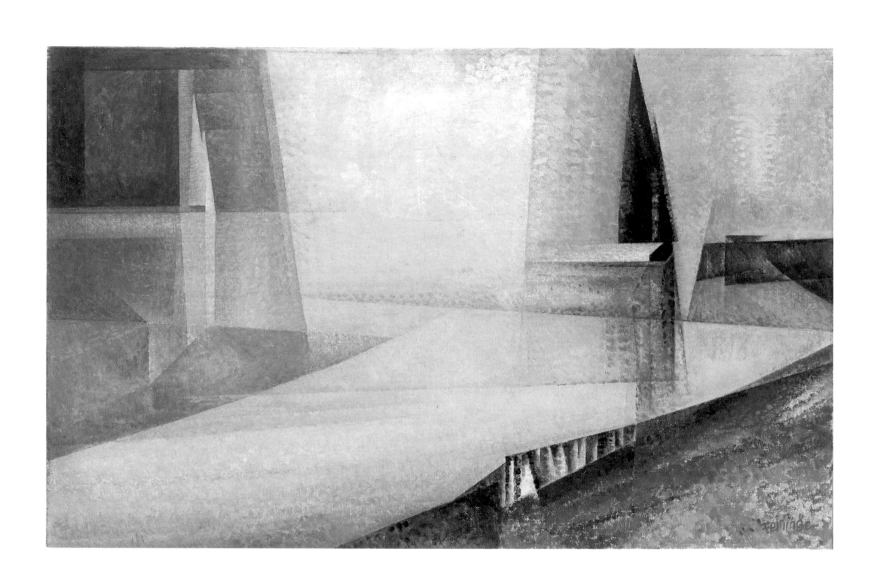

fig. 135. **Mouth of the Rega III (Regamündung III),** 1929–30
Oil on canvas, 18⅞ x 30¼ in. (48 x 76.5 cm)
Hamburger Kunsthalle, on permanent loan from the Foundation for the
Hamburg Art Collections

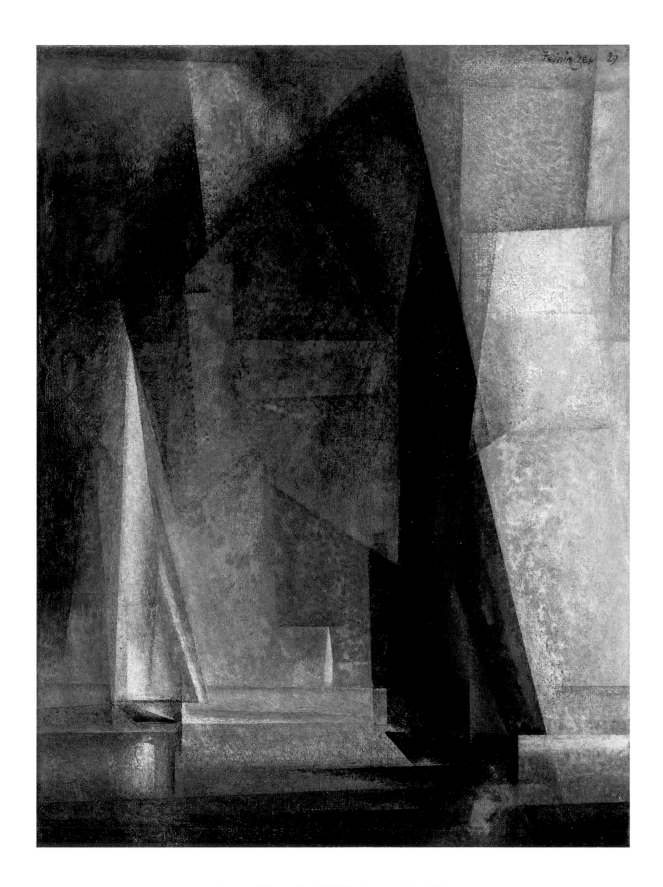

fig. 136. ***Calm at Sea III (Stiller Tag am Meer III),*** 1929
Oil on canvas, 19¼ x 14⅛ in. (49 x 36 cm)
Private collection; courtesy Moeller Fine Art, New York and Berlin

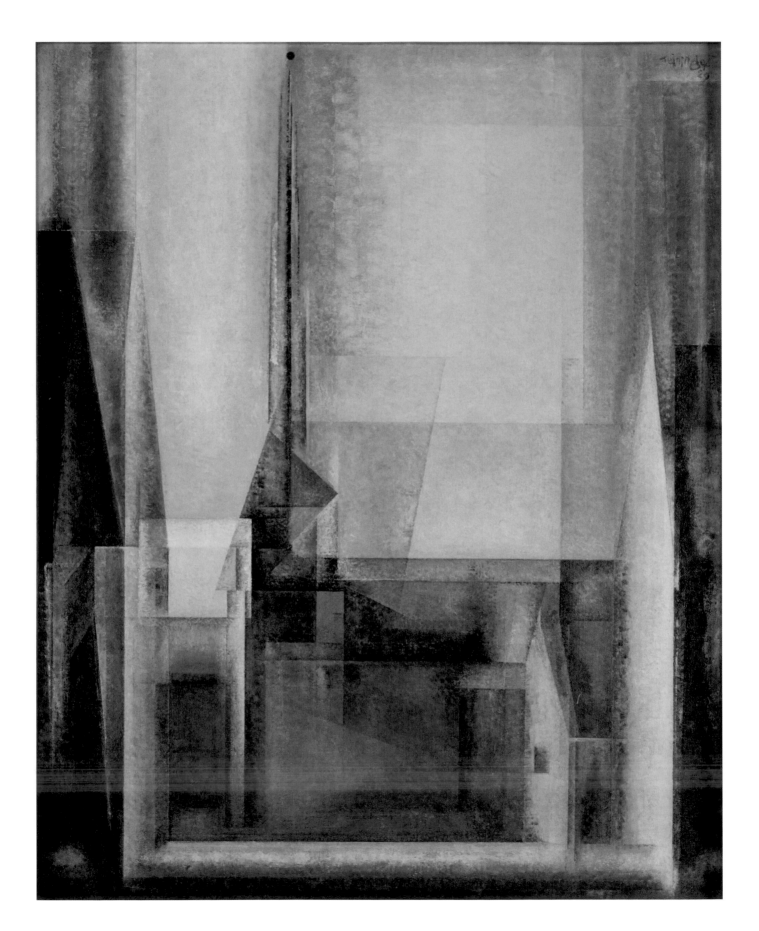

fig. 137. *Gelmeroda XII (Church at Gelmeroda, XII),* 1929
Oil on canvas, 39⅝ x 31¾ in. (100.7 x 80.7 cm)
Museum of Art, Rhode Island School of Design, Providence; gift of
Mrs. Murray S. Danforth

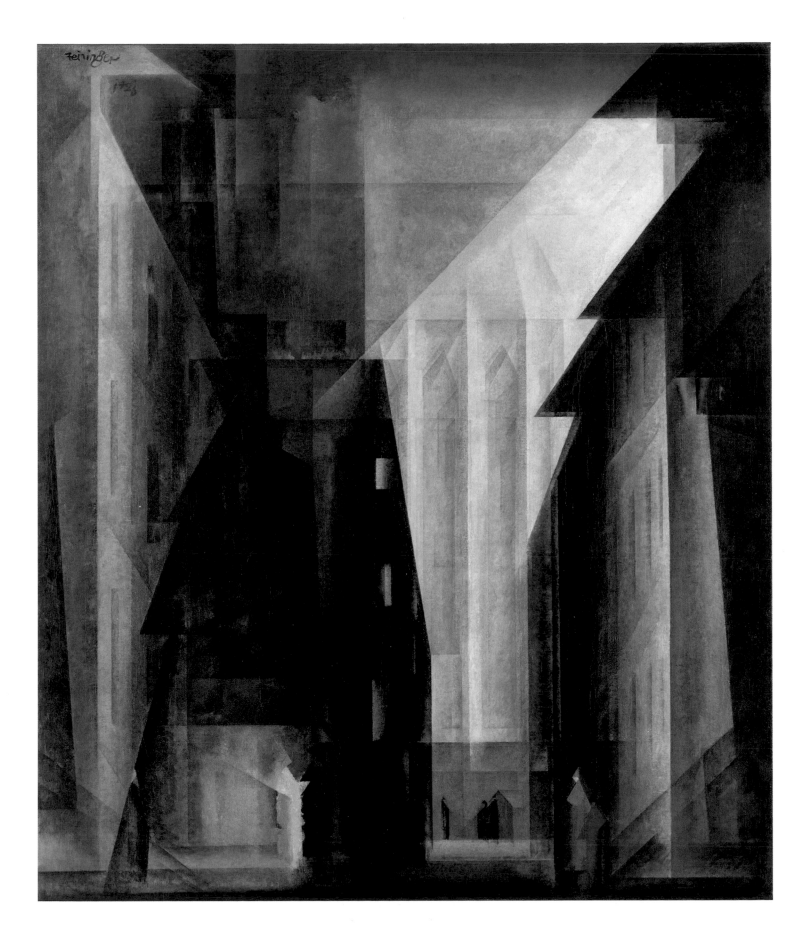

fig. 138. ***Church of the Minorites II (Barfüsserkirche II),*** 1926
Oil on canvas, 42¾ x 36⅝ in. (108.6 x 93 cm)
Walker Art Center, Minneapolis; gift of the T. B. Walker Foundation,
Gilbert M. Walker Fund 1943.20

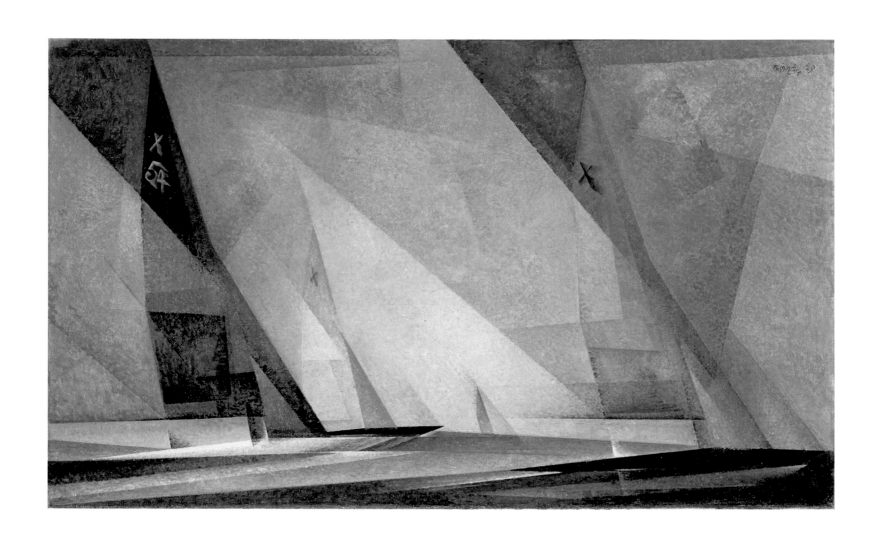

fig. 139. *X 54 (Sailboats),* 1929
Oil on canvas, 17 x 28½ in. (43.2 x 72.4 cm)
Detroit Institute of Arts; gift of Robert H. Tannahill 69.305

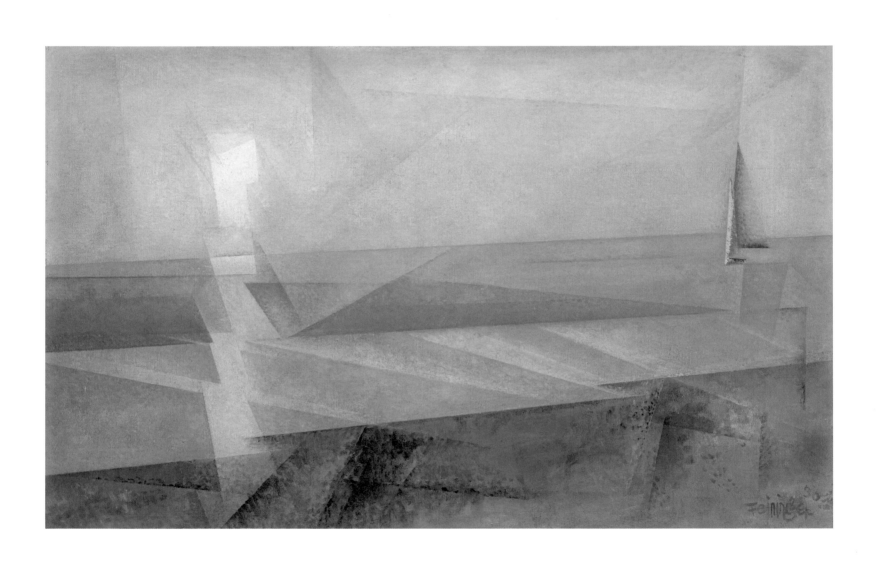

fig. 140. *Sunset at Deep (Sunset),* 1930
Oil on canvas, 18⅞ x 30⅝ in. (47.9 x 77.8 cm)
Museum of Fine Arts, Boston; The Hayden Collection—
Charles Henry Hayden Fund 41.568

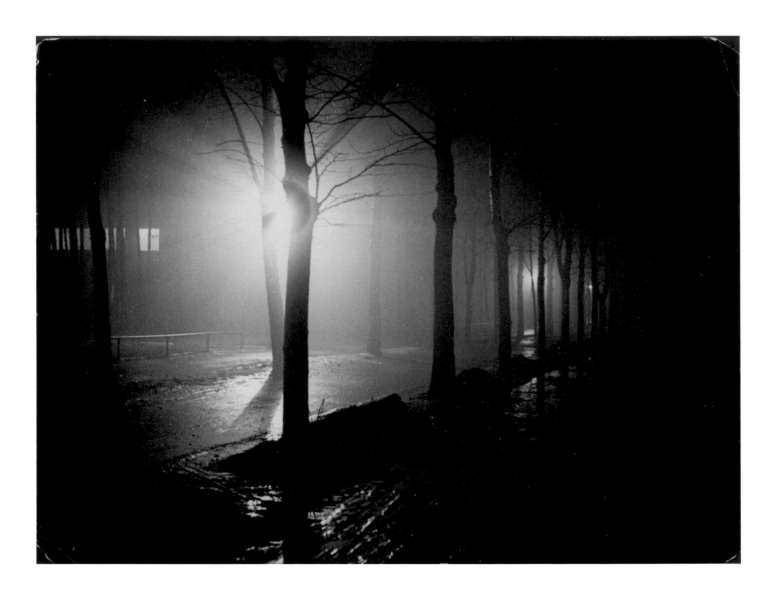

fig. 141. **Untitled (A misty night in the Burgkühnauer Allee, Dessau),** 1929
Gelatin silver print, 7 x 9⁵⁄₁₆ in. (17.7 x 23.7 cm)
Houghton Library, Harvard College Library, Harvard University, Cambridge, Massachusetts; gift of T. Lux Feininger

fig. 142. **Untitled (The Albers-Feininger house in a fog, Dessau),** 1929
Gelatin silver print, 7 x 9⁵⁄₁₆ in. (17.7 x 23.7 cm)
Houghton Library, Harvard College Library, Harvard University, Cambridge, Massachusetts; gift of T. Lux Feininger

fig. 143. **Untitled (Stand of pinetrees in front of the house occupied by the artist and his family, Dessau),** 1929
Gelatin silver print, 7 x 9⁵⁄₁₆ in. (17.7 x 23.7 cm)
Houghton Library, Harvard College Library, Harvard University, Cambridge, Massachusetts; gift of T. Lux Feininger

The Politics of Nazism

Feininger responded to his 1931 retrospective much as he had to his 1917 debut at Der Sturm—by wanting to escape. "I have the feeling that the exhibition tears away my [anonymity]—there is almost a feeling of 'exhibitionism' because the effect on the public of such strange work must be principally one of curiosity and unfamiliarity; 'sensationalism.'"[290] As before, he produced very little art in the months after the retrospective. By the time he left for Deep that summer, he had regained his equilibrium and was looking forward to a new, more emotionally intense period in his art. Once there, he began a series of preliminary compositions in charcoal culled, as he later described it, from "the foggy chaos of my imagination."[291]

No sooner had Feininger started working on these charcoal compositions than he was caught up in Germany's rising political crisis.[292] He had gotten a foretaste of what the Nazi seizure of power would mean a year earlier, in September 1930, when Nazi Party member Wilhelm Frick was elected to the Reichstag and named Minister of the Interior of Thuringia. To direct the art academy, which had reclaimed the buildings vacated by the Weimar Bauhaus, Frick appointed Paul Schultze-Naumburg, whose 1925 book on art and race had paired modern paintings with photographs of deformed and diseased people. Following Frick's order to remove all vanguard modern art from public display, Schultze-Naumburg had destroyed the Bauhaus murals, including those by Schlemmer. Similarly, Wilhelm Koehler, director of Weimar's Schloss Museum and a longtime advocate of Feininger's work, was forced to dismantle the museum's contemporary art installation, including its rooms of work by Klee and Feininger. Julia wrote immediately to Koehler: "I came home and fell through the door; we read in the paper about what is supposed to have happened at your Schloss Museum—is it true? That the pictures of modern painters, the names Klee, Kandinsky, and Feininger were mentioned, have been removed? At the ministry's instructions? . . . I can understand that you're fighting for your rights and don't want to alarm us before everything is finally decided, but if the newspaper reports are true, that the pictures have already been removed, can we please ask for them to be returned immediately."[293]

Like many Germans, Feininger viewed the Nazi Party's ascendancy as temporary, and he acceded, without protest, to Koehler's plan to transfer the removed art to the Museum Folkwang in Essen, still under control of the Social Democrats. In July 1932, however, when the National Socialists gained a majority in the Reichstag, the political implications of Nazi power became impossible to ignore. Feininger's prominence in the Nationalgalerie had drawn the Party's attention; almost immediately after it took control of the Reichstag, Feininger received notice of a new ordinance taxing artists' unsold pictures, sketches, and study materials. Although the issue was resolved, the National Socialists' overt efforts to discourage artists they considered suspicious made Feininger "simply sick at heart."[294] That August, the Dessau city council, now under Nazi control, voted to close the Bauhaus as of October 1. "It is terrible in Germany," Feininger wrote.

"If one were to seek comfort with friends today, whom could one turn to? Everything is shaky, in boundless fear of the times upon us and poisoned by politics!"[295] With his colleagues leaving Dessau for Berlin, where the Bauhaus had relocated, Feininger contemplated finding a small apartment in Halle for himself and Julia. Ultimately, Halle's high cost of living convinced him to remain in his rent-free house in Dessau, which the city's mayor allowed him to retain temporarily. From there, he watched as Hitler, named chancellor in January 1933, assumed dictatorial powers under the Ermächtigungsgesetz (Enabling Act) passed in March, and began his persecution of Jews and political opponents.

Almost immediately after Hitler's ascendancy, modern art fell victim to the National Socialists' agenda to eliminate all art that did not promote what they viewed as "healthy" Aryan values. Modernity, with its accelerated pace of change and simultaneity of experience, had created psychological fragmentation and anxiety; what was needed, the Nazis claimed, was an art that engendered order, coherence, and pride in Germany. They were not the first group to identify modernity with instability and dislocation. The idea, first proposed by German sociologist Georg Simmel in his groundbreaking 1902 study "The Metropolis and Mental Life," had been embraced earlier by German Expressionist artists, who posited art as a refuge from the inchoateness and corruption of modern urban life. For them, art involved a transformation of consciousness that would return unity, harmony, and a sense of community to society, thereby revitalizing it. It was thus ironic that German Expressionist paintings were among the first to be singled out as degenerate by the National Socialists in exhibitions intended to show the German people the products of "cultural collapse" that would be purged from the Third Reich. In March 1933, the government in Dessau hung city- and state-owned works by modern artists in two display windows of the hardline Nazi Party newspaper, *Die Mitteldeutsche Anhaltische Tageszeitung* (*The Middle German Anhaltian Daily Newspaper*), accompanied by a "review" that, among other things, charged Feininger with being a top-ranking Bolshevik.[296] The following day, storm troopers searched Feininger's "beloved home in Dessau."[297] At once, he put his furniture and household belongings in storage and sent his art to the Staatliche Galerie Moritzburg to be warehoused under the protection of Schardt. For the next year and a half he and Julia lived without a studio in Deep and with friends in Berlin.

With the world crumbling around him, Feininger was determined to remain focused on his art. The decision echoed his assertion during World War I that "those who serve art have the obligation to stay free of 'party' fanaticism. . . . One can choose between living in the midst of turmoil . . . or withdrawing from today's over-activity, carrying within one's mind and heart the picture of this world according to one's consciousness."[298] Thus Feininger chose to ignore the country's rising dangers, predicting that the April 1933 passage of the Civil Service Law authorizing the state to fire all non-Aryan public officials and send political opponents to detention camps without trial would engender a reaction within the international community strong enough to stop these

affronts to decency. "The world is [outraged] about the Jewish persecutions and other barbarisms against arts and sciences," he wrote to Julia on April 6. "Max Reinhardt has been ousted from his theater and his scenery forbidden! For 35 years the world's greatest and most universally admired theatrical manager + genius! But in France, the US and in England and Russia the indignation is so great against the persecution that already these countries threaten a world boycott."[299] Three days later he repeated the thought: "Once it becomes obvious in the 'Reich' how much damage the agitation of the anti-Semites does to the holy prosperity, this movement will be stopped dead in its tracks."[300] Yet despite his outward confidence that anti-Semitic actions, including the national boycott of all Jewish businesses and professions, would cease once their economic impact became obvious, he worried about friends and about Julia's relatives notwithstanding their acculturation. "The horror is paralyzing. You understand me . . . I cannot say more" he wrote cryptically.[301] A month later, on May 10, the regime staged events in cities all over Germany that resulted in the burning of thousands of books accused of promoting "un-German" ideas.

Even in the face of these atrocities, Feininger held on to his vision of an idealized Germany. After World War I, he had watched with horror as Germany descended into unrest and economic instability as a result of the degrading and economically destructive conditions imposed on it by the Treaty of Versailles. Sympathetic to the anger and discontent of German citizens over the treaty's humiliation of Germany and the ensuing chaos and impoverishment of the Weimar period, he welcomed Hitler's promise to return the country to greatness. Naively, both he and Julia applauded the Führer's May 17, 1933, speech to the Reichstag in which the Nazi leader attributed responsibility for "the problems causing today's unrest" to the treaty and vowed to "put an end to a period of human aberration in order to find the way to an ultimate consensus of all on the basis of equal rights."[302] Feininger was not alone in the early months of the Third Reich in viewing Hitler's vows to rebuild a beaten-down Germany as laudable. Nevertheless, it is disquieting that at the very moment when the situation in Germany was spiraling out of control, he seemed unaware of the dangers of Fascism and anti-Semitism to his family and to Europe. Two days after Hitler's speech, he wrote to Julia:

> **I am quite enraptured and totally enthusiastic about Hitler's speech in front of the Reichstag—in front of the world!—Have I not asked a thousand times: why doesn't someone stand up and proclaim in clear public view what millions know and no one has said out loud? Where does the blame lie for the impoverishment of the whole world? And where does the path lead that the world must follow if peace and prosperity should ever emerge again? The old Hindenburg? Ach! This infinitely revered old man is lacking the strength, the sacred, working, active fire, the *vision*!—For all times this speech by Hitler must be considered the highest achievement, a monument of patriotism as it has never before been announced to a people so absolutely and unanimously. And finally the world has**

found in three men—Mussolini, Roosevelt and Hitler—the leaders it has been screaming for!—None of them "professional" politicians, but intellects superior to their time and filled with fullest, strongest humanity—You have to break an egg to make an omelet; we must forget what many have suffered undeservedly in this country, and look instead to the hope for unity which seemed unthinkable even a few months ago. . . . Who today cannot be affected by enthusiasm about such a great deed? All special interests seem small and insignificant. Hitler's speech is admirable in all details—nothing remained unsaid and it stood joined and unified in iron logic.[303]

The realities of Nazi politics, however, soon grew ominous. Feininger's friend Schardt had been hired in June 1933 by Bernhard Rust, the Nazi Minister of Education, Science, and Culture, to reinstall the Kronprinzenpalais after Justi was sent on indefinite leave for supporting the work of vanguard artists, Feininger included. With the help of loans from all over Germany, Schardt created a didactic chronological presentation of "Nordic" art, in which he positioned German Expressionism as the culmination of the Gothic-Romantic tradition that had begun with Caspar David Friedrich and Karl Friedrich Schinkel (1781–1841). Schardt's argument failed to convince Rust, who dispatched the director back to the Moritzburg Museum. There he discovered that as of November 27, the museum's modern art had been put on display in a "chamber of horrors," accessible only upon payment of a fee and registration in the visitor's book. A portend of the "degenerate" art shows that would take place in Germany over the next four years, Halle's display was drawn exclusively from its own collection—which, thanks to Schardt's advocacy, included a large number of Feiningers.

Understandably, these events pressed on Feininger, who produced few paintings between 1932 and 1936. His limited output worried him, making him wonder "if I might prove myself worthy to be called an 'artist' ever again."[304] "I've seen myself *dying* in all that

fig. 144. **Untitled (photograph of a model boat),**
c. 1928–32
Gelatin silver print, 9⅜ x 7 in. (23.8 x 17.7 cm)
Houghton Library, Harvard College Library, Harvard University, Cambridge, Massachusetts; gift of T. Lux Feininger

makes life for the Artist worth living and I have bitten down my grief and said to myself: if it's in me at all, I *shall* yet succeed!"[305] Deep became his refuge, a place of peace and distance "from all world events."[306] There, in the quiet of a familiar seaside village, living "totally 'out of this world,'" he looked through portfolios of nature notes to find "magical seedlings for new creative opportunities."[307] In his watercolors and drawings from these years, which typically isolate lone ships far out at sea in full sail, Feininger created a metaphor of life in a world in which "everyone is ready and willing to hurt one another. Not a bit of common sense or human kindness seem to remain."[308] He accentuated the

otherworldliness of these ship images by frequently basing them, not on actual observed ships, but on the model boats he and his sons had made and raced on the Rega every year since 1925 (fig. 144). The theme of dislocation found a powerful articulation in the summer of 1934 in *The Red Fiddler (Der rote Geiger)*, which recapitulated a watercolor he had made during World War I (figs. 145, 146). The painting was Feininger's first large-scale figurative oil since 1927 and the only one he ever painted while on vacation. A visual symbol of the artist's isolation in an unhinged world, Feininger's casting of a fiddler as the painting's protagonist makes the canvas one of his most autobiographical.

Tragically, *The Red Fiddler* was prophetic. That September, at the 1934 annual Nazi Party rally at Nuremberg, notoriously recorded in Leni Riefenstahl's propaganda film *Triumph of the Will* (1935), Hitler excoriated all forms of modern art and enjoined Jewish artists and writers from publicly practicing their craft. Six months later, on March 27, 1935, Schmidt-Rottluff called Feininger to tell him that their art was being judged that day by a commission likely to denounce their work.[309] The following month, Moritz Noack, the ex-husband of Feininger's daughter Marianne, left Berlin with his new wife after she received a letter stating that she and all other Jewish authors were banned from publishing or practicing their profession in public. What Feininger called the "hopeless period of cultural history" drew even closer, when he had to assemble documents proving his Aryan heritage in order for his son Lux to be admitted to the Reich's Kulturkammer (Chamber of Culture), a prerequisite for showing one's art in Nazi Germany.[310] Both of Lux's maternal grandparents were Jewish, and under the Nuremberg laws passed that September he was considered a "half breed." Thus Lux was relieved to hear in May that his status as a non-German excused him from membership in the Kulturkammer, a loop-

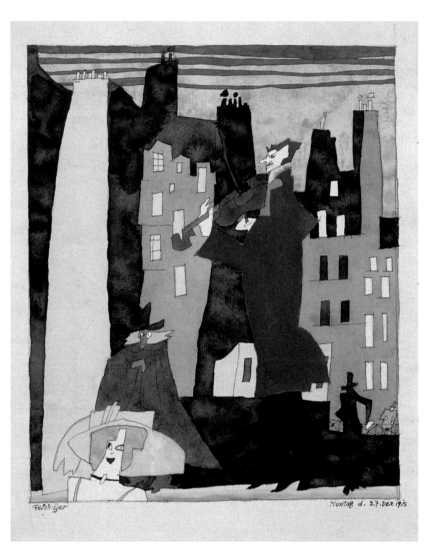

fig. 145. **Untitled (The Red Fiddler)**, 1915
Graphite, ink, and watercolor on paper, 12⅝ x 9¼ in.
(32 x 23.4 cm)
Private collection

fig. 146. ***The Red Fiddler (Der rote Geiger)***, 1934
Oil on canvas, 39½ x 31½ in. (101.3 x 80 cm)
Private collection

hole that became increasingly moot after the Gestapo closed all Jewish-owned galleries, including fifty in Berlin alone. Ultimately Feininger was called upon to document his own Aryan heritage in order to "create art," a claim he easily proved: "we, the Feiningers, have been 'pure Aryans' from time immemorial, and believing Catholics from Swabia and even if they offered me a 'million' for it, I would not be able to find a 'non-Aryan' in our clans' past."[311] Still, the fear that he would be prohibited from painting made him particularly sensitive to being labeled a Jew, and on several occasions he tried to correct publications that had classified him as Jewish. In 1935, in an effort to expunge his name from a dictionary of Jewish art, he wrote to his lawyer: "I find the affair is slowly getting out of

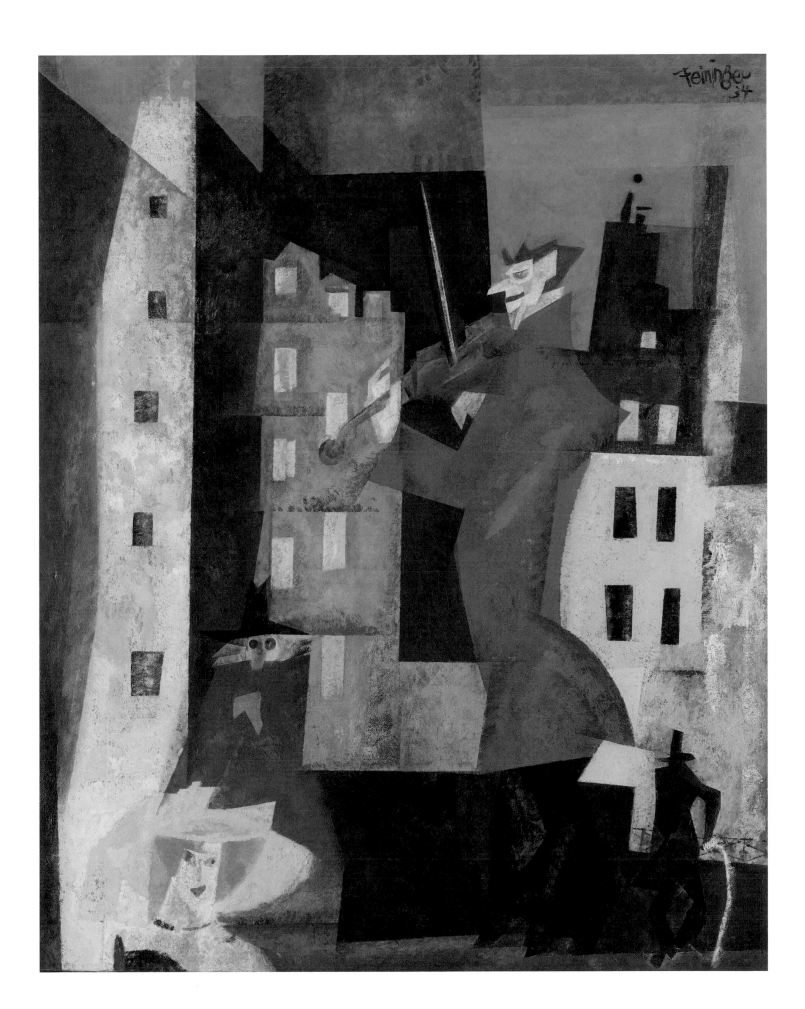

hand. How dare Dr. Karl Schwartz annex me for 3,000 years of Jewish art? I wonder what else might surface?"[312]

Feininger's assessment that "the madness is becoming orgiastic" became more poignant that August 1935 in Deep, where he went with his son Laurence after vacationing there with Julia in June.[313] By then, banners had been hung at the entrance to the village explicitly forbidding Jewish visitors. In an almost desperate desire not to acknowledge the implications of this "monstrous insult inflicted upon an entire race," Feininger encouraged Julia to join him, arguing that her June registration with the city was still valid, thus making it unnecessary for her to register again and show proof of her race.[314] Just days later, however, he advised her not to come, having been asked by their landlord of many years that she stay away for fear he would lose his job. Repulsed by the community's cowardice and hypocrisy, Feininger got into an argument with the mayor, who had called him a Jew. He felt vindicated that his forceful complaints had made it safe for Julia to visit Deep should she ever wish to, but the altercation left him in "no condition for creative work."[315] For Julia, the situation was more painful: "I cannot write at all. You will understand . . . the whole affair is nauseating. . . . Deep is now dead for me."[316]

Back in Berlin that October, having received the last installment of his Halle fee, Feininger faced a bleak economic future. Although a small number of galleries were still showing avant-garde art, public institutions had ceased buying it and purchases by private collectors were increasingly rare. "The end will come when our savings are used up," he reported to Scheyer in January 1936.[317] "We are beginning to wish we had not hung on until now. We see but a very slight chance of continuing to exist on present lines. . . . We shall have to give up even this little apartment soon if the opposition to my work continues."[318] That spring, days before Schardt's forced resignation from the Staatliche Galerie Moritzburg, Feininger arranged to have his Bauhaus friend Hermann Klumpp take the art Schardt was storing for him in the museum's gate tower to Klumpp's family farm in Quedlinburg.[319]

Several months earlier, in January 1936, Feininger had received an invitation to teach a summer course at Mills College in Oakland, California. The proposal came from Alfred Neumeyer, a German art historian who had fled Germany the year before. Encouraged by Julia, who was alarmed by the country's now legally sanctioned anti-Semitism, Feininger accepted the offer, not because he had hopes for his chances as an artist in America or because he felt marginalized enough to go into exile, but primarily because vacationing in Deep was no longer possible given the city's overt hostility to Jews. Only weeks before, he had severed his association with the Blue Four in the United States because of its inability to generate even one sale of his art, explaining to Scheyer that "the art situation over there, as you describe it, is catastrophic; I simply cannot go along with this anymore."[320] Convinced that his economic failure in the States was irreparable, he reasoned that he "might just as well take the opportunity to withdraw [from the Blue Four], and cease forcing myself upon the notice of people who are not

interested in what I do."[321] As with many Germans who continued naively to hope that everything would turn out well, Feininger felt no need to flee the horrors that were occurring in his country. When friends spoke of it, he would say, "They can do nothing to an American."[322] As the day for his departure drew closer, Feininger was so convinced that he would face spiritual death in the United States that he tried to cancel his contract with Mills. In the end, he capitulated to Julia's entreaties, boarding a ship for New York with her on May 6.

Feininger spent two of his five months in America teaching and the rest sightseeing along both the West and the East Coast, reconnecting with German and American friends, and meeting collectors, dealers, and museum directors.[323] While he was away, coincident with the 1936 summer Olympic Games being held in Berlin, Hamburg's Kunstverein opened the exhibit *Deutsche Kunst im Olympiajahr* (German Art in Olympics Year), which included Feininger's work. If the museum had hoped to take advantage of the regime's desire to appear culturally liberal during the Olympics, it didn't succeed: the show was forced to close after a few days; the Kunstverein was temporarily shuttered; and the group that had organized the show, the Deutscher Künstlerbund (League of German Artists), was outlawed. The newspaper report of the show's closure carried an illustration of one of Feininger's paintings with the caption: "we need waste no words saying that Cubism no longer counts as artistic revelation in Germany in 1936."[324] Feininger's work fared no better at the Kronprinzenpalais, whose director had managed to keep a selection of non-figurative Expressionist works on view during the preceding three years. For the Olympic Games, he had reorganized the gallery's upper floors, setting aside space for a survey of "foreign masters." As one SS periodical caustically reported: "Thank God that it has been discovered that the real cultural Bolshevists, namely Klee, Kandinsky and Feininger, were foreigners. Previously they were proudly ranked among our own. Because of their new passports these pioneers of absolute destruction haven't yet been thrown on the floor."[325] On October 30, Rust closed the Kronprinzenpalais.

Despite Julia's escalating fears as a Jew in Nazi Germany, she and Feininger returned to the country at the end of their five-month stay in America, even though many of their friends had already fled Germany. Their family, too, was dispersing: Andreas to Stockholm, Lux to New York, and Laurence to Italy.[326] With his savings depleted, and living in a "complete vacuum," Feininger nevertheless hesitated to repatriate to the United States without knowing how he would survive there.[327] "We simply cannot stay here another year," Julia wrote despairingly to Lux. "But you see, we have to have an important exhibition because we have to make a living."[328] Leaving Germany assumed greater urgency after Feininger received a summons in March 1937 from the regional National Socialist Party in Berlin to appear before the commission with his identity papers. When a telegram from Neumeyer arrived on May 28 inviting Feininger to replace Oskar Kokoschka (1886–1980), who had abruptly canceled his contract to teach at Mills

College that summer, Feininger hurriedly packed his belongings, feeling "twenty-five years younger since I've known I was going to a country where artistic imagination and abstraction are not seen as an absolute crime as they are here."[329] Thirteen days after receiving Neumeyer's telegram, Feininger was once again on his way to New York with Julia. That he left behind his two daughters from his first marriage and his former wife, all Jews, suggests his blindness to the severity of Nazi anti-Semitism.[330] Four years later, in 1941, the Nazis began to implement Die Endlösung (The Final Solution), their plan to eradicate the Jewish population of Europe.

A month after Feininger fled his adopted country, the Third Reich staged its most brutal assault against modern art with the opening in Munich of an exhibition intended to clarify for the German people what kind of art was "un-German" and therefore unacceptable.[331] *Entartete Kunst* (Degenerate Art) opened on July 19 in nine narrow rooms of Munich's Hofgarten with more than six hundred paintings, sculptures, prints, and books confiscated from the collections of thirty-two German public museums. Among the

assembled works were twenty-four Feininger paintings, prints, and watercolors. To accentuate the impression of chaos made by the dense installation and thereby exacerbate feelings of repulsion and indignation, the Hofgarten's walls were festooned with self-incriminatory, out-of-context statements by artists and critics and "explanatory" texts by Hitler, Joseph Goebbels, and Alfred Rosenberg, the Nazi ideologue and key architect of the party's opposition to modern art (figs. 147, 148). In large handwriting on the wall next to one of Feininger's paintings, for example, was an extract from A. Udo's Dadaist manifesto: "We act as if we were painters, poets or the like but we are only and nothing but brazen in lewdness. We have brazenly perpetuated a great swindle on the world and breed snobs who lick our boots."[332] To add to the unsettling combination of image and text, the authorities hired actors to roam the galleries wildly gesticulating in indignation. As the show traveled throughout Germany and Austria over the next three years, important objects were removed for sale on the international market, and replaced in the exhibition by less significant work, especially graphics. Only two Feininger paintings accompanied the exhibition after it left Munich; from October 1938 on, his representation was limited to woodcuts.

Even before *Degenerate Art* closed in Munich, committees from the Reich's Chamber of Art had begun confiscating the remaining modern art collections from German museums and taking them to Berlin. The purge affected over 20,000 works, including more than 460 by Feininger. The regime offered four dealers—Hildebrand Gurlitt, Ferdinand Möller, Karl Buchholz, and Bernard Bohmer—the opportunity to buy the purged works or swap them for acceptable historical pieces.

fig. 148. **Feininger's paintings *Towers over the City, Halle (Die Türme über der Stadt)*, 1931, and *Vollersroda III*, 1928, at the exhibition *Entartete Kunst* (Degenerate Art) in Munich,** 1937.
Photographer unknown

Of Feininger's confiscated pieces, 25 paintings, 85 works on paper, and more than 280 prints were ferreted out of the country this way.[333] The more public transformation of "degenerate art" into hard currency occurred at an auction, held on June 30, 1939, at the Galerie Theodor Fischer in Lucerne, Switzerland. One hundred twenty-five paintings were auctioned, including two by Feininger that were purchased after the close of the auction by the Nierendorf Gallery in New York.[334]

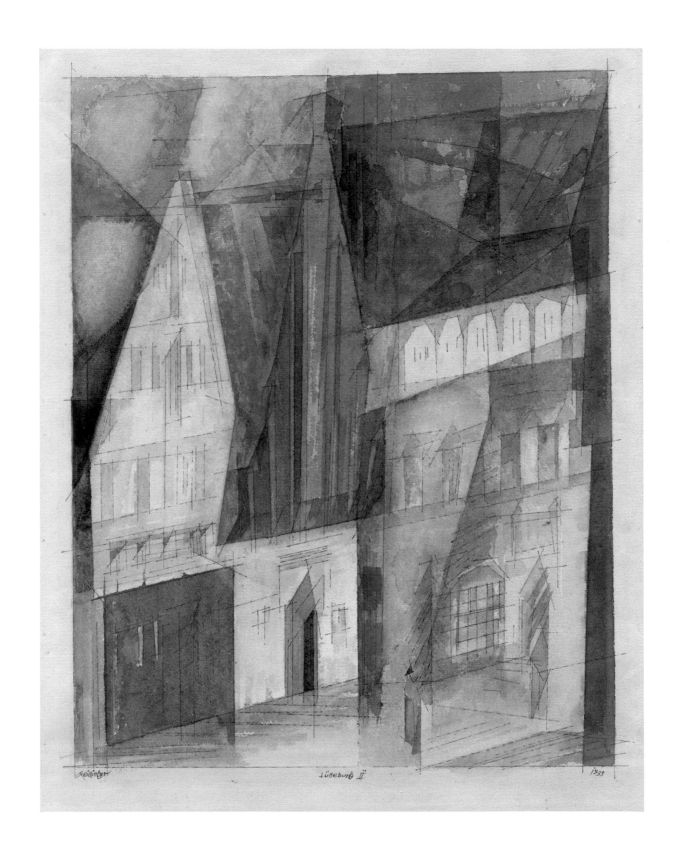

fig. 149. *Lüneburg II,* 1933
Watercolor and ink on paper, 13⅞ x 7¼ in. (43.6 x 35.1 cm)
Solomon R. Guggenheim Museum, New York; estate of Karl
Nierendorf, by purchase 48.1172.473

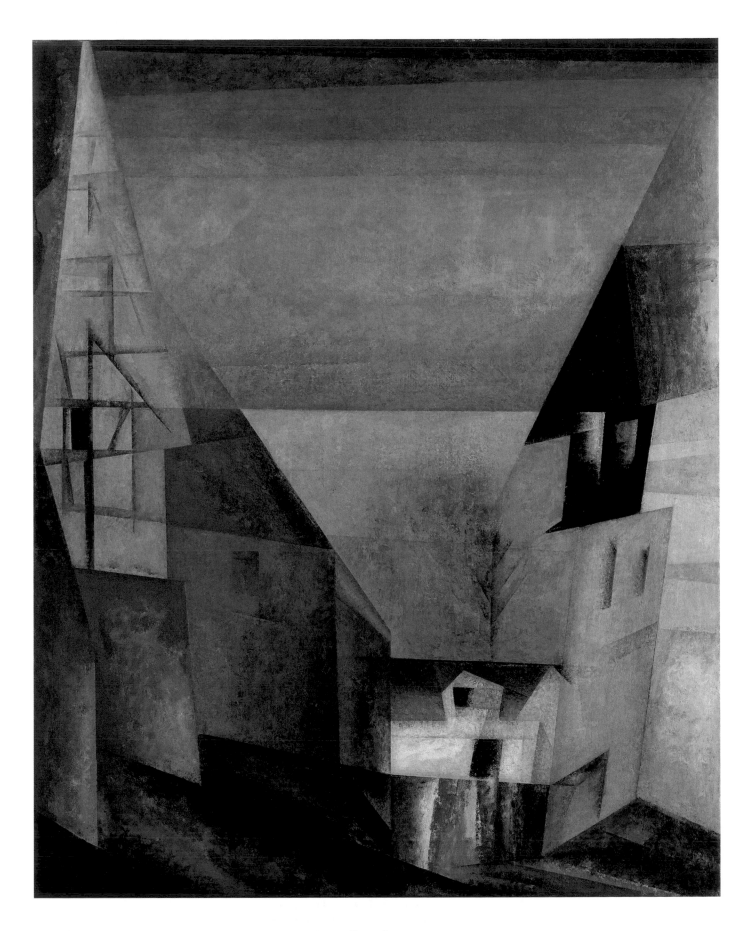

fig. 150. *Spring, Vollersroda,* 1936

Oil on canvas, 39⅜ x 31½ in. (100 x 80 cm)

Private collection, on permanent loan to the Hamburger Kunsthalle

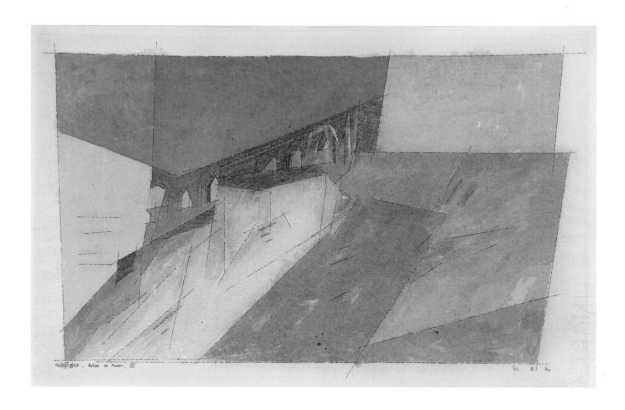

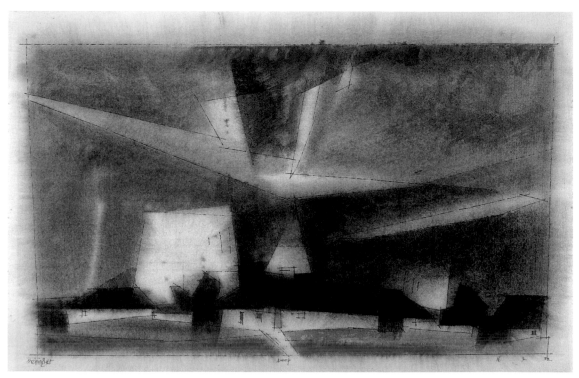

fig. 151. **Ruin by the Sea, III (Ruine am Meer, III),** 1934
Watercolor and ink on paper, 11 x 17½ in. (28 x 44.5 cm)
Private collection; courtesy Moeller Fine Art, New York and Berlin

fig. 152. **Deep,** 1932
Watercolor, charcoal, and ink on paper, 10⅝ x 17¼ in. (27 x 43.8 cm)
Fundacíon MAPFRE, Madrid; courtesy Moeller Fine Art, New York and Berlin

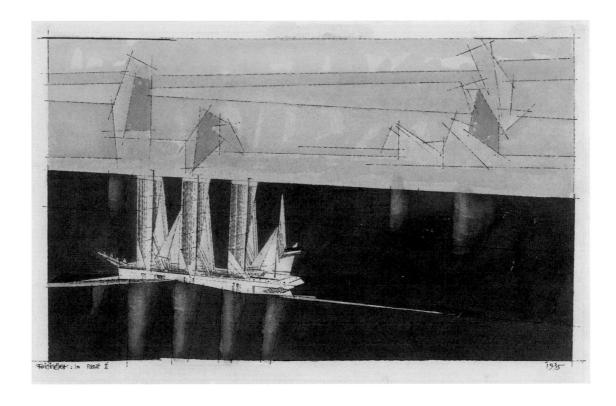

fig. 153. **In the Trade Wind II (Im Passat II),** 1935
Watercolor and ink on paper, 11⅞ x 19⅛ in. (30.1 x 48.6 cm)
Hamburger Kunsthalle; gift of Julia Feininger

fig. 154. **Glassy Sea,** 1934
Watercolor and ink on paper, 13⅜ x 18⅞ in. (34.1 x 38.1 cm)
The Museum of Modern Art, New York; given anonymously (by exchange) 258.1944

Return to New York

Feininger docked in New York on June 17, 1937, on his way to California for the summer. It was one month before his sixty-sixth birthday, and he had two dollars in his pocket and an almost paralyzing fear of his future based on having often "watched from Europe the sad spectacle of important European artists settling in the states and losing their rank and their integrity."[335] His time in Germany comprised more than two-thirds of his life; it was the site of his "most precious experiences."[336] In America, exiled from what he considered his "proper artistic home," he was starting a new life as a virtually unknown artist.[337] Still, as a returning expatriate, Feininger's adjustment was far easier than that of most émigrés, who arrived with neither command of English nor American citizenship. He spent his first months after his return to New York from California exploring his boyhood haunts. "I am in a very unusual frame of mind, at present," he wrote to his British friend Theodore Spicer-Simson. "Imagine the almost unprecedented home-coming of an American, after nearly 50 years absence . . . to his native city. The changes that have taken place in that period of time are astonishing enough; but, on the other hand, so much still remains in parts of the city, unchanged, just as it was in the 80s, that it calls up all my fondest boyhood memories. I find myself in a state of continual wonderment, discovering sentiments I certainly never had when I was a boy. . . . There is nothing that does not affect me in some way; every step I take . . . is a source of pure delight."[338] He wrote to his son Lux that being back in America initially "seemed to me a fairytale . . . that I was actually walking on the grounds of my youth."[339]

Feelings of dislocation soon followed, as Feininger discovered that the city of his childhood—low and horizontal, with open train tracks and rivers filled with tall-masted sailing ships—no longer existed. "At the end I was sorry to be disappointed again and again by the newness found on my search for remembered scenes from my childhood. Today there is hardly a corner in Berlin and the surrounding region for which I do not have stronger feelings. It is strange. Yonder lies an entire cemetery of memories and here I am all alone in the city where I was born, which seems to have known scarcely anyone I meet."[340] He reiterated the thought years later to Alfred Barr: "Coming back after so many years of absence has been a strange experience. I went away a musician; I came back as a painter. People I had known before were most of them dead. Of the conditions and surroundings I had been familiar with nothing was left. I had to readjust myself in every respect and sometimes felt my very identity had shriveled within me."[341]

Acclimating to new surroundings proved unsettling. "I find it very difficult to forget the last 40–50 years spent in a different world entirely," Feininger wrote to Scheyer.[342] For seven months, he and Julia lived in the Hotel Earle. Not until January 1938 did they move into what would be their last home: a cramped, low-ceilinged apartment on Twenty-second Street whose second bedroom, barely large enough to accommodate his easel, served as his studio. In the past, Feininger had found inspiration in nature or in small villages, whose slower, more regular patterns of life encouraged stability and order. Now,

fig. 155. **Offshore,** 1938 (study for mural at the Marine Transportation Building, World's Fair, New York) Watercolor and ink on paper, 6⁵⁄₁₆ x 24⅞ in. (16 x 63.2 cm) Private collection

he found himself surrounded by the noise, dirt, and visual cacophony of the world's most modern city. Encouraged by his childhood friend Kortheuer, who lived in Falls Village, a small town in northwestern Connecticut, he began summering there that year. But not even the village's proximity to Sharon, where he spent much of his childhood, or its visual similarity to the Harz Mountains satisfied his desire for solitary communion with nature. "What I really miss," he would later write, "is drawing from nature and making 'notes,' for instance by the Baltic Sea, in Deep, or in the villages surrounding Weimar. Somehow the motifs in this place do not suffice; they contain too few of my inner wishes and lead only to naturalistic results."[343] Not surprisingly, it was well over two years before he started to paint; in a letter to Jawlensky, he confessed that "the break was too great to heal quickly."[344] When he *did* start, in November 1939, it was with images of sailing boats and dunes (figs. 167, 174) that echoed those in earlier canvases. Feininger had always found subject matter for his paintings in his own sketches, watercolors, and oils. In the past, he had based paintings on woodcuts. Now, as he set about "patiently rebuilding what [he] had almost forgotten," he turned again to woodcuts for inspiration, creating oils of motifs he had printed almost twenty years earlier (figs. 177–80).[345]

Financially, Feininger's first years in New York were dismal—"living on the edge of poverty" was how his son Lux described his parents' lifestyle.[346] Feininger had been prevented from taking currency out of Germany, and his first shows in New York—at Marian Willard's East River Gallery and Karl Nierendorf's gallery on Fifty-seventh Street—yielded no sales. Nor did Scheyer, with whom Feininger had reconciled, generate any income for him. "The West is no field for exhibits bringing sales. Such a thing as a sale out there is almost unheard of," he would write to her.[347] What sustained him through 1938 was a mural commission for the Marine Transportation Building at the New York's World's Fair.[348] The building's architects accepted his proposal to depict an ocean steamer and sailing ships flying signal flags. The theme was familiar to him, and he drew multiple drafts of the image before handing the approved design over to union painters, who transferred it onto the pavilion's exterior wall (figs. 155, 241). The following year, Wilhelm Valentiner, now director of the Detroit Institute of Arts and art advisor to the 1939 World's Fair, arranged for him to receive one of the Fair's most important mural

commissions: the three inner courtyard walls of the Masterpieces of Art Building, which would house more than three hundred Old Master paintings dating from the Middle Ages to 1800, assembled by Valentiner from around the world. In creating his design, Feininger was precluded from using his customary planar layering of color by the mural's size and the necessity of completing it in three months.[349] His solution was to appropriate the technique he had introduced in his watercolors of washing color over a network of open, pulsing lines, drawn first in charcoal and then in ink (fig. 156). The strategy of suggesting rather than defining form resulted in a weightless, dematerialized effect, as if one were seeing the image through atmospheres of fog or mist, much like those he

had recorded in his photographs. For the courtyard's longest wall, Feininger chose as his subject a palindrome in which diagrammatic images of sailing ships, buildings, and arched viaducts on the mural's left and right sides loosely mirrored each other across an uncluttered center (fig. 157). The image autobiographically visualized the vast ocean that separated Feininger's former life in Europe from his new life in America, unconsciously clarifying his hope that the two parts of his life were but mirror images of each other. The resulting effect—monumental yet ethereal—also captured how Feininger experienced

fig. 156. *Cathedral of Cammin,* 1938
Watercolor and ink on paper, 11⅜ x 17⅞ in. (28.9 x 45.4 cm)
The Brooklyn Museum; bequest of Edith and Milton Lowenthal
1992.11.8

New York's sunlit building façades, atmospherically pierced by hard black shadows. The experience of designing the World's Fair murals triggered in Feininger a desire to translate these sensations of New York into oil, although he cautioned that "it is only a question of whether I love the city sufficiently more than a thousand other scenes and memories to make the attempt."[350] By 1940, he was ready to try.

Feininger's hiatus from painting had given him time to reassess his formal means and liberate himself from the "severe constraints of straight and rigid lines."[351] He credited Julia with encouraging him to adopt a freer form. "I have come to believe, myself, that my sense of duty stood in my way for years; for having proceeded so far (in my formal painting), it appeared to me something of a deserting of my course to give up until I had succeeded further still."[352] By November 1940, he was surprising even himself by his ability to depict Manhattan as a dematerialized color-light space, devoid of narrative elements. Having honed his vision of the city's architecture through his photographs, he saw

fig. 157. **Landscape with Hills,** 1939 (study for mural at the Masterpieces of Art Building, World's Fair, New York)
Watercolor, 9¼ x 50 in. (23.5 x 127 cm)
Location unknown

what most others overlooked: light's effect on the perception of spatial relationships. At dusk, when the lights go on and "the buildings and sky amalgamate," or at midday, when the glaring sun casts shadows on brilliantly lit surfaces, he found "motifs of colossal consequence."[353]

Feininger's first group of Manhattan oils was inspired by a two-block-long wall of buildings on Lexington Avenue that were "almost the same height and stretch[ed] across two blocks. . . . Seen in perspective, these houses together form a *cliff*, rhythmically perforated by four stories of window openings whereby—and this is their real attraction—each building has its own tone of brown, gray, rust colors, while two or three stand in full white between them where they form an exciting series of vertical fields, either mixed or contrasting with the whole length of the block."[354] To portray the agitation he felt in seeing "the color of the pale bluish lavender sky above and alongside" this cliff of buildings, Feininger dispensed with clearly demarcated edges and smoothly applied layers of thinned paint in favor of imprecise boundaries and aqueous areas of color, "enciphered into one another on the image surface" (fig. 176).[355] The effect was a chromatically and texturally rich surface, suffused with animate light, much like what he had admired in the work of J. M. W. Turner (1775–1851) since childhood. The new style suited Feininger, who reported to friends in the spring of 1941 that he had "finally gotten past the grueling period of acclimation" and was painting every day.[356]

Financially, Feininger's situation remained precarious through 1942. He had begun 1940 with only enough money to last through October, all his hopes pinned on the sale of a watercolor.[357] "A feeling of insecurity never leaves us, with respect to existence," he reported.[358] "From no side is there any outlook."[359] When sales of his art *were* made, they were of Nazi-confiscated pieces that dealers had bought on the international market, thus generating no income for him. "It is our fate to be outcasts from Europe—our works scattered, the aura of our reputations gone," he wrote wistfully to Scheyer.[360] With the war crippling all interest in luxuries, the future seemed uncertain.[361] "Sometimes I question the wisdom of continuing, when I might possibly take a position as handy-man or elevator-boy in some building," he lamented.[362] In 1941 Curt Valentin, who became Feininger's primary dealer that year, organized a dual show of the artist's work with Mirian Willard, whose gallery had moved across the hall from his on Fifty-seventh Street. Although press reception was positive, the complete absence of sales led the dealers to judge that the times were too unfavorable to repeat a dual show the following year. Faced with an "astonishing record of reverses," Feininger concluded that America "is no country for

artists to thrive in . . . art is the least regarded of all paths here; it is the step child of the nation."[363] The five years that Feininger had spent in America without public or financial support—with the exception of his World's Fair murals—took their toll; by 1942, images of instability and alienation had begun to dominate, as in *Blind Musician at the Beach*, which reprised a 1915 watercolor he had made in the dark days of World War I (fig. 160).

The turning point came suddenly and unexpectedly in late 1942. Feininger had almost not submitted an entry to the Metropolitan Museum of Art's *Artists for Victory*

fig. 158. **Untitled (Buildings and figures, New York),**
c. late 1930s–40s
35mm slide, 1³⁄₁₆ x 1³⁄₈ in. (3 x 3.5 cm)
Harvard Art Museums, Busch-Reisinger Museum, Cambridge, Massachusetts; gift of T. Lux Feininger BRLF.1005.213

exhibition, and even after his 1936 *Gelmeroda XIII* was accepted as one of the three hundred paintings deemed worthy of exhibition, he had not expected much (fig. 168).[364] But on the morning of December 7, 1942, while he was reflecting on the Japanese bombing of Pearl Harbor the year before, a messenger arrived with a check and registered letter from the museum announcing that Feininger's painting had been awarded a $2,500 purchase prize. Writing to Lux, Feininger was characteristically subdued: "Gosh, dear old son, it was a happy day today." The more practical Julia noted in her diary, "All bills paid, no more debts."[365]

Two years later, in October 1944, the Museum of Modern Art fulfilled the promise Barr had made to Feininger in 1930 by opening the first retrospective of the artist's work in his native country. The show and its two-and-a-half-year tour to ten U.S. cities confirmed Feininger's status as an important twentieth-century artist. Remembering the vitriol leveled at the artist's inclusion in its 1929 *Paintings by 19 Living Americans* show, the museum went out of its way to distance Feininger from the country with which the United States was now at war. Barr's entire catalogue essay, titled "Lyonel Feininger—American Artist," was a paean to Feininger's Americanisms: his antiquated American speech, his parental connections to America, his boyhood reminiscences of growing up in New York City, and his status as a twentieth-century, Whistler-style expatriate. Little was said of his fifty years in Germany or his German heritage. Comparisons were made between Feininger and American Precisionists, but not between Feininger and German Expressionists, with the exception of Marc, whose premature death in 1916 exonerated him from the taint of the Nazi regime. Barr closed his essay by quoting Feininger: "In Germany I was 'der Amerikaner'; here in my native land I was sometimes classified and looked upon as a German painter . . . but what is the artist if not connected with the Universe."[366] The stratagem worked; Feininger's years in Germany went unnoticed. What the public enthusiastically embraced was the artist's adroit union of modernist abstraction with recognizable imagery. Finally, he could write of "a regular landslide of 'success'" regarding sales of his work.[367]

The opportunity the retrospective afforded Feininger of assessing his career encouraged him to persevere with the freer style he had developed since coming to the United States. In *Courtyard III*, for example, he floated a delicate scaffold of ruled lines over a glazed ground of multiple layers of paint, which he sandpapered and scraped to create a rich finish (fig. 185). He described the result as "a kind of 'graphics in oil.'"[368] By reducing form to an absolute minimum and dramatically simplifying the complexities of color and paint application, Feininger created a dematerialized, rhythmic vitality. Even when he hearkened back to his experiences of German villages and the Baltic Sea by recasting earlier compositions, he did so with greater simplicity and economy of means. As he jubilantly reported to Schardt, "The ballast has been thrown off to let me fly free."[369]

Feininger's embrace of line as the exclusive carrier of form and spatial relationships was strengthened by his friendship with Mark Tobey (1890–1976), a fellow member of the Willard Gallery stable with whom he would correspond until his death.[370] Tobey's calligraphic style and engagement with Asian art fueled Feininger's similar proclivities. He had long been an admirer of Japanese prints, which he credited with influencing his comics and caricatures. Now he turned his attention to other Asian art, finding inspiration in *Flight of the Dragon,* Laurence Binyon's 1911 pioneering study of Chinese and Japanese aesthetics. Reminded of Julia's earlier transcription of Lao-Tse's writing, he copied selected passages of Binyon's book. He was particularly affected by the art historian's assertion that "the artist must pierce beneath the mere [surface] aspect of the world to seize and himself be possessed by that great cosmic rhythm of the spirit which sets the currents of life in motion. . . . When the rhythm is found we feel that we are put into touch with life, not only our own life, but the life of the whole world. . . . Art is a hint and promise of that perfect rhythm, of that ideal life. . . . Art is but the expression of a harmony of life, a fine balance of all the forces of the human spirit."[371] For Feininger, as for the artists described in Binyon's book, it was not enough to project subjectivity onto the external world; the task was to penetrate beneath surface appearance to the essential beauty and harmony that underlie all things. To do this required freeing oneself of ego and the impediments of mind; only by opening the

fig. 159. **IV B (Manhattan),** 1937
Watercolor and ink on paper, 12 x 9½ in. (31.4 x 24 cm)
Private collection

doors of one's inner self and feeling part of the "current of great power" could the laws of nature be grasped.[372] Feininger's lifelong aim had been to apprehend and portray those laws; now, with "patient struggle," he felt that he had once again begun to inflect his art with the universe's rhythmic vitality and harmony.[373] As he had said in 1933, "Art *is* Spirit."[374]

Feininger's fusion of the personal and the objective put him at odds with the majority of American artists in the 1940s. Aesthetically, his art resonated with that of Precisionist painters Charles Demuth (1883–1935) and Charles Sheeler (1883–1965). With Demuth, he shared a vocabulary of interlocking ray lines that activate the space around objects; with Sheeler, he shared a belief that everything in the world has an order and beauty, which it is the artist's duty to portray with as little ego as possible. By the mid-1940s, however, Precisionism had been replaced by painterly expressionism and hard-edged geometric abstraction, both of which Feininger rejected. He had long claimed that art could not depend on the brain alone, insisting that "in the end there is no force comparable with that of nature. Abstraction alone does not lead to a real solution; it must be born of experience, in humility before nature and its limitless diversity."[375] Not surprisingly, when the American Abstract Artists invited him to join the group in 1942, he demurred, writing, "My artistic faith is founded on a deep love of nature, and all I represent or have achieved is based on this love."[376] Yet he was equally uncomfortable with excessive subjectivity, which he equated with "exhibitionism."[377] In an interview with the artist and publisher Alexander Liberman (1912–1999), he described how he "wanted to tie [himself] down, tie down the ego. It was my idea to eliminate all traces of the personal and do the suprapersonal. I do not like the Expressionists; they draw their insides."[378] The attitude put him at a commercial disadvantage: "everything that is not immediately visible in art eludes Americans; it even poses an obstacle to appreciation. . . . For my part I am trying to restrain my ego and precisely here lies the difficulty."[379]

On May 7, 1945, Germany surrendered to the Allies. A month later, Feininger learned that his first wife, Clara, had been killed en route to Auschwitz in the Nazi's intensified campaign against Jews during the final months of the war.[380] The news likely helped close the chapter on Germany for him. As he watched Berlin be divided and Germany's borders be withdrawn—his beloved Deep (renamed Mrzeyno) ceded to Poland, and Weimar to East Germany—he mourned the past, knowing it was irretrievable. Bombs had destroyed much of Germany and war had scattered his art and his friends; yet Germany remained his aesthetic home. He kept up a regular correspondence with former Bauhaus and Die Brücke members, especially Marcks, Muche, Heckel, and Schmidt-Rottluff, and sent as many care packages as was feasible to his two daughters, who had miraculously survived the war, as well as to former friends in Germany and his son Laurence in Italy, all of whom had been made destitute by the war.[381] Gropius's letter asking former members of the Bauhaus to donate five dollars a month to "help our old friends get safely through the worst period of starvation" was yet another reminder of

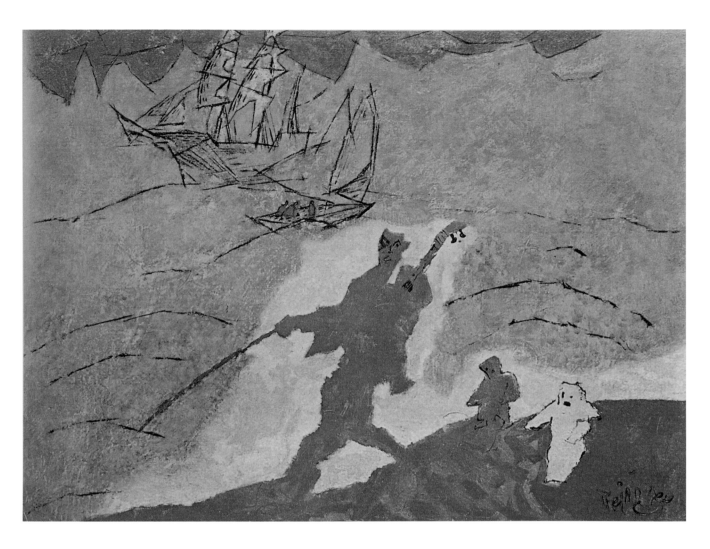

fig. 160. **Blind Musician at the Beach,** 1942
Oil on canvas, 15 x 20 in. (38.1 x 50.8 cm)
Location unknown

the desperation in postwar Europe.[382] "What is happening today is against all reason and human dignity," Feininger lamented.[383] He found himself mourning the loss of not one, but two worlds: The "Old New York" of his childhood, which hardly existed anymore, and the Germany he had known for well over half his life. Memories of his experiences there lived on within him, "transfigured and unsullied."[384] As he wrote to Heckel in 1952, "it sometimes seems much more real than everyday existence here."[385] In his deepest thoughts, he still lived in the Germany of "good, bygone days; and here I create . . . things that have little to do with the U.S.A."[386]

In Germany, Feininger had been revered as one of the country's leading artists, and his friends had been exalted figures within the art community. In America, he was without a preexisting foundation upon which to build a reputation. "The world seems to be populated chiefly by 'Displaced Persons' and the old-time traditions of home and family-life are becoming rare," Feininger wrote to Kortheuer.[387] His belief that one's own conviction was the true measure of success or failure did not lessen his pleasure in meeting people who knew his former work in Germany. "In this sort of recognition lies much sustaining power," he acknowledged. "One is not an object of mere sensational interest for a short time, but has one's place in the cultural order, and that place is secure

fig. 161. **Untitled (New York)**, c. 1940s–50s
35mm slide, 1³⁄₁₆ x 1⁵⁄₈ in. (3 x 4 cm)
Collection of Danilo Curti-Feininger

fig. 162. **Untitled (New York)**, c. 1940s–50s
35mm slide, 1³⁄₁₆ x 1⁵⁄₈ in. (3 x 4 cm)
Collection of Danilo Curti-Feininger

and lasting."[388] Even his 1944 retrospective at the Museum of Modern Art had left little residue. "How appallingly little carrying force exhibitions have in this country," he lamented to Tobey. "Whereas in Europe they grow outward and are taken into account and form a foundation which may be built on."[389] Age and lack of shared experiences kept him from becoming friends with younger artists, with the exception of Tobey. Otherwise, his primary alliances were with childhood friends and German émigrés, particularly his former Bauhaus colleagues Josef Albers (1888–1976) and Gropius with whom he taught in the summer of 1945 at Black Mountain College, an experimental school near Asheville, North Carolina, and in whose homes in Connecticut and Massachusetts, respectively, he summered in subsequent years. In the city, he went out very little, especially after 1948, when he developed an antipathy to crowds, perhaps as a result of the incipient hearing loss that would ultimately cause him to stop playing the violin. By then, his son Laurence was in Italy directing a boys' choir; Andreas was in New York working as a photographer for *Life* magazine; and T. Lux was painting and would soon begin teaching art, first at New York's Sarah Lawrence College and later at the Boston Museum of Fine Arts School.

During the 1940s, aside from a few Manhattan subjects, Feininger painted Baltic Sea images almost exclusively, deriving compositions from earlier work and the hundreds of sketches and notes he had brought with him from Germany. His memories of these "most precious experiences" were continually rekindled by Julia's habit of reading aloud to him from one of her diaries on New Year's Eve and by their frequent evening projections onto the walls of their New York apartment and summer rentals of photographs he had taken during his years in Germany.[390] The new way of seeing afforded by these projected images encouraged Feininger to turn his attention to close-up views of nature. In the all-over textural patterns of natural forms, Feininger found inspiration for pictorially describing the world's oneness. By the mid-1940s, his color slides of trees, sand, rocks, and the architecture of New York, ultimately numbering in the thousands, had become an alternative form of expression, as health problems reduced his stamina and decreased his output in oil (figs. 161, 162).

Despite the escalating strain that painting put on him, Feininger continued to push toward greater fullness of expression. The displacement of his lower vertebra in November 1946 from a spine injury incurred several years earlier kept him in pain and at home for much of the following year. By March 1948, still unwell, he agreed to an operation. Five weeks of hospitalization caused him to miss seeing his biennial show at the Valentin Gallery. Despite his characteristic optimism—"But, What Ho! Cheerily, cheerily onward toward better times, what?" he had written to Tobey—he completed only three paintings that year.[391] Nevertheless, as he approached his eightieth year, he felt full of ideas and not as old as he had expected. "At all events, I expect to 'carry on' as usual for quite some time to come."[392] By 1951, in paintings that he felt were "in some respects *deeper*" than those of earlier years, he transferred to oil the insights he had gained from his photographic close-ups of nature by obliterating all but the hint of recognizable shapes with a gestural, all-over surface.[393] As if to reinforce the otherworldly qualities of these nebulous shapes, he gave the paintings symbolic titles such as *The Vanishing Hour* (fig. 163) and *Shadow of Dissolution* (1953). Before, he had always worked methodically, basing his oil paintings on watercolors, woodcuts, or charcoal sketches. Now Feininger "thought" less and worked at times "in utter unconsciousness of what may be the final achievement; when the work stands suddenly finished before me on the easel, I experience surprise at times approaching a feeling of terror, that this thing has come to life."[394] To Lux, he attributed his annihilation of precise forms to his desire for unity.[395] To Schmidt-Rottluff, he wrote: "For quite some time a livelier essence is running through my paintbrush; for years I have not worked so fresh as now, and what delights me, is that I grasp oil painting afresh now, after reducing it to a 'second fiddle' for years, in favor of graphic line."[396] This newfound painterly freedom visually aligned Feininger's work with that of a younger generation of artists who emphasized direct, unpremeditated gesture. Yet while he admired the vitality of these "adventuresome American Moderns," he distrusted their inclination toward brutality and self-exposure as inimical to the cosmic values he prized.[397]

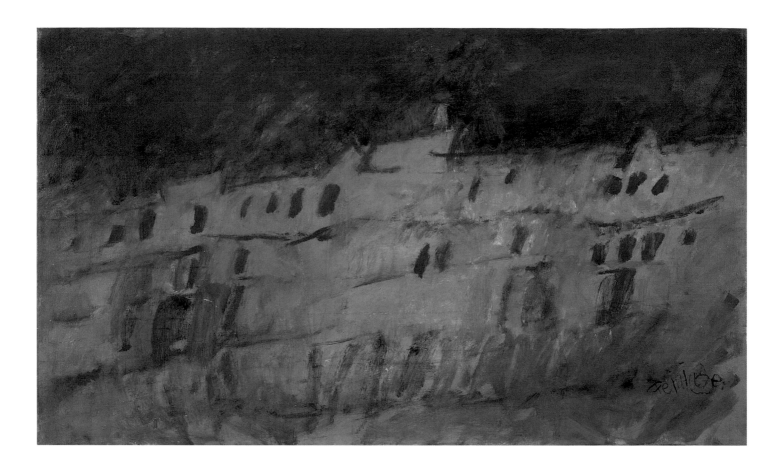

fig. 163. ***The Vanishing Hour,*** 1951–52
Oil on canvas, 19 x 32 in. (48.3 x 81.3 cm)
Private collection

Dispensing with calculated forms was precarious, but Feininger was determined not to lose courage before he attained something decisive. Equating it to the "'last lap' on the track," he urged himself not to be "'scared' . . . Why should one stop *exploration*? . . . even if it seems a bit foolhardy. Later on it may appear quite all one hoped for."[398] He persevered through 1954 with transcendently radiant canvases, but began to feel his strength ebbing in 1955, noting ruefully that perhaps he had "run [his] race."[399] That summer in Stockbridge, Massachusetts, where he had vacationed intermittently since 1946, hurricanes, heat waves, and unprecedented rain curtailed his production. Marian Willard had become his primary dealer following Curt Valentin's death the previous summer, but a year later, the "irrevocable loss" he felt at his friend's death still "weighed on [his] soul."[400] Despite his characteristic optimism about his "endeavor to open up new outlooks," he nevertheless was grateful that Willard postponed his 1955 show out of deference to the paucity of his work that year: a single painting.[401] In September, he slipped getting out of the bathtub, cracking his shoulder and causing internal injuries to his liver and gallbladder. "It doesn't do to recall things too closely even now," he wrote, "where shadows are lengthening."[402] At the same time, he looked forward to new experiments and fresh activity in painting. Ten days before his death on January 13, 1956, he wrote to Schmidt-Rottluff, "I won't let myself be persuaded that the time has come for slowing down."[403]

fig. 164. **Untitled "ghosties" (Four Dogs and One Owl),** 1953
Watercolor and ink on paper, 3 x 6⅛ in. (7.6 x 15.6 cm)
Moeller Fine Art, New York and Berlin

fig. 165. **Untitled "ghosties" (Four Figures),** 1954
Watercolor and ink on paper, 6¼ x 7⅞ in. (15.9 x 18.7 cm)
Moeller Fine Art, New York and Berlin

fig. 166. **Untitled "ghosties" (Five Figures),** 1953
Watercolor and ink on paper, 4⅜ x 6⅜ in. (11 x 16.2 cm)
Moeller Fine Art, New York and Berlin

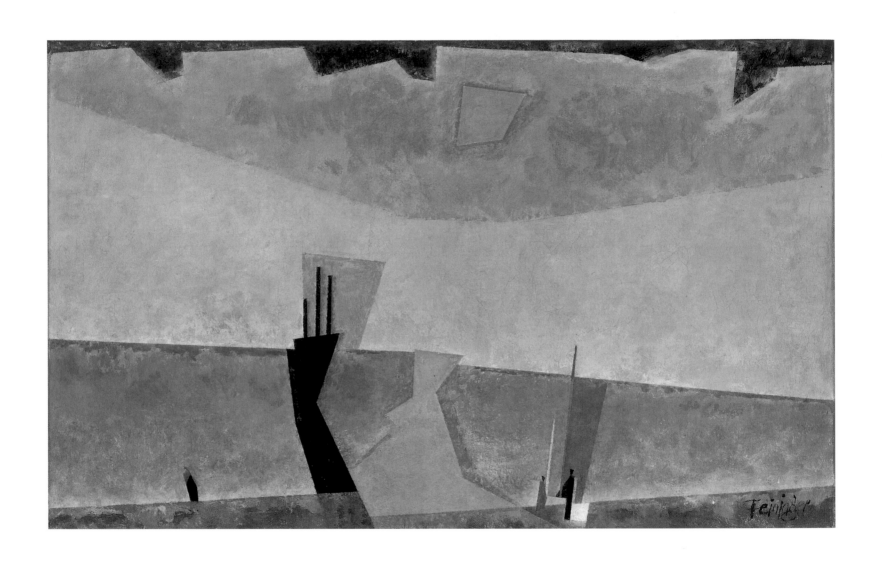

fig. 167. *Storm Brewing,* 1939
Oil on canvas, 19 x 30½ in. (48.2 x 77.5 cm)
National Gallery of Art, Washington, DC; gift of Julia
Feininger 1967.12.1

fig. 168. *Gelmeroda XIII (Gelmeroda),* 1936
Oil on canvas, 39½ x 31⅝ in. (100.3 x 80.3 cm)
The Metropolitan Museum of Art, New York;
George A. Hearn Fund 42.158

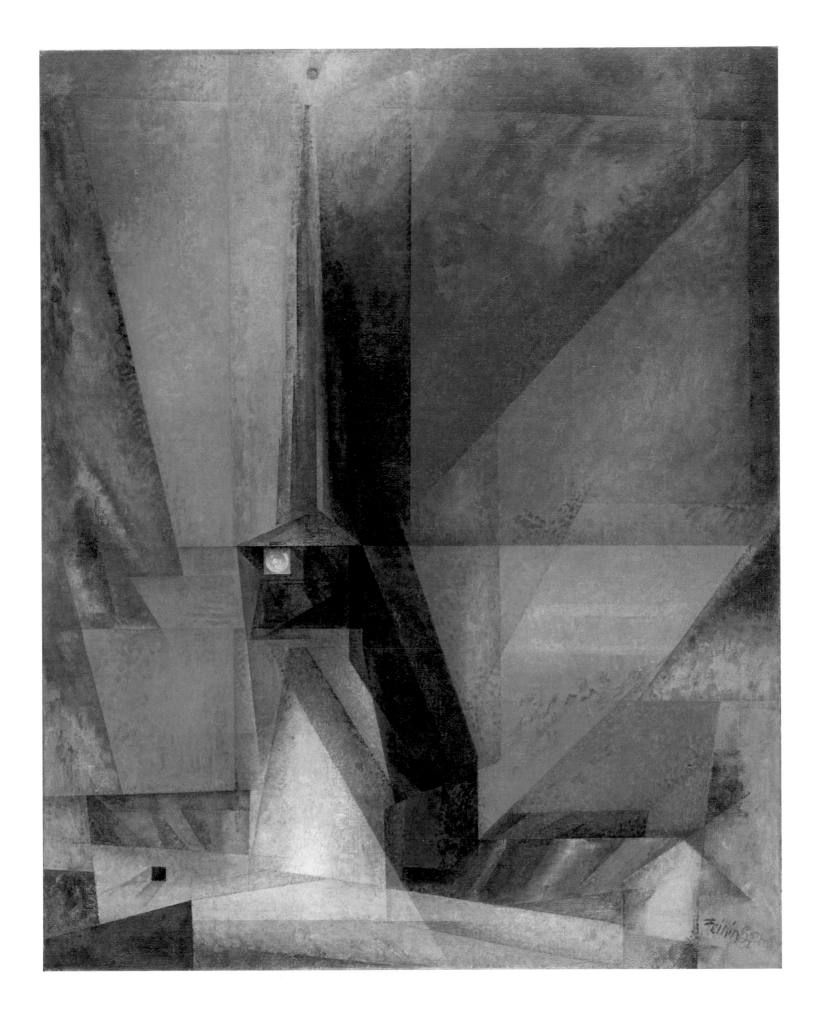

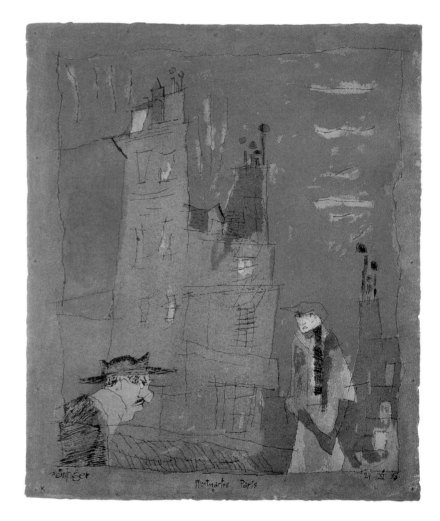

fig. 169. **Untitled (Manhattan at Night),** 1937
Watercolor and ink on paper, 12⅜ x 9½ in. (31.4 x 24.2 cm)
Collection of Renée Price

fig. 170. ***Montmartre, Paris,*** 1938
Watercolor and ink on paper, 12³⁄₁₆ x 10 in. (31 x 25.4 cm)
Private collection

fig. 171. *Manhattan Skyscrapers,* 1942
Ink and charcoal on paper, 22$\frac{1}{16}$ x 15$\frac{5}{8}$ in. (56 x 39.7 cm)
Whitney Museum of American Art, New York; exchange 53.54

fig. 172. **Off the Coast,** 1942
Watercolor and ink on paper, 12¼ x 18⅞ in. (31.1 x 47.9 cm)
Whitney Museum of American Art, New York; purchase 42.35

fig. 173. **Jagged Clouds, I,** 1950
Watercolor and ink on paper, 12⁷⁄₁₆ x 18⅞ in. (31.6 x 48 cm)
The Brooklyn Museum; Carll H. De Silver Fund 51.90

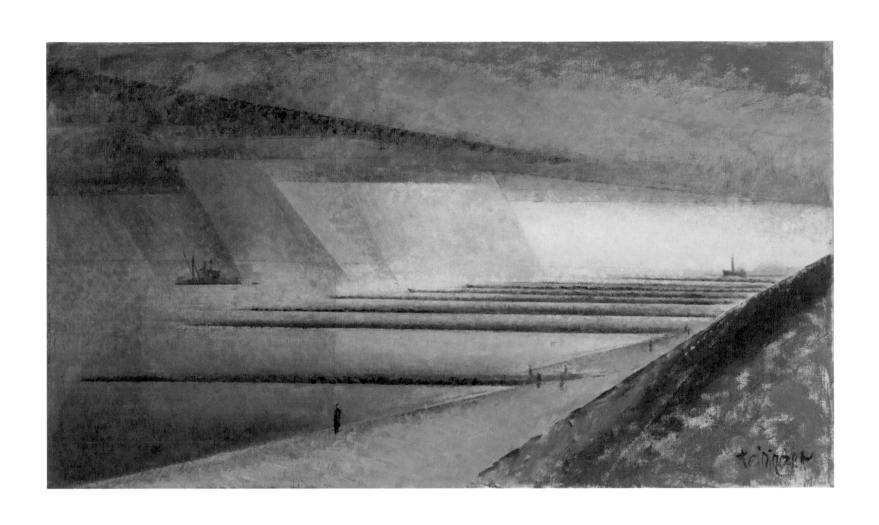

fig. 174. **Dunes and Breakwaters,** 1939
Oil on canvas, 24 x 36 in. (60.9 x 91.4 cm)
Private collection

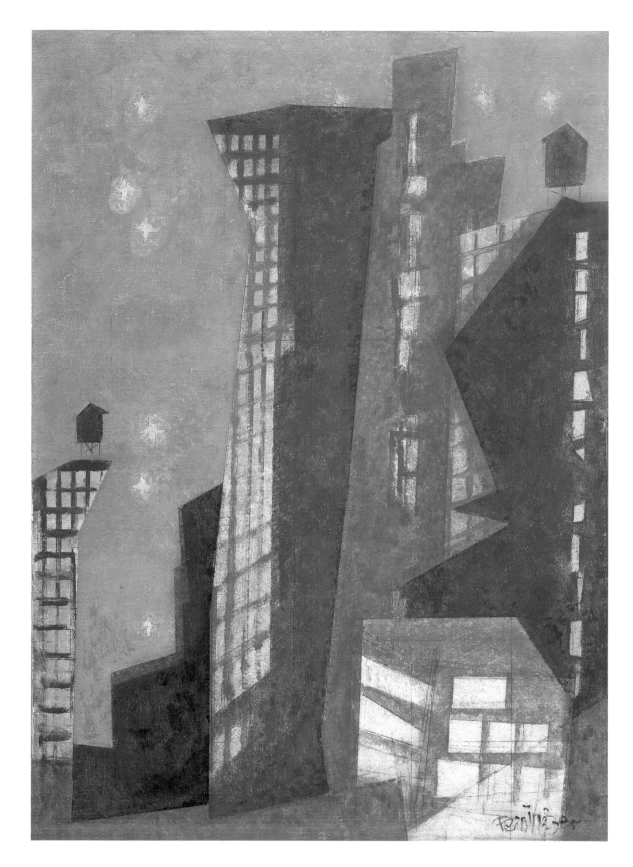

fig. 175. *Manhattan, Night,* 1940
Oil on canvas, 24 x 16⅞ in. (61 x 43 cm)
Private collection; courtesy Moeller Fine Art, New York and Berlin

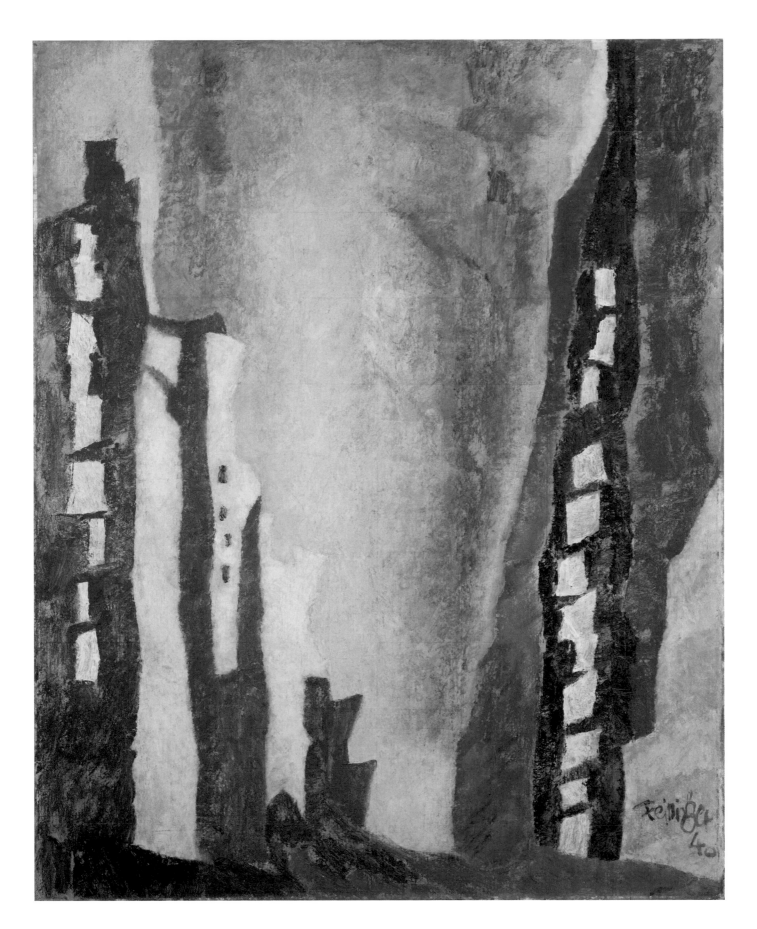

fig. 176. *Manhattan I,* 1940

Oil on canvas, 39⅝ x 31⅞ in. (100.5 x 80.9 cm)

The Museum of Modern Art, New York; gift of Julia Feininger 259.1964

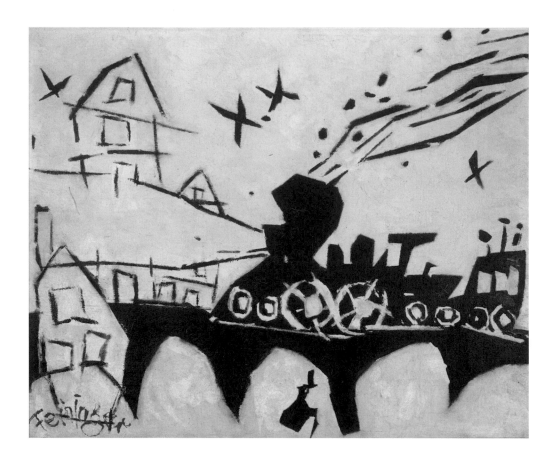

fig. 177. **The Night Express,** 1941
Oil on canvas, 14 x 17 in. (35.6 x 43.2 cm)
Private collection

fig. 178. **Locomotive on the Bridge (Zug auf der Brücke),** 1918
From the portfolio *Ten Woodcuts by Lyonel Feininger*, 1918
Woodcut, 6⅞ x 9⅛ in. (17.4 x 23.1 cm)
The Museum of Modern Art, New York; purchase 572.1949.4

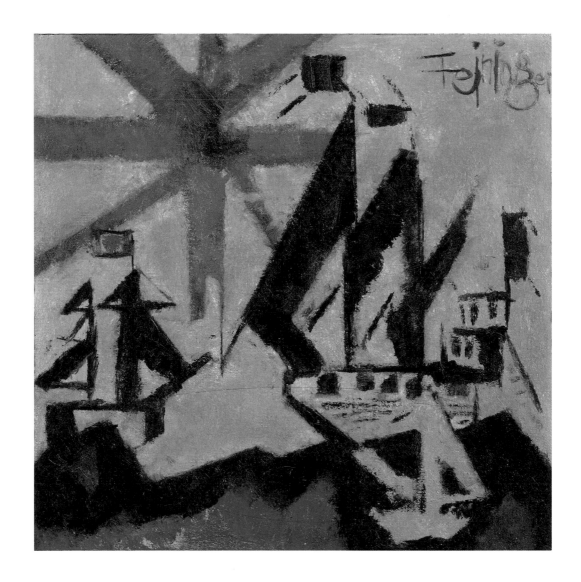

fig. 179. **Peaceful Navigation,** 1941
Oil on canvas, 17 x 17 in. (43.2 x 43.2 cm)
The Caroline and Stephen Adler Family

fig. 180. **Ships and Sun, 3 (Schiffe und Sonne, 3),** 1918
Woodcut, 4¾ x 5 in. (12 x 12.6 cm)
Private collection

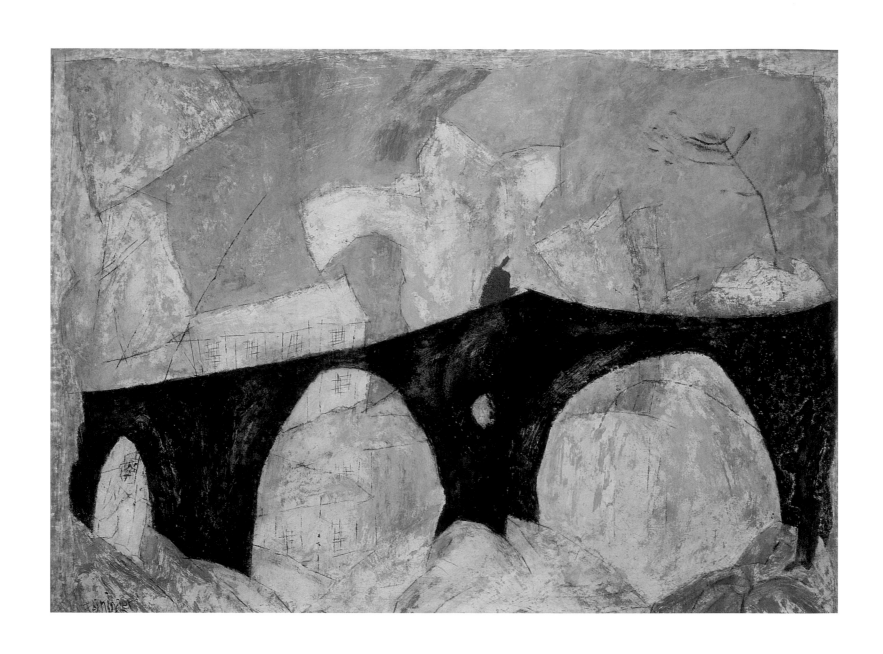

fig. 181. **The Anglers (Black Bridge),** 1942
Oil on canvas, 17 x 23 in. (43 x 58 cm)
Private collection

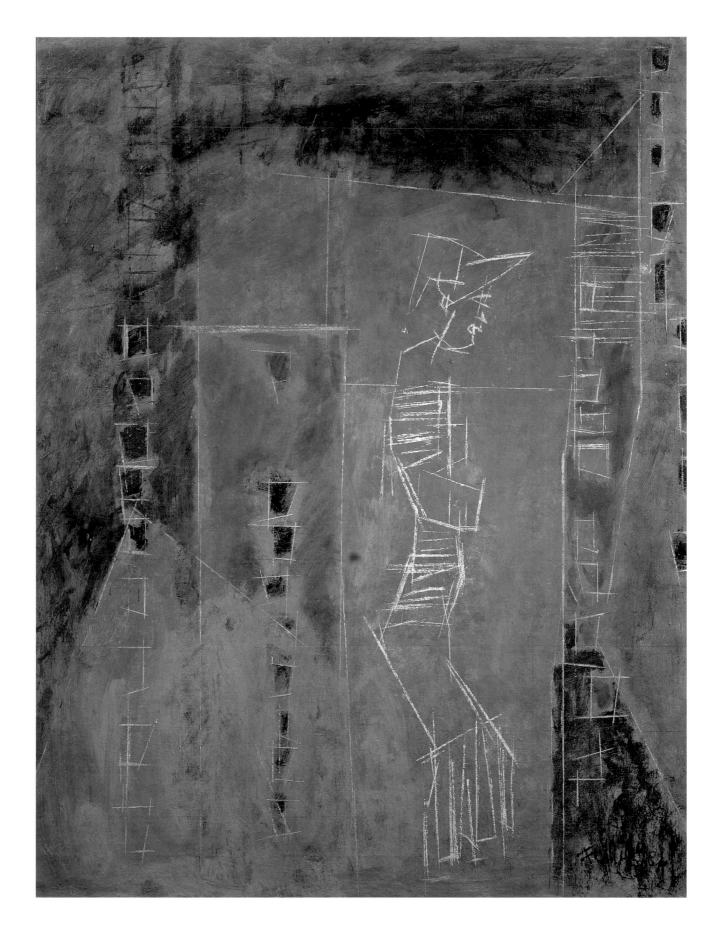

fig. 182. **Moonwake,** 1945
Oil on canvas, 30 x 23 in. (76.2 x 58.4 cm)
Collection of Carol and Paul Miller

fig. 183. *Clouds Over the Baltic,* 1947
Watercolor on paper, 12⅜ x 18⅞ in. (31.5 x 48 cm)
The Brooklyn Museum; bequest of Mrs. Carl L. Selden 1996.150.11

fig. 184. *Mid-Manhattan,* 1952
Watercolor, charcoal, and ink on paper, 20¼ x 15⅝ in. (51.5 x 39.7 cm)
The Metropolitan Museum of Art, New York; George A. Hearn Fund 53.176

fig. 185. *Courtyard III,* 1949
Oil on canvas, 23½ x 18½ in. (59.7 x 47 cm)
The Metropolitan Museum of Art, New York; bequest of
Miss Adelaide Milton de Groot 67.187.161

fig. 186. *The Spell,* 1951
Oil on canvas, 30 x 24 in. (76.2 x 60.9 cm)
Collection of Geraldine S. Kunstadter; courtesy Moeller Fine Art,
New York and Berlin

fig. 187. *The Cutting,* 1949
Oil on canvas, 17 x 28 in. (43.2 x 71.1 cm)
Private collection

fig. 188. **Sunset Fires,** 1953
Oil on canvas, 24 x 36 in. (61 x 91.4 cm)
Private collection

fig. 189. **Marine,** 1954
Watercolor on paper, 11⅞ x 18¼ in. (30.2 x 46.4 cm)
The Metropolitan Museum of Art, New York; George A. Hearn Fund 56.74

fig. 190. *Fenris Wolf,* 1954
Oil on canvas, 20 x 30 in. (50.8 x 76.2 cm)
Private collection, on permanent loan to Hamburger Kunsthalle

fig. 191. **Lyonel Feininger,** c. 1950. Photograph by Andreas Feininger

Notes

1. T. Lux Feininger, Lyonel's youngest son, became his father's "unremunerated amanuensis," as he called himself, following Julia Feininger's death in 1970. T. Lux Feininger, letter to the author, 16 October 2010. In a number of the articles he authored, T. Lux discussed his father's divided national loyalties and longing for the past: "When in Germany he would remark on the strangeness of the Germans and liked to remember that he was not a German. In America he used to say that he would never have become a painter if he had always lived there." T. Lux Feininger, "Mein Vater hat einen Fehler gemacht: Vera Graaf Interview mit T. Lux Feininger 1986," *Zeitschrift für Kunst und Kultur* 5 (1986): 60–66. See also T. Lux Feininger, "Lyonel Feininger in Deutschland," in *Lyonel Feininger: Von Gelmeroda nach Manhattan*, ed. Roland März, exh. cat. (Berlin: G + H Verlag, 1998), 354–59; and T. Lux Feininger, "Laurence Feininger: In Memoriam" (unpublished) (Cambridge, MA, November 1979), courtesy of Danilo Curti-Feininger.

2. Feininger to Julia, 2 August 1927, Lyonel Feininger papers, Houghton Library, Harvard College Library, Harvard University, Cambridge, Massachusetts (hereafter cited as LFP-HCL).

3. The Feiningers were Catholic in predominantly Protestant Baden, Germany. For generations, the family owned a successful porcelain shop in Durlach. When the 1848 revolution broke out, three brothers out of the sixteen Feininger children joined the dissidents. The defeat of the revolution by the Prussian army in 1849 placed all three in jeopardy—especially the youngest, who had served as an officer in the uprising. A year later, the three brothers immigrated to America. Lyonel's grandfather, Adolph, settled in Columbia, South Carolina, with his wife and four children and opened a tobacco shop. After retiring, he turned his attention to his large vineyard. For further history of the Feininger family, see Ursula Merkel, "Schiff und Wolkenkratzer—Skizzen zur Familiengeschichte und zu Parallelen im Werk von Lyonel Feininger und seinen Söhnen," in *Feininger: Eine Künstlerfamilie*, exh. cat. (Ostfildern-Ruit, Germany: Hatje Cantz, 2001), 11–19; and idem., "Auf den Spuren der Feiningers," in *Intelligenz und Provinzblatt für Durlach* 31 (fall 1999): 25–32, and "Adolph Feininger Dead: The Father of the Famous Violinist Is no More," *The State*, 10 November 1891, 5.

4. The identification of Germany with education and culture and, conversely, of America with its absence was widespread in the nineteenth century. One of Germany's best-selling novels of this period was Ferdinand Kürnberger's *Der Amerika-Müde* (1855), loosely based on the experiences of Austrian poet Nikolaus Lenau, who emigrated to the United States but repatriated in disgust at what he regarded as the country's materialism and boorishness. The story ends with the émigré fleeing a country he regarded as unrepentantly uncultured.

5. Karl William Frederick Feininger was born on July 31, 1844. Passport records confirm that he was nine when he immigrated to America.

6. Karl studied violin in Columbia, South Carolina, with August Koepper, a disciple of the distinguished German violinist Ferdinand David, with whom Karl would study at the Leipzig Conservatory. For further information, see Helen Kohn

Hennig, *Columbia Capital of South Carolina 1786–1936* (Columbia, SC: Columbia Sesqui-Centennial Commission, 1936), 176; I am grateful to Debra Bloom of the Richland County Public Library for providing this citation.

7. Hegel, quoted in Henry Paolucci, *Hegel: On the Arts*, Milestones of Thought (New York: Frederick Ungar, 1979), xviii.

8. Karl Feininger, *An Experimental Psychology of Music* (New York: August Gemünder and Sons, 1909), 302.

9. First quote, ibid., 278. Second quote, ibid., 189.

10. Karl served between September 1864 and July 1865 in the Second Brigade Band of the Tenth New Hampshire Volunteers, also known as the Hilton Head Post Band. The band's primary function was to perform during military services and ceremonies. Lyonel incorrectly assumed because the band was stationed in South Carolina that his father had fought with the Confederacy. He told this to his biographer, Hans Hess, who included the information in his catalogue essay for the Museum of Modern Art's 1944 Feininger retrospective. The story was repeated in Frederick S. Wight's essay on the artist in *Jacques Villon—Lyonel Feininger*, exh. cat. (Boston: Institute of Contemporary Art; New York: Chanticleer Press, 1949). Feininger's wife, Julia, corrected the error before the publication of Hess's *Lyonel Feininger* (New York: Harry N. Abrams, 1961). The artist's son, T. Lux, researched the issue further and discovered that Karl served under the pseudonym Frederick Hoffmann, an alias Lux speculated he adopted in deference to his parents, who lived in a Confederate state. For information on the Second Brigade Band, see Richard C. Spicer, "'An Inspiration to All': New Hampshire's Third Regiment and Hilton Head Post Bands in Civil War South Carolina," in *Bugle Resounding: Music and Musicians of the Civil War Era*, ed. Bruce C. Kelley and Mark A. Snell (Columbia: University of Missouri Press, 2004), 71–105. For T. Lux's speculation on the subject, see "Lyonel Feininger in Deutschland," 355–56.

11. Elisabeth Feininger's parents, Johannes (John) and Maria Elisabeth (Mary) Lutz, left Lingenfeld, in the upper Rhine valley of Germany, following the country's crop failures and agrarian unrest in the 1840s. They opened a merchant tailor shop in Elizabeth, New Jersey, where they raised a family of six. Elisabeth was born on December 25, 1849. She and Karl married on April 21, 1870, in Elizabeth; Lyonel was born sixteen months later.

12. Karl Feininger achieved wide success as a composer and violinist between 1866 and 1900, particularly in Brazil and Germany. Franz Liszt praised the 1870 Berlin performances of his symphony Opus 12, and critics lauded his orchestral compositions. His violin recitals received favorable notice in the *New York Times*. After his return to America in 1900, he focused primarily on teaching and pedagogy, deriving his primary income from his position as head of the music department at the Low and Heywood School in Stamford, Connecticut, where he worked for twenty-two years, until his death in 1922.

13. Elisabeth Lutz Feininger to Lyonel Feininger, 9 May 1913, LFP-HCL.

14. Feininger to Alfred Vance Churchill, 27 January 1891, Alfred Vance Churchill papers regarding Lyonel Feininger, 1888–1944, Archives of American Art, Smithsonian Institution, New York, and Washington, DC (hereafter cited as AVCP-AAA).

15. Feininger to Julia, 9 December 1905, LFP-HCL.

16. Edward Bruce, a violin student of Karl Feininger's who would later run the Public Works of Art Project (PWAP) and the Treasury Department's Mural Division during Franklin Roosevelt's administration, remembered playing in a chamber concert with Lyonel in 1884 in Plainfield, New Jersey. Feininger played first position on a Knopf violin. Bruce to Feininger, 29 February 1912, LFP-HCL.

17. Based on Feininger's retrospective accounts of his childhood, it has generally been assumed that he was lonely and often abandoned by his parents. This may not be entirely accurate. The family spent summer vacations together in North Adams, Massachusetts, and Lake George, New York, and Feininger was often taken as a small child to Plainfield on the days his parents taught music at Miss Kenyon's. He deeply admired his father and often wrote as an adult of his unconditional love for him. See Feininger to Julia, 10 November 1905, 11 April 1914, and 15 August 1917, LFP-HCL; and Feininger to Kortheuer, 11 July 1896, collection of the late Horace Richter (see note 22 for location of letters). The two took three summer trips together before Lyonel was sixteen: to Niagara Falls, Lake Ontario, and the Saint Lawrence River. As a child, however, Feininger also experienced the instability of constantly being uprooted. He and his sisters boarded with strangers when their parents were on tour, and, when together, the family moved frequently to various residencies in New York City, including St. Marks Place, where Feininger was born; Fourth Avenue; 311 East Fifty-third Street; 430 West Fifty-seventh Street; and 326 West Fifteenth Street.

18. Feininger wrote often as an adult of his stays with the Clapps, each time giving slightly different information about the amount of time he spent with them. Piecing together these accounts, it is reasonable to assume that he lived with them periodically between the ages of two and nine; that his sister Helen Bartram was born there in 1873; that he and Helen boarded there for an extended period during their parents' 1874 musical tour of Brazil; and that after his sister Elsa was born in 1876, all three children boarded there.

19. Lyonel Feininger, "Feininger Reminiscences," 20 July 1944, The Museum of Modern Art Archives, New York: Alfred H. Barr, Jr., Papers, 3a.A. (hereafter cited as AHB).

20. Feininger to T. Lux, 27 June 1953, quoted in Hess, *Lyonel Feininger*, 2.

21. Feininger's reminiscences of his childhood are filled with descriptions of trains, boats, and sailing model yachts on the pond at Central Park. "The black locos of the N.Y.C. with 'diamond' smokestacks, and the locomotives of the N.Y., N.H. and H.R.R. with elegant straight smokestacks painted, like the driving wheels, a bright vermillion red, and oh, the brass bands about the boiler and the fancy steam

domes of polished brass. . . . And the Hudson, teeming with vessels, schooners, sloops, not to speak of the magnificent side-wheelers plying up and down the river: The *Mary Powell*, *Albany*, *Drew*. . . . The Naval Parade of 1887 . . . wooden barque-rigged men-of-war in procession." Feininger, quoted in Alfred H. Barr, Jr., "Lyonel Feininger—American Artist," in *Lyonel Feininger and Marsden Hartley*, exh. cat. (New York: The Museum of Modern Art, 1944), 7–8. Feininger's experience with model yachts increased when he was fourteen and he was taken out of school because of delicate health. After his doctor prescribed sun as a cure, his father—who had earlier limited Feininger's visits to Central Park because they interfered with his violin practice—allowed him to spend all his time there sailing his model boats. "I became enamored of model-yacht building and sailing, and every day saw me at the pond in Central Park trying out models I had built. I was intensely interested in the yacht-races for the America's Cup in '85, '86 and 87." See "Feininger Reminiscences," 20 July 1944, unpublished, MoMA Archives, New York: AHB 3a.A. "When the three captains came to the pond . . . in those times there was something to look at indeed, and when the 'captains' (sometimes all three of them at once) brought out their newest creations, the three-foot class, there was no end of excitement for the boys at the pond. The models were exquisitely designed, built, and rigged, with housing, topmasts, and automatic steering gear. Among them were schooners of exceeding beauty, copies in miniature of the celebrated yachts. . . . In the forenoon we would generally have the pond to ourselves. I was in constant attendance, for at that time I had been taken out of school, being thought to be in delicate health, which I surely was not." Feininger to T. Lux, quoted in Hess, *Lyonel Feininger*, 4.

22. H. (Herman) Francis (Frank) Kortheuer, two years Feininger's junior, lived across the street from him at 429 West Fifty-seventh Street. Their fathers knew each other through music. Kortheuer's father, a German émigré like Karl, was a concert pianist, composer, and lecturer on music theory. Kortheuer later became an engineer, specializing in telecommunications. The many letters Feininger wrote to him between 1887 and 1903 provide valuable information on the artist's early life and first decade in Germany. These letters are in the possession of the family of the late Horace Richter of Atlanta; copies are in the H. Francis Kortheuer collection of Lyonel Feininger letters, sketches, and clippings, 1887–1944, Archives of American Art, Smithsonian Institution, Washington, DC, and New York. I am grateful to Lloyd Richter for lending me the originals of these letters, and to David Harman for introducing me to the Richter family. For further biographical information on Kortheuer, see his letter to Ernst Scheyer, 18 March 1959, reprinted in Scheyer's *Lyonel Feininger: Caricature and Fantasy* (Detroit: Wayne State University Press, 1964), 171–76.

23. Feininger to Julia, 5 October 1927, reprinted in June L. Ness, ed., *Lyonel Feininger* (New York: Praeger, 1974), 159.

24. Most scholars have assumed that Feininger first began working on Wall Street when he moved to New Jersey in the summer of 1887. However, a letter to Kortheuer from 11 June 1890 confirms that he had already been working there for nine months. Quoted in Scheyer, *Lyonel Feininger: Caricature and Fantasy*, 34. Lyonel wrote that his father considered him "unmusical" because of his "inclination for technical construc-

tions . . . I tinkered too much for his taste. He was annoyed that I was able to drive pins into the wooden models I was building without bending them . . . he seemed to think that this precluded all feeing for art." Feininger to Julia, 9 December 1905, LFP-HCL.

25. Lyonel's sisters attended the Ursuline Convent School for two years, 1887–89. For information on the school, see "Convent Schools in Belgium," *New York Times*, 29 November 1874.

26. Hamburg's Allgemeine Gewerbeschule was a general vocational school whose aim was to educate craftsmen and apprentices in professions such as metalwork, engineering, mechanics, and the visual arts. While at the school, Feininger studied with P. Woldemar, who taught freehand drawing, drawing of plaster statues, and decorative painting. My thanks to Mareike Wolf for this information.

27. Feininger had earlier expressed his ambivalence about music in the many "concert pieces," as he called them, that he and Kortheuer drew in which they caricatured singers and orchestra members, particularly violinists.

28. Feininger wrote to Kortheuer of his success at art school: "Well, two great joys have happened, first I have been promoted to the upper class by the *director* himself, who is not supposed to (and as a rule, *does* not) interest himself in scholars who have been in the lower class (I mean middle class, as there are 3 for painting), and what is more, he told his clerk that I had made 'riesigen Fortschritt' ('huge progress') and was already prepared to enter the upper class. . . . I will tell you how many I had in the exhibition. I had *thirteen, XIII, 13*, and that was more than any other boy had in the exhibition and our school has over 3000 scholars." Feininger to Kortheuer, 4 April 1888, collection of the late Horace Richter, Atlanta.

29. Feininger to Kortheuer, 27–28 February 1888, collection of the late Horace Richter, Atlanta.

30. Feininger lived for his first few months in Berlin at the boardinghouse owned by Regierungsrat Meitzen. While he was there, Frau Meitzen died. See Feininger to Kortheuer, 7 September 1888 and 16 April 1890, collection of the late Horace Richter, Atlanta.

31. Feininger to Kortheuer, 29 June 1889, collection of the late Horace Richter, Atlanta.

32. Feininger attributed his being a "bad student" to his desire for something more than the imitation of nature. See Lyonel Feininger, "Ont Collaboré a ce Numéro, Les Peintres, Sculpteurs, Graveurs: Lyonel Feininger, Régnault-Sarasin, H. Ymart, A-H. Gorson, Czarnecki, A. Mérodack-Jeaneau," *Les Tendances Nouvelles*, no. 56, 1912. Reprinted in *Les Tendances Nouvelles* 4, nos. 52–63 (New York: Da Capo, 1980), 1339–40. Feininger's lackluster performance at the school was confirmed by Ernst Hancke, whose class Feininger entered in his second semester at the Academy, and who assessed Feininger at the end of the year as "lacking industriousness, abilities noticeable, progress insufficient." Archives of the Universität der Künste Berlin.

33. Feininger to Kortheuer, 28 July 1888, collection of the late Horace Richter, Atlanta. Over the next two years, Feininger assiduously studied the work of German and American illustrators, concluding that the Americans Frederick Burr Opper (1857–1937), Arthur Burdett (A. B.) Frost (1851–1928), Peter Newell (1862–1924), Eugene Zimmermann (1862–1935), and Joseph Pennell (1857–1926) were "the best in the world." Feininger to Kortheuer, 8 March 1890, collection of the late Horace Richter, Atlanta.

34. For description of Karl and Elisabeth's tumultuous relationship, see "Wedding Days They Woe," *Bridgeport (CT) Sunday Herald*, 27 October 1895. Karl Feininger filed for divorce in 1895 on grounds of desertion.

35. Feininger, quoted in T. Lux Feininger, "Lyonel Feininger in Deutschland," 357.

36. For discussion of Feininger's caricatures, see Ulrich Luckhardt, *Lyonel Feininger* (Munich: Prestel, 1989); Ulrich Luckhardt, *Lyonel Feininger: Karikaturen* (Cologne: DuMont, 1998); Paul Thiel, "Bemerkungen zum Frühwerk Lyonel Feiningers (1871–1956)," *Bildende Kunst* 2 (1986): 84–87; Ulrich Luckhardt, Martin Sonnabend, and Regine Timm, *Lyonel Feininger: Karikaturen, Comic Strips, Illustrationen, 1888–1915* (Hamburg: Kunst und Gewerbe Museum; Hannover: Wilhelm Busch Museum, 1981); Ulrich Luckhardt, "Vom populären Karikaturisten zum unbekannten Maler—Lyonel Feiningers Weg zum unabhängigen Künstler," in *Lyonel Feininger: Von Gelmeroda nach Manhattan*, ed. Roland März, exh. cat. (Berlin: G + H Verlag, 1998), 224–29; and Scheyer, *Lyonel Feininger: Caricature and Fantasy*.

37. Feininger to Kortheuer, 8 March 1890, collection of the late Horace Richter, Atlanta.

38. Feininger to Kortheuer, 16 April 1890, collection of the late Horace Richter, Atlanta.

39. Feininger to Kortheuer, 29 July 1888, quoted in Scheyer, *Lyonel Feininger: Caricature and Fantasy*, 30.

40. Ibid. Feininger met Alfred Churchill upon entering the Academy in October 1888; Fred Werner at the Pension Müller; and Fritz Strothmann at the Academy in 1889. Churchill left Berlin for Paris in 1890 and returned to America in 1891. Their correspondence through 1913 offers valuable insight into Feininger's developing attitudes toward art.

41. Feininger to Kortheuer, 8 March 1890, collection of the late Horace Richter, Atlanta.

42. Fred Werner to Feininger, 23 January 1920, copy in LFP-HCL (original in Art Gallery of New South Wales, Coolabah, Australia).

43. Feininger to Churchill, 11 June 1890, AVCP-AAA.

44. Ibid.

45. Feininger to Kortheuer, 10 June 1890, collection of the late Horace Richter, Atlanta.

46. For discussion of Karl Feininger's conflicting loyalties between Germany and America, see T. Lux Feininger, "Lyonel Feininger in Deutschland"; and idem., "Laurence Feininger: In Memoriam."

47. Feininger to Churchill, 7 October 1890, AVCP-AAA. Years later, Feininger acknowledged that his father had been right regarding his education and future; see T. Lux Feininger, "Lyonel Feininger in Deutschland."

48. Feininger to Julia, 4 April 1928, LFP-HCL. Based on later letters—to Churchill and Werner—it is likely that the friend for whom Feininger pawned his watch was Werner. See Feininger to Churchill, 7 October 1890, AVCP-AAA; and Feininger to Werner, 15 September 1919, LFP-HCL.

49. Feininger to Churchill, 16 November 1890, AVCP-AAA.

50. Feininger, quoted in I. Lux Feininger, *Lyonel Feininger: City at the Edge of the World* (New York: Praeger, 1965), 91.

51. Feininger to Churchill, 24 November 1890, AVCP-AAA.

52. "Being here for my future good, it is advisable . . . to lay some sort of a foundation of a moral sort." Feininger to Churchill, 27 January 1891, AVCP-AAA.

53. First quote, Ibid. For Feininger's phrase "human and yet, divine," see Feininger to Churchill, n.d. [1890], AVCP-AAA.

54. Ibid.

55. Feininger to Churchill, 14 May 1891, AVCP-AAA. See also Feininger to Churchill, 1 May 1891, AVCP-AAA. Feininger later attributed his father's determination to put him in business to Karl's "infallible conception that one had to earn money, learning to take care of oneself with a profitable occupation. The standard of measuring the performance was the amount of cash, or whatever of general recognition it could bring. Now from this point of view my father himself is not a success, but for just this failure of his he may have meant well to push me into what he thought was the right direction." Feininger to Julia, 5 August 1917, MoMA Archives, New York: William S. Lieberman Papers, I.A.81.d.

56. Adolf Schlabitz's private art school in Berlin catered to students preparing for the Academy's entrance exam. The school closed every August for vacation, which is why Feininger studied there only six weeks, from mid-June to the end of July.

57. Feininger described his acceptance into Friedrich's class to Churchill: "I am going to the Academie and have visited Professor Friedrich, of the Higher Antike Klasse (the highest drawing class in the Academy). . . . I went to him with my heart in my shoes to beg the favor that he would let me take simply the *very difficult* trial for admittance to his class. He not only said that he would take me without trial—that I might announce myself at the beginning of the winter term as in his class—but also said that I would be an Anregung [inspiration] for his class on account of my composition talent (so he called it)!" Feininger to Churchill, 6 October 1891, AVCP-AAA.

58. Feininger to Churchill, 17 February 1892, AVCP-AAA.

59. Feininger to Churchill, 12 January 1892, AVCP-AAA.

60. Ibid.

61. Feininger described his drawings for the *Berliner Illustrierte Zeitung* as being for a "Hintertreppen Roman," or "backstairs" novel. Feininger, quoted in Scheyer, *Lyonel Feininger: Caricature and Fantasy*, 54.

62. Feininger to Churchill, 24 June 1893, AVCP-AAA.

63. Ibid.

64. Feininger to Churchill, 6 April 1894, AVCP-AAA.

65. Feininger to Churchill, 22 June 1894, AVCP-AAA.

66. Feininger described the search for "American" stereotypes to Churchill: "Of course the German types *are* accepted unquestionably in America; but my intention is to *create* the more suitable tradition of our Dutch, Spanish etc. *ancestry*, putting them into quaint tales and legends, showing them in their roles of ancestral nations, with all their humorous, quaint, stolid, excentric [*sic*] etc. traits." Ibid.

67. Feininger's drawings in *Harper's Young People* accompanied three John Kendrick Bangs stories: "How Fritz Became a Wizard," "A Birthday Party in Topsy Turvydom," and "The Old Settler at Zurich."

68. From the beginning of his illustration career, Feininger chafed at the subordination of his creativity. A few months after he began working for *Ulk*, he wrote to Kortheuer: "I am regularly employed giving form and life to other people's ideas, and it is very hard work when one has not been accustomed, like myself, to working out other people's ideas or to thinking their way." Feininger to Kortheuer, 18 May 1895, collection of the late Horace Richter, Atlanta.

69. Feininger started contributing regularly to *Lustige Blätter* in 1896; to *Das Narrenschiff* in 1898; to *Lachendes Jahrhundert* in 1901; and to *Der liebe Augustin* in 1904.

70. Feininger to Churchill, 26 April 1896, AVCP-AAA.

71. Ibid.

72. Ibid.

73. Ibid. Three months later he wrote to Kortheuer: "I, too, have had here my nearest and dearest lack in the sympathy and understanding which was my due, not only two years back when I was suffering so bitterly myself, but since *years entire* on every subject affecting in any way my emotional life. . . . We *all* need it—this understanding, this tender sympathy!" See Feininger to Kortheuer, 11 July 1896, collection of the late Horace Richter, Atlanta.

74. Description in Feininger to Kortheuer, 27 July 1897, collection of the late Horace Richter, Atlanta.

75. Feininger to Kortheuer, 20 December 1897, collection of the late Horace Richter, Atlanta.

76. "This has been the cruelest time for us that we have ever experienced, having seen my dear, poor little sister Elsa wither and sink into the grave, of that dreadful, dreadful disease, Consumption." Feininger to Churchill, 14 January 1899, AVCP-AAA.

77. Feininger to Kortheuer, 11 January 1903, collection of the late Horace Richter, Atlanta.

78. Feininger to Kortheuer, 28 November 1903, collection of the late Horace Richter, Atlanta.

79. Feininger confessed feeling constrained from returning to America by his "dread of facing the uncertain." Feininger to Kortheuer, 24 May 1896, collection of the late Horace Richter, Atlanta.

80. Feininger to Kortheuer, 28 November 1903, collection of the late Horace Richter, Atlanta.

81. Georg Hermann, quoted in Scheyer, *Lyonel Feininger: Caricature and Fantasy*, 85.

82. Feininger to Churchill, 11 June 1890, AVCP-AAA.

83. Feininger articulated his discontent about his lack of creative independence to Julia, his future wife, soon after meeting her: "It is grotesque to be eternally condemned to create travesties; with a heaven of beauty inside me that ordinary philistines could never conceive of . . . no wonder that we of the 'trade,' we sensitive cartoonists, all become melancholic. . . . Just sever the connection between the head and the hand—that's all we need to do." Feininger to Julia, 11 October 1905, LFP-HCL.

84. Alexander Moszkowski, quoted in Luckhardt, *Lyonel Feininger*, 11.

85. Feininger to Churchill, 26 April 1896, AVCP-AAA.

86. For discussion of the Berlin Secession, see Peter Paret, *The Berlin Secession: Modernism and Its Enemies in Imperial Germany* (Cambridge, MA: The Belknap Press of Harvard University Press, 1980).

87. Feininger to Julia, 15 October 1905, LFP-HCL.

88. Feininger to Julia, 4 October 1905, LFP-HCL. In the same letter, Feininger repeated the assertion that his wife and children were strangers to him.

89. Julia was born on November 23, 1880, and died in 1970. Her mother, Jeanette Zuntz (1852–1909), was one of eleven children of Leopold and Julia Zuntz who owned the prosperous coffee roasting company Zuntz. Julia's father, Bernhard Lilienfeld, was born in 1844 and died in 1925. I am grateful to Dick Plotz for this genealogical information.

90. Four years before meeting Julia, Feininger had described his ideal partner: "There is an unquenched longing in my breast, one which has been there in my childhood's days already . . . and now this longing which sometimes seems to burst my heart is for the sweetest of all companionship, that of a soul to call *your own*, of whom you KNOW that its every wish and thought coincides with your own." Feininger to Kortheuer, 15 June 1896, collection of the late Horace Richter, Atlanta.

91. Feininger's daughters were age two and three when he separated from Clara. He went for three years without seeing them. They visited him periodically after that, but he was never as close to them as he was to the three sons he had with Julia. After the war, he corresponded with his daughters and sent them care packages. After his death, Julia gave each of them two small paintings as their inheritance.

92. As Feininger wrote to Julia that October: "You have led me this summer into a new wonder land, into a country which I could never enter except led by your hand and by your love . . . you are my fairy-tale-princess and my prophetess." Feininger to Julia, 5 October 1905, LFP-HCL.

93. Feininger had been recommended to James Keeley by an editor at the *New York Times* who had known Feininger's work for years. For discussion of Feininger's comics, see "Tribune's New Comic Supplement Begins Next Sunday," *Chicago Daily Tribune*, 29 April 1906, J2;

"Artist Feininger Returns to His Native Land," *Chicago Daily Tribune*, 13 May 1906, E3; Art Spiegelman, "Art Every Sunday," *New York Times Book Review* 99, 2 October 1994, 11; Roland Heinrich, "Hans, Fritz and the Kin-der-Kids," in 2 (Winter 1995): 72–77; Brian Walker, "Lyonel Feininger," in *Masters of American Comics*, ed. John Carlin, Paul Karasik, and Brian Walker, exh. cat. (New Haven: Yale University Press, 2005), 186–93; and Carlin's essay in this volume.

94. Feininger to Julia, 8 February 1906, LFP-HCL.

95. Julia to Feininger, 10 February 1906, LFP-HCL.

96. Feininger to Julia, 8 February 1906, LFP-HCL.

97. Feininger described his comic series to Julia: "The series I have in mind, if it is 'accepted,' is sure to span a period of months, if not a year or more. I propose telling of three young lads' adventures, on land and by sea, from New York to Ireland, England, Russia, Germany, France, Italy, Turkey, Egypt, Africa proper, China, Japan, and the South Pole. I picture three wakeful and inventive boys. They embark on a transatlantic journey in some impossible sort of vessel, let's say a bathtub, equipped with their ingenious and impractical fantasy. One of the boys is a 'learned Kid,' another the 'jiu-jitsu Youngster,' and the third 'Piemouth,' a cook. With this combination we can arrange for all manner of argument and action, while at the same time incorporating a whole gamut of *foreign* characteristics. Adventures of the most absurd kind while crossing the Atlantic—what then happens to them in Ireland and England, well, you can just imagine what sort of variety this has to offer. Eating candles in Russia and partaking in otherwise moving activities there; getting into trouble with a constable in Berlin; a ghost in an old castle on the Rhine—*every* country must have its own characteristic guises, customs, landscapes, and lifestyles. And all this can be *instructive* to a certain extent." Feininger to Julia, quoted in Luckhardt, "Vom populären Karikaturisten zum unbekannten Maler," 228.

98. "Artist Feininger Returns to His Native Land," *Chicago Daily Tribune*, 13 May 1906, E3.

99. Feininger to Julia, 30 May 1913, LFP-HCL.

100. Feininger to Julia, 17 January 1906, LFP-HCL.

101. For Feininger's description of illustration as calling "for continual effort of both imagination and memory," see Feininger to Kortheuer, 19 November 1894, collection of the late Horace Richter, Atlanta.

102. Feininger to Julia, 5 September 1907, LFP-HCL.

103. Not until November 1907 did Feininger describe meeting members of the Dôme group—Oskar Moll, Walter Bondy, Hans Purrmann—in a letter to Julia's mother, Jenny Lilienfeld, 16 November 1907, LFP-HCL. Oskar Moll's wife, Margareta, confirmed that she and her husband did not meet Feininger until the fall of 1907. See Margareta Moll to Ernst Scheyer, quoted in Scheyer, *Lyonel Feininger: Caricature and Fantasy*, 99.

104. Feininger to Jenny Lilienfeld, 16 November 1907, LFP-HCL. Matisse opened his art school to the public in January 1908 with the encouragement of Sarah Stein and Hans Purrmann and the financial backing of Michael Stein. Purrmann, the school's student monitor, was "the bulwark of the Matisse school," according to Gertrude Stein. Quoted in

Scheyer, *Lyonel Feininger: Caricature and Fantasy*, 101. For information on the Matisse School, see Jack D. Flam, *Matisse on Art* (Berkeley and Los Angeles: University of California Press, 1995).

105. Feininger to Richard Götz, quoted in Hess, *Lyonel Feininger*, 32. Five years later, Feininger repeated the story of his artistic awakening to Kubin: "Then suddenly came liberation! A contract with Chicago made it possible to move to Paris, and at long last get to know the world of art! I could think, feel and work *for myself*. . . . Only during the last five years did I learn *what* art *could* and *had to be* for me! Since that time my awakening and development went quickly and strongly forward—I have never formed myself consciously on others, but nevertheless derived from them the knowledge of art—and everything in my *intuition*, which for decades had withered (nay, been *suppressed* because of the publishers), began to develop." Reprinted in Ness, *Lyonel Feininger*, 36.

106. Otto Eysler, publisher of the *Lustige Blätter*, wrote to Feininger on 20 August 1907: "Again, months have passed since we have been able to feature any pictures of yours, because a certain stoppage has arisen in our relations since your submission for our last theme. Because I have an interest in seeing you represented in *Lustige Blätter*, I would like to speak with you quite openly. We have always regarded your drawings as ornament and enrichment for our paper. But unfortunately, popular judgment shows that you have adopted a certain grotesqueness during your stay in Paris that is unintelligible to the German public." Quoted in Luckhardt, *Lyonel Feininger: Karikaturen*, 19. See also Luckhardt's essay in this volume.

107. Feininger to Kortheuer, 30 January 1898, quoted in Scheyer, *Lyonel Feininger: Caricature and Fantasy*, 86.

108. Feininger described his early oils as "comfortless things" in a letter to Julia, 18 September 1931, LFP-HCL.

109. First quote, Feininger to Julia, August 1907, quoted in März, "Lyonel Feininger—Der Maler," in *Lyonel Feininger: Von Gelmeroda nach Manhattan*, ed. Roland März, exh. cat. (Berlin: G + H Verlag, 1998), 28. Second quote, Feininger to Julia, 29 August 1907, LFP-HCL.

110. Feininger, quoted in Alexander Liberman, "Feininger: An Eyewitness in the Studio of a Great American Artist," *Vogue* 127 (April 1956): 92. Ten years earlier, Feininger had cited the same precedent in a letter to T. Lux: "When I began to paint in 1907 I was only a caricaturist, and my direction in oil painting was unclear. The placard [Plakat] seemed to me the only possibility. Or to put it more clearly, my ideal was to build images from colored silhouettes. Somewhat like Mami's earlier silhouettes." Quoted in März, "Lyonel Feininger—Der Maler," 28.

111. For Feininger's worship of Van Gogh during this period, see Feininger to Churchill, 3 March 1913, AVCP-AAA; and Feininger to Julia, 5 June 1930, LFP-HCL.

112. Feininger to Julia, 3 August 1909, LFP-HCL.

113. Feininger to Julia, 16 August 1908, quoted in Luckhardt, *Lyonel Feininger*, 28.

114. Feininger to Julia, 5 August 1917, MoMA Archives, New York: William S. Lieberman Papers, I.A.81.d.

115. "Hooray for prostitution," Feininger joked to Julia on 29 June 1908. "I damn well need to earn a decent living at long last." Feininger to Julia, 14 July 1908, LFP-HCL.

116. "Basically every step I undertake to approach people is a self-humiliation, which they certainly see in this way, too. Even more so from the point of view of my artistic self-esteem—but I would be glad to have a business-like connection with these people. Success will come for me best and most certainly, if people appreciate me [for something other than illustration], for only then can something durable begin with them. Yet we are still far from this." Feininger to Julia, 4 August 1909, LFP-HCL. A week later, he lamented that he had not even been invited to the Saturday *Lustige Blätter* conference where commissions were assigned. Because of his higher fee, the editors told him they had no "ideas" for him. Feininger to Julia, 12 August 1909, LFP-HCL.

117. Feininger, quoted in Scheyer, *Lyonel Feininger: Caricature and Fantasy*, 137.

118. Scheffler, quoted in Luckhardt, *Lyonel Feininger*, 22.

119. According to Feininger, he learned about Matisse's response to his work in the Salon des Indépendants through Robert Delaunay. He subsequently told the story to Charlotte Teller, who reported it in "Feininger-Fantasist," *International Studio* 63, no. 249 (November 1917): xxv–xxx. Feininger repeated it to Alfred Barr, 30 June 1928, MoMA Archives, New York: AHB 3a.A. It is highly unlikely, however, that Matisse would have been threatened by an unknown artist whose work was less radical than his. It is even more implausible that he would have acknowledged it to anyone had it been the case. My thanks to Jack Flam for his insight into Matisse's character.

120. Albert Gleizes, quoted in Bruce Altshuler, *The Avant Garde in Exhibition* (New York: Harry N. Abrams, 1994), 27.

121. Feininger to Churchill, 13 March 1913, AVCP-AAA.

122. Feininger to Kubin, 28 September 1916, reprinted in Ness, *Lyonel Feininger*, 49.

123. Feininger to Churchill, 13 March 1913, AVCP-AAA.

124. Feininger to Julia, 14 May 1911, LFP-HCL.

125. Feininger to Julia, 3 April 1913, LFP-HCL.

126. Feininger would vehemently reject Robert Delaunay's subsequent move into nonobjective imagery. Describing the French artist's *Circular Forms* in the 1913 Herbstsalon, he wrote: "But I have little understanding of *one* of the big names—in Delaunay's works I can see only sterile, stubborn, and not even well-clarified experiments with the purely physical problems of light. An *instrument* would give us much clearer and better spectral analysis. Aside from the pretentious manner, a poverty of formal invention is evident, suggesting a totally mechanized mind. But perhaps what he is aiming for will have a productive effect in others as a theory, if they have enough strength to give it form. After all, the best thing about today is that there are so many different ways of making art. The individual may well only be the researcher for others." Feininger to Kubin, 5 October 1913, quoted in Luckhardt, *Lyonel Feininger*, 30.

127. Der Blaue Reiter debuted at Der Sturm from 12 March to early April 1912; Die Brücke at Galerie Fritz Gurlitt in April 1912; Futurism at Der Sturm from 12 April to early May 1912.

128. For critical praise of Feininger's oils in the 1912 Berlin Secession, see Paret, *The Berlin Secession*, 217.

129. By April 1912, Schmidt-Rottluff and Feininger had begun taking excursions together; by December, the Feiningers were inviting the Schmidt-Rottluffs to share Christmas with them; see Schmidt-Rottluff to Julia and Lyonel Feininger, n.d. [1912], LFP-HCL. Feininger and Schmidt-Rottluff remained close friends thereafter. For further discussion of their relationship, see Heinz Spielmann, "Karl Schmidt-Rottluff and Lyonel Feininger: An Artists' Friendship," in *Lyonel Feininger: Loebermann Collection, Drawings, Watercolors, Prints*, ed. Ingrid Mössinger and Kerstin Drechsel, exh. cat. (Munich: Prestel in association with Kunstsammlung Chemnitz, 2006), 140–45.

130. Feininger to Churchill, 3 February 1913, AVCP-AAA.

131. Feininger to Churchill, 13 March 1913, AVCP-AAA.

132. Feininger to Erich Heckel, 27 December 1953, LFP-HCL.

133. Feininger to Churchill, 13 March 1913, AVCP-AAA.

134. Edward A. Kramer to Feininger, 2 March 1912, quoted in Hess, *Lyonel Feininger*, 58.

135. Kramer to Julia Feininger, 19 December 1912, LFP-HCL.

136. Feininger to Julia, 15 September 1913, LFP-HCL.

137. First quote, Feininger to Julia, 3 April 1913. Second quote, Feininger to Julia, 18 May 1913, LFP-HCL. Feininger was alone in Weimar from April 3 to June 9, when Julia and the family joined him. They left in mid August; Feininger remained until late September.

138. Feininger to Churchill, 13 March 1913, AVCP-AAA.

139. Writing to Kubin, Feininger articulated his emotional attachment to these architectural forms: "The villages—there must be nearly a hundred in the vicinity—are gorgeous. . . . There are some church steeples in God-forsaken villages which belong among the most mystical achievements of so-called civilized man that I know." Feininger to Kubin, 15 June 1913, reprinted in Ness, *Lyonel Feininger*, 40. In 1917, at the height of World War I, these images would assume even greater meaning: "The church, the mill, the bridge, the house, and the graveyard have filled me with deep and devotional feelings from my early childhood. They are all symbolic; it is however only since this war that I have realized why I have to keep representing them in my painting." Feininger to Adolf Knoblauch, published in "Knoblauch, Adolf und Lyonel Feininger: Zwiegespräch," *Der Sturm* 8 (September 1917); reprinted in Ness, *Lyonel Feininger*, 29.

140. Feininger to Kubin, 28 September 1916, reprinted in Ness, *Lyonel Feininger*, 49. Feininger repeated the idea to Alfred Frankenstein decades later: "The whole world is nothing but order." Quoted in Frankenstein, "Lyonel Feininger," *American Magazine of Art* 31 (May 1938), n.p.

141. Feininger to Kubin, 21 January 1913, reprinted in Ness, *Lyonel Feininger*, 39.

142. Feininger, quoted in Martin Faass, "Obsession Gelmeroda," in *Lyonel Feininger: Von Gelmeroda nach Manhattan*, ed. Roland März, exh. cat. (Berlin: G + H Verlag, 1998), 235.

143. Julia to Feininger, 22 May 1914, LFP-HCL.

144. Feininger to Julia, 9 June 1914, LFP-HCL.

145. Feininger to Julia, 18 May 1913, LFP-HCL.

146. Feininger to Julia, 9 June 1914, LFP-HCL.

147. Feininger to Julia, 11 April 1914, LFP-HCL.

148. Ralph Waldo Emerson, *Nature* (Boston: James Munroe, 1836), 13.

149. Feininger to Paul Westheim, 14 March 1917, reprinted in Ness, *Lyonel Feininger*, 27.

150. First quote, Feininger to Kubin, n.d. [March 1917], copy in LFP-HCL (original in Kubin-Archiv, Lenbachhaus, Munich). Second quote, Feininger to Julia, 15 August 1917, LFP-HCL.

151. Feininger, quoted by T. Lux Feininger in conversation with the author.

152. Feininger to Knoblauch, reprinted in Ness, *Lyonel Feininger*, 28.

153. Ibid., 31.

154. For excerpt of Franz Marc's letter, see Luckhardt, *Lyonel Feininger*, 7.

155. Feininger to Kubin, 17 September 1913, reprinted in Ness, *Lyonel Feininger*, 42.

156. Hartley to Feininger, n.d. [October or November 1915], LFP-HCL.

157. Feininger sold three works from the Herbstsalon; one to Poiret, one to Koehler, and one to a collector in the Rhineland. See Feininger to Barr, 24 August 1944, LFP-HCL.

158. Feininger to Julia, 4 April 1913, LFP-HCL.

159. Feininger to Julia, 1 June 1913, LFP-HCL.

160. Feininger to Julia, n.d. [1913], LFP-HCL.

161. For discussion of Feininger's art during the war, see Peter Nisbet, "Lyonel Feininger's *The Green Bridge II*: Notes on War and Memory," *North Carolina Museum of Art Bulletin* 17 (1997): 56–69.

162. Feininger, quoted in ibid., 57.

163. Feininger to Kubin, 25 March 1918, copy in LFP-HCL (original in Kubin-Archiv, Lenbach-Haus, Munich).

164. Feininger to Kubin, 15 January 1915, reprinted in Ness, *Lyonel Feininger*, 48.

165. Feininger to Alfred Barr, 14 May 1928, MoMA Archives, New York: AHB 3.A.

166. Feininger's 1916 exhibition at Der Sturm was not a two-person show, as many scholars have assumed, but a survey of three artists: Feininger, Conrad Felixmüller (1897–1977), and Paul Kother (1878–1963). My thanks to Mareike Wolf for researching this.

167. Feininger to Julia, 30 August 1917, LFP-HCL.

168. Draft of Feininger's letter to the American Embassy in Berlin, 17 August 1916, LFP-HCL.

169. Feininger to Julia, 27 August 1917, LFP-HCL. He was particularly indignant that the American government attributed imperialist motives to Germany when the same criticism could be applied to the nations that fought against Germany.

170. "The perfect *harmony* of nature, architecture and humanity is somewhere different than it is in Germany! Beauty exists everywhere, often unconsciously; it is always allowed to be there and represents a need—*only in Germany* it is not recognized properly: wherever it is meant to happen, it is created in sobriety, in bureaucracy with police rules or in insufferable pretentiousness. It has not always been like this in this unfortunate country, but it is like this *today*." Feininger to Julia, 13 June 1914, LFP-HCL. "Germans have basically little feeling for form and are, in general, not creative by inclination." Feininger to Kubin, reprinted in Ness, *Lyonel Feininger*, 39.

171. Paul Westheim, quoted in Ulrich Luckhardt, *Lyonel Feininger—Rieder Gallery*, exh. cat. (Munich: Galerie Rieder, 2001); Theodor Däubler, quoted in "Lyonel Feininger in the Sturm Art Salon," *Berlin Börsen-Courier*, 23 September 1917.

172. For Schelling quote, see Regine Prange, "The Crystalline," in *The Romantic Spirit in German Art, 1790–1990*, eds. Keith Hartley, Henry Meyric-Hughes, Peter-Klaus Schuster, and William Vaughne, exh. cat. (London: Thames and Hudson, 1994), 155. For discussion of the crystalline, see Ingrid Wernecke and Roland März, *Kristall: Metapher der Kunst. Geist und Natur von der Romantik zur Moderne*, exh. cat. (Quedlinburg, Germany: Lyonel-Feininger-Galerie, 1997) and Matthias Schirren, "Lichtreflexionen: Lyonel Feiningers Architekturvisionen und die romantische Tradition der Modernen Architektur in Deutschland," in *Lyonel Feininger: Von Gelmeroda nach Manhattan*, ed. Roland März, exh. cat. (Berlin: G + H Verlag, 1998), 252–61.

173. Feininger to Kubin, 23 March 1918, reprinted in Ness, *Lyonel Feininger*, 51.

174. For assertion of Walden's intervention, see Luckhardt, *Lyonel Feininger*, 34. Feininger quoted in Martin Faass, "Aufbruch zur Fläche—Feiningers Holzschnitte," in *Feininger und das Bauhaus: Weimar—Dessau—New York*, ed. Andrea Fromm, exh. cat. (Apolda, Germany: Kunsthaus Apolda Avantgarde, 2009), 31. For further discussion of Feininger's woodcuts, see Andrea Fromm, "Feininger am Bauhaus—Transpositionen in Holzschnitt, Aquarell und Gemälde," in *Feininger und das Bauhaus*, 11–29.

175. First quote, Feininger to T. Lux, quoted in T. Lux Feininger, "Lyonel Feininger's Woodcuts," in *Lyonel Feininger: Loebermann Collection, Drawings, Watercolors, Prints*, ed. Ingrid Mössinger and Kerstin Dreschel, exh. cat. (Munich: Prestel in association with Kunstsammlung Chemnitz, 2006), 90. Second quote, Feininger to T. Lux, quoted in T. Lux Feininger, "Father and Sons," in *Feininger: Eine Künstlerfamilie*, exh. cat. (Ostfildern-Ruit: Hatje Cantz, 2001), 21.

176. Feininger to Knoblauch in 1917, reprinted in Ness, *Lyonel Feininger*, 29.

177. Feininger to Julia, 18 February 1921, LFP-HCL.

178. Feininger, quoted in Uta Gerlach-Laxner, "Lyonel Feininger und Paul Klee: Malerfreunde am Bauhaus," in *Lyonel Feininger—Paul Klee: Malerfreunde am Bauhaus*, ed. Uta Gerlach-Laxner and Ellen Schwinzer, exh. cat. (Bonn: VG Bild-Kunst, 2009), 17. The desire to reconnect with childhood was widespread. See Charles Baudelaire's definition of genius as "no more than childhood recaptured at will." Charles Baudelaire, "The Painter of Modern Life," in *Selected Writings on Art and Artists*, ed. P. E. Charvet (Cambridge: Cambridge University Press, 1981), 398. Similarly, Edward Hopper wrote wistfully of "those intense, formless, inconsistent souvenirs of early youth whose memory has long since faded by the time the power to express them has arrived." Hopper on Burchfield in "Charles Burchfield: American," *The Arts*, 4 July 1928, 7.

179. Feininger, quoted in Gerlach-Laxner and Schwinzer, *Lyonel Feininger—Paul Klee: Malerfreunde am Bauhaus*.

180. For primary sources on this period, see *The Weimar Republic Sourcebook* (Berkeley and Los Angeles: University of California Press, 1994).

181. For information on the Novembergruppe and Arbeitsrat für Kunst, see Joan Weinstein, *The End of Expressionism: Art and the November Revolution in Germany, 1918–19* (Chicago: University of Chicago Press, 1990); and Ida Katherine Rigby, *An Alle Künstler: War—Revolution—Weimar* (San Diego: San Diego State University Press, 1987).

182. Feininger to Georg Tappert, 8 December 1918; this letter and other documents on the Workers Council for the Arts were provided by Mareike Wolf.

183. Bruno Taut, quoted in Rigby, *An Alle Künstler*, 79.

184. Wilhelm Valentiner began his career as Wilhelm von Bode's assistant at the Nationalgalerie Berlin. In 1908, he joined the staff of New York's Metropolitan Museum of Art. He happened to be in Germany when World War I broke out and volunteered to serve in the German Army. After his return to the United States in 1922, he became an important champion of German art, including Feininger's. He co-organized the 1923 exhibition of German art at the Anderson Galleries and made many of the first purchases of German art for the Detroit Museum of Art after he joined its staff. For a biography of Valentiner, see Margaret Sterne, *The Passionate Eye: The Life of William R. Valentiner* (Detroit: Wayne State University Press, 1980).

185. Feininger was listed as a member of the Workers Council subcommittee of artists and writers living in Berlin in the leaflet that the group sent to newspapers in April 1919.

186. For discussion of Feininger's repeated use of the Gelmeroda church motif, see Faass, "Obsession Gelmeroda," 230–37; and Wolfgang Büche, ed., *Lyonel Feininger: Gelmeroda. Ein Maler und sein Motiv*, exh. cat. (Stuttgart: Gerd Hatje, 1995).

187. The portfolio in which *Gelmeroda* was included was published as a supplement to the periodical *Der Anbruch* edited by Otto Schneider and J. B. Neumann in conjunctions with Neumann's *Graphisches Kabinett*.

188. Feininger to Kubin, 13 March 1919, copy in LFP-HCL (original in Kubin-Archiv, Lenbachhaus, Munich).

189. Gropius was asked to run Weimar's School of Applied Arts in 1915 after its director, Henry van de Velde, resigned. Gropius refused and the school carried on through the war "like the sleeping princess," as Feininger described it (quoted in Hess, *Lyonel Feininger*, 89). Early in 1919, Gropius agreed to lead Weimar's School of Applied Art as well as the city's Academy of Art. On 20 March 1918, the provisional local state government approved his request to rename the combined school the "State Bauhaus" in Weimar.

190. Taut, quoted in Rigby, *An Alle Künstler*, 78.

191. For discussion of Feininger at the Bauhaus, see Martin Faass, "Lyonel Feininger," in *Bauhaus*, ed. Jeannine Fiedler (Hagen, Germany: Könemann, 2006), 268–77; Peter Hahn, "Papileo: Lyonel Feininger als Bauhaus Master," in *Lyonel Feininger: Von Gelmeroda nach Manhattan*, ed. Roland März, exh. cat. (Berlin: G + H Verlag, 1998), 262–71; Fromm, "Feininger am Bauhaus," 11–27; Charles W. Haxthausen, "Walter Gropius and Lyonel Feininger: Bauhaus Manifesto, 1919," in *Bauhaus 1919–1933: Workshops for Modernity*, ed. Barry Bergdoll and Leah Dickerman, exh. cat. (New York: The Museum of Modern Art, 2009), 64–77; Michael Siebenbrodt, "Lyonel Feininger at the State Bauhaus in Weimar," in *Lyonel Feininger in Weimar*, ed. Ernst-Gerhard Güse, exh. cat. (Weimar: Klassik Stiftung Weimar; Bonn: VG Bild-Kunst, 2006); and Klaus Weber, "'Clearly I'm for the Printing Workshop': Lyonel Feininger at the Bauhaus," in *Lyonel Feininger: Loebermann Collection, Drawings, Watercolors, Prints*, ed. Ingrid Mössinger and Kerstin Dreschel, exh. cat. (Munich: Prestel in association with Kunstsammlung Chemnitz, 2006), 112–21.

192. Walter Gropius, *Programm des Staatlichen Bauhauses in Weimar*, April 1919.

193. Feininger's woodcut *Cathedral* has mistakenly been titled "Cathedral of Socialism." The misattribution probably resulted from an advertisement for the Bauhaus written in 1923 by Oskar Schlemmer in which he cites the school as a rallying point for those who "believe in the future—storming the heavens, wanting to build the Cathedral of Socialism." See Hahn, "Papileo Lyonel Feininger als Bauhaus Meister."

194. Feininger to Gropius, quoted in Walter Gropius, "My Friendship with Feininger," in *Lyonel Feininger*, ed. June L. Ness (New York: Praeger, 1974), 256.

195. Feininger to Julia, 20 May 1919, LFP-HCL. For description of Feininger and Gropius's early relationship, see Feininger to Julia, 5 June 1919, LFP-HCL.

196. Writing to Fred Werner, Feininger elaborated: "Fame has come, almost overnight, to your old chum Leo! For I have two paintings (*Cubic* paintings, mind you!) in the 'National Galerie' in Berlin! And seven drawings, all hanging in their glory on the wall! Think of me, a rank Outsider! An *American*, too! And then consider that Germany is broadminded enough to take and buy and hang my pictures in the 'Holy of Holies'!" Feininger to Werner, 5 September 1919, LFP-HCL.

197. Feininger installed his show in the corridor previously hung with engravings and photographs of famous paintings.

198. Feininger to Bernhard Lilienfeld, 30 June 1919, LFP-HCL.

199. Ibid.

200. Feininger to Bernhard Lilienfeld, 30 May 1919, LFP-HCL. Throughout 1919, Feininger worried about the punitive conditions imposed on Germany by the Versailles Treaty. See, for example, Feininger to Julia, 22 and 28 June 1919, LFP-HCL.

201. Feininger described "becoming a kind of soul doctor, my work at the beginning is more psychological"; Feininger to Julia, 17 June 1919, LFP-HCL. For his theory of art education, see "Theory of Art Education," reprinted in Ulrich Luckhardt, *Lyonel Feininger: Retrospective in Japan*, exh. cat. (Tokyo: Tokyo Shimbun, 2008); and Feininger, "A Few Notes Regarding Art Instruction," reprinted in Ness, *Lyonel Feininger*, 59–61.

202. Itten recalled that Feininger "advised only those who came to him. He did not teach." Quoted in Hahn, "Papileo Lyonel Feininger als Bauhaus Meister," 263.

203. Feininger to Julia, 14 June 1919, LFP-HCL.

204. Feininger, quoted in Weber, "Clearly I'm for the Printing Workshop," 116.

205. Gropius, quoted in Michael Siebenbrodt, "Lyonel Feininger at the State Bauhaus in Weimar."

206. Muche, quoted in Felicitas Tobien, *Lyonel Feininger* (Kirchdorf, Germany: Berghaus, 1989), 14–15.

207. "Gropius sees the craft in art, I see the spirit," Feininger wrote to Julia on 30 May 1919, LFP-HCL.

208. Feininger to Julia, 26 and 27 May 1921. LFP-HCL.

209. Feininger to Julia, 17 November 1921, LFP-HCL.

210. Gropius, quoted in Weber, "Clearly I'm for the Printing Workshop," 117.

211. Feininger to Julia, 17 November 1921, LFP-HCL.

212. Feininger described an impromptu musical evening at his house in which Brönner praised his interpretation of Bach and expressed his astonishment that Feininger did not become a musician: "Bach was so ingrained in my being. Yet we found that the essence of Bach was also expressed in my paintings." Feininger to Julia, 18 May 1920, LFP-HCL.

213. For discussion of Feininger's fugues, see Laurence Feininger, *Das musikalische Werk Lyonel Feiningers* (Tutzing, Germany: H. Schneider, 1971); Andreas Hüneke, "Das Wesen Bachs in der Malerei; Feiningers Bezug zur Musik," in *Lyonel Feininger: Lüneburger Giebel* (Lüneburg, Germany: Kulturforum Gut Wienebüttel, 1991); Karin von Maur, "Feininger und die Kunst der Fuge," in *Lyonel Feininger: Von Gelmeroda nach Manhattan*, ed. Roland März, exh. cat. (Berlin: G + H Verlag, 1998), 272–85; and Christiane Weber, *Lyonel Feininger: Genial—Verfemt—Berühmt* (Weimar: Weimarer Taschenbuch, 2007), 70–73; and Bryan Gilliam's essay in this volume.

214. The most successful performances of Feininger's fugues were those played by Willi Apel in December 1924 at the Bauhaus and in Dresden in a church on Easter 1925. Paul Aron's performance of Feininger's fugues at the opening of the Bauhaus Masters exhibition at the Galerie Hugo Erfurth in Dresden in 1925 received favorable newspaper coverage. *Fugue VI*, which Westheim published in his almanac, premiered at the opening of the Blue Four show at the Los Angeles Museum in 1926.

215. Feininger described his reaction to the performance of his fugue in Halle in a letter to Scheyer, 23 December 1925, reprinted in *Galka E. Scheyer and the Blue Four: Correspondence, 1924–1945*, ed. Isabel Wünsche (Wabern/Berne, Switzerland: Benteli, 2006), 127. His more elaborate description appeared in a letter to Laurence, 19 October 1925, quoted in Weber, *Lyonel Feininger: Genial—Verfemt—Berühmt*, 73.

216. Feininger to Julia, 9 November 1929, reprinted in Ness, *Lyonel Feininger*, 193.

217. Feininger to Julia, 27 May 1914, quoted in Weber, *Lyonel Feininger: Genial—Verfemt—Berühmt*, 70. Feininger had always turned to music as a refuge. "When I was unable to paint, I played Bach; it was the only way to lull my troubles," he wrote. "With the sounds of music the poor human spirit climbs to heights where some sort of tranquility and peace can be found." Feininger to Julia, 27 August 1913, MoMA Archives, New York: William S. Lieberman Papers, I.A.81.d.

218. Feininger to Julia, 18 February 1921, LFP-HCL.

219. First quote, Feininger to Julia, 25 September 1913, LFP-HCL. Second quote, Feininger to Churchill, 13 March 1913, AVCP-AAA. Feininger had used musical analogics earlier in describing the printing of his illustrations: "The whole must be conducted like an orchestra. Only in this way can you achieve the magic integration of the hues and their values with the rich complementing function of shapes, textures and blots." Feininger to Kortheuer, quoted in Scheyer, *Lyonel Feininger: Caricature and Fantasy*, 83.

220. Feininger to Julia, 11 September 1920, LFP-HCL.

221. Feininger to Julia, 25 September 1913, LFP-HCL.

222. Feininger to Julia, 11 February 1922, LFP-HCL.

223. Feininger, quoted in Hüneke, "Das Wesen Bachs in der Malerei; Feiningers Bezug zur Musik," 17.

224. Feininger, quoted in Frankenstein, "Lyonel Feininger," n.p.

225. When asked years later whether he thought Feininger was an architect's painter, Gropius said, "No, I don't believe Feininger thinks or builds in terms of architecture. Feininger is absorbed in the phenomenon of light. These straight lines are rays. They are not architectural, they are optical." Frederick S. Wight, "Lyonel Feininger," in *Jacques Villon—Lyonel Feininger*, exh. cat. (Boston: Institute of Contemporary Art and New York: Chanticleer Press, 1949), 32.

226. Feininger to Julia, 10 September 1922, quoted in Joseph W. Gluhmann, "Lyonel Feininger: The Early Paintings" (Ph.D. diss., Harvard University, 1969), 378.

227. Feininger to Julia, 9 September 1922, LFP-HCL.

228. Ibid.

229. Friedrich, quoted in Wieland Schmied, "Faces of Romanticism: Friedrich, Delacroix, Turner, Constable," in *The Romantic Spirit in German Art 1790–1990*, ed. Keith Hartley et al., exh. cat. (London: Thames and Hudson, 1994), 29. For Feininger quoting Friedrich to his students at Mills, see Peter Selz, "Lyonel Feiningers Rückkehr nach Amerika," in *Lyonel Feininger: Von Gelmeroda nach Manhattan*, ed. Roland März, exh. cat. (Berlin: G + H Verlag, 1998), 349.

230. Julia to Feininger, 4 September 1922, LFP-HCL.

231. Feininger to Julia, 5 October 1922, LFP-HCL.

232. Feininger to Julia, 14 November 1921, quoted in Weber, "Clearly I'm for the Printing Workshop," 118.

233. Feininger to Julia, 4 September 1922, LFP-HCL. See also Feininger to Julia, 28 July 1923, LFP-HCL.

234. Feininger to Julia, 1 August 1923, LFP-HCL.

235. Julia to Feininger, 3 July 1924, LFP-HCL. Tensions at the Bauhaus remained high even after Gropius secured outside funding: "I had to twice postpone my departure [for Deep] by several weeks in order to serve as a witness in one of the court cases going on there. As a consequence, I was out of my mind for some time afterward." Feininger to Scheyer, 10 August 1924, reprinted in Wünsche, *Galka E. Scheyer and the Blue Four*, 73.

236. First quote, Feininger to Julia, 30 June 1924, LFP-HCL. Second quote, Feininger to Julia, 23 August 1924, LFP-HCL.

237. First quote, Feininger to Julia, 12 March 1925, LFP-HCL. Second quote, Feininger to Adolf Behne, 28 November 1924, quoted in preface to *Lyonel Feininger: Von Gelmeroda nach Manhattan*, ed. Roland März, exh. cat. (Berlin: G + H Verlag, 1998), 20.

238. First quote, Feininger to Julia, 30 June 1924, LFP-HCL. Second quote, Feininger to Scheyer, 13 December 1924, reprinted in Wünsche, *Galka E. Scheyer and the Blue Four*, 83. In September 1924, Feininger notified Gropius of his desire to leave the Bauhaus: "If at all possible, I want to move away from Weimar this coming winter. I cannot stand it there any longer. I think the modus of a longer vacation for medical reasons—which do exist—is most suitable to effect my dispensation from Weimar and government service; it neither suits me nor appeals to me. Our Bauhaus community is my innermost affair, and I could never be untrue to it. But I would be untrue to *myself* and *my family* if I remained in the same position." Feininger to Gropius, 6 September 1924, quoted in Hahn, "Papileo: Lyonel Feininger als Bauhaus Master," 269.

239. Feininger to Julia, 29 July 1923, LFP-HCL.

240. First quote, Feininger to Julia, 6 December 1925, LFP-HCL. Second quote, Feininger to Julia, 19 August 1924, LFP-HCL.

241. Feininger to Julia, 19 August 1924, LFP-HCL. For further commentary, see Feininger to Julia, 22 August 1924, LFP-HCL. By then, the political situation had become so distressing that Feininger and Julia took their sons out of school in Weimar and sent them to a boarding school run by their art-historian friend Alois Schardt.

242. Feininger to Julia, 19 August 1924, LFP-HCL.

243. Feininger to Julia, 9 February 1922, LFP-HCL. He wrote again that July about not wanting to return to America, "the country of my birth which I have not set foot in since I have engaged in art, nor would I want to enter as an artist." Feininger to Mr. Herwig, 1 July 1922, copy in LFP-HCL (original in collection of Arthur Vershbow, Newton, Massachusetts).

244. Feininger to Julia, 23 January 1924, LFP-HCL.

245. Feininger to Julia, 24 August 1924, LFP-HCL.

246. Feininger was distraught at being sued by his ex-wife. "Whoever knows me, realizes how unfair the reproaches are, which are raised in the accusation; Clara's insistence that I *neglected* my obligations for support is simply a malicious interpretation of the conditions of my life during these last years of inflation, which have seen a decline of fortune and total indebtedness; it so happened that I *could not* meet my obligations literally—to my continued sorrow. We sacrificed *our* subsidy from Papa, 900 M per month and the rent. As long as I was able to squander my works during inflation, I gave *all* she asked and much more, when you consider what I was required to do by law, which was always 'MK 5000' per year, no more." Feininger to Julia, 11 November 1924, LFP-HCL.

247. Julia to Feininger, 17 August 1924, LFP-HCL.

248. Feininger described Muche's trip to America and characterized Archipenko in a letter to Scheyer, 13 December 1924, reprinted in Wünsche, *Galka E. Scheyer and the Blue Four*, 81.

249. Looking back at this show in 1931, *Art Digest* observed: "Back in 1923 when war prejudice against anything Germanic still existed, the New York art public was given the opportunity to see what the Germans . . . were doing in the field of fine art in an exhibition at the Anderson Galleries, but the show received scant notice." MoMA Archives, New York: Department of Public Information Records, II.A.4.

250. First quote, Feininger to Julia, 26 August 1924, LFP-HCL. Second quote, Feininger to Scheyer, 13 December 1924, reprinted in Wünsche, *Galka E. Scheyer and the Blue Four*, 81.

251. Feininger had met Galka Scheyer in August 1922, during Germany's hyperinflation, when she traded food canned at her family's factory for art. When she asked Feininger to join the Blue Four in 1924, he had warned her: "Don't hope to be able to convince everyone, or even to interest them in our European art; our intellectualism will never be grasped in America . . . everyone there finds modern painting and architecture and the new applied art loathsome." Feininger, quoted in Barbara McCloskey, "Lyonel Feininger," in *New Worlds: German and Austrian Art, 1890–1940*, ed. Renée Price, Pamela Kort, and Leslie Topp, exh. cat. (New York: Neue Galerie, 2001), 363. For extensive discussion of Scheyer and the Blue Four, see Vivian Endicott Barnett, *The Blue Four Collection at the*

Norton Simon Museum (New Haven: Yale University Press in association with the Norton Simon Art Foundation, 2002); Vivian Endicott Barnett and Josef Helfenstein, *The Blue Four: Feininger, Jawlensky, Kandinsky, Klee in the New World*, exh. cat. (New Haven: Yale University Press; Cologne: DuMont, 1997); W. Joseph Fulton, *The Blue Four: Feininger, Jawlensky, Kandinsky, Paul Klee: Galka E. Scheyer Collection* (Pasadena, CA: Pasadena Art Museum, 1956); and Wünsche, *Galka E. Scheyer and the Blue Four*.

252. Scheyer to the Blue Four, summer 1924, reprinted in Wünsche, *Galka E. Scheyer and the Blue Four*, 74.

253. Scheyer to Blue Four, 10 March 1936, reprinted in Wünsche, *Galka E. Scheyer and the Blue Four*, 255.

254. Feininger to Stefan Pauson, 26 November 1925, quoted in Hess, *Lyonel Feininger*, 106.

255. For Feininger's studio being commandeered, see Feininger to Schmidt-Rottluff, 28 August 1923, LFP-HCL.

256. Feininger to Julia, 7 July 1924, LFP-HCL. For Feininger in Deep, see T. Lux Feininger, "Lyonel Feininger in West-Deep," *Baltische Studien* 49 (1962–63): 101–20.

257. Feininger, quoted in Birte Frenssen, "It Is Fascinating to Watch How the Stream Runs . . . ," in *Lyonel Feininger: Vom Sujet zum Bild*, ed. Kornelia von Berswordt-Wallrabe, exh. cat. (Bonn: VG Bild-Kunst, 2007), 68.

258. Feininger to Julia, 14 May 1932, reprinted in Kornelia von Berswordt-Wallrabe, ed., *Lyonel Feininger: Vom Sujet zum Bild*, exh. cat. (Bonn: VG Bild-Kunst, 2007), 177.

259. Julia to Feininger, 15 February 1925, LFP-HCL.

260. Feininger to Julia, 11 May 1929, reprinted in Ness, *Lyonel Feininger*, 186.

261. First quote, Feininger to Julia, 2 March 1925, LFP-HCL. Second quote, Feininger to Julia, 21 February 1925, LFP-HCL.

262. Feininger to Julia, 21 February 1925, 19 September 1927, 26 September 1927, and 2 December 1927, LFP-HCL.

263. "I am not thinking of pictures in the traditional sense— I don't paint in order to create 'art'; it is such a deeply painful human urge to render innermost experiences, to lift them from the past. Perhaps quite wrong! Yet, in the present there is only the act of creation itself. With we 'expressionists,' the *incentive* originates in the longing for lost happiness." Feininger to Julia, 2 August 1927, LFP-HCL. "Only joy can carry us into the highest heights." Feininger to Julia, 23 January 1924, LFP-HCL.

264. Feininger to Julia, 4 April 1928, LFP-HCL.

265. Feininger to Julia, 14 February 1925, LFP-HCL.

266. Moholy-Nagy's "Malerei Photographie Film" was published in *Leipziger Jahresausstellung* in 1925. Feininger reacted to it in a letter to Julia, 9 March 1925, LFP-HCL.

267. Feininger was pessimistic about Hindenburg's election as president: "The savior, who is to lead the country again into war, because humanity and brotherhood and the building of peaceful relations with the neighbours take much too long and demand too much self-denial and true manly discipline and Christian attitude. All foreign credits have stopped as a consequence of the candidacy of Hindenburg and the material want

and misery will come back more than ever." Feininger to Julia, 26 April 1925, LFP-HCL.

268. Julia to Feininger, 14 June 1925, LFP-HCL.

269. Feininger to Julia, 12 March 1925, LFP-HCL.

270. Feininger to Julia, 14 August 1926, LFP-HCL.

271. The entire Bauhaus faculty moved to Dessau in April 1925 with the exception of Gerhard Marcks, who went to teach near Halle because there had not been room or money to reinstall his ceramics workshop in Dessau. For discussion of the Feininger/Marcks friendship, see *Feininger & Marcks: Tradition aus dem Bauhaus*, exh. cat. (Bremen: Gerhard Marcks Haus, 2011).

272. Feininger to Julia, 4 August 1926, LFP-HCL. All of the Master Houses were duplexes. The Feiningers shared theirs with the Moholy-Nagys; the Muches with the Schlemmers; and the Kandinskys with the Klees.

273. For a discussion of Feininger's photography, see Sasha Nicholas's essay in this volume. See also Laura Muir, *Lyonel Feininger: Photographs (1928–1939)*, exh. cat. (Cambridge, MA: Harvard Art Museum; Ostfildern-Ruit, Germany: Hatje Cantz, 2011); Andreas Hüneke, "'Das Photographieren hat mir das Sehen auf eine neue Art gesteigert': Feininger als Photograph," in Wolfgang Büche, Andreas Hüneke, and Peter Romanus, *Lyonel Feininger: Die Halle-Bilder*, exh. cat. (Munich: Prestel, 1991), 90–95; Laura Muir, "Lyonel Feininger's Bauhaus Photographs," in *Bauhaus Construct: Fashioning Identity, Discourse and Modernism*, ed. Jeffrey Saletnik and Robin Schuldenfrei (London: Routledge, 2009), 125–41.

274. Feininger to Julia, 6 November 1928, LFP-HCL.

275. Feininger to Julia, 31 May 1929, LFP-HCL.

276. Feininger wrote to Alfred Barr that he had been given permission by the authorities in Washington to remain for a year or two in Dessau, after which he needed to return to the United States "or be blotted off the lists." Feininger to Barr, 30 June 1928, MoMA Archives, New York: Barr: 3a.A.

277. Feininger to Julia, 23 May 1929, LFP-HCL.

278. Henry McBride in the *New York Sun*, 14 December 1929, MoMA Archives, New York: Barr: 3a.A.

279. Barr wrote to Feininger: "The critics, followed by much of the public, disliked the inclusion of a painter whom they did not know and whom they felt really belonged to German art. I pointed out that your art is conspicuously different from that of your German contemporaries and that you are after all no more an expatriate than Whistler or Mary Cassatt. But these arguments were of little use in conquering prejudice. This year we expect to have a German exhibition including about twenty artists, among whom you would certainly be numbered in Germany. I fear, however, that since you have already been included in the American exhibition your reappearance as a German would simply lead to further futile controversy which would almost certainly give our ignorant critics opportunity to wag their tongues instead of attending to business of estimating the worth of German paint-

ing, which as it is will have all too much prejudice to overcome. For these reasons, I feel it best not to exhibit your work this year, but to attempt to arrange a one man exhibition within the next two or three years which will show your work at its best." Barr to Feininger, September 1930, LFP-HCL.

280. Feininger to Julia, 12 June 1930, LFP-HCL.

281. For decades it was thought that Feininger used only photographs as compositional guides for his Halle paintings. In 1995, a group of "nature notes" of the city was discovered. See Wolfgang Büche, *Lyonel Feininger: Halle-Bilder, Die Natur-Notizen*, exh. cat. (Leipzig: Beck und Eggeling, 2000).

282. Feininger to Julia, 26 March 1931, LFP-HCL.

283. Feininger to Julia, 16 September 1931 LFP-HCL.

284. Feininger, quoted in Hess, *Lyonel Feininger*, 124.

285. Feininger to Julia, 16 May 1931, LFP-HCL.

286. Feininger to Julia, 7 May 1931 LFP-HCL.

287. For a detailed discussion of Feininger's retrospective at the Kronprinzenpalais, see Jörn Grabowski, "Lyonel Feininger und die Sammlung der Moderne im Kronprinzenpalais 1919–1937," in *Lyonel Feininger: Von Gelmeroda nach Manhattan*, ed. Roland März, exh. cat. (Berlin: G + H Verlag, 1998), 328–35.

288. The bulk of the Essen show had been drawn from works in Julia Feininger's collection. Ludwig Justi, the director of the Kronprinzenpalais, replaced some of these works with loans from private collections. As Julia described it: "Justi has hung everything he received as loans from private collectors and left out many of my pictures, because he is a museum professional and wanted to avoid people saying: aha, a private show of Frau Feininger's. A view which one must and can respect." Julia to Feininger, 16 September 1931, LFP-HCL.

289. "And imagine, that our American Embassy received an invitation! I had thought of it, but at the same time scrapped the idea of intimating that as a 'German Artist' I am not 'a citizen of the German Reich,' but rather an 'American import!' As you see, I serve an 'international benefit.' 'Cordial relations between my adopted homeland and the United States' are 'documented by the museum having honored one of America's artists in an official place.' This means that my life's work has really fulfilled a valuable purpose on a human level, and was not just created as a luxury. A pity that Barr is not here!" Feininger to Julia, 18 September 1931, LFP-HCL.

290. Feininger to Julia, 16 September 1931, LFP-HCL.

291. Feininger to Julia, 4 June 1932, LFP-HCL.

292. For discussion of Feininger and Nazi art policy, see Sabine Eckmann, "The Loss of Homeland and Identity: Georg Grosz and Lyonel Feininger," in *Exiles and Émigrés: The Flight of European Artists from Hitler*, ed. Stephanie Barron, exh. cat. (Los Angeles: Los Angeles County Museum of Art, 1997), 296–303; Andreas Hüneke, "'So Much for Creative Art in This Country!' Feininger and Nazi Art Policy," in *Lyonel Feininger: Loebermann Collection*,

Drawings, Watercolors, Prints, ed. Ingrid Mössinger and Kerstin Dreschel (Munich: Prestel in association with Kunstsammlung Chemnitz, 2006), 193–99; Mario-Andreas von Lüttichau, "'Wartesaal' Berlin," in *Lyonel Feininger: Von Gelmeroda nach Manhattan*, ed. Roland März, exh. cat. (Berlin: G + H Verlag, 1998), 336–45.

293. Julia Feininger to Koehler, 27 November 1930, quoted in Hüneke, "So Much for Creative Art," 193.

294. Feininger to Julia, 10 July 1932, LFP-HCL.

295. Feininger to Julia, 19 September 1932, LFP-HCL.

296. Julia Feininger reported to Alois Schardt on 18 March 1933: "The pictures of contemporary painters that have been bought over the years by the city and the state have been exhibited by the new government in the windows of the most hardline National Socialist newspaper and on the same day a 'review' was published in the same newspaper. I am simply unable to repeat what this review said. Among other things Leo was made out to be a top-ranking communist and the consequence of that was that yesterday our house was searched." Quoted in Hüneke, "So Much for Creative Art," 194.

297. Feininger to Scheyer, 8 April 1936, reprinted in Wünsche, *Galka E. Scheyer and the Blue Four*, 260.

298. Feininger to Kubin, 15 January 1915, copy in LFP-HCL (original in Städtische Galerie, Lenbachhaus, Munich).

299. Feininger to Julia, 6 April 1933, LFP-HCL.

300. Feininger to Julia, 9 April 1933 LFP-HCL.

301. Ibid.

302. For Julia's endorsement of Hitler's speech, see her letter to Feininger, 18 May 1933, LFP-HCL. For the full text of Hitler's speech to the Reichstag, see Max Domarus, ed., *Hitler: Speeches and Proclamations, 1932–1945, The Chronicle of a Dictatorship*, vol. 1, *The Years 1932–1934* (Würzburg, Germany: Bolchazy-Carducci, 1990).

303. Feininger to Julia, 19 May 1933, LFP-HCL.

304. Feininger to Julia, 14 May 1932, LFP-HCL.

305. Feininger to Julia, 19 May 1933, LFP-HCL.

306. Feininger to Julia, 9 April 1933, LFP-HCL.

307. First quote, Feininger to Walter Klemm, 31 May 1933, quoted in Lüttichau, "'Wartesaal' Berlin," 339. Second quote, Feininger to Julia, 9 April 1933, LFP-HCL.

308. Feininger to Julia, May 1935, quoted in Gluhmann, "Lyonel Feininger: The Early Paintings," 332.

309. Feininger to Julia, 27 March 1935, LFP-HCL.

310. "I think it is best to stay calm. I can only say that I am hopeful (hopeful! In this hopeless period of cultural history, in a country where every essential artistic effort is systematically persecuted, you only have hope for your own work)." Feininger to Julia, 19 March 1935, quoted in Lüttichau, "'Wartesaal' Berlin," 342.

311. Feininger to Johannes Kleinpaul, 3 August 1935, in *Letzter Stunde, 1933–1945: Schriften Deutscher Künstler des zwanzigsten Jahrhunderts*, vol. 2, ed. Diether Schmidt (Dresden: Verlag der Kunst, 1964).

312. Feininger to his lawyer, Dr. Herrmannsdorfer, 17 September 1935, LFP-HCL. Feininger repeats his concern over being labeled a Jew in a letter to Julia, 20 September 1935, LFP-HCL.

313. Feininger to Julia, 13 September 1935, LFP-HCL. Feininger's 1935 summer in Deep was divided into two periods: he spent April 27 to June 21 there, with Julia joining him in late May and staying through June. He returned on August 29 with his son Laurence and remained through the end of September.

314. Feininger to Julia, 29 August 1935, LFP-HCL.

315. Feininger to Julia, 3 September 1935, LFP-HCL.

316. Julia to Feininger, 5 September 1935, LFP-HCL.

317. Feininger to Scheyer, 2 January 1936, reprinted in Wünsche, *Galka E. Scheyer and the Blue Four*, 254.

318. Feininger to Scheyer, 8 April 1936, reprinted in ibid., 259, 261.

319. Hermann Klumpp stored Feininger's art until 1971, when Feininger's heirs won a lawsuit to have it returned to them. In the compromise that was reached, some of the work was returned to Feininger's heirs and some remained in Quedlinburg, where it formed the core collection of what is now the Lyonel-Feininger-Galerie. For description of this case, see Paul Gardner, "The Case of Herr Klumpp," *Connoisseur* 215, no. 886 (November 1985): 133–35; and Ralph F. Colin, "The Recovery," in *Lyonel Feininger*, exh. cat. (New York: Acquavella Galleries; Washington, DC: The Phillips Collection, 1985), n.p.

320. Feininger to Scheyer, 2 January 1936, reprinted in Wünsche, *Galka E. Scheyer and the Blue Four*, 254.

321. Feininger to Scheyer, 8 April 1936, reprinted in ibid., 261.

322. Feininger, quoted in T. Lux Feininger, "Lyonel Feininger in Amerika," in *Lyonel Feininger: Zurück in Amerika, 1937–1956*, ed. Wolfgang Büche, exh. cat. (Munich: Hirmer, 2009), 157.

323. On his first trip to America since leaving in 1871, Feininger reconnected with old friends: Frank Kortheuer; Fritz Strothmann, a former fellow student at the Berlin Art Academy; Galka Scheyer; J. B. Neumann, a gallerist who had handled Feininger's work in Berlin; and Alfred Barr. He also visited the house in Sharon, Connecticut, where he had boarded as a boy with the Clapps. "I could scarce credit my eyes; I had thought of it as having long ago disappeared, for it was old and shaky in 1876 already; but no, it stood exactly as I remembered it, only spick and span in a new coat of white paint. On the porch facing the road sat an old, old man in a rocking chair. When I got out of the car and walked in a daze through the gate and up the path leading to the front door . . . I spoke to him but he was almost as deaf as a stone. . . . The old man thawed somewhat, and asked my name. No sooner had I told him he shouted out as though electrified: 'Carl [sic] Feininger' . . . 'that was a great fiddler! He played at a church concert and took off all the strings of his fiddle but one, and played a tune to bring the roof down!' I remembered the young fellow who had been so enthusiastic about my father's playing that my parents spoke of it after the concert. The likely young fellow was this old man, stone deaf. . . . But after 60 years he still remembered that concert . . . it was to me the most unexpected, incredible meeting of my whole life." Feininger to T. Lux, quoted in Hess, *Lyonel Feininger*, 135.

324. Review of the Hamburg Kunstverein show, "Kulturelle Anarchie in Hamburg," quoted in Hüneke, "So Much for Creative Art," 196.

325. Review of the Nationalgalerie Berlin's installation, "Kronprinzenpalais säuberungsbedürftig," quoted in ibid., 196.

326. Laurence Feininger's deep-seated loyalty to Germany was similar to that of his father: "As I am done with my studies, I shall cross myself three times and shall leave Germany; God knows where I'll end up but no matter, so long as it is not Germany. Some exile or other it is sure to be, for I am afraid that I'll always remain a German, despite my US citizenship." Laurence, spring 1933, quoted in T. Lux Feininger, "Laurence Feininger: In Memoriam," 8–9. Like his father, Laurence was naively optimistic about the threat posed by Fascism and anti-Semitism. In July 1939, he returned to Italy after a visit to New York: "'Don't worry!' was his word; 'it won't come to much and anyway Italy is not going to be dragged into it.'" Quoted in ibid., 2. In 1942, Laurence was placed in various civilian detention camps, first under Italian rule and, after 1943, under the Germans. He was released in 1945.

327. Feininger to Scheyer, 14 June 1937, reprinted in Wünsche, *Galka E. Scheyer and the Blue Four*, 269.

328. Julia to T. Lux, 8 April 1937, LFP-HCL.

329. Feininger to T. Lux, quoted in Hess, *Lyonel Feininger*, 136.

330. Feininger's daughters apparently knew little about their Jewish heritage. Lore described her mother's 1944 death in a letter: "My mother committed a great folly: a Jewish married couple with whom she was friends advised her to convert to the 'Jewish faith' because in the end she would receive 'reparations' as one of the persecuted. . . . That was a 'deadly mistake!' Even though she was only a 'half-breed,' she was taken into a concentration camp, where I saw her once more; but later she was taken out of Theresienstadt [concentration camp] and— while attempting to flee during a stopover—she was shot. . . . Where, nobody knows." Lore, quoted in *Komponisten in Berlin: Eine Dokumentation*, ed. Bettina Brand et al. (Kassel, Germany: Furore-Verlag, 1989), 304.

331. For a full analysis and history of the Degenerate Art show, see Stephanie Barron, *"Degenerate Art": The Fate of the Avant-Garde in Nazi Germany* (Los Angeles: Los Angeles Country Museum of Art; New York: Harry N. Abrams, 1991); and Hüneke, "So Much for Creative Art," 192–99.

332. A. Udo's manifesto, quoted in Hüneke, ibid., 197.

333. Most of the Feininger works purchased by the Buchholz Gallery were brought to New York by its director,

Curt Valentin, who had opened the gallery's New York branch in 1937. Ferdinand Möller purchased eighteen Feininger paintings, which he sent to Wilhelm Valentiner, then director of the Detroit Institute of Arts, which had made the first American museum acquisition of the artist's work, *The Side-wheeler II (Raddampfer II)* (see fig. 71). After the war, Möller's Feiningers were confiscated as enemy property by the U.S. government. In the agreement reached with the government, Möller's widow donated *The Green Bridge II (Grüne Brücke II)* (see fig. 90) to the North Carolina Museum of Art, where Valentiner was then director.

334. Karl Nierendorf opened an art gallery in Cologne with his brother, Josef, in 1918. When J. B. Neumann immigrated to New York in 1923, Nierendorf took over Neumann's Graphisches Kabinett in Berlin. In 1936, Nierendorf immigrated to New York and opened a gallery; in 1937 he became Feininger's primary dealer. The artist annulled his contract with Nierendorf in July 1939 over what he viewed as the dealer's careless handling of art and financial irregularities. See Feininger to Scheyer, 10 July 1939, November 1939, January 1940, and March 1940, LFP-HCL.

335. Feininger to Alois Schardt, 16 August 1940, quoted in Hess, *Lyonel Feininger*, 146.

336. Feininger to Muche, 27 August 1951, LFP-HCL.

337. Feininger to Heckel, n.d. [1951], LFP-HCL.

338. Feininger to Theodore Spicer-Simson, 18 September 1937, quoted in Hess, *Lyonel Feininger*, 140.

339. Feininger to T. Lux, quoted in T. Lux Feininger, *Lyonel Feininger: City at the Edge of the World*, 88.

340. Feininger to T. Lux, quoted in T. Lux Feininger, "Lyonel Feininger in Amerika," 158.

341. Feininger, quoted in Barr, "Lyonel Feininger—American Artist," 13. Julia's response to America was harsher than Lyonel's, as her later description of a meeting about the World's Fair commission attests: "Again, such a typical, corrupt New Yorker occasion, whereby one does not know whether to explode out of anger or weep out of sadness that everything is handled with such pettiness and precondition . . . everything . . . is nothing more than the most corrupt nepotism." Julia Feininger to Laurence, 3 March 1939, LFP-HCL.

342. Feininger to Scheyer, March 1940, LFP-HCL.

343. Feininger to T. Lux, quoted in Wolfgang Büche, "Zürück in New York—Zurück in einer vertrauten Fremde," in *Lyonel Feininger: Zurück in Amerika, 1937–1956*, ed. Wolfgang Büche, exh. cat. (Munich: Hirmer, 2009).

344. Feininger to Alexei Jawlensky, 23 July 1938, quoted in Hess, *Lyonel Feininger*, 142.

345. Feininger to Gustav Breuer, 12 July 1939, quoted in Peter Selz, "Watercolors from Feininger's American Period," in *Lyonel Feininger: Loebermann Collection, Drawings, Watercolors, Prints*, ed. Ingrid Mössinger and Kerstin Drechsel, exh. cat. (Munich: Prestel in association with Kunstsammlung Chemnitz, 2006), 221.

346. T. Lux Feininger, conversation with the author.

347. Feininger to Scheyer, 9 May 1943, reprinted in Wünsche, *Galka E. Scheyer and the Blue Four*, 300.

348. The Marine Transportation Building was designed by Ely Jacques Kahn and Muschenheim & Brounn. Feininger's mural was located on an exterior wall to the right of the entrance, which was bordered on each side by eighty-foot-high reconstructions of the prows of superliners.

349. The selection process was still underway on 3 March 1939; the pavilion opened on 9 June 1939. See Julia Feininger to Laurence, 3 March 1939, LFP-HCL; and Julia Feininger to Maria Marc, quoted in Luckhardt, *Lyonel Feininger*, 44.

350. Feininger to T. Lux, 31 March 1943, quoted in Hess, *Lyonel Feininger*, 153.

351. Feininger to Schardt, 3 February 1942, quoted in Hess, *Lyonel Feininger*, 148.

352. Ibid., 148, 150.

353. Feininger, quoted in Alfred H. Barr, Jr., "In Remembrance of Feininger," in *Lyonel Feininger*, ed. June L. Ness (New York: Praeger, 1974), 255.

354. Feininger to T. Lux, quoted in T. Lux Feininger, "Lyonel Feininger in Amerika," 160.

355. Feininger to T. Lux, 1 July 1947, quoted in Weber, *Lyonel Feininger: Genial—Verfemt—Berühmt*, 120.

356. Feininger, 15 May 1941, quoted in ibid., 116.

357. Feininger to Scheyer, 9 January 1940, LFP-HCL.

358. Feininger to Marcks, 9 March 1941, LFP-HCL.

359. Feininger to Scheyer, 1 March 1940, LFP-HCL.

360. Feininger to Scheyer, 9 May 1943, LFP-HCL.

361. In response to Galka Scheyer's invitation to visit her in California, Feininger wrote: "It is heartbreaking for us, but we simply do not dare to leave this place now. The future is so uncertain." Feininger to Scheyer, 1 March 1940, LFP-HCL.

362. Feininger to Scheyer, 24 January 1941, LFP-HCL.

363. Ibid. One of the "reverses" Feininger faced in 1941 was the firing of Alexander Dorner from his position as director of the Museum of the Rhode Island School of Design, ending Dorner's plan to write a monograph on Feininger's work.

364. Feininger was so convinced that his work would not be selected by the Metropolitan Museum that he missed the deadline for submission. Only the intervention of dealer Karl Lilienfeld made it possible for *Gelmeroda XIII* to be among the three thousand submitted paintings. *Gelmeroda XIII* passed the first jury, becoming one of three hundred works selected for consideration. Feininger described attending the opening of the exhibition of the these works to T. Lux: "Yesterday I went to the 'Varnishing' (as they persist in calling it) of the new exposition of American painting at the Metropolitan Museum, having one of my paintings included. . . . It is a show to demonstrate the Victory of the American Artist, and when pictures (3000 of them) have gone through the process of being juried, and 300 chosen, . . . there is a second jury to decide which paintings seem worthy of acquisition by the Metropolitan. . . . Well, there we now have a painting in the pool and a one-in-ten-thousand chance that it might be 'acquired.' . . . Gosh, was I discouraged when . . . I caught a glimpse of all the folks milling around. . . . But I did discover my 'Gelmeroda' (now modestly designated under the caption: 'Church'), hung very nicely." Feininger to T. Lux, 6 December 1942, quoted in Hess, *Lyonel Feininger*, 152.

365. Feininger and Julia to T. Lux, quoted in ibid., 153.

366. Feininger, quoted in Barr, "Lyonel Feininger—American Artist," 13.

367. Feininger to Lux, 28 January 1945, quoted in Hess, *Lyonel Feininger*, 155.

368. Feininger to Marcks, 31 December 1948, LFP-HCL.

369. Feininger to Schardt, quoted in Luckhardt, *Lyonel Feininger*, 160.

370. For the correspondence between Feininger and Mark Tobey, see Achim Moeller, ed., *Years of Friendship, 1944–1956: The Correspondence of Lyonel Feininger and Mark Tobey* (Ostfildern-Ruit, Germany: Hatje Cantz, 2006).

371. From Feininger's transcribed excerpts of Binyon's *Flight of the Dragon*, LFP-HCL.

372. Ibid.

373. Feininger to Jawlensky, 23 July 1938, quoted in Hess, *Lyonel Feininger*, 142.

374. Feininger to Julia, 19 May 1933, LFP-HCL.

375. Feininger to Schardt, 7 January 1952, quoted in Hess, *Lyonel Feininger*, 159.

376. In response to the invitation to join the American Abstract Artists, Feininger wrote: "Forgive please, this retarded answer to your cordial invitation to become an active member of your organization. If I have so long delayed in responding, it is because I have been deeply revolving the question in my mind. And I have reached the conclusion that I cannot conscientiously join your faith for the reason that I would at best be an incomplete co-worker. My artistic faith is founded on a deep love of nature, and all I represent or have achieved is based on this love. I understand fully that all that I admire in the theory of a nonobjective art is outside of my capabilities—and that I should become inarticulate, which would be the worst fate that could befall an artist. We all must work out our own salvation in our own way." Feininger to American Abstract Artists, 1942, Archives of American Art, Washington, DC, reprinted in Ness, *Lyonel Feininger*, 61.

377. Feininger to T. Lux, 11 July 1940, quoted in T. Lux Feininger, *Lyonel Feininger: City at the Edge of the World*, 90.

378. Feininger, quoted in Alexander Liberman, "Feininger: An Eyewitness in the Studio," 93.

379. Feininger, quoted in T. Lux Feininger, "Lyonel Feininger in Amerika," 159.

380. Information about Clara Feininger's death provided by the United States Holocaust Memorial Museum and the central database of shoah victims' names. A commemorative stone in Berlin (Bezirksamt Tempel-Schöneberg) states that Clara Fürst was deported to

Theresienstadt on January 10, 1944, and transported to Auschwitz on October 23. She was killed on arrival at the camp. I am grateful to Dietlinde Hamburger for researching this information.

381. "We are flooded with the most heartrending accounts, and demands for practical help—untold packages of food and necessities are sent to at least a dozen people in Germany and Italy." Feininger to Mark Tobey, 17 September 1947, reprinted in Moeller, *Years of Friendship*, 58. See also Feininger to Lore, 24 May 1947, LFP-HCL.

382. Gropius to former members of the Bauhaus, 30 October 1946, LFP-HCL.

383. Feininger to Heckel, 11 August 1953, LFP-HCL.

384. "It is quite amazing how the past lives on within, transfigured and unsullied, and in certain moments inspires renewed momentum and creative energy. Overall, I look back on a life that appears to me today to have been almost paradisiacal." Feininger to Marcks, 20 May 1948, LFP-HCL.

385. Feininger to Heckel, 27 February 1952, LFP-HCL.

386. Feininger to Heckel, 23 July 1950 LFP-HCL.

387. Feininger to Kortheuer, 7 April 1946, collection of the late Horace Richter, Atlanta.

388. Feininger to Schardt, 3 February 1942, quoted in Hess, *Lyonel Feininger*, 147.

389. Feininger to Tobey, 25 September 1952, reprinted in Moeller, *Years of Friendship*, 135.

390. Feininger to Muche, 27 August 1951, LFP-HCL.

391. Feininger to Tobey, 12 April 1948, reprinted in Moeller, *Years of Friendship*, 67.

392. Feininger to Tekla Hess, 15 July 1951, quoted in Hess, *Lyonel Feininger*, 160.

393. Feininger to Marianne Feininger-Noack, 18 March 1954, quoted in ibid., 168.

394. Feininger to Schardt, 7 April 1946, quoted in ibid., 158.

395. "I am coming to the point where I start to despise solid forms in the interest—so it seems to me—of unity. It is dangerous to enter into this condition, and I take fright and return to the opposite as a cure." Feininger to T. Lux, 12 September 1955, quoted in ibid., 166.

396. Feininger to Schmidt-Rottluff, 3 January 1956, LFP-HCL.

397. Feininger to Tobey, 19 November 1954, reprinted in Moeller, *Years of Friendship*, 184.

398. Feininger to T. Lux, 3 January 1954, quoted in Hess, *Lyonel Feininger*, 170. In the same letter, he elaborated: "I am almost scared of what I did yesterday; it is, in a way outrageous; but I think I must 'get head' of my own courage if there is to be anything decisive attained."

399. Feininger to Tobey, 27 October 1955, reprinted in Moeller, *Years of Friendship*, 216.

400. Feininger to Tobey, 27 October 1955, reprinted in Moeller, *Years of Friendship*, 216.

401. Feininger to Tobey, 28 September 1955, reprinted in ibid., 210.

402. Feininger to Tobey, 31 August 1954, reprinted in ibid., 166.

403. Feininger to Schmidt-Rottluff, 3 January 1956, LFP-HCL.

Piemouth comes to the rescue of the Kin-der-Kids

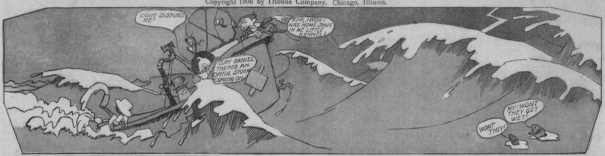

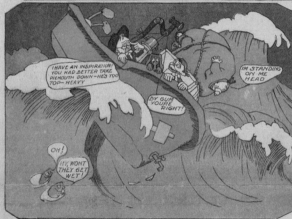

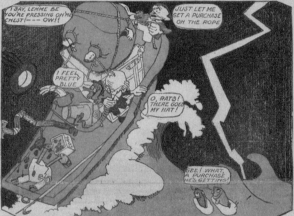

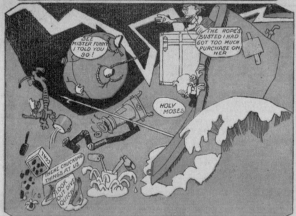

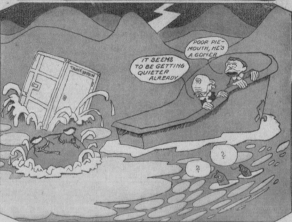

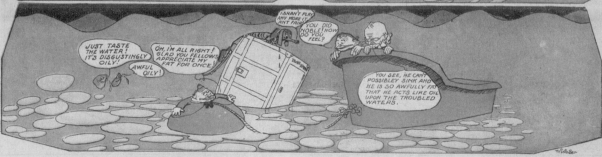

Graphic Poetry:

Lyonel Feininger's

Brief and Curious

Comic-Strip Career

John Carlin

No matter how great their talent or vision, very few artists get to participate in the birth of a new medium. Yet that is what Lyonel Feininger did in 1906, the precise moment when newspaper comics transformed from a popular medium into an art form.

Aside from a six-month stay in Paris in 1892–93, the American-born Feininger had then been living in Germany since 1887 and had built a successful career as a cartoonist and illustrator, publishing drawings in prominent German and American magazines. As early as 1894, the twenty-two-year-old artist wrote to his childhood friend from New York, Frank Kortheuer, "I am . . . devoting all my work to developing a field of illustration in which I shall feel myself contented."[1] Most of these early drawings were very good, but they would have been lost in the dustbin of history except for two things: Feininger later became an important fine artist; and in 1906 James Keeley, editor of the *Chicago Tribune*, visited Germany and hired five local cartoonists to elevate the degraded medium of Sunday comic strips into something more suitable to the tastes of his aspiring middle-class readers.[2] That path had been blazed in the *New York Herald* by the cartoonist Winsor McCay (1867–1934), whose *Little Nemo in Slumberland* began in 1905 and within a few short months established the primary formal vocabulary of artistic expression in comics for the next hundred years.[3]

American newspaper comics originated in the late nineteenth century with dramatic single-panel drawings—notably Richard Outcault's *Yellow Kid*—that introduced humorous situations and odd characters rather than merely illustrating fashion, art, and entertainment in connection with news stories and feature articles.[4] In the 1890s, newspapers were the preeminent form of American popular culture, and they served to create the shared sense of social reality as much as to report on it, just as the Internet and mass media do today.

The first newspaper comics were crude and unsophisticated compared to the illustrated drawings that had become an important part of American culture in the days before photography through magazines such as *Harper's Weekly*, for which Winslow Homer (1836–1910) created illustrations reporting on the Civil War and domestic prints that paralleled and rivaled his great paintings of the period such as *Snap the Whip* (1872). Magazine illustration reached its peak with the barbed political drawings of Thomas Nast (1840–1902) for *Harper's*, which were sophisticated in both conception and execution (fig. 193). His crosshatch style and use of dramatic caricature set the tone for what was considered great professional illustration in America throughout the late nineteenth century. Nast's most important disciple was a talented illustrator named Frederick Burr Opper (1857–1937), whose work in *Puck* and *Harper's* is among the most skillful of any artist at the time—though it was also derivative and uninspired. Around 1900, Opper was hired by William Randolph Hearst and began to transform his style into something much more crude and original for his comic strips and editorial illustrations (fig. 194). In the process, he helped invent a new form in which artfully rendered imagery was replaced by seemingly casual, antic doodles that conveyed the humor and

hectic rhythm of modern America. Opper produced some of the earliest and most interesting serialized comic strips for Hearst, including *And Her Name Is Maud* and *Happy Hooligan*, which improved upon Outcault's rather crude but wildly popular groundbreaking strip *Buster Brown*, as well as other successful comics such as *The Katzenjammer Kids*, first drawn by Randolph Dirks and modeled on the *Max and Moritz* series (fig. 195) by the German illustrator Wilhelm Busch (1832–1908).

Busch had also been a primary influence on Feininger in his early magazine illustration work. In another letter to Kortheuer, Feininger wrote: "I am going to send you one of Wilhem Bushes [*sic*] german caricature books. They are not very finely drawn but they are full of life and humor."[5] The key ingredient of Busch's success was a continuing cast of characters who got in and out of trouble in humorous ways that were conveyed through the style of the drawings as much as the stories and dialogue. They were funny to look at, which is what caught the eye of the popular audience as well as young artists such as Feininger.

THE "BRAINS"
THAT ACHIEVED THE TAMMANY VICTORY AT THE ROCHESTER DEMOCRATIC CONVENTION.

In some ways, Feininger may have been looking for Keeley in 1906 as much as the editor was looking for him. Then in his mid-thirties, the American artist had reached the highest level of his profession as a freelance magazine illustrator, but he was frustrated because his work was done at the service of editorial direction and was not entirely under his artistic control. He did not have "final cut," as it were. Keeley gave it to him, along with a contract worth $6,000, a huge sum at the time, to produce two comic-strip series: *The Kin-der-Kids* and *Wee Willie Winkie's World*.

The money allowed Feininger and his soon-to-be wife to move to Paris in July of 1906, where he would come in contact—at precisely the right time—with avant-garde art, another medium giving birth to something radical and new at the dawn of the twentieth century. At the same time as he was drawing comics for the *Chicago Tribune*, he was also contributing to the vanguard Parisian magazine *Le Témoin*, along with other young artists, including Juan Gris (1887–1927) and Félix Vallotton (1865–1925), who would figure in the rise of modern art.[6] Feininger's Parisian illustrations share stylistic elements with his comics, notably exaggerated caricature and simplified flat designs, but they were mostly single-panel drawings rather than panels arranged on a page.

Feininger was one of five illustrators from Germany who debuted in the *Tribune* in 1906; the others were Hans Horina (personally recommended by Feininger), Karl Pommerhanz (1857–c. 1940), Victor Schramm, and Lothar Meggendorfer (1847–1925). While the other four artists simply continued to produce their European style of

humorous illustrations in a larger size for an American audience, Feininger, the only American among them, explored the possibilities offered by the new format. The *Tribune* celebrated his arrival in the comic pages by calling him "the most popular cartoonist in Germany's capital" and proclaiming, "There is no better draftsman in the world than Mr. Feininger."[7] He took full advantage of the opportunity, elevating his own career as an illustrator by creating an entirely new form that was suited to the newspaper page but exceeded what any other cartoonist, except McCay, was capable of doing at the time.[8]

By 1906, full-page color newspaper comics had been around for about ten years, typically appearing in a Sunday supplement, but many of the elements we associate with the form—sequential drawings with word balloons telling a humorous or adventurous story over time—had not yet emerged. Most comics were single panels with characters arranged in a single location with dialogue, as in *Yellow Kid*. Dirks's *Katzenjammer Kids* (also called *The Captain and the Kids*) and Outcault's *Buster Brown* began using a sequence of panels that could be read from left to right, top to bottom to create a situation or scene. The prototype for this approach had existed in Europe for decades, notably in the prescient work of the Swiss caricaturist Rodolphe Töpffer (1799–1846) and to a lesser degree in that of Busch, who arranged sequential drawings to denote action. In America, A. B. Frost (1851–1928), a student of Thomas Eakins familiar with the motion studies of the English photographer Eadweard Muybridge (1830–1904), pioneered a similar use of sequential drawings by the 1890s. The essential element that McCay and Feininger added to the form was an overall pattern or design that allowed the page to be read both as a series of elements one after the other, like language, and as a group of juxtaposed images, like visual art. This design became the cornerstone of artistic expression in comics, demonstrating that the medium was capable of multilayered expression without sacrificing its playful and childlike appeal.

Feininger's first full-page comic appeared in the *Chicago Sunday Tribune* on May 6, 1906 (see fig. 20). A tour-de-force single panel that shows off his virtuosity as a draftsman and designer, it depicts the "Kin-der-Kids" coming toward the reader as they sail past the Statue of Liberty out of the New York Harbor.[9] Feininger did not introduce the multipanel design until two weeks later, with a masterful page in which a series of whales dances around the main characters' "tub" boat in the story as well as in the page design (fig. 196). He also began to treat the edges of the panels as a design element, using cut corners to create a half-diamond shape on top and bottom and full diamond in the center.

fig. 194. Frederick Burr Opper, **"Alice in Plunderland,"** c. 1905
Pen and ink on paper
Collection of Art Spiegelman

fig. 195. Wilhelm Busch, **"Second Prank,"** from *Max and Moritz: A Story of Seven Boyish Pranks*, 1865

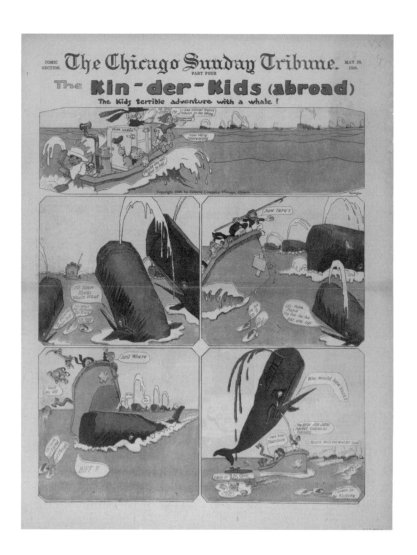

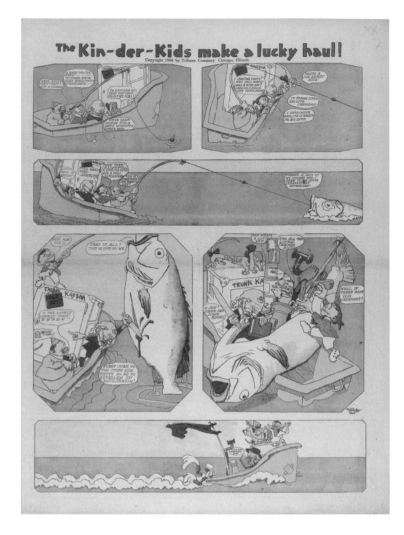

fig. 196. **The Kin-der-Kids (Abroad), "The Kids, Terrible Adventure with a Whale!"**
From the *Chicago Sunday Tribune*, May 20, 1906
Commercial lithograph, 23⅜ x 17¹³/₁₆ in. (59.4 x 45.3 cm)
The Museum of Modern Art, New York; gift of the artist
260.1944.4

fig. 197. **The Kin-der-Kids, "The Kin-der-Kids Make a Lucky Haul!"**
From the *Chicago Sunday Tribune*, June 10, 1906
Commercial lithograph, 23⅜ x 17¹³/₁₆ in. (59.4 x 45.3 cm)
The Museum of Modern Art, New York; gift of the artist
260.1944.6

Feininger's use of borders as design elements rather than invisible frames for the sequential pictures seems to be something he invented by applying American design techniques he admired, such as "glass windows and hanging electric lamp fixtures by the Tiffany company,"[10] to the printed page in a manner that also suggests Art Nouveau as well as British Arts and Crafts designs in the work of artists such as William Morris (1834–1896). In all of these turn-of-the-century aesthetic models, organic natural forms became abstract formal elements in a way that anticipated modern non-objective art.

At the same time, Feininger applied lessons he gleaned from Japanese prints, perhaps by way of poster designs by European artists such as Henri de Toulouse-Lautrec (1864–1901; fig. 202). The author of a 1952 article about Feininger in the *New York Times* noted that the artist kept two Japanese prints "under a glass-top on the coffee-table in [his] living room" and reported that the artist recalled wanting, in 1906, to get "some of that effect, the clear silhouette, the angular gesture" in his comics.[11] Two weeks after the whale page appeared, Feininger raised the stakes with a masterful arrangement of waves (fig. 192) that echoes the famous woodcut *The Great Wave at Kanagawa* by the Japanese artist Katsushika Hokusai (1760–1849; fig. 198), as well as spidery bolts of lightning that create another design element across the page. This

fig. 198. Katsushika Hokusai, **The Great Wave at Kanagawa,** from **Series of Thirty-six Views of Mount Fuji,** 1831–33
Woodblock print, 10 x 15 in. (25.4 x 38.1 cm)
The Metropolitan Museum of Art, New York; H. O. Havermeyer Collection, bequest of Mrs. H. O. Havermeyer, 1929 JP1847

fig. 199. Utagawa Hiroshige I, **Carp (Koi)**, from the series **An Assortment of Fish (Uo tsukushi),** c. 1835–39
Woodblock print, 6¾ x 9 in. (17.2 x 22.9 cm)
Museum of Fine Arts, Boston; Chinese and Japanese Special Fund and the William Sturgis Bigelow Collection 50.663

Japanese influence reached full flower the following Sunday in a comic in which the Kids capture a fish the size of a whale (fig. 197), a work that shares its scale and dramatic use of formal elements of print texture and color with a famous woodcut of a single leaping fish by Utagawa Hiroshige (1797–1858; fig. 199).

Feininger remained in Europe while these remarkable pages appeared inside the largest-circulation newspaper in the American Midwest, so it is hard to know what he was looking at and whether he was influenced by cartoonists in other American newspapers at the time. In New York, McCay was at the start of an almost six-year run of *Little Nemo in Slumberland* (along with a more adult and even more darkly surreal serial called *Dream of the Rarebit Fiend*). The first few Sunday *Little Nemo* pages show McCay's inventive and restless mind seemingly working through most permutations of what an artist could do with a Sunday comic strip (fig. 200). He plays with the ideas of color, panel design, and overall page design and hints at narrative sequences that go beyond a single page and extend over time. He also plays with the idea of sequential motion, famously captured by Muybridge's photographs and inspiring the other great American popular medium of the time: movies.

In contrast to McCay's extended engagement with comics, Feininger's newspaper work lasted less than a year, but his approach was more refined, decorative, and poetic. McCay largely left comics behind after 1910 to pioneer the invention of another, perhaps more influential medium: animated films. Feininger, on the other hand, evolved into a seminal early abstract artist who used his training in caricature and print design to bring to life single-panel paintings, prints, and drawings. In many ways, McCay pioneered what we now call graphic novels, using sequential panel drawings to explore complex aesthetic, social, and psychological topics, while Feininger's work initiated something closer to what could be called graphic poetry.

The poetic aspect of Feininger's comics is borne out in the formal complexity of individual Sunday pages such as the nineteenth in the series, which depicts a chimney

sweep helping another character climb back onto the pitched roof atop an urban garret apartment (fig. 21). As in most of Feininger's work, the story and text are secondary to the graphic poetry, as the artist plays with the idea of panels by creating what appear to be three vertical panels in the top row and two horizontal panels below separated by decorative borders. In the top row, the apartment window forms another sort of panel sequence, which itself is divided into four smaller panels by the window frame. In addition to the playful use of framing devices, Feininger creates an overall mood for the piece through contrasting gray and blue tones as well as a musical rhythm from the repetition of the pitched roof in each of the five panels. This masterful arrangement gives the page visual complexity far beyond the simple story being told.

This approach was even more apparent in his other *Tribune* comic strip, *Wee Willie Winkie's World*, which had almost no action or humor. Rather, it was a kind of organic tone poem in which the familiar elements of the world around the tiny central figure grow to symbolic and expressive proportions. In the complete run of eighteen pages, Feininger's use of designed borders and representational elements such as sticks, clouds, rain, and roads to create overall patterns within the formal boundaries of a rectangular printed page grew to masterful proportions. Such border designs were relatively unique to Feininger's comics and not something that McCay or other comics artists drew in such a deliberate way at the time. McCay, for example, was more interested in the geometry of the page and the apparent optical illusion created through the contrast of flat design and perspective than in the rhythmic interplay of organic forms across the page.

Feininger's comic forms show interesting parallels with the designs of another great American artist coming into his own at the time: the architect Frank Lloyd Wright (1867–1959), whose works from this period, such as the Darwin D. Martin House in Buffalo (1904) and the Meyer May House in Grand Rapids, Michigan (1908), also combined organic elements culled from nature with design patterns that augured twentieth-century abstract art. Windows designed by Wright for the Martin House (fig. 201), for example, parallel Feininger's border designs, showing a general propensity for such organic abstract forms in various types of art at the time.

Feininger's prescient originality in comic art can also be understood in light of his background in music. His father was a concert violinist, and Lyonel first went to

fig. 200. Winsor McCay, **"Little Nemo in Slumberland,"** 1908
From the *New York Herald*, July 26, 1908
Private collection

fig. 201. Frank Lloyd Wright, **pair of pier cluster windows,** 1904
Clear glass, iridized glass, cathedral glass, gilded glass, and brass cames, 41 ½ x 26 in. (105.4 x 66 cm)
Fabricated by Linden Glass Company for the Darwin D. Martin House, Buffalo, New York

Germany at age sixteen to study music. *Wee Willie Winkie's World* brings to the Sunday comics page a type of tone poem similar to those being produced in avant-garde classical music, in compositions such as Igor Stravinsky's *The Rite of Spring*, which premiered in 1913, or by Charles Ives (1874–1954), whose *Central Park in the Dark* (1906) features pop tunes from New York nightclubs that clash with natural sounds of the nearby park. Although we do not know whether Feininger heard such compositions at the time, Ives's approach in *Central Park* finds an echo in one of Feininger's *Wee Willie Winkie's World* pages in the relationship between a manmade windmill and the moon and clouds. The angle of the path through the meadow in this comic also mimics the shape of the windmill, creating a subtle visual "rhyme" like a poem or a theme repeated in a piece of music.

One of the most plausible musical touchstones for this approach to nature as a relationship of abstract elements is Claude Debussy's celebrated *Prelude to the Afternoon of a Faun*, which premiered in 1894 and is based on a poem by Stéphane Mallarmé. The *Prelude* uses unusual formal composition and instrumentation to create a sense of nature through the experience of listening rather than through direct representation, much as the scenes in *Wee Willie Winkie's World* are meant to suggest nature as it is experienced by the central character (and the reader), rather than in a literal way.[12]

Debussy created discrete units of sound, sometimes called "cells," which he combined in an abstract rather than linear way.[13] Feininger also used abstract formal relations to create a mood through visual symbolism. He then established visual echoes among the various natural and pastoral elements to evoke the feeling of nature rather than merely representing it. This goes beyond what other groundbreaking graphic artists did in their popular poster designs. In a poster promoting the dancer Jane Avril, Toulouse-Lautrec conveys the cacophony of a cafe concert by crowding the composition and jamming a large double bass into the foreground so you have to literally get past the instrument to enter the space (fig. 202). Toulouse-Lautrec arranged lines and forms to create an impression of the relationship between how we experience musical and visual forms. Feininger, in these eighteen seemingly simple comic-strip pages, done at the very beginning of the medium, reaches as far as any artist has been able to in creating pages you can enter into and read, while at the same time using color, form, and a novel kind of visual poetry to elevate the experience into something that connects our humanity with the world the artist brings to life.[14]

fig. 202. Henri de Toulouse-Lautrec, **Jane Avril,** 1893
Lithograph, 51⅛ x 37⅜ in. (129.9 x 95 cm)
Los Angeles County Museum of Art; gift of
Mr. and Mrs. Billy Wilder 59.80.15

After his brief, creative, and lucrative stint as a newspaper cartoonist, Feininger went on to become a seminal modern artist, which is the primary subject of this exhibition. Aspects of his skill and innovation as an illustrator and newspaper comics pioneer informed his entire career, from the woodblock toys resembling comic characters that he made for his children, to the caricature figures reading newspapers in his early paintings, to the unique musical quality of line and color in his mature work. These aspects of his work are products of many years of masterful practice organizing forms within rectangular panels. In his mature art, Feininger continued to work in series so that the relations of shapes such as buildings and cathedrals echoed one another across multiple compositions. Never again, however, did he compose multiple panels of imagery within a single frame.

As a cartoonist, Feininger stands somewhat apart from the main evolution of the form because his work was so early and so fully mature at a time when the public was not ready to accept and celebrate the medium as art. It would be almost two decades before work such as George Herriman's *Krazy Kat* could become a cornerstone of critical and artistic appreciation,[15] and almost eighty years before Art Spiegelman's *Maus* showed that funny drawings could be powerful media for personal, social, and formal expression. At the dawn of comics, Feininger seemed to see and be capable of producing the medium in a fully mature way. *The Kin-der-Kids* and *Wee Willie Winkie's World* are the proud and capable grandparents of Spiegelman's *In the Shadow of No Towers* and Chris Ware's *Jimmy Corrigan*, among a parade of interesting contemporary artistic comics that look back with respect and awe to the work Lyonel Feininger created in just a few months in 1906.

1. Feininger to Frank Kortheuer, Berlin, 2 April 1894, collection of the late Horace Richter, Atlanta.

2. Ulrich Luckhardt, *Lyonel Feininger* (Munich: Prestel, 1989), 15.

3. See John Carlin, "Masters of American Comics: An Art History of Twentieth Century American Comic Strips and Books," in *Masters of American Comics*, ed. John Carlin, Paul Karasik, and Brian Walker (New Haven: Yale University Press, 2005), 28–37.

4. For an overall history of comics, see ibid., 25–175.

5. Feininger to Kortheuer, Berlin, 8 March 1890, collection of the late Horace Richter, Atlanta.

6. Luckhardt, *Lyonel Feininger*, 19.

7. "Tribune's New Comic Supplement Begins Next Sunday," *Chicago Daily Tribune*, 29 April 1906, J2.

8. Feininger also provided initial sketches for two other comic series, *Sir Lance-a-Lot* and *The Timid Pirate*. Luckhardt, *Lyonel Feininger*, 15. According to Luckhardt, Feininger's brief comic-strip career ended in November of 1906 because the *Tribune* insisted that he move to Chicago and he was unwilling to do so.

9. Prior to the appearance of this page, Feininger had published a full-page self-portrait presenting himself as puppet master dangling his characters from strings, with a label protruding from his right ear, signed "your Uncle Feininger" (see fig. 19).

10. Feininger to Kortheuer, 2 April 1894, collection of the late Horace Richter, Atlanta.

11. Aline B. Louchheim, "Feininger Looks Back on 80 Years," *New York Times*, 23 March 1952.

12. Feininger wrote to Alfred Kubin in 1913: "Even the best work, drawn directly after nature, would seem boring and pointless to me if it were an end in itself (that is, the final picture). . . . I have to be seized by the irresistible impulse to form and shape, and *then*, sometimes years later, the picture comes that represents reality as I experience it. The 'real reality,' if I happen to catch sight of it again, looks very paltry compared with my picture." Luckhardt, *Lyonel Feininger*, 17–19.

13. See, for example, Elliott Antokoletz, *Musical Symbolism in the Operas of Debussy and Bartok* (Oxford: Oxford University Press, 2004).

14. This approach to representing nature as a relationship of abstract elements rather than descriptive imagery goes back to Ralph Waldo Emerson's groundbreaking essay "Nature" from 1836.

15. The most important early recognition of Herriman's work (and comics as a potential form of artistic expression) was in Gilbert Seldes's *The Seven Lively Arts* (New York: Harper and Brothers, 1924).

In the Shadow of Bach: Lyonel Feininger as Musician

Bryan Gilliam

fig. 203. **Lyonel Feininger playing the violin,** 1951.
Photograph by Andreas Feininger

It is generally known among Lyonel Feininger enthusiasts that the German-American art-ist came from a musical background and not only played the violin, piano, and organ but also composed fugues—in the academic style of Bach—for piano and organ. Little of this would be very unusual for a cultured German family around the turn of the century, but the Feiningers were hardly bourgeois musical dilettantes. Lyonel's father, Karl, was a world-class concertizing violinist and a composer who drew praise from the revered Hungarian composer and pianist Franz Liszt. Young Lyonel, trained in music since early childhood, was poised for a career in concert violin as well.

Sixteen-year-old Lyonel was sent to study at the very Leipzig conservatory where his father had studied. In a desire to find his own way, he broke with family tradition and embarked upon a path in the visual arts, eventually enrolling in Berlin's Königliche Akademie (Royal Academy) in 1888. By coincidence he shared a student apartment with a musician, Fred Werner, an organist from Australia, who was also studying in Berlin. Werner introduced Feininger to the world of German Baroque music through the great contrapuntal compositions of Johann Sebastian Bach. Music-making in the Feininger home had gravitated toward the nineteenth-century German Romantic tradition, and Feininger's musical encounter with Bach was an epiphany. In a synagogue, not far from their Unter den Linden apartment, Werner played Bach for Feininger, who exclaimed that a new world had opened up for him. Together they studied Bach's *Wohltemperierte Klavier* (Well-Tempered Clavier), two volumes of twenty-four preludes and fugues in all the major and minor keys for keyboard (published in 1724 and 1742 respectively). Feininger's son Laurence claimed that his father not only memorized them but could play any piece transposed to any key.[1]

Violin was Feininger's chief instrument, and although he surely had some key-board training from his mother—a pianist and accompanist of international stature—he admitted to being a mostly self-taught keyboard player with limited technical skill. Obviously there would probably be few, if any, essays on Feininger as an instrumentalist or a composer were it not for his stature as a visual artist. But it is equally true that no study of Feininger as an artist can be called complete without understanding the central role that music played in his life. This essay explores this centrality in the context of the German Kulturnation, in which music served a national role, and through the way music, principally the work of Bach, shaped Feininger's personal journey as an artist.

Karl Feininger's Idealist roots are found in Immanuel Kant and Arthur Schopenhauer, who both posited a world consisting of two fundamental spheres: one outer and physical and the other inner and transcendent, existing *outside* physical expla-nation—in short, a phenomenal realm, which is representational, and a noumenal realm, which is beyond description and sometimes known as the *Ding an Sich* (thing-in-itself). For German artists of Karl Feininger's generation, a group heavily influenced by both Kant and Schopenhauer, the inner realm is venerated as a spiritual space free from the constraints of society, its rules and its laws. It is thus hardly surprising that Schopenhauer

would declare music—non-representational, indeed, invisible—to be superior to all other arts. When Schopenhauer's philosophy of a noumenal inner will first appeared in 1819, it was met with derision and controversy, but by the end of the century—with the help of Richard Wagner's proselytizing—Schopenhauer's ideas were firmly established in most German artistic and intellectual circles, attaining permutations that the philosopher himself might not have understood.

Although he was born in New York, this was the cultural milieu Lyonel Feininger knew during his formative years. His parents were musicians of German origin; Karl was born in southwest Germany in 1844 and came to the United States with his parents in the wake of the failed 1848–49 revolution in Baden. His mother was a pianist who toured Europe and the Americas with her husband. Karl studied violin in the United States with August Koepper, returning to Germany at age sixteen to study at the conservancy in Leipzig with Koepper's teacher, the great violinist and composer Ferdinand David.

Karl Feininger's interest in composition may well have originated during his Leipzig years while under the tutelage of David. Karl made his debut as a composer of large orchestral works in Berlin in 1886 and had other works, including symphonies, suites, and symphonic poems, performed in the German capital during the next couple of years.[2] Lyonel's father was also a committed music educator, and in his book, *An Experimental Psychology of Music* (1909), he sums up years of pedagogy and musical speculation, engaging music from various points of departure, including mechanism, teaching, criticism, and psychology. One of his more unusual conjectures is his theory of the relationship between color, temperament, and tempo (fig. 204). While there is little evidence to suggest that Karl's color hypotheses had any direct effect on his son as a visual artist, Lyonel's personal philosophy and veneration of music as the "language of [his] innermost life" suggest that the theories expressed in his father's book made an impression.[3] The ideas Karl proposed in his 1909 study were likely communicated to Lyonel as a child when he studied violin with his father—including Karl's interpretation of Schopenhauer's noumenal inwardness as containing a mystical-religious dimension in which the will is associated with a Christ-like state of grace. Karl even went so far as to find religious corollaries to the fundamental triad: the tonic, mediant, and dominant were reflections of God, man, and nature, and, by extension, the father, son, and holy spirit. Lyonel adopted his father's metaphysical notions of music as a meta-art, a healing space

fig. 204. **Karl Feininger's Color-Temperament-Tempo Theory as illustrated in his 1909 book *An Experimental Psychology of Music*** Red: Mental (largo); Orange: Speech (grave); Yellow: Poetry (lento); Green: Romantic (adagio); Blue: Dramatic-Idealism (andante); Indigo: Physical-Spiritual Unity (allegro); Violet: Dramatic (presto)

44 *An Experiential Psychology of Music.*

Light oscillation, distributively or dissipatingly, inclines from perpendicularity to horizontality of motion, producing the primary colors in its gradual transition

FIGURE 18.

from the perpendicular clarity of white into the totally horizontally inclined opacity of black. Colors are, therefore, degrees of reflection and deflection from clarity into

where an imperfect human soul, "failed by visual expression, coils its way in sound to peace and calm."[4] For him, as for his father, music had the power to redeem:

> **My need to communicate is so great that I cannot express it only in words. Often I sit at the organ and search for redemption [Erlösung] in Bach's mighty tones. A fugue or a chorale builds from a world-enraptured transfiguration . . . I am not the most modern [artist] rather a person who must break with his time in order to live. Thus I may live behind the times.[5]**

The highest form of music, in the nineteenth-century German Idealist tradition, is instrumental. Because such music is devoid of words, it is considered ideal for "transcendent reflection."[6] The German Romantic poet and scholar Friedrich Schlegel, who famously called music "the art of this century,"[7] saw this art form as the closest thing to philosophy itself. To Schlegel, the ineffability of music, its "semantic inexhaustibility," made it the most romantic of the arts.[8] Unlike the plastic arts, music's complexities flow from moment to moment in a state of constant growth and evolution. Perhaps this sense of timelessness in music explains some of the infatuation with Bach in nineteenth-century Romantic-dominated Germany. In Bach's own time, richly contrapuntal music was considered anachronistic when compared to the new, fleet Italian style of Georg Phillipp Telemann. The man who was once behind the times became a cultural icon in early nineteenth-century post–French Revolutionary Germany.

Bach and German Romanticism

The Romantic construct of a nonrepresentational inner sublime *(das Erhabene)* that resists concrete description upset the eighteenth-century emphasis on universal reason and privileging the individual (part) over society (whole). The profound inner searching and longing of the individual for the whole can never be assuaged, but the search is nonetheless central to life. This longing is the context for *Bildung*—the uniquely German word comprising elements of education, cultivation, and self-discovery. Feininger saw himself firmly within this tradition. There is, of course, a distinct nationalistic aspect to *Bildung*; German Romanticism is incomprehensible without recognizing it as a response to France, to the Enlightenment, and to Germany's defeat at the hands of Napoleon. Unlike France, which was unified through politics, Germany was unified through culture.[9] In the early nineteenth century there was no German state, only a nation of principalities linked by an overarching idea of a unified culture of literature, philosophy, art, and—most important—music.

Bach's music was central to this conception of a unified German culture. Bach, who was considered old-fashioned in the eighteenth century, returned in the early nineteenth century as the era's artistic hero, his piety, individualism, and disregard for his modern contemporaries attaining mystical proportions. The major German artists and thinkers of this time were all in general agreement: among all composers, Bach was the

closest thing to the divine. By the mid-nineteenth century, Leipzig, the city of Bach, had become a mecca for Romantic composers such as Mendelssohn, who was largely responsible for the great Bach revival. It is in this context that we can better understand Karl Feininger's decision to travel to Leipzig to study violin and his desire for Lyonel to do the same.

Bach and Feininger

By the time Lyonel Feininger arrived in Germany in 1887, the Bach revival was accelerating in a unified German Empire, founded in the year of Feininger's birth, 1871. In 1900, the New Bach Edition, the scholarly edition of Bach's complete works based on critical primary and secondary sources (started in 1851) was published simultaneously with the inauguration of an annual Bach festival to be celebrated in various major cities throughout the empire, beginning with Berlin in 1901. Transcriptions of Bach's enormous organ repertoire were made by renowned composers such as Max Reger, Feruccio Busoni, and Gustav Mahler. Bach, the musical deity who had watched over an imagined early nineteenth-century German nation, was now the symbol of a growing empire. Bach's stature as being both behind and ahead of his time was the bedrock upon which Feininger established his worldview of art.

fig. 205. *The Virtuoso,* 1919
Woodcut, 13 x 18 in. (33 x 45.7 cm)
Kunstsammlungen Chemnitz, Chemnitz, Germany

Feininger's reed organ, made by the Etley Company in Vermont, was as integral a component of his studio as brushes, an easel, and a palette. There, at a moment of creative impasse he might well go to his organ and play Bach fugues as a way of artistic concentration—focusing on the composer's counterpoint, with all its problems and solutions of musical structure and development. From Bach he learned about the organization of sonic space: the thematic subject and answer, retrograde, inversion, episode, stretto, and the like. Feininger admired Bach's rejection of grandiosity in favor of slowly drawing his audience inward into his complex sonic craft. As he often said, the listener was not quickly rewarded when listening to Bach's music, but received higher recompense with effort and study—a quality Feininger identified in his own art. Feininger likewise esteemed Bach's elevation of the provincial to the level of the universal and the metaphysical. As Romantic-era music critic Wilhelm Triest claimed of Bach's music, "[it] provides a satisfaction beyond the satisfaction of an art that merely pleases."[10] Feininger, similarly rejecting "the merely charming in art,"[11] saw his goal as the "realization of his most profound expression."[12]

What so impressed Feininger about the fugue was its ability to express a full range of human emotions, while simultaneously obeying strict contrapuntal laws that were centuries in their making. It would be a fallacy to suggest any one-to-one relationship between the aural and the visual in his work, with theme equated with line or a

mirror image with inversion. Music was far too important for this German Idealist to have it brought down from the higher realm of sound.

Feininger believed that his Cubism—what he called "Prism-ism"—rested upon the foundation of a concentrated monumentality equivalent to Bach's. One wonders whether Feininger knew of Carl Friedrich Zelter's observation that the way to the actively monumental *required* a simplicity that only Bach could produce. Those active visual echoes surrounding the outlines of Feininger's depicted village church exteriors might well be a response to a sonic memory of the grand musical reverberations of Bach.

That sense of visual reverberation dominates the scene in his famous woodcut of a cathedral that adorned the cover of Walter Gropius's 1919 Bauhaus manifesto (fig. 101). It was during this period at the Bauhaus that Feininger went from fugue analysis to actual fugue composition. He welcomed, but never pressed for, the performance of his fugues in public venues and, indeed, there were few public performances of the works during his lifetime—a reflection perhaps of an ambivalence felt by Feininger toward his new medium.

Feininger was enticed by the Bauhaus vision for the arts in Germany, a utopian nostalgia for the German Middle Ages with its focus on a creative *Gemeinschaft* (community) of various forms of art and design—hence Feininger's Gothic cathedral on the Bauhaus cover. But the dominant post—World War I artistic aesthetic rejected this idealism and spirituality as symbols of the bygone Wilhelmine era. Renewed German fascination with Bach did not abate, but it took a different turn during the Weimar Republic. Kurt Weill, for example, composed a little fugue in his prelude to *Die Dreigroschenoper* (The Threepenny Opera) (1928), but all the harmonies are quirky and the orchestration (saxophone, clarinet, trumpet, and trombone, among others) strange by Baroque standards: both aspects were meant to take the audience out of its idealized comfort zone. In short, the overriding aesthetic of the period was one of alienation and irony, something in which Feininger—a generation older than Weill—would take no part.

Feininger remained a post-Romantic believer; while the likes of Weill, Paul Hindemith, and Ernst Krenek were putting Bach in unfamiliar contexts, Feininger composed Bach-like fugues in a remarkably "untimely" style, undisturbed by Viennese serialism, Berlin Neue Sachlichkeit (New Objectivity), or Parisian Musique concrète. The inspiration for his compositional activity between 1921 and 1927 was twofold: first, the artistic interchanges with the musician Hans Brönner in Weimar, including Brönner giving Feininger an edition of Bach's *Die Kunst der Fuge* (The Art of Fugue) (1751), and second, Brönner's gift of a fugue to Feininger for his fiftieth birthday in 1921. Feininger was previously unaware of Bach's final, unfinished magnum opus, which comprises fugues of increasing complexity, and he and Brönner spent long afternoons and evenings playing through the work, discussing the pieces at length afterward. The exercise was instructive. For a self-taught composer, Feininger shows remarkable ingenuity in his contrapuntal works. His fugues, exceedingly difficult to play, served him as a heuristic device to learn

fig. 206. **Feininger at the organ in his studio, Weimar,** 1922. Photographer unknown

fig. 207. *Fugue VI for Organ in C Major,* 1922
Houghton Library, Harvard College Library, Harvard
University, Cambridge, Massachusetts

more about structure and the developmental possibilities of a theme; they show no concern for the practicalities of performance. Indeed, these works can be remarkably unidiomatic for the instrument, and, in some places, he writes for notes lower than the organ keyboard. The parallel fifths and octaves, the occasionally strange leading voice, and idiosyncratic dissonance treatment would have made any teacher of counterpoint scratch his head. But despite the occasional contrapuntal mistakes and harmonic abnormalities, of which Feininger was aware, these works remained close to his heart. Among the dedicatees of his fugues was his father, for whom he wrote his longest fugue in 1922—the year of Karl Feininger's death.

Lyonel Feininger brought his gifts as a graphic artist to the notation of his musical scores. His fugues were as meticulously written out as they were musically constructed; the presentation of the notes was no less important than the contrapuntal layout of the subjects and answers—their call and response. Such visual precision was the result of a notational stencil he crafted out of zinc, complete with clefs, stems, note heads and the like so that the final manuscript deceptively looked like a published score.

Feininger's last completed fugue dates from 1927, and he never openly explained his reasons for not writing music after that point. It was well known that his wife, Julia, herself a painter and amateur musician, was increasingly opposed to his composing, which had overtaken his preoccupation with painting.[13] Given that his artistic output decreased dramatically between 1922 and 1927, she might well have felt that his time-consuming musical compositions compromised his livelihood as a painter. By 1927, the year of the first Nuremberg Rally of the National Socialists and two years after the publication of the first volume of Adolph Hitler's *Mein Kampf*, the survival of German democracy was an open question. Regardless of whether or not this directly impacted Feininger's music-making, the growing menace of Nazism made it a stressful time for him. As his son Laurence later observed, "he was already thinking of leaving Germany

and could not compose in peace."[16] In America, Laurence suggested that "the vastly altered conditions of living and especially the existential worries of the first years in New York, as well as the scarcity of outward inspiration, may have helped prevent him from planning new fugues."[14]

What was a "true believer" such as Feininger to think about an anti-Semitic malignant political movement, which had claimed Bach as its own, as the "most German of all Germans," the greatest German musician of all time? Feininger's faith in the German Kulturnation had never before been shaken, not even during the grim years of the Great War, but he found himself in a strange position: American born, of "Aryan" blood, and married to a Jew. Feininger, the artist, thought he could find refuge from politics in his studio—with painting and music—but the outside world kept intruding. Despite threats and denouncements, he stayed in his beloved Germany, in a state of uncanny silence and denial, until 1937, when many of his modernist colleagues had already left.

But his was a unique emigration: an American artist taking refuge in his native country while retaining a firm lifelong belief in the superiority of German culture, despite a malicious Nazi government that rose to power and claimed its own German cultural dominance. Feininger embraced America, never having given up his U.S. passport, and continued to play Bach and Dietrich Buxtehude on the reed organ in his New York studio. Later he bought a Baldwin upright piano for his living room, having left his Bechstein grand piano behind. He continued to play on both keyboards every day as an intellectual and spiritual exercise. "I guess that's heaven," he wrote his friend Mark Tobey in 1949: "In painting, music, and *nature* the same spirit of advance, continuation, the beat of the heart, the trembling leaves in a forest, a breathlessness, halting and advancing again—the dark charm of night."[15]

1. Laurence Feininger, *Das musikalische Werk Lyonel Feininger* (Tutzing, Germany: H. Schneider, 1971).

2. "Karl Feininger Dead. Violinist and Composer. Dies at His City Home at 77 Years." *New York Times*, 2 February 1922.

3. Feininger to Julia, 9 November 1929, reprinted in *Lyonel Feininger*, June L. Ness, ed. (New York: Praeger, 1974), 193.

4. Feininger to Adolf Knoblauch, reprinted in Ness, *Lyonel Feininger*, 30–31.

5. Ibid.

6. Mirko M. Hall, "Friedrich Schlegel's Romanticization of Music," *Eighteenth-Century Studies* 42, no. 3 (spring 2009), 414.

7. Ibid.

8. Ibid., 418.

9. Two book length studies discuss, analyze, and contextualize this important European cultural split: Louis Dumont, *German Ideology: From France to Germany and Back* (Chicago: University of Chicago Press, 1994) and Wolf Lepenies, *The Seduction of Culture in German History* (Princeton, NJ: Princeton University Press, 2006).

10. Wilhelm Triest, quoted in Gerhard Herz, "Johann Sebastian Bach in the Early Romantic Period," *Essays on J.S. Bach* (Ann Arbor, MI: UMI Research Press, 1985), p. 80.

11. Feininger, May 1914.

12. Feininger to Paul Westheim, 14 March 1917, reprinted in Ness, *Lyonel Feininger*, 27.

13. Julia's uncle, Albert Bing, was the Kurt Weill's first music teacher.

14. Laurence Feininger, *Das musikalische Werk Lyonel Feininger*.

15. Feininger to Tobey, 1949, reprinted in *Years of Friendship 1944–1956: The Correspondence of Lyonel Feininger and Mark Tobey*, Achim Moeller, ed. (Ostfildern-Ruit: Hatje Cantz, 2006), 87.

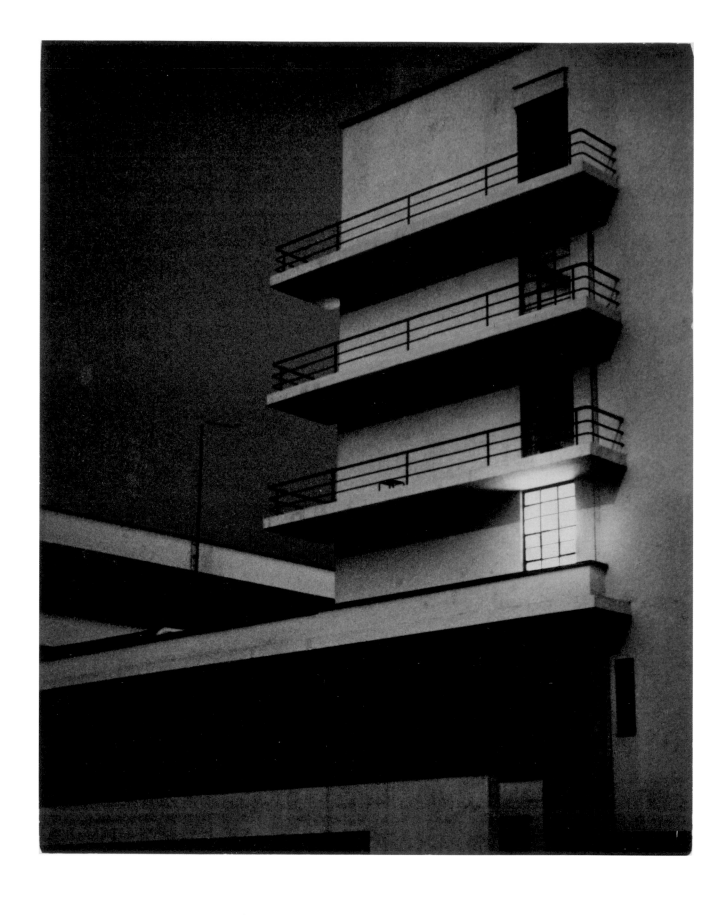

The Inveterate Enemy of the Photographic Art: Lyonel Feininger as Photographer

Sasha Nicholas

Lyonel Feininger wore many guises as an artist and creator—painter, printer, illustrator, comic artist, toy maker—but he is seldom thought of as a photographer. Among the members of the Feininger family, that title is usually reserved for Andreas, Feininger's eldest son, who earned renown for his panoramic depictions of America following World War II, and also for T. Lux, the youngest of the Feininger children, whose photographs of Bauhaus life in the 1920s are among the most lively documents of daily life at that legendary institution. Like his sons, however, Feininger was an avid photographer who amassed an enormous cache of eighteen thousand slides and negatives over the course of his lifetime.[1] In 1928, the year Feininger began his intensive engagement with photography, he ranked as one of the most famous and highly respected painters in Germany. Approaching his late fifties, he was living at the Bauhaus in Dessau, where he held the prestigious title of Formmeister (Master of Form). In the years to follow, photography would become one of Feininger's central pursuits. By the time he returned to America in 1936 after a fifty-year absence, the artist had produced more than four thousand negatives of motifs that had occupied his art throughout his career—railroads, Baltic seascapes, the winding lanes and vernacular architecture of German cities and towns.[2] Feininger neither explained his decision at the height of his career to delve into photography with such fervor, nor did he clarify the place of these images within his oeuvre. The photographic archive he left behind thus stands as a kind of enigma. A closer look, however, reveals that photography offered Feininger another creative guise—one that would become as varied and multivalent as his other endeavors and offered aesthetic lessons that informed the rest of his art.

Few studies of Feininger's work examine his photography; those that do typically suggest that the artist's interest in the medium emerged only in the late 1920s.[3] His engagement with the camera actually began decades earlier, in his first years working as a painter. In 1892, the twenty-one-year-old Feininger, then a student at Berlin's Königliche Akademie (Royal Academy), was excitedly describing his plan to buy a camera to his friend Alfred Churchill (1864–1949)—a decision that conflicted with his apparent antipathy toward photography:

> **Think of it, dear Al! I, the inveterate enemy of the Photographic art, at least such you knew me for formerly, am, if I find I can conveniently afford the outlay, going to buy me a good camera suited to out-of-door work and arranged for both instantaneous *sun*-studies or for time exposures when there is no strong sunlight. I got a prominent photographer to show me some cheap and yet efficient cameras, yesterday, and find that for thirty-four and forty marks I can get a first class little instrument, taking photo twelve by nine centimeters.[4]**

Feininger did not raise the subject of a camera again in his letters for several years, but if he had bought one, he would have been among the earliest amateurs to explore the medium. Eastman, the first company to produce gelatin roll film cameras,

fig. 208. **Untitled (Bauhaus Dessau, Studio Building from the South, Night),** 1929
Gelatin silver print, 7 x 5⅝ in. (17.9 x 14.3 cm)
Bauhaus-Archiv, Berlin

introduced its first Kodak in 1888; by 1900, dramatic price decreases had made film cameras much more accessible to the general population.[5] It is certain that Feininger acquired a camera by January 1903, when he lamented to his childhood friend Frank Kortheuer about having spent the equivalent of ten dollars on his Folding Pocket Kodak Camera. Though Kodaks had become highly affordable in the United States, the company's monopoly in Germany, Feininger complained, allowed it to charge exorbitant prices not only for cameras but for "wretched" quality film.[6] The artist's awareness of technical details and comments about his process hint that he was already using photographs as a compositional tool for his illustrations, shooting at a variety of angles in order to evaluate different views of a subject. "The days are gone when I need to take six and eight dozen snapshots of things," he explained to Kortheuer.[7]

Photography continued to play a role in Feininger's early development as he transitioned from illustration work to oil painting. In 1906, when he began to plan his first oil compositions, he took photographs and made sketches in tandem.[8] The few extant negatives from that year, produced at his favored summer retreat, the island of Rügen in the Baltic Sea, portray the Impressionist-inspired imagery that the artist would depict in oil the following year: sun-drenched fields, haystacks, and thatched cottages (figs. 209–11).[9] Exploring subjects from the dual perspectives of photography and drawing likely served as a confidence-building exercise as Feininger reached a critical juncture in his career. At this point, however, he seemed to view photography as a tool rather than as an end in itself. Indeed, he had argued since his days as a student in Berlin that photographic realism and painterly imagination were incompatible. Feininger's new ventures into painting strengthened his commitment to the idea that copying directly from nature stifled both emotional expression and formal invention. "Any naturalistic imagery produced in situ," he would later write, "always remains captive to some degree of rationalistic reproduction which it is our task to eliminate. It is for us to seek our own, uninfluenced final form for our expression of longing."[10]

fig. 209. **Untitled (Haystacks),** before 1906
Negative, 3¾ x 4¾ in. (9.5 x 12 cm)
Harvard Art Museums, Busch-Reisinger Museum,
Cambridge, Massachusetts; gift of T. Lux Feininger
BRLF.675.150

fig. 210. **Untitled (Haystacks),** 1906
Graphite on paper, 5¼ x 8½ in. (13.3 x 21.6 cm)
Harvard Art Museums, Busch-Reisinger Museum,
Cambridge, Massachusetts; gift of Julia Feininger BR63.361

For compositional inspiration Feininger began to turn to his trove of "nature notes" or *natur-notizen*—rapid drawings he made on site and saved until an impulse triggered him to adopt a sketch as the basis for a painting. Feininger began producing the nature notes during his student years, initially using them as the basis of illustrations and subsequently as inspiration for his oils. Often, he would return to a nature note years after creating it, as with the 1906 sketches from Rügen that informed the oils he painted the following year. As Feininger delved into painting, he began to rely on the percolation of the image through time and memory to animate his paintings with an ineffable spiritual presence that he felt realism alone could not capture. The apparent straightforwardness

of photography—a quality encapsulated by Eastman's famous 1888 slogan, "You Press the Button, We Do the Rest"—must have seemed antithetical to this process. Thus it is no surprise that the ambivalence about photography Feininger voiced in his 1892 letter to Churchill returned, and he abandoned the medium as a creative pursuit in 1907. The term "photographic" became, for him, synonymous with apathetic ease; to make paintings based on "simple, large color planes keyed together on the painting surface," he stated, "is the aim; not photographically diversified modulation of color. Clear forms, which carry the space element and the subject in all simplicity and directness."[11] From 1907 until 1928, he used photography exclusively for family snapshots and as a tool for documenting his work.

Feininger's interest in photography resurged in 1928 at the Bauhaus in Dessau, when he created a series of works marked by a modernist ambition and formal prowess that rivals any other Bauhaus photography of the period. Late that year and into the spring of 1929, he began roaming around the school's grounds at night, taking a group of hauntingly atmospheric shots of the faculty housing and new academic buildings designed by Bauhaus founder Walter Gropius (1883–1969) (figs. 208, 213). Feininger's most immediate inspiration for returning to photography was his children's sudden enthusiasm for the medium during the mid-1920s. In 1925, nineteen-year-old Andreas started shooting with his mother's old Goertz-Anschutz glass-plate camera and was soon deeply devoted to the medium; that same year, fifteen-year-old T. Lux had discovered what he later described as an old Kodak box camera (probably the Folding Pocket Kodak that Feininger purchased in 1903) in the attic in Weimar and soon carried a camera with him almost constantly.[12] A fascination with photography had caught on among Feininger's other children as well; Lore Feininger, the artist's eldest daughter from his first marriage, began working in the studio of a fashion photographer in Berlin and taking portraits independently, and Feininger's middle son, Laurence, was experimenting casually with the medium.[13]

This flurry of activity captured Feininger's attention. As T. Lux later recalled, "our photographing rather copiously gave him somehow the idea he would like to do it too."[14] By 1927, another key development had made the medium more accessible: Andreas outfitted the cellar of the family's newly constructed Master House at 3 Burgkühnauer Allee in Dessau with a makeshift darkroom and an enlarger. The family also acquired several new cameras, including the one that Feininger would bring on his first photo expeditions in Dessau: the Voigtländer Bergheil, a glass-plate folding camera designed for ambitious amateurs.[15] Experimenting with this device, particularly its heavy glass plates, was cumbersome but rapidly instructed Feininger, as T. Lux described, "not to waste things but to limit oneself to essentials. . . . to pay close attention to the light."[16] Advice on printing and paper (the latter was almost a fetish for Feininger) likely came from Andreas, whose innate proclivity for mechanics made him a masterful technician.[17]

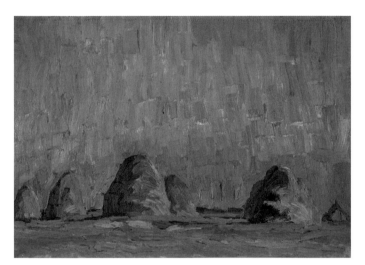

fig. 211. **Haystacks,** 1907
Oil on board, 13¾ x 19⅝ in. (34.9 x 49.8 cm)
Private collection; courtesy Moeller Fine Art, New York and Berlin

Despite these developments at home, Feininger's resumption of photography is surprising given his former ambivalence about the medium, which was piqued once again amid the debates surrounding Gropius's controversial decision to hire László Moholy-Nagy (1894–1946) to replace Johannes Itten as director of the Bauhaus introductory course in 1923. In the years immediately after the school's 1919 founding, photography had no place in the pedagogical program and few students practiced it.[18] This changed with the arrival of the young Hungarian Moholy-Nagy, whose first Bauhaus

book, *Malerei Photographie Film* (1925), set out the radical thesis that an authentically modern visual language could spring only from the camera's mechanical eye. Photography was not formally introduced into the Bauhaus curriculum until 1929 with the hiring of Walter Peterhans, but Moholy-Nagy's ideas compelled students and Masters alike to take the medium more seriously.[19] Under his influence, an array of energized young students began to experiment with the techniques he advocated, including unconventional perspectives, fragmentation, photograms, and multiple exposures. These were made possible by the Leica I, the first highly portable, short-exposure, user-friendly 35mm film camera, which became nearly ubiquitous among Bauhaus students after its release onto the market in 1925.

The changes in Bauhaus life signaled by Moholy-Nagy's hiring were not welcomed by Feininger. By replacing Itten with Moholy-Nagy, Gropius had initiated a broader shift in the Bauhaus's program—moving the school away from its early, rather romantic fidelity to traditional artistic training and disciplines to the maxim "art and technology—a new unity."[20] Moholy-Nagy's *neue sehen* (new vision)—the idea that the purely mechanical vision of the camera could surpass the limits of the human eye and modernize perceptual experience—fit squarely within the new technological regime that Gropius sought to establish. These changes were unsettling to many of the first-generation Bauhaus Masters, including Paul Klee (1879–1940) and Oskar

fig. 212. **Untitled (Lyonel Feininger with Camera),** 1931. Photograph by T. Lux Feininger

Schlemmer (1888–1943), but to Feininger they were abhorrent: "I resist the motto 'art and technology' with full conviction . . . the demand for their conjunction is senseless in every respect. A true technician will justifiably proscribe any artistic comingling; and the greatest technical perfection on the other hand, can never replace the divine sparks of art!"[21] Moholy-Nagy's opposition to traditional easel painting seemed a direct attack on Feininger's faith in the spiritual underpinnings of art, which he believed could only be imparted by the artist's hand. "This essay," Feininger lamented of *Malerei Photographie Film*, "weighs down on my heart! . . . Just optics, mechanics, retiring of the 'old' static painting, which one has to get used to seeing first . . . Gropius regards this attitude as representative and we shall create with our art something antiquated, merely tolerated

fig. 213. **Untitled (Bauhaus),** 1929
Gelatin silver print, 6¹⁵⁄₁₆ x 8½ in. (17.7 x 21.6 cm)
The Museum of Modern Art, New York; Thomas
Walther Collection, gift of Thomas Walther
1669.2001

fig. 214. **Untitled (Bauhaus, Dessau, at
night),** 1929
Gelatin silver print, 7 x 9⅜ in. (17.9 x 23.9 cm)
Bauhaus-Archiv, Berlin

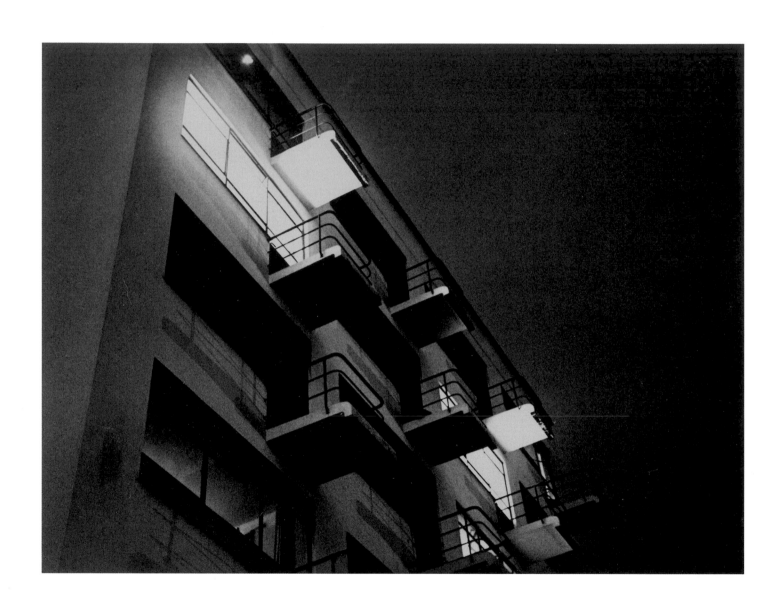

fig. 215. **Untitled (Bauhaus, Dessau, balcony of the atelier building, night),** 1929
Gelatin silver print, 7 x 9⅜ in. (17.9 x 23.9 cm)
Bauhaus-Archiv, Berlin

in the new Bauhaus. In itself [photography] is a technical, very interesting gadget for the masses—but why call this mechanization of all optics by the name of art[?]"[22] Although Feininger continued to live at the Bauhaus and remained loyal to Gropius, the school's pedagogical shift led him to cease teaching in 1925.

By late 1928, when Feininger began to spend his evenings roaming Dessau in search of photographic motifs, the fervor of these debates had subsided—indeed, Moholy-Nagy, who had become Feininger's neighbor, resigned along with Gropius from the school earlier that year. And yet despite his dismissal of the "mechanization of optics" and the "gadget for the masses," Feininger suddenly reengaged with the camera. His first photographs depict the trees and streets immediately around his Master House (see fig. 141). By March 1929, he began portraying the school's new academic buildings—geometric glass shapes emerging gently from the damp evening haze, in soft focus, like ghosts of Gropius's starkly angular designs (fig. 214).[23] Photographing almost exclusively at night allowed Feininger to expand on his painterly explorations of what he called the "magical, veiled world" that appeared early or late in the day.[24] Moisture in the air and street-lamp reflections offered him a range of light effects to explore and manipulate. "I intentionally did not focus sharply," he told his wife, Julia, "the almost full moon was hanging high in the hazy sky and there were many lanterns in the horizon . . . this looks very strange, long stretched out layers of light and dark stripes illuminated by lights like round accents, all in a foggy haze."[25]

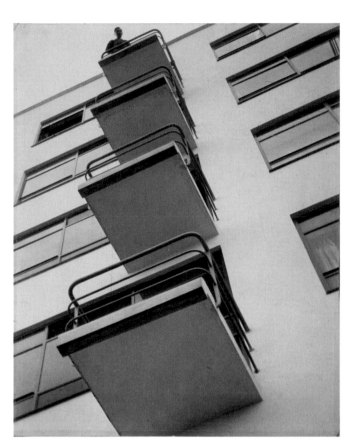

fig. 216. László Moholy-Nagy, **Bauhaus Balconies,** 1926
Gelatin silver print, 19½ x 15½ in. (49.5 x 39.3 cm)
George Eastman House, Rochester; museum purchase

In other early shots, Feininger experimented with the sharp obliques that Moholy-Nagy had advocated as a method for disrupting conventional perspectives. Indeed, his use of this technique in depicting the façade of the Bauhaus atelier building recalls Moholy-Nagy's photograph of the same subject (figs. 215, 216). The camera, Feininger discovered, was a powerful tool for refreshing his vision: "Dessau has gradually assumed a totally different aspect for me since I have been walking around so much with the camera, and increasingly paying close attention."[26] An indication that this renewed connection with photography enabled Feininger to find resonance in Moholy-Nagy's idea of "new vision" is found in his March 1929 photograph of light streaming into the dark night air from the window of the younger artist's former studio, which was next door to Feininger's own residence (fig. 217).[27] The studio had been reoccupied by Josef Albers after Moholy-Nagy left the Bauhaus in 1928, but Feininger nonetheless titled his photograph *"Moholy's studio window" around 10 p.m.*, the emphasis of his quotation marks suggesting a hint of nostalgic longing for his former colleague. Although he had initially disagreed with Moholy-Nagy's ideas, Feininger came to respect him as a "most amiable, most willing, and lively man" who "took care of the exchange and circulation of the Bauhaus-ideas." After Moholy-Nagy left the Bauhaus, Feininger lamented the loss of his colleague's "friendly strong voice penetrating the walls of my studio."[28]

While the photographs Feininger took of the Bauhaus buildings suggest a kind of rapprochement with Moholy-Nagy and the school's "shutterbugs," they also hold fast to the artist's own idiosyncratic vision.[29] In stressing the dominance of light and atmospheric phenomena over architecture, and by utilizing the long exposures required by the glass-plate Bergheil (as opposed to the more rapid snapshot technology of a Leica), they retain an unearthly, romantic tenor that belies the technological spirit of the Bauhaus buildings and of the photographic medium itself. As images that fuse formalist innovation with a heightened awareness of the artist's hand and time's passage, Feininger's photographs are suspended, like so many of his paintings, between a fascination with modernity and a yearning for a prelapsarian sense of quietude and harmony. In sensibility, these works share as much with the pictorialist movement led by Americans Alfred Stieglitz (1864–1946) and Edward Steichen (1879–1973), who sought to make their photographs emulate paintings, as with contemporaneous photographic experiments at the Bauhaus. Pleased with the photographs he produced in 1928–29, Feininger gave a group of them to Gropius, who admired them so much that he published two in his 1930 book *Bauhaus Buildings Dessau*. This would be the only time that Feininger's photographs appeared publicly during his lifetime; despite the care he took in processing, titling, and signing his prints, he did not seek out an audience for them, perhaps owing in part to the lukewarm support he received from his wife, Julia, who hoped he would focus on painting and only "take photos on the side."[30]

Feininger's Bauhaus photographs stand as independent artistic achievements, but they also correlate to the artist's quest to infuse his canvases with greater transparency in the mid- to late 1920s. During this period, he began to layer thin glazes of oil onto his canvases and then scrubbed them with washes of turpentine to expose the layers of paint underneath, a process that suffused his surfaces with depth and luminosity while reducing some of the formal rigidity that had defined his paintings earlier in the decade. This approach is most directly embodied in *Broken Glass (Glasscherbenbild)* (1927; fig. 128), a highly singular canvas depicting stacked shards of glass as a metaphor for layers of transparent light, and it also pervades architectural compositions such as *Gelmeroda XII (Church at Gelmeroda, XII)* (1929; fig. 139) in which overlapping planes of dappled color transform a modest village church into a monumental, floodlit cathedral. The increasingly central role of light and translucency in his paintings must have made photography especially invigorating for Feininger. In the pair of

fig. 217. ***"Moholy's studio window" around 10 p.m.*** *("Moholy's atelierfenster" abends um 10 uhr)*, c. 1929
Gelatin silver print, 7 x 5 in. (17.8 x 12.8 cm)
Bauhaus-Archiv, Berlin

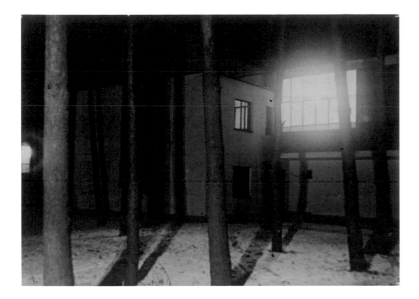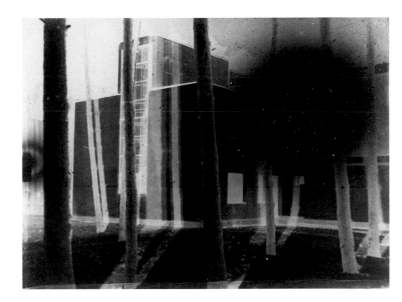

fig. 218. **Burgkühnauer Allee 4, around 10 at night (Burgkühnauer Allee 4, nachts um 10 Uhr),** c. 1929
Gelatin silver print, 5 x 7 in. (12.8 x 17.8 cm)
Bauhaus-Archiv, Berlin

fig. 219. **Untitled (Bauhaus),** c. 1930
Gelatin silver print, 7¹⁄₁₆ x 9⁵⁄₁₆ in. (17.9 x 23.7 cm)
The Museum of Modern Art, New York; transferred from the Museum Library SC.2007.66

positive and negative prints he made of *Burgkühnauer Allee 4, around 10 at night* (figs. 218, 219), a rhythmic composition of trees illuminated by a radiant window in the damp winter air, Feininger uses the medium as a tool for inverting and sculpting light, and for exploring the possibility of seeing both inner and outer structure (a spatial effect also achieved by Gropius's revolutionary glass curtain walls).[31] In some cases, Feininger's photographs guided the creation of works in other media. His evening ventures on the streets of Dessau, for example, led to the painting *Lighted Windows I* (*Beleuchtete Häuserzeile*) (figs. 220, 221), while a series he shot of his hand-carved toys in various configurations inspired a group of architectural drawings with a latticed linearity that presages his late oils. By the end of 1928, the range of creative impulses offered by photography made it a reprieve from the struggles and stresses of painting; as Feininger told Julia during a difficult period, photography was "the most tolerable occupation of all."[32]

Feininger's self-proclaimed "dark-room orgy" of 1928 led him to systematically integrate the medium into his painting process when he was given the most important commission of his career the following year.[33] In 1929, at the suggestion of Staatliche Galerie Moritzburg director Alois Schardt, the city of Halle hired Feininger to paint an image of the city; over the next two and a half years, the project would expand into eleven paintings, with Feininger spending months at a time working in a studio that Schardt provided in the tower of the Moritzburg castle, which housed the museum. At the outset, Feininger determined he would use photography to assist with this momentous assignment; upon arriving in Halle in early May 1929, he began to photograph the city views that most interested him. By mid-month, he described his progress to Museum of Modern Art director Alfred H. Barr, Jr.: "I have been taking photos of the principal sites, especially of the Old Market-place with its campanile, and imposing church incorporating four towers of two earlier churches! . . . There is a darkroom being fitted out for me in the building of the museum, and then I can get to enlarging my plates."[34] Julia warned her husband not to rely on photography to transform his experiences into painterly

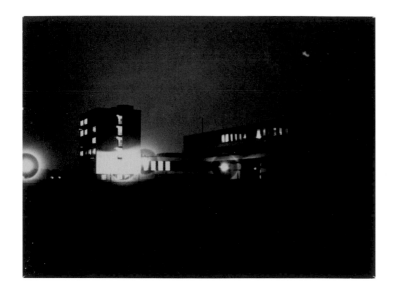

fig. 220. **Untitled (Bauhaus, Dessau, at night),** 1929
Gelatin silver print, 7 x 9⅜ in. (17.8 x 23.8 cm)
Bauhaus-Archiv, Berlin

fig. 221. *Lighted Windows I (Beleuchtete Häuserzeile),* 1929
Oil on canvas, 14¼ x 22 in. (36.2 x 55.9 cm)
Staatliche Kunstsammlungen, Dresden

compositions, but the artist felt confident about his new method. "I agree precisely with what you say about working from photographs," he told her, "but I still believe that I am so strongly rooted in the pictorial approach and understand the requirements of the picture well enough (in contrast to the view from nature) to be able to handle it. . . . Taking photographs has intensified my vision in a new way, but I do realize that I have to transmute the impressions so gained with even greater concentration than before."[35]

Due to the pressure to quickly select motifs for the Halle series during his two-month visit to the city in the spring of 1929, Feininger's photographic approach now was dramatically different than in the previous year. Looking through the lens of his Bergheil with an eye toward painting, he honed in on selected views of Halle with methodical rigor. Although he continued to draw his usual nature notes, only photography allowed him to identify a large number of potential motifs in a short period and to capture minute compositional variations of a given subject by shooting it repeatedly from slightly different angles.[36] Compiling a large cache of photographs during his initial visit to Halle provided Feininger the resource to begin his paintings after leaving the city, and despite the unfamiliarity of incorporating them into his process, he was stimulated by the image variety and formal insights as he began making charcoal studies for the paintings during his Baltic Sea vacation that summer. "It is very difficult to get away from photography to some degree initially, but to make up for it the shots provide a multitude of impulses and an abundance of beauty, so all I have to do is pick and choose," he wrote Schardt in July.[37]

As Feininger delved into painting the Halle series, basing at least four of the eleven Halle paintings on a single photograph and others on composite views, his photographs illuminated underlying formal relationships that in turn guided his painterly compositions.[38] The photograph (fig. 222) that he used as a basis for *Church of St. Mary at Night, Halle (Marienkirche bei Nacht)* (1931; fig. 224), for example, portrays the view down a street adjacent to the Romanesque towers of Halle's Church of St. Mary, with the buildings and street forming a frame around the ghostly night sky. Feininger transmitted

this composition to his painting, animating the scene with the addition of figures on the street and staggered prismatic planes along the church's façade. Feininger was keenly attuned to photography's capacity for interpreting light at different times of day in formal terms. Shooting in Halle's late-day sun, for instance, had helped him see "colossal motifs emerge from sharp, slanted shadows and planes in the full sun—resulting in a new flatness of space."[39] The Halle photographs, less creative endeavors than meticulous documents of the city's architecture and qualities of light, heightened Feininger's formal acuity while also reinforcing his avoidance of the specifically photographic in his oils. "I notice one thing," he remarked, "the more I use the camera, the more I distance myself in my drawing from any photographic elements—I could almost speak of an entirely new strength of form, a kind of renaissance from ossified style into vitality."[40]

As the project neared its completion, however, Feininger's long-standing ambivalence about photography resurfaced. The pressure to finish the cycle began to fill him with anxiety; with the late works in the series, particularly *The Cathedral, Halle (Der Dom in Halle)* (which he reworked obsessively during January 1931), he fretted that photography had led him astray (fig. 132). "I'll never work after a photo again; this is quite abominable and leads away from anything pictorial and from painting altogether," he lamented.[41] In spite of this repudiation, the results of Feininger's work in Halle suggest that the medium, having always been a source of apprehension, was a convenient scapegoat for his difficulties rather than a genuine hindrance. Among all of the Halle paintings, those that are drawn from a single photographic source—such as *Church of St. Mary, I, Halle (Marienkirche I)* (1929; Stätische Kunsthalle Mannheim), *Church of St. Mary at Night, Halle (Marienkirche bei Nacht)*, and *The Bölbergasse, Halle* (1931, figs. 130, 131; destroyed in World War II)—are the most formally commanding works in the series, invested with the sense of lucidity and grandeur that is the hallmark of Feininger's most powerful compositions. The paintings that were composed primarily from sketches or from composites, by contrast, are often characterized by a muddled planar density that feels both overlabored and unresolved. Feininger's struggle toward the end of the series may have owed more to the other extraordinary conditions of the project—working in an unfamiliar location, the demands of a commission, the time constraints that discouraged his usual habit of allowing imagery to filter through his memory—than to his incorporation of photography into the process.[42]

The Halle episode is sometimes portrayed as Feininger's "fundamental renunciation" of photography, and the evidence indicates that he rarely, if ever, painted directly from photographs again.[43] Nonetheless, he continued to explore Halle with a camera until his final days there in May 1931 and the medium remained central to his creative pursuits in the following years.[44] In the spring of 1931, he used his Halle earnings to acquire a Leica I (model A), which he was pleased to discover "worked flawlessly."[45] The portability of the Leica allowed him to document village scenes on a trip to Brittany and to expand his photographic series of a favorite subject: trains, which he had first started

to shoot in the Dessau Bahnhof in 1929 (fig. 223). Another factor soon changed Feininger's relationship with photography further: the closure of the Bauhaus in Dessau in 1933 and attendant loss of his Master House brought an end to his darkroom work. Though the expulsion from Dessau and growing Nazi threat did much to stifle his creative output in painting during this period, Feininger remained consistently active with the

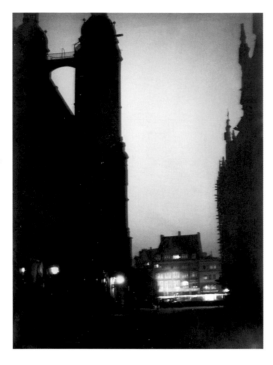

fig. 222. **Untitled (Church of St. Mary at Night, Halle),** 1929–30
Gelatin silver print, 7 x 5 in. (17.8 x 12.7 cm)
Stiftung Moritzburg, Kunstmuseum des Landes Saschen-Anhalt

fig. 223. **Untitled (Dusk in the Station Yard),** 1929–30
Gelatin silver print, 7 x 9⅜ in. (17.7 x 23.7 cm)
Houghton Library, Harvard College Library, Harvard University, Cambridge, Massachusetts; gift of T. Lux Feininger

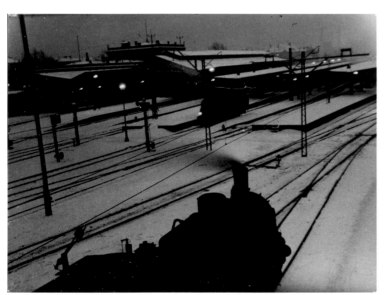

Leica during the mid-1930s. Shifting to the use of a professional developer, he created an extensive photographic archive (negatives and slides as well as a few prints) of clouds and weather formations on the Baltic Sea, the ruined church at Hoff, and his model boats sailing on the Rega River (fig. 144)—images from which he would draw inspiration for the rest of his life. But it was the move to the United States in 1937 that would once again—and perhaps most profoundly—reconfigure Feininger's relationship with the medium in the final decades of his life.

Feininger's return to the United States in the wake of Nazi persecution and after an absence of fifty years was a watershed for the artist. The trauma of leaving Germany and then finding himself in a city dramatically changed from the New York of his childhood made Feininger feel as though his "very identity had shriveled within" him.[46] For his first two years in America, he was unable to paint, telling his friend the painter Alexei Jawlensky (1864–1941) in 1938, "until now I have still not done any painting here. The break was too great to heal quickly. . . . Over there: a cemetery of dearest memories; here: impressions that cannot be assessed without a resolute grasp and persistent struggle."[47] Though he could not initially find inspiration to paint, Feininger was immediately compelled to take photographs, and these images became a means for reconnecting with his native city. His first shots include the elevated railroads, particularly the Second Avenue El, which he recalled observing with fascination during its construction in the 1870s (fig. 225), and New York Harbor, where he loved to watch boats as a child. Soon thereafter, he began to survey the city's apartment buildings and glamorous new Art Deco skyscrapers, which, in 1939, would become the subject of his first oils painted in the United States.[48]

As he approached subjects in New York, Feininger had difficulty producing nature notes—indeed the number of sketches he made in the United States is marginal compared to his vast archive of German subjects.[49] Photography became the primary means for what Feininger had previously accomplished with the notes: "to wrest the secrets of atmospheric perspective and light and shade gradation, likewise rhythm and

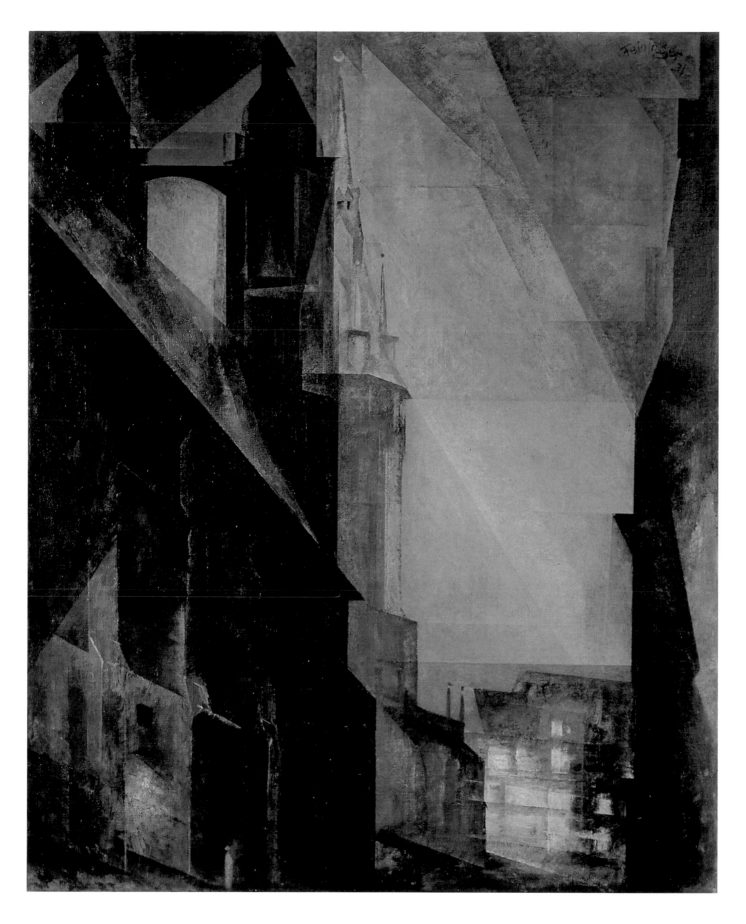

fig. 224. **Church of St. Mary at Night, Halle**
(Marienkirche bei Nacht), 1931
Oil on canvas, 39⅜ x 31½ in. (100.5 x 80 cm)
Von der Heydt-Museum, Wuppertal, Germany

fig. 225. **Untitled (Buildings and elevated train tracks, New York),** c. late 1930s–40s
35mm slide, 1³⁄₁₆ x 1³⁄₈ in. (3 x 3.5 cm)
Harvard Art Museum, Busch-Reisinger Museum, Cambridge, Massachusetts; gift of T. Lux Feininger BRLF.1006.141

fig. 226. **Untitled (New York),** c. late 1940s–50s
35mm slide, 1³⁄₁₆ x 1³⁄₈ in. (3 x 3.5 cm)
Collection of Danilo Curti-Feininger

balance between various objects, from Nature."[50] In his photographs, which alternate between slide and negative format, New York becomes a "motif for the transmutation of space and atmosphere into symbol" (figs. 225, 226).[51] Taking the place of sketches, the photographs allowed Feininger to study the geometric contours and soaring diagonals of buildings, the cadences of their façades and windows, and the "atmosphere, color, and contrast" that made New York "the most astonishing city in the world."[52] Once he returned to painting in 1939, Feininger transferred the formal insights and sensory experiences gained through his New York photographs to his canvases—works like *Manhattan I* (1940; see fig. 176), in which the "continuous 'cliff'" (as he called it) formed by one of the city's urban canyons appears to eerily melt into the earth.[53]

Like his oils of the late 1940s and 1950s—paintings such as *Courtyard III* (1949; see fig. 185) in which spidery lines are inscribed over fields of gestural color—many of Feininger's photographs from the final years of his life are more abstract and insistently tactile yet suffused with a kind of graceful ethereality (figs. 227–29). Material situations and natural phenomena that had always intrigued him—reflections in street puddles and the sea, architectural shadows, lighted windows, shards of glass, cloud formations, tangled filigrees of bare tree branches, old cobblestones, and gravely stone paths—became the subjects of his lens. Shooting primarily in color with a Contax camera, which he presumably acquired after his return to the United States, he also took up new subjects, including city sunsets, architectural ornaments, wildflowers, hands, cemetery headstones,

fig. 227. **Photo-abstraction,** c. 1940s–50s
35mm, 1³⁄₁₆ x 1³⁄₈ in. (3 x 3.5 cm)
Harvard Art Museum, Busch-Reisinger Museum,
Cambridge, Massachusetts; gift of T. Lux Feininger
BRLF.1008.113

fig. 228. **Untitled (Fence),** c. 1940s–50s
35mm slide, 1³⁄₁₆ x 1³⁄₈ in. (3 x 3.5 cm)
Harvard Art Museum, Busch-Reisinger Museum,
Cambridge, Massachusetts; Gift of T. Lux Feininger
BRLF.1009.22

fig. 229. **Cloud, window,** c. 1940s–50s
35mm slide, 1³⁄₁₆ x 1³⁄₈ in. (3 x 3.5 cm)
Harvard Art Museum, Busch-Reisinger Museum,
Cambridge, Massachusetts; gift of T. Lux Feininger
BRLF.1010.173

cars, and fire hydrants.[54] All of these are catalogued with serial enthusiasm and often presented in close-up views devoid of context, recalling the material studies that Josef Albers, one of Feininger's colleagues during the summer of 1945 at Black Mountain College in North Carolina, assigned his students. The camera's unique ability to show "the tiniest objects in melting close up," Feininger told his friend the painter Mark Tobey (1890–1976), was "delicious beyond any painters [*sic*] capacity to produce; pure products of the lens . . . reveals aspects of space and focusing far beyond our limited eyesight."[55] As with his black-and-white New York photographs, Feininger chose not to make prints from his more than 2,200 color slides. Instead, he projected them together with old slides from Germany in viewing exercises for himself, Julia, and visitors to their house, who would spend evenings surveying these magnified views of the world.[56] "The eye learns a new, wonderful way of seeing hereby," Feininger exulted to his old Bauhaus colleague Gerhard Marcks in 1948.[57]

For an artist who considered light the ordering principle of the world, the source of clarity amid chaos—so much so that he named his youngest son after the Latin word for light, *lux*—the camera provided a vital and transformative "new way of seeing." Photography would gain importance in Feininger's final years. As the nature notes began to increasingly serve as an archive of Feininger's past, the camera nurtured his ongoing engagement with the world around him. The sheer quantity of late photographs and their wide-ranging subject matter affirm the extent to which they enabled his "study of the million aspects of reality . . . [which] inspired him with an almost ecstatic fervor."[58] Feininger's intimately rendered details of the earth's surface and atmospheric swaths of sky collectively portray a vision of the world that is at once minute and expansive, earthbound and otherworldly. No longer photography's "inveterate enemy," Feininger embraced the medium without reservation. As he told Tobey in June of 1955, seven months before his death, "there is hardly anything new left to do this year; but I have one advantage left: I've learned by now how to make the best of the camera eye."[59]

1. The Houghton Library, Harvard College Library, Harvard University, Cambridge, Massachusetts, possesses 531 photographic prints (given by T. Lux Feininger) and seventeen negatives. The Busch-Reisinger Museum, Harvard University, has approximately 18,000 negatives, eight prints, and fifty-eight contact strips. An additional eighteen prints, including a group Feininger gave to Walter Gropius in 1929, are now in the collection of the Bauhaus-Archiv, Berlin; three prints are in the collection of the Museum of Modern Art, New York.

2. This figure is based on the number of the negatives held by the Busch-Reisinger Museum; given the number of undated negatives (approximately 1,700) and slides that are dated "1940s–1950s" but which depict subjects that could only have been shot prior to Feininger's departure from Germany in 1937, it is undoubtedly a low estimate.

3. Among broader studies of Feininger's art, the few that make mention of his photographs tend to do so in relation to his Halle period of 1929–31, when photography was central to the conception of his paintings. Only two essays have dealt with Feininger's photography in greater depth: the Halle photographs are discussed in Andreas Hüneke, "'Das Photographieren hat mir das Sehen auf eine neue Art gesteigert': Feininger als Photograph," in Wolfgang Büche, Andreas Hüneke, and Peter Romanus, Lyonel Feininger: Die Halle-Bilder, exh. cat. (Munich: Prestel, 1991), 90–95; and Feininger's awakening interest in photography in Dessau is discussed in Laura Muir, "Lyonel Feininger's Bauhaus Photographs," in Jeffrey Saletnik and Robin Schuldenfrei, eds., Bauhaus Construct: Fashioning Identity, Discourse and Modernism (London: Routledge, 2009), 125–41. See also Laura Muir, Lyonel Feininger: Photographs (1928–1939), exh. cat. (Cambridge, MA: Harvard Art Museum; Ostfildern, Germany: Hatje Cantz, 2011) (unpublished at the time of this essay's completion).

4. Feininger to Alfred Churchill, 17 February 1892, Alfred Vance Churchill papers regarding Lyonel Feininger, 1888–1944, Archives of American Art, Smithsonian Institution, Washington, DC, and New York (hereafter cited as AVCP-AAA).

5. The price of a Kodak was twenty-five dollars in 1888; by 1900, the price for the most basic model, the Brownie Camera, was one dollar with film that sold for fifteen cents a roll, making it financially accessible to virtually everyone. An entire camera could be purchased for what had previously been the price of one daguerreotype. See Miles Orvell, American Photography (Oxford: Oxford University Press, 2003), 35.

6. Feininger to Francis Kortheuer, 11 January 1903. Letter from the collection of the late Horace Richter (a copy is available at the Archives of American Art). Eastman Kodak introduced the Folding Pocket Kodak Camera, now considered the ancestor of all modern roll-film cameras, in 1898.

7. Ibid.

8. On August 23, 1906, Feininger tells Julia he has discovered "splendid subjects for painting" and goes on to remark that he has been taking photographs with an old acquaintance, Mr. Reichardt, a pharmacist from Potsdam. "Under my tutelage," he writes, "we had some nice photography excursions looking for beautiful landscape motifs." Lyonel Feininger papers, Houghton Library, Harvard College Library, Harvard University, Cambridge, Massachusetts (hereafter cited as LFP-HCL).

9. No prints from Feininger's early experiments with photography appear to have survived aside from casual family snapshots, which date as early as 1905. He writes in later correspondence with Julia about discovering a cache of negatives dating before 1905: "Being preoccupied with this intense review of hundreds of photos from the past I have reconnected with our wonderful youth together in such a lively way! . . . I took so many [photographs] myself, which I never imagined possible—I had maintained for years that I had not taken any pictures before 1905." (The whereabouts of these negatives are unknown.) Feininger to Julia, 19 January 1931, LFP-HCL.

10. Feininger to Lothar Schreyer, 1917, quoted in Christiane Weber, Lyonel Feininger: Genial-Verfemt-Berühmt (Weimar: Weimarer Taschenbuch, 2007), 68. In 1913, Feininger wrote that his "method, though it is not so much method, as necessity, or work, forbids me to reproduce an impression of Nature immediately in painting." Feininger to Churchill, 13 March 1913, AVCP-AAA.

11. Feininger to T. Lux Feininger, 2 July 1946, quoted in T. Lux Feininger, Lyonel Feininger: City at the Edge of the World (New York: Frederick A. Praeger, 1965), 35.

12. T. Lux thought that the Kodak box camera belonged to his grandmother in her youth, but this seems impossible since these were not available earlier than 1888. Most likely the camera was the one his father had described purchasing in 1903. See Jeannine Fiedler, "T. Lux Feininger: 'I am a painter and not a photographer!'" in Jeannine Fiedler, ed., Photography at the Bauhaus (Cambridge, MA: The MIT Press, 1990), 45.

13. The narrative that T. Lux has described is one in which "all the males in the family were making photographs." See T. Lux Feininger, "Lyonel Feininger's Photography" (1995), Lyonel Feininger Archive, Busch-Reisinger Museum, Harvard University, Cambridge, Massachusetts. Indeed, T. Lux and Andreas would go on to achieve acclaim as photographers. Both were featured in the landmark exhibition Film und Foto (1929) in Stuttgart and would become affiliated with the pioneering photography agency Dephot; Andreas trained as an architect and went on to pursue photography as a career, while T. Lux ultimately abandoned photography in favor of painting. It is rarely noted that Feininger's daughter Leonore ("Lore") was also a photographer; after working in Berlin for fashion photographer Karl Schenker, Lore taught photography at the Steinplatz Art Academy until the end of World War II. See Leonore Feininger, "Zuerst Kam Das Klavier . . ." in Bettina Brand et al., Komponistinnen in Berlin (Berlin: Senator für Kulturelle Angelegenheiten, 1987), n.p. Lyonel avidly followed the photography careers of his children; one of his proudest moments was when T. Lux, Andreas, and Lore were all featured in a 1930 photography exhibition in Munich (see Feininger to Julia, 20 June 1930, LFP-HCL).

14. T. Lux Feininger, quoted in Muir, "Lyonel Feininger's Bauhaus Photographs," 127.

15. The Bergheil was produced from 1911 until World War II by Voigtländer in Braunschweig, Germany. By the time Feininger started using the Bergheil, its glass-plate technology was already being supplanted by the Leica.

16. T. Lux Feininger, quoted in Fiedler, "T. Lux Feininger," 46.

17. In the mid- to late 1920s, Feininger and Andreas also took trips in search of motifs to photograph. Exploring the medium together fostered their development as photographers. Andreas would later write his father: "what I have dealt with theoretically, I learned from your 'messed up' fotos already years ago, such as your fotos from Halle and the Leica pictures from France. The only basic difference between us consists of the fact that you have all these things 'within you,' whereas I have to capture them 'from outside,' that is, you do them and I write about them, practice and theory." Andreas Feininger to Feininger, 1–2 January 1937, LFP-HCL.

18. Some of the rival reformed schools in Germany had adopted photography as part of their programs earlier than the Bauhaus, for example, the Lette-Verein in Berlin, the Folkwang School in Essen, and the School of Arts and Crafts at Burg Giebichenstein in Halle. The Bauhaus, by contrast, was dominated in its early years by more traditional disciplines. For further information, see Katherine C. Ware, "Photography at the Bauhaus," in Jeannine Fiedler, ed., Bauhaus (Hagen: Konemann, 2006), 506–29.

19. Though Peterhans began teaching at the Bauhaus during the period that Feininger was taking photographs, he was primarily a still-life photographer and an astute technician whose influence did not reach the Feininger family. Andreas attended Peterhans's lectures in 1932, but was dissatisfied with them. See T. Lux's comments in Fiedler, "T. Lux Feininger," 47–48.

20. Gropius introduced this maxim in 1923; it represented a dramatic reformulation of the original Bauhaus manifesto's mystical call to make "architecture and sculpture and painting . . . one day rise towards heaven as the crystalline symbol of a new and coming faith."

21. Feininger to Julia, 1 August 1923, LFP-HCL.

22. Feininger to Julia, 9 March 1925, LFP-HCL.

23. Feininger's admiration for Gropius's Bauhaus buildings in Dessau is clear from his first visit: "Yesterday I went to see the large Bauhaus building. . . . I am simply delighted, it is a perfectly grand, unified, completely independent work standing there . . . It is all admirable, in terms of form, space, and also as an intellectual and human achievement." Feininger to Julia, 30 August 1926, LFP-HCL.

24. Feininger to Julia, LFP-HCL. Feininger's inclusion of the exact time on some of his prints is an indication that he was highly attuned to temporal nuances. Muir notes that nighttime photography was likely convenient for Feininger because he needed to devote the daylight hours to painting. Muir, "Lyonel Feininger's Bauhaus Photographs," 128.

25. Feininger to Julia, 22 March 1929, LFP-HCL.

26. Feininger to Julia, 31 October 1928, LFP-HCL.

27. Laura Muir has interpreted this photograph as a meditation on the absence of Moholy-Nagy and suggests a

correlation between Feininger's glass-plate negatives and the form of the studio window. Muir, "Lyonel Feininger's Bauhaus Photographs," 130.

28. Feininger to Julia, 29 June 1928, LFP-HCL.

29. After a visit with Gropius, Julia reported to Feininger that "he is enthusiastic about your photos and very impressed that you have joined the shutterbugs." Julia to Feininger, 20 April 1929, LFP-HCL.

30. Julia to Feininger, 13 June 1931, LFP-HCL. "My mother wanted at no time to know anything about it," T. Lux later remarked with regard to his father's photographs. Fiedler, "T. Lux Feininger," 48.

31. These photographs also recall Feininger's 1915 oil *Avenue of Trees (Allée)* (see fig. 81).

32. Feininger to Julia, 31 October 1928, LFP-HCL.

33. Feininger to Julia, 6 November 1928, LFP-HCL.

34. Feininger to Alfred H. Barr, Jr., 16 May 1929, Alfred H. Barr, Jr. Papers, the Museum of Modern Art Archives, New York. During this early period, Feininger also took a fascinating series of photographs of objects in the Staatliche Galerie Moritzburg collection with the intention of giving them to the museum. The negatives and several prints of these are now in the Houghton Library and Busch-Reisinger Museum collections.

35. Feininger to Julia, 21 May 1929, LFP-HCL. In the same letter, he added: "You know, that I have a very sharply focused way of observing nature and in photography I meet with very familiar experiences, which I have developed by means of painting already a long time ago."

36. Scholars initially believed Feininger did not produce nature notes in Halle and that he relied solely on photographs to formulate the preparatory drawings for the paintings. The notes were later discovered in a Paris bookshop. See Wolfgang Büche, *Lyonel Feininger-Halle-Bilder: Die Natur-Notizen*, exh. cat. (Leipzig: Beck und Eggeling, 2000).

37. Feininger to Alois Schardt, 4 July 1929, quoted in Büche, *Lyonel Feininger-Halle-Bilder*, 16.

38. For a more detailed analysis of the Halle paintings and their related drawings and photographs see Büche, Hüneke, and Romanus, *Lyonel Feininger-Die Halle-Bilder*.

39. Feininger to Julia, 28 May 1929, LFP-HCL.

40. Feininger to Julia, 31 May 1929, LFP-HCL.

41. Feininger to Julia, 22 January 1931, LFP-HCL. Julia concurred, having cautioned Feininger for years that he would "always be handicapped by the highly material aspect of photography." Julia to Feininger, 17 May 1929, LFP-HCL.

42. The Halle paintings were exhibited to acclaim at Feininger's 1931 retrospective at the Nationalgalerie in Berlin. They were subsequently placed in a permanent installation in the Staatliche Galerie Moritzburg, but on Nazi orders, they were banished to the museum's attic, in a so-called "chamber of horrors" in 1935. The Nazis confiscated the paintings from the museum in 1937, after which they were either sold or destroyed. Only two of the paintings are now owned by the museum.

43. Hüneke, "'Das Photographieren hat mir das Sehen auf eine neue Art gesteigert': Feininger als Photograph," 92.

44. Before leaving Halle, Feininger took a series of last-minute photos: "11 o'clock this morning I went with my camera to take some pictures, because I won't have many opportunities any more. I already developed plates of beautiful narrow streets." Feininger to Julia, 11 May 1931, LFP-HCL.

45. Feininger to Julia, 16 June 1931, LFP-HCL. Just prior to acquiring the Leica, Feininger wrote to Julia about the difficulty of shooting the train subjects with the glass-plate camera: "Yesterday on the way from Bitterfeld I several times took snapshots from the moving train of the big factory chimneys against the evening sky—in front were locomotives and behind them sheds—I hope some of it will be visible on the negatives. Such motifs have been my silent longing for a long time and I believe, I can capture them later with a 'Leica.' A camera with plates is very cumbersome for this and it was almost like witchcraft, to make these exposures four times in two minutes." Feininger to Julia, 7 April 1931, LFP-HCL.

46. Feininger, quoted in Alfred H. Barr, Jr., "Lyonel Feininger—American Artist," *Lyonel Feininger/Marsden Hartley*, exh. cat. (New York: The Museum of Modern Art, 1944), 13.

47. Feininger to Alexei Jawlensky, 27 July 1938, quoted in Sabine Eckmann, "The Loss of Homeland and Identity: George Grosz and Lyonel Feininger," in Stephanie Barron, ed., *Exiles and Emigrés: The Flight of European Artists from Hitler*, exh. cat. (Los Angeles: Museum Associates, Los Angeles County Museum of Art, 1997), 297.

48. *Dunes and Breakwaters*, 1939 (fig. 174), based on a memory of the Baltic, would be another one of Feininger's earliest oils in New York; its composition was a synthesis of a photograph and a nature note.

49. Feininger told T. Lux: "What I really miss is drawing after nature, making 'Notizen' [notes] as at the Baltic, in Deep, or in the villages in the vicinity of Weimar. Somehow I have no satisfaction from the subjects hereabouts; they form too little of my own, inner preference and only result in naturalistic efforts." Feininger to T. Lux Feininger, 6 October 1953, quoted in *City at the Edge of the World*, 114. Wolfgang Büche, however, has suggested that Feininger's production of the notes actually began to decline in the years before he left Germany. See Büche, "Back in New York—Zurück in einer vertrauten Fremde," in Wolfgang Büche, ed., *Lyonel Feininger: Zurück in Amerika, 1937–1956*, exh. cat. (Munich: Hirmer, 2009), 11–19.

50. Feininger to Churchill, 13 March 1913, AVCP-AAA.

51. Feininger to Alois Schardt, 3 February 1942, quoted in Ulrich Luckhardt, *Lyonel Feininger* (Munich: Prestel, 1989), 156.

52. Ibid.

53. Feininger to T. Lux, 8 June 1944, quoted in T. Lux Feininger, *City at the Edge of the World*, 111.

54. It is unclear what model of Contax Feininger used, but he likely bought it to replace the Leica when he came to the United States. The complex vertical shutter system of Contax cameras, which were first produced in 1932 and quickly became the Leica's main competitor, allowed for a higher maximum shutter speed.

55. Feininger to Mark Tobey, 27 October 1955, reprinted in Achim Moeller, ed., *Years of Friendship, 1944–1956: The Correspondence of Lyonel Feininger and Mark Tobey* (Ostfildern-Ruit: Hatje Cantz, 2006), 216.

56. On 3 January 1955, Feininger wrote to Mark Tobey about the slide projections: "Last night we had a few friends here and brought out the color films and gave quite a projection evening. You have no idea how impressive the color shots came out on the wall; I only wish you could have been with us." Reprinted in Moeller, *Years of Friendship*, 192.

57. Feininger to Gerhard Marcks, 31 December 1948, LFP-HCL.

58. T. Lux Feininger, "Two Painters," *Chrysalis* IX, nos. 9–10 (1956). 4.

59. Feininger to Mark Tobey, 10 June 1955, reprinted in Moeller, *Years of Friendship*, 198.

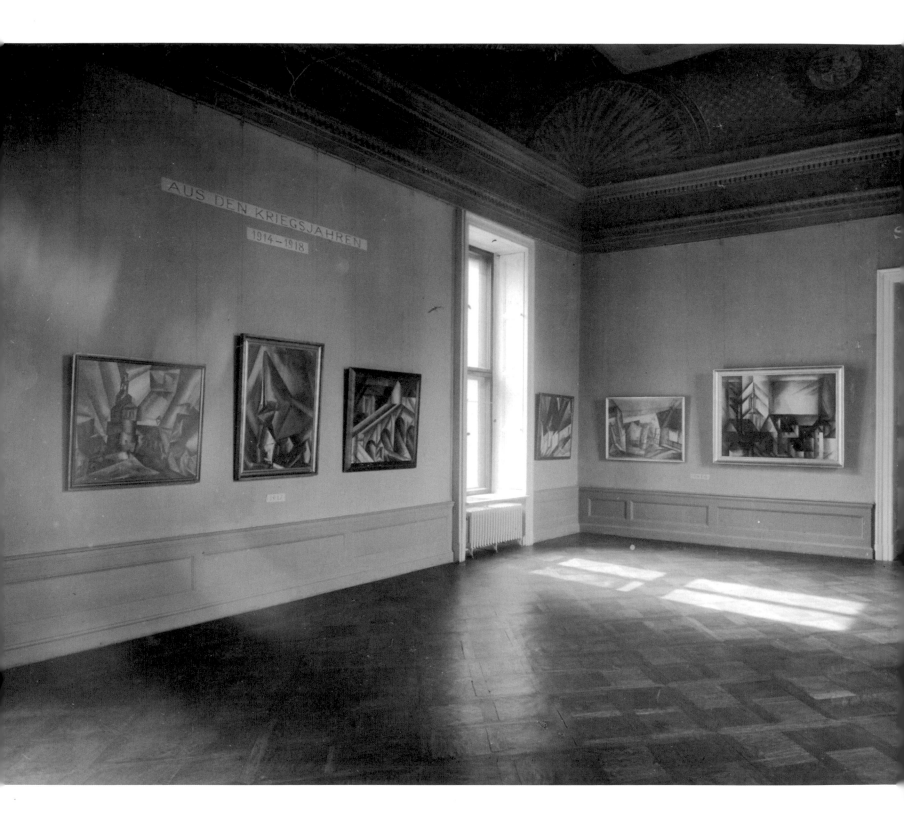

Lyonel Feininger:

Notes on the Career of

an American in Germany

Ulrich Luckhardt

fig. 230. **Installation view of Feininger's retrospective at the Nationalgalerie in the Kronprinzenpalais, Berlin,** 1931/1932

The American Lyonel Feininger had two careers as an artist in Germany. By 1905, he had reached the pinnacle of his career as a caricaturist and cartoonist for humor magazines, creating drawings that became increasingly political as time went on. When his first comic strip, *The Kin-der-Kids*, premiered in the *Chicago Sunday Tribune* on April 29, 1906, the newspaper called him "Feininger the Famous German Artist," adding: "There is no better draftsman in the world than Mr. Feininger."[1] This was certainly a realistic assessment of his reputation in Germany. Feininger had spearheaded the genre of cartooning, publishing well over two thousand illustrations in many different satirical magazines between 1890 and 1915—not only in Germany but also in France and the United States. His skill as a draftsman and his unusually colorful compositions made his caricatures immediately recognizable to readers after 1900.

The visual trademark Feininger had created for himself with his cartoons laid the foundation for his second artistic career, which began in Paris on April 21, 1907, with his first painting, a small still life. By this time, the artist had begun to distance himself from his caricatures, which he called those "clown japes that the world knows me by,"[2] but he was unable to give up this work for financial reasons. In Paris he began to convert the figurative compositions from his satirical cartoons into painted works. Within a year, he freed himself from these models and invented autonomous compositions for his paintings. In the beginning, Feininger's work as a painter was unknown in Germany. Until 1910, he continued to feed his family by drawing caricatures, although by this time he had abandoned traditional design. Like the paintings he was creating at the time, his cartoons had taken on a completely new form that must have unsettled his publishers. "Unfortunately, general opinion has shown that during your stay in Paris you have adopted a certain grotesque and extreme tone that the German public no longer understands," wrote Dr. Otto Eysler, publisher of *Lustige Blätter*, on August 20, 1907.[3] This criticism had no effect on Feininger; he was determined to become a painter.

In 1910, Feininger's *Longeuil, Normandie* (see fig. 41) was included in the twentieth exhibition of the Berlin Secession, his first painting to be shown in public; he showed two more in the Secession the next year. These paintings, which were unmistakably based on elements from his caricatures, received scant attention. His participation, the following spring, in the twenty-seventh exhibition of the Société des Artistes Indépendants in Paris, which included six of Feininger's paintings, also did not bring him the success he desired. All interest and discussion at the Salon des Indépendants that year was directed at the Cubists, whose works appeared in public as a large group for the first time. In a 1917 profile of the artist, the American journalist Charlotte Teller reported that Feininger mentioned only one reaction from the 1911 Salon, regarding his painting *Green Bridge* of 1909 (fig. 51): "Matisse had come in to hang a picture of his own in the space alongside. For a long time he stood staring at Feininger's canvas. Then he turned around and took his picture out with him. Haled by his astonished coterie, he explained that he would have to do his painting over before he would let it stand comparison with Feininger's. And he did."[4]

Even though his participation in this exhibition did not bring financial success, Feininger's encounter with French Cubism fundamentally changed his own art, which up to that point was still influenced by his cartoons. The radical formal realignment he undertook following the 1911 Salon was what made Feininger's second career as a painter possible. In Germany, Feininger's work soon drew the attention of the artists who formed Der Blaue Reiter in 1911, including Wassily Kandinsky, Alexei Jawlensky, and Paul Klee, and in 1913 they invited him to participate in the Erster Deutscher Herbstsalon (First German Autumn Salon), which was held at the Galerie Der Sturm in Berlin. With his five paintings in this exhibition, Feininger was suddenly placed at the center of modernism, in the company of Marc Chagall, Umberto Boccioni, Robert and Sonia Delaunay, Fernand Léger, and Marsden Hartley. In addition, he finally achieved financial success; at least three of the paintings he exhibited were sold, one to the Parisian fashion designer Paul Poiret.[5]

The success of the Herbstsalon, which remained a solitary event due to the outbreak of World War I, prompted gallery owner Herwarth Walden to organize a solo exhibition for Feininger at Der Sturm in 1917, in which 111 works were shown, including 46 paintings. The exhibition prompted a public discussion of Feininger's work among leading German critics, especially Paul Westheim, publisher of the *Kunstblatt*. In 1921, Willi Wolfradt published the first monograph of Feininger's work, in the series Junge Kunst.

By 1919, Feininger had reached the initial peak of his career as a painter. That year, he became the first artist hired to teach at the Staatliche Bauhaus by its founder, the architect Walter Gropius. The Bauhaus had a revolutionary influence on subsequent aesthetic developments around the world. Feininger was now a leader of the modern art movement in Germany, alongside his friends and fellow Bauhaus faculty members Klee, Kandinsky, Oskar Schlemmer, and László Moholy-Nagy. Feininger also achieved commercial success during this period. In 1918, a solo exhibition had opened in Munich at the Galerie Neue Kunst Hans Goltz displaying thirty-four paintings and as many works on paper; the following year he had four large exhibitions, at galleries in Frankfurt, Dresden, and Berlin, as well as a joint show with Klee at the Kestner Gesellschaft in Hanover, a renowned private art society. The exhibition in Berlin, at the Galerie J. B. Neumann, was without a doubt the most successful: Fifteen paintings were purchased by private collectors, and the Städtische Museum in Stettin bought *Benz VI*, the first of Feininger's paintings to be purchased by a museum. These successes led to numerous subsequent exhibitions at art galleries and museums, which increasingly purchased his work for their collections. Feininger was soon represented by paintings or works on paper in every German museum collection that was open to the modern art of the Bauhaus school.[6] In addition to Stettin, Feininger's works could now be found in museums in Erfurt, Dresden, Essen, Krefeld, Leipzig, Weimar, Wiesbaden, Wuppertal, Dessau, Halle, and Berlin. The large retrospective solo exhibition that the Nationalgalerie in Berlin arranged for Feininger in 1931 for his sixtieth birthday confirms the importance placed on

Feininger's artistic work before the National Socialist takeover in 1933 (fig. 230). However, as early as 1919 Feininger's work could be found on permanent display at the Kronprinzenpalais (Crown Prince's Palace), where the Nationalgalerie housed its contemporary art. Two of his paintings, *Vollersroda III*, acquired by the Nationalgalerie, and *Gelmeroda IV*, which Feininger loaned to the museum, hung in the entrance area along with the legendary and now missing *Turm der blauen Pferde* (Tower of Blue Horses) by Franz Marc. This configuration alone documents how highly Feininger's work was regarded both by the broader circle of museum directors and by private collectors.

fig. 231. **Cover of *Der Sturm*** VIII, no. 6, with illustration by Feininger (Berlin: Herwarth Walden, 1917). Collection of Danilo Curti-Feininger

By January 1933—and earlier in several cities, such as Dessau—National Socialist art doctrine was being enforced in public museums. Museum directors who had promoted modern art, whether Expressionism, Bauhaus art, or New Objectivity, were immediately discharged and modernist works of art banished into storage. An exception was Alois Schardt, director of the Staatliche Galerie Moritzburg in Halle and the man who commissioned Feininger to paint a series of Halle cityscapes between 1929 and 1931. A member of the Nationalsozialistische Deutsche Arbeiterpartei, or NSDAP (National Socialist German Workers Party), Schardt was appointed director of the Nationalgalerie in Berlin after his predecessor, Ludwig Justi, was dismissed by the National Socialists. In the major department for contemporary art, housed in the Kronprinzenpalais, Schardt attempted to advocate "Nordic Expressionism" in its racial sense as the continuation of the Gothic and German Romantic movements. Schardt's mission failed, however, and the National Socialists removed him from his post after only a few months. Likewise Harald Busch, director of the painting gallery at the Hamburg Kunsthalle, also attempted to highlight the Nordic elements in the paintings of Edvard Munch, Emil Nolde, and Feininger, who loaned works to the museum, in order to continue showing the art he favored. He believed that by cloaking the works under the term "Nordic," which had positive connotations for the National Socialists, he would be able to protect modern art. He was sorely mistaken and was relieved of his post in 1935.

The worst was still to come. On July 24, 1937, Hitler ordered the confiscation of so-called "degenerate" works of art, and in July and August of that year a search was carried out of all German museums. Everything that the commission confiscated

was transported to a central storehouse in Berlin or denounced at the "Degenerate Art" exhibition in Munich. More than four hundred works by Feininger alone were confiscated. Almost all of the paintings survived World War II because they were sold for foreign currency to private collectors abroad; many of the works on paper, however, were destroyed.

Following the interruption of the modern art movement in Germany perpetrated by the Third Reich, Feininger's work again began to play an important role after 1945. However, this development took two entirely different courses in the two countries that existed side-by-side after 1949—the Federal Republic of Germany in the West and the German Democratic Republic in the Soviet-occupied East.

After the war, West German museums attempted to reacquire works that had been confiscated as "degenerate" in 1937, and they included Feininger's paintings next to those of Klee, Schlemmer, and Kandinsky to complete their displays of the development of modern art. This generation of museum directors and curators saw Feininger's art as a part of their personal background; the Bauhaus painters were a natural part of the modern art movement, and in the 1950s it was museum policy in the Federal Republic of Germany to acquire these works. Therefore, all of the larger museums had "their" Feininger, and the subsequent generation of directors gratefully inherited these works to hang among the group of "classic" works that every collection had to exhibit. Holdings were added to here and there in West German museums, while only a single representative painting by Feininger could be found in many museum collections in East Germany—in contrast to Klee or Kirchner, for example, who were often represented by several works.

The reception of Feininger's work among private collectors took a different course. As soon as money was made during the postwar reconstruction and the art market established, Feininger became a favorite of collectors. Like Nolde's colorful still lifes of flowers and landscapes, Feininger's depictions of sailboats and buildings were the perfect representatives of a temperate modernism in which the original object could still be recognized. As a result, Feininger's art was popularized in calendars, art prints, and postcards and thereby made accessible to the broader public.

The situation was completely different in the German Democratic Republic. Because so many of Feininger's works had been confiscated by the National Socialists, and because many of his prewar collectors had either emigrated during the Third Reich or fled to the West to avoid Soviet troops after the end of the war, very few Feininger originals remained in the country, and his works could be seen only as reproductions in a few art books. Therefore, in the East, where Feininger had painted almost all of his motifs in villages in Thuringia and at the Baltic Sea, his original works were nearly inaccessible. However, even though very few of Feininger's pieces could be seen in East German museums, reproductions of them became artistic symbols allowing people to identify with German motifs in spite of the Communist regime.

With the Reunification of East and West Germany in 1989, the reception of Feininger's art was given a new impetus. His recognizable motifs have created an inter-

est in the places he painted, leading to exhibitions such as *Feininger at the Baltic Sea*, *Feininger in Lüneburg*, *Feininger in Halle*, *Feininger in Gelmeroda*, *Feininger in the Harz Mountains*, and *Feininger in Paris*, to name only a few from the past two decades. These projects have yielded increasingly detailed insight into the genesis of Feininger's work—especially in the former East Germany, where the demand to experience Feininger's art firsthand has been especially high. City walking tours that follow Feininger's footsteps in Halle and Weimar, as well as a bike trail on the Baltic island of Usedom, testify to this.[7]

The many exhibitions in museums and galleries in recent decades, as well as academic interest in his work—especially the relationship between topography and motifs—have made Feininger one of the most popular twentieth-century artists in Germany, alongside Klee, Marc, and Nolde. The fact that he was an American is incidental. In every description of German art history, his work stands for the development of an independent German modern art movement. And every German knows at least one of his paintings, *Church of St. Mary, Halle*, 1930 (Pinakothek der Moderne, Munich), which was reprinted millions of times on a postage stamp for standard letters.

1. *Chicago Sunday Tribune*, 24 April 1906, Comic Supplement, 2.

2. Feininger to Julia, Berlin, 8 October 1905, Lyonel Feininger papers, Houghton Library, Harvard College Library, Harvard University, Cambridge, Massachusetts.

3. Eysler quoted in Ulrich Luckhardt, *Lyonel Feininger: Karikaturen* (Cologne: DuMont, 1998), 19.

4. Charlotte Teller, "Feininger—Fantasist," *The International Studio* 63, no. 249 (November 1917): xxvi.

5. Poiret purchased the painting *Teltow I*, 1912 (current location unknown), one of Feininger's first Cubist works.

6. The only German museums to reject the latest artistic developments at the Bauhaus were those that had embraced the Expressionist movement centered around the group Die Brücke, founded in Dresden in 1905, which included Ernst Ludwig Kirchner, Karl Schmidt-Rottluff, Erich Heckel, and Max Pechstein.

7. The steps taken to romanticize Feininger can be quite obvious, as in the life-size, blue painted figure of Feininger standing at an easel on the balcony of the Hotel Elephant in Weimar—the same balcony on which Hitler stood when he gave his speeches in Weimar.

Chronology

fig. 232. *Lyonel Feininger, Dessau,* 1928.
Photograph by Andreas Feininger

1871

July 17. Lyonel Feininger (Charles Léonell Feininger) is born in New York City on St. Marks Place, the first child of violinist and composer Karl Friedrich Feininger, born in Durlach in Baden, Germany, and singer and pianist Elisabeth Cecilia, née Lutz, born in Elizabeth, New Jersey, to German émigré parents.

1873

Lyonel's sister Helen Bartram is born.

Over the next fourteen years, the Feininger family moves frequently, living variously at: Fourth Avenue; 311 East Fifty-third Street; 430 West Fifty-seventh Street; 326 West Fifteenth Street. During his parents' concert tours in South America and Europe, Feininger and his sisters often board in Sharon, Connecticut, with the Clapp family.

1876

Feininger's sister Elisabeth (Elsa) is born.

As a young boy, Feininger is fascinated by the steamboats and sailing ships on the Hudson and East Rivers and by the trains going in and out of Grand Central Station. By age five, he can draw them from memory.

1880

Feininger meets Frank Kortheuer, two years his junior, when the family moves to West Fifty-seventh Street. The two become lifelong friends. They spend their time drawing and making models of trains and ships, which they sail on the pond in Central Park.

Feininger begins violin lessons with his father; by 1884 he is playing publicly in chamber concerts.

1885

Fall. Lyonel drops out of Public School 69 due to family worries over his health; for the next year, he spends his days in Central Park sailing his model boats on the pond.

1886

Fall. Feininger takes a job as a messenger in the Wall Street brokerage firm of one of his father's friends.

1887

July 1. When his parents depart for a European concert tour, Feininger and his sisters move to a boardinghouse in Plainfield, New Jersey. Feininger commutes into the city for work six days a week.

October 19. Feininger sails for Hamburg, Germany, on the Hamburg-American steamer "Gellert," with the intention of studying violin at the Leipzig Conservatory. Discovering that his teacher is away, he enrolls in Hamburg's Allgemeine Gewerbeschule (General Vocational School); six months later, he is promoted to the upper class.

1888

June 25. Feininger leaves the Allgemeine Gewerbeschule at the end of the term and moves to Berlin to prepare for entrance to the Königliche Preußische Akademie der Wissenschaften zu Berlin (Royal Prussian Academy of Arts, Berlin). He passes the exam on October 1 and studies at the school for the next two years. There, he becomes friendly with fellow American student Alfred Vance Churchill.

October. Feininger's father, Karl, returns to New York from the couple's Brazilian tour without his wife, Elisabeth; they divorce in 1895.

Feininger and his mother move into the Pension Müller, a boardinghouse at Unter den Linden 16 in Berlin. The majority of his fellow boarders are foreigners or caricaturists for the city's humor magazines. His roommate, Australian music student Fred Werner, introduces him to Johann Sebastian Bach's fugues.

1889

Fall. A fellow Pension Müller boarder shows Feininger's work to the editor of *Humoristische Blätter*; the magazine publishes fourteen of his illustrations between January and June 1890.

1890

June. Karl Feininger visits his family in Berlin in hopes of reconciling with his wife. His concern over his son's lack of general education leads to the mutually agreed-upon-decision that Lyonel should attend the Jesuit-run Collège Saint-Servais in Liège, Belgium. Lyonel enrolls in September and remains for one year.

1891

Late May. Feininger leaves Saint-Servais and returns to Berlin, where he studies for two months at Adolf Schlabitz's private art school to prepare for reapplying to the Royal Academy.

August. Feininger vacations for the first time on the island of Rügen in the Baltic Sea, he often summers here and in Heringsdorf on the Baltic Sea island of Usedom every year through 1912.

fig. 233. Portrait of Feininger, January 6, 1896.
Photographer unknown

fig. 234. Portraits of Feininger and his second wife, Julia,
1906. Photographer unknown

October. Feininger reenters Berlin's Royal Academy, gaining admission to its highest level drawing class, taught by Woldemar Friedrich. Dissatisfied with the Academy's focus on technique at the expense of expression, Feininger determines to go to Paris. In March, he leaves the academy and begins earning money for the trip by making illustrations for cigar-box labels and a novelette.

1892

November. Feininger goes to Paris, where he stays for six months. He spends his time sketching figures on the street and attending figure-drawing classes at the Atelier Colarossi.

1893

May. Feininger returns to Berlin determined to launch his career as a caricaturist.

1894

January. Feininger receives his first significant commission, from the weekly magazine *Harper's Young People* (renamed *Harper's Round Table* in the spring of 1895), to create illustrations around which John Kendrick Bangs writes "nonsense" stories.

1895

Feininger begins to work regularly for *Ulk* (Joke), the "funny paper" supplement of the *Berliner Tagblatt* (Berlin Daily). The magazine specializes in black-and-white line drawings. Feininger contributes to the publication through 1914.

1896

Feininger begins drawing caricatures for the weekly humor magazine *Lustige Blätter* (Funny Paper), whose printing facilities are equipped to produce halftone reproductions.

Over the next ten years, Feininger becomes one of Berlin's most renowned caricaturists. Although he works primarily for *Ulk* and *Lustige Blätter*, he publishes as well in other German-language journals, including *Das Narrenschiff* (Ship of Fools; 1898); *Berliner Illustrirte Zeitung* (Berlin Illustrated Times; 1902–8); *Der liebe Augustin* (Dear Augustinian; 1904); *Simplicissimus* (1906); *Das Schnauferl* (The Jalopy; 1907–10); *Blätter für Sporthumor* (Paper for Sports Humor; 1908); *Licht und Schatten* (Light and Shadow; 1911–13); and *Wieland* (1914–15).

1898

November 26. Feininger's sister Elsa dies of tuberculosis.

1899

January 11. Feininger's sister Helen dies of tuberculosis.

1900

Feininger meets Clara Fürst, a pianist and daughter of mural painter and Berlin Secession member Gustav Fürst.

1901

Feininger and Clara Fürst marry; their first daughter, Eleonora (Lore), is born on December 14.

Winter. Feininger participates as a non-member in the Berlin Secession's works-on-paper annual; he exhibits with the group in a similar capacity in 1902 and 1903.

1902

November 18. Feininger's second daughter, Marianne, is born.

1905

August. While vacationing with his family on the Baltic coast, Feininger meets and falls in love with Julia Berg, née Lilienfeld, an art student recently separated from her husband. Upon Feininger's return to Berlin, he separates from his wife and begins corresponding with Julia, who has moved to Weimar to study graphics at the Großherzogliche Kunstgewerbeschule (Grand Ducal School of Applied Arts).

1906

Feininger formally changes his name from "Léonell" to "Lyonel."

February. Feininger receives an offer from the *Chicago Tribune* to produce two comic strip series: *The Kin-der-Kids* and *Wee Willie Winkie's World*. After visiting Julia in Weimar to discuss the offer, he signs a contract with the newspaper and resigns from *Ulk* and *Lustige Blätter*.

March. Feininger moves to Weimar. For the next five months, he and Julia explore and sketch the small medieval villages surrounding the city.

July. Feininger and Julia move to Paris.

fig. 235. Feininger in his Paris studio at 242 Boulevard Raspail, Paris, c. 1906. Photographer unknown

fig. 236. Feininger with his three sons, summer 1912. Photograph by Julia Feininger

November. The *Chicago Tribune* terminates Feininger's contract; the last installment of *Kin-der-Kids* appears on November 18; the last *Wee Willie Winkie's World* on January 20, 1907. To earn money, Feininger begins drawing caricatures for the newly launched art journal *Le Témoin* (The Witness), which continues publishing his work until it folds in 1910.

December 27. Andreas Bernhard Lyonel, Feininger's first son with Julia, is born.

1907

Feininger begins frequenting the Café du Dôme, the gathering place for German-speaking artists in Paris; he becomes particularly friendly with Jules Pascin, Hans Hoffmann, and Richard Götz.

April. Feininger completes his first oil painting on board, a still life, followed by Parisian architectural scenes. He spends the summer in the Black Forest and on Rügen making small-scale paintings on board of haystacks and farmhouses.

Fall. Through the Café de Dôme, Feininger meets German vanguard artists Oksar Moll, Hans Purrmann, Rudolph Levy, and Rudolph Grossmann, all of whom are disciples of Henri Matisse; he completes his first three figurative oil paintings on canvas by year's end.

1908

April. Feininger and Julia travel to London in hopes of being married. Discovering that English matrimonial law requires a three-week residency, they return to London in September and are married. After a two-week honeymoon in Paris, they settle in Germany, renting a spacious villa in Zehlendorf, a Berlin suburb, which is their home until 1919. Feininger continues to produce oil paintings while reestablishing his contacts with German-language humor magazines.

Winter. Feininger becomes a member of the Berlin Secession; he exhibits with the group every year between 1908–12 and again in 1914.

1909

April 5. Laurence Karl, Feininger's second son, is born.

1910

Spring. Feininger debuts an oil painting in the Berlin Secession annual.

June 11. Feininger's third son, Theodore Lucas (T. Lux), is born.

November. Feininger contributes forty-three works to the Berlin Secession's works-on-paper annual; the show increases his recognition as a fine artist.

1911

April. Feininger spends four weeks in Paris, where he is represented in the Salon des Indépendants by six paintings; the show introduces him to Cubism.

1912

Feininger meets artists Erick Heckel and Karl Schmidt-Rottluff, members of the German Expressionist group Die Brücke (The Bridge), who invite him to exhibit with the group which has relocated to Berlin from Dresden; he declines.

Feininger begins to incorporate the fractured forms of Cubism into his work.

November. Alfred Kubin, the visionary draftsman and member of Der Blaue Reiter (The Blue Rider) group of German Expressionists, initiates a correspondence with Feininger.

1913

Winter. Feininger exhibits for the first time in the United States, in a show of German graphic art at New York's Photographic Society.

April. Feininger spends several months alone in Weimar before his family joins him on June 9, beginning a pattern of working apart from his family for a few months each year. He intensively sketches the villages surrounding Weimar, particularly Gelmeroda, Mellingen, Vollersroda, Umpferstedt, Gaberndorf, and Hopfgarten.

Over the next fourteen months, Feininger designs prototypes of wooden toy trains for the Munich-based manufacturer Otto Löwenstein; he finalizes the designs several months before the outbreak of World War I, which terminates the project.

June. Feininger resigns from the Berlin Secession, but exhibits with the group once more the following year.

July. Franz Marc, co-founder along with Vassily Kandinsky of Der Blaue Reiter, invites Feininger to participate in the Erster Deutscher Herbstsalon (First German Autumn Salon) being organized for September by Herwarth Walden, publisher of the avant-garde magazine *Der Sturm* (The Storm) and owner of the gallery of the same name; Feininger exhibits five paintings in the show, three sell.

fig. 237. Group photograph of the Bauhaus Masters, 1926 (from left to right): Josef Albers, Hinnerk Scheper, George Muche, László Moholy-Nagy, Herbert Bayer, Joost Schmidt, Walter Gropius, Marcel Breuer, Wassily Kandinsky, Paul Klee, Feininger, Gunta Stölzl and Oskar Schlemmer. Photographer unknown

December. For Christmas, Feininger makes small, hand-painted wooden toy trains for his sons; the following Christmas, he expands his range of subjects to include people, buildings, and boats. Feininger continues to make small wooden toy sculptures for much of his life, eventually gifting them to friends and their children.

1914

January. Feininger exhibits with Die Brücke and Der Blaue Reiter artists at Galerie Ernst Arnold in Dresden.

April/June. Feininger works alone in Weimar for two non-consecutive months; his family joins him in July.

July 28. World War I begins; Feininger and his family return to Berlin in early August.

1915

October. Feininger and the American painter Marsden Hartley exchange letters and visits following Hartley's one-man show in Berlin.

1916

June. Feininger exhibits at Walden's Galerie Der Sturm, in a three-person show with Paul Kother and Conrad Felixmüller.

1917

April 6. The United States enters World War I on the Allied side.

Late June. Feininger travels with his family to Braunlage, a resort in the Harz Mountains.

August 7. Feininger leaves his family in Braunlage and returns to Berlin to prepare for his upcoming show at Galerie Der Sturm; he is put under "city arrest" and has to report daily to the local police station.

September 2. Feininger's first one-person show opens at Galerie Der Sturm, with more than one hundred paintings and works on paper.

September 6. City officials deny Feininger permission to rejoin his family in Braunlage, where they remain through September.

1918

In Berlin, facing a shortage of painting materials, Feininger begins making woodcuts; he finds the technique well-suited to his aesthetic needs and produces 117 prints by year's end.

Early August. Through Walden's intervention, Feininger receives permission to summer again in Braunlage.

November 11. Germany signs Armistice, ending World War I.

1919

March. Feininger joins the artists' council of the Arbeitsrat für Kunst (Workers Council for the Arts), which aims to integrate art into everyday life. The group's leaders are architects: Walter Gropius, Bruno Taut, and Adolph Behne; Erick Heckel, Karl Schmidt-Rottluff, and Max Pechstein, are among the group's artist members.

November. Feininger creates the woodcut *Rathaus* for the title page of the Arbeitsrat's book, *Ja! Stimmen des Arbeitsrates für Kunst in Berlin* (Yes! Voices of the Workers Council for the Arts in Berlin); he prints fifty-five woodcuts of the image for the publication's deluxe edition.

April. Gropius appoints Feininger "Master" at the Bauhaus, the newly founded state art school in Weimar born out of the merger of the city's Hochschule für bildende Kunst (Academy of Fine Arts) with its Kunstgewerbeschule (School of Applied Arts). Gropius selects Feininger to design the title page of the *Bauhaus Manifesto*, for which he creates his woodcut *Cathedral*.

June. The Nationalgalerie in Berlin acquires Feininger's painting *Vollersroda*, which hangs on permanent view in the entrance along with another of his paintings and seven of his drawings; other German museums and galleries begin to exhibit his work extensively.

1920

Feininger's first one-person museum exhibition opens at the Anger Museum, Erfurt.

Fall. The Bauhaus graphics workshop, under the artistic direction of Walther Klemm, produces Feininger's portfolio *Twelve Woodcuts*, a selection of small-format prints created before the Bauhaus period.

1921

June. Feininger succeeds Klemm as artistic director of the graphics workshop at the Bauhaus. Under Feininger's leadership, the workshop produces important one-person portfolios of prints by Kandinsky, Oskar Schlemmer, Georg Muche, and Gerhard Marcks, as well as four group portfolios of prints by Bauhaus Masters and German, Italian, and Russian artists.

July. Inspired by Hans Brönner's birthday gift of a fugue, Feininger composes his first fugue; he completes eleven more between 1921 and 1927; two additional fugues remain incomplete.

Detroit Institute of Arts, on the advice of former Arbeitsrat für Kunst member Wilhelm Valentiner, acquires *The Side-wheeler II (Raddampfer II)* (1913), the first of Feininger's paintings to enter an American museum collection.

1922

February 1. Lyonel's father, Karl, dies in New York.

Summer. Feininger visits the North German villages of Lüneburg, Lübeck, and Neubrandenburg. In August, he joins Gropius and Kandinsky in Timmendorf on the Baltic Sea.

fig. 238. Julia and Feininger in his studio in Dessau, 1927. Photographer unknown

1923

August. In hopes of justifying its existence to the regional government of Thuringia, the Bauhaus mounts an exhibition of marketable products, which its faculty and students create in partnership with industry.

October 15–30. Feininger works in a studio at the Anger Museum, Erfurt, made available to him by the museum's director.

Anderson Galleries in New York hosts *A Collection of Modern German Art*, the first comprehensive overview of avant-garde German art in the United States; Feininger is represented by forty-seven works. Disappointing sales and lukewarm reviews convince Feininger of America's lack of appreciation for German art.

1924

Summer. Feininger travels for the first time to Deep, a fishing village in Pomerania on the Baltic Sea; he and his family vacation there every summer for the next twelve years.

March 31. The collector Emmy ("Galka") Scheyer forms Die Blaue Vier (The Blue Four), consisting of Feininger, Kandinsky, Paul Klee, and Alexei Jawlensky, with the aim of promoting sales and joint exhibitions of their work in the United States.

August. Feininger exhibits for the first and only time with the Novembergruppe, formed in 1919, whose ideological aims are similar to those of the Arbeitsrat für Kunst.

December 3. Willi Apel (Appelbaum) performs Feininger's fugues for the first time in a piano recital at the Bauhaus.

December 15. The Thuringian parliament, under pressure from the craftsmen's unions and the National Socialists, sharply reduces funding for the Bauhaus and announces its intention to dismiss all Bauhaus faculty after six months.

1925

February 20. Daniel Gallery hosts the first exhibition of Die Blaue Vier in New York.

February. The Bauhaus faculty votes to relocate the school to Dessau.

April. With a few exceptions, Bauhaus faculty members move to Dessau, where they live for one year in temporary quarters while awaiting completion of the "Master Houses" designed by Gropius.

fig. 239. *Julia and Lyonel Feininger, Dessau*, 1931. Photograph by Andreas Feininger

fig. 240. Feininger's studio at the Bauhaus, Dessau, c. 1933. Photographer unknown

1926

July. The Feiningers move into a Master House in Dessau, which they share with László and Lucia Moholy-Nagy. Feininger lives with his family in the house for the next seven years; in exchange for forgoing a salary, he has no teaching obligations.

1927

July 25. Lyonel's mother, Elisabeth, dies in Berlin.

December. Alfred J. Barr, Jr., who will become the founding director of the Museum of Modern Art in New York, visits the Bauhaus and Feininger in Dessau.

1928

Spring. Thirteen of Feininger's paintings are included in a group show of modern German art in private collections at the Kronprinzenpalais (Crown Prince's Palace), the modern art building of the Nationalgalerie Berlin.

Feininger begins an intensive engagement with photography after his sons Andreas and T. Lux build a darkroom in the family's basement in Dessau; he continues experimenting with the medium on and off for the rest of his life.

1929

May. At the urging of Alois Schardt, the director of the Staatliche Galerie Moritzburg in Halle, in northeast Germany, the city's mayor commissions Feininger to paint a view of the city; Schardt provides Feininger with a studio in the museum's gate tower. The commission expands into a cycle of eleven paintings, which Feininger works on over the next two years.

December. Museum of Modern Art director Alfred Barr includes Feininger's work in *Paintings by 19 Living Americans*, the second exhibition mounted by the newly founded museum; New York art critics vehemently object to Feininger's inclusion, questioning the museum's decision to classify him as an American artist.

1930

November. At the order of Nazi party member Wilhelm Frick, Minister of the Interior for Thuringia, the Schloss Museum in Weimar removes Feininger's art from display, along with that of other artists in its modern collection.

1931

September. In celebration of Feininger's sixtieth birthday, the Nationalgalerie Berlin mounts a large-scale retrospective of the artist's work. At the close of the show, the museum installs a "Feininger room" in its permanent collection galleries.

1932

October 1. The National Socialists, now in control of Dessau's city council, dissolve the Bauhaus, which continues as a private school in Berlin. The Feiningers obtain permission to remain in Dessau until March of 1933.

1933

January 30. Adolph Hitler becomes Chancellor of Germany.

March. Feininger's paintings, along with other city- and state-owned modern art, are exhibited for ridicule in the windows of the Nazi party newspaper, *Die Mitteldeutsche Anhaltische Tageszeitung*; the next day, stormtroopers search the Feininger house.

Feininger arranges through Schardt to store his art in the Moritzburg Museum and he and Julia leave Dessau and go to Deep. They spend the next year and a half there and in Berlin, living with friends.

November. Halle's newly elected Nazi mayor quarantines the Moritzburg Museum's modern art collection, including its Feiningers, in a "chamber of horrors" that is accessible only by paying a fee and registering in a visitors' book.

1935

April. Feininger travels to Deep with Julia. When he returns on August 29 with his son Laurence, he finds anti-Semitic banners posted at the village's entrance; the couple's longtime landlord, afraid of losing his job, requests that Julia, a Jew, not rejoin Feininger.

May. The Kulturkammer (Chamber of Culture) demands proof of Feininger's Aryan ancestry; he submits the requisite documents but is able to exhibit only infrequently thereafter due to the regime's hostility to modern art.

1936

Spring. Feininger arranges for Hermann Klumpp, a family friend, to take his art, which Schardt has been storing in the Moritzburg Museum, to the Klumpp family farmstead in Quedlinburg in the Harz Mountains.

Feininger accepts an invitation from Alfred Neumeyer to teach a summer course at Mills College in Oakland, California. He and Julia arrive in New York on May 14 and are met by Frank

Kortheuer, his childhood friend now living in Falls Village, Connecticut. They continue on to California, where they stay with Galka Scheyer in Los Angeles before traveling to San Francisco and Oakland. In June, the Mills College art gallery mounts Feininger's first solo show in the United States; it travels to the San Francisco Museum of Art. The Feiningers spend August traveling through New England before returning to Berlin.

October 30. Nazi Minister of Education, Science and Culture, Bernhard Rust, announces the regime's campaign to cleanse German museums of "degenerate art."

1937

April. Karl Nierendorf, an émigré dealer who showed Feininger's work in his Berlin gallery, mounts a major show of it at his New York gallery; he remains Feininger's primary dealer until July 1939 when Feininger severs his ties with Nierendorf over what he considers the dealer's financial malfeasance.

June 11. Feininger and Julia leave Germany permanently after the artist receives an invitation to teach again at Mills College. At the end of the summer term, they move to New York City, where their youngest son, T. Lux, has relocated; Andreas moves there two years later. Their middle son, Laurence, moves to Italy.

July 19. The Nazis open the *Entartete Kunst* (Degenerate Art) exhibition in Munich, with over 600 examples of modern art confiscated from German museums, including 24 Feininger works; a modified version of the show tours Germany for the next three years. The remaining modern art in public collections, including 460 works by Feininger, is sent to Berlin to be sold or burned.

1938

January. Feininger and Julia rent an apartment at 235 East Twenty-second Street in New York, their primary residence for the remainder of their lives. Feininger's income derives exclusively from a commission to design the exterior mural on the Marine Transportation Building at the 1939 New York World's Fair.

June. The Feiningers spend the summer in Falls Village, Connecticut, near the Kortheuers; they return every summer through 1944 and continue to visit occasionally thereafter.

1939

June. Wilhelm Valentiner commissions Feininger to design the courtyard mural for the Masterpieces of Art Building at the World's Fair.

November 19. Feininger begins to paint in oil; over the next two years, he bases his subject matter on sketches, recollections, and previously executed works (including woodcuts) of sailing ships and dunes of the Baltic Sea.

1940

Summer. Feininger initiates a series of paintings of Manhattan skyscrapers.

1941

March. Feininger begins an association with Curt Valentin, who had opened the New York branch of Berlin's Buchholz Gallery in 1937 (renamed the Curt Valentin Gallery in 1951); Valentin remains Feininger's dealer until the gallery owner's death in 1954.

fig. 241. View of Feininger's mural at the Marine Transportation Building at the World's Fair, New York, 1939. Photographer unknown

fig. 242. View of one of three walls of Feininger's mural at the Masterpieces of Art Building at the World's Fair, 1939. Photograph by Lyonel Feininger

fig. 243. *Portrait of Lyonel Feininger*, 1943. Photograph by Josef Breitenbach

The Buchholz and Willard Galleries, located on the same floor on Fifty-seventh Street, jointly host a retrospective of Feininger's paintings and watercolors.

Valentin publishes the portfolio *Ten Woodcuts by Lyonel Feininger*.

1942

December. Feininger's 1936 painting *Gelmeroda XIII* wins an acquisition prize at the *Artists for Victory* exhibition at New York's Metropolitan Museum of Art; the $2,500 prize money allows Feininger to pay his debts.

With America at war with Italy, Feininger's son Laurence is declared an enemy alien by the Italian authorities and sent to civilian detention camps; he is released in 1945.

1944

April. Feininger meets painter and fellow Willard Gallery artist Mark Tobey, with whom he corresponds for the rest of his life.

October. The Museum of Modern Art mounts a joint retrospective of Feininger's and Hartley's work, which travels to ten American cities, solidifying Feininger's reputation in the United States.

1945

Summer. At the invitation of former Bauhaus colleague Josef Albers, Feininger teaches a summer course at Black Mountain College, an experimental school near Asheville, North Carolina. Gropius leads the college's architecture studies, while Feininger, Albers, Robert Motherwell, Fannie Hillsmith, Alvin Lustig, and Ossip Zadkine teach art courses.

September. Feininger and Julia spend several months in Museum of Modern Art curator Dorothy Miller's two-room house in Stockbridge, Massachusetts, where they stay every summer through 1948; in lieu of rent, Feininger gives Miller a watercolor each year.

1947

Feininger suffers chronic pain, inflammation, and lameness caused by a spine injury several years earlier that had displaced his vertebra.

Feininger is elected president of the Federation of American Painters and Sculptors.

1948

March. Feininger undergoes an operation on his back; he stays in the hospital for five weeks and is too weak to leave his apartment for several months thereafter.

1949

December. The Institute of Contemporary Art, Boston, opens a joint retrospective of Feininger's and Jacques Villon's art; the show travels to the Phillips Gallery, Washington, DC, and the Delaware Art Center in Wilmington.

1950

The industrial designer Henry Dreyfus commissions Feininger to design a forty-two-foot-long mural for the first class dining room of the American Export Lines steamer U.S.S. *Constitution*.

May. Feininger's first solo show in Europe since his departure in 1937 opens at the Kestner-Gesellschaft in Hanover; the show travels to Munich, Braunschweig, Mannheim, Düsseldorf, Paris, Hamburg, Berlin, and London.

June. Feininger and Julia spend the summer in Cambridge, Massachusetts, near their son T. Lux, who teaches painting at the Boston Museum of Fine Arts School.

1951

July. Feininger celebrates his eightieth birthday at Walter Gropius's home in South Lincoln, Massachusetts, where he and Julia stay for several months before going to Plymouth, Massachusetts; they return to Plymouth each subsequent fall for the next two years.

1953

The Feiningers summer in New Haven, Connecticut, at the home of Josef and Anni Albers.

1955

Following Valentin's death in 1954, Miriam Willard becomes Feininger's primary dealer.

Feininger is elected a member of the National Institute of Arts and Letters.

October 31. Feininger falls while getting out of the bath, suffering serious injuries that require complete immobilization for four weeks. The accident leaves him weak, with chest cramps.

1956

January 13. Feininger dies at the age of eighty-five in his New York apartment. He is buried in the Mount Hope Cemetery in Hastings-on-Hudson, New York.

fig. 244. Feininger at work, January 1951. Photograph by
Andreas Feininger

fig. 245. Feininger, T. Lux, and Tomas Feininger sailing boats in
Central Park, June 1951. Photograph by Andreas Feininger

fig. 246. Feininger's hands with his woodcut *Old Gables in
Lüneburg* (1924), 1951. Photograph by Andreas Feininger

fig. 247. Feininger and T. Lux Feininger in front of Feininger's murals
for the œConstitution, June 1951. Photograph by Andreas Feininger

Checklist of the

Exhibition

All works were shown at both venues unless otherwise noted below.

"The First Salutation (in New York Harbor): 'Check, please!'" ("Der erste Gruß [im Hafen von Newyork]: 'Zahlen, bitte!'"), *Lustige Blätter* XIX, no. 26, 1904
Commercial lithograph, 12⅛ x 8⅜ in. (27.3 x 21.4 cm)
Lyonel-Feininger-Galerie, Quedlinburg, Germany
(fig. 13)

"The Furious Locomotive" ("Die tobsüchtige Lokomotive"), *Der liebe Augustin* I, no. 15, 1904
Commercial lithograph, 12⅛ x 9⅛ in. (31 x 23.4 cm)
Lyonel-Feininger-Galerie, Quedlinburg, Germany
(fig. 12)

"Visit to the Balkan" ("Besuch am Balkan"), *Lustige Blätter* XIX, no. 44, 1904
Commercial lithograph, 10⅞ x 8½ in. (27.7 x 21.5 cm)
Lyonel-Feininger-Galerie, Quedlinburg, Germany
(fig. 14)

"The Pied Piper of England" ("Der Rattenfänger von England"), *Lustige Blätter* XX, no. 42, 1905
Commercial lithograph, 10¾ x 8⅜ in. (27.2 x 21.4 cm)
Lyonel-Feininger-Galerie, Quedlinburg, Germany
(fig. 15)

The Kin-der-Kids, from *The Chicago Sunday Tribune*, April 29, 1906
Commercial lithograph, 23⅜ x 17¹³⁄₁₆ in. (59.4 x 45.3 cm)
The Museum of Modern Art, New York; gift of the artist 260.1944.1
(fig. 19)

The Kin-der-Kids: Abroad, "Triumphant Departure of the Kids, in the Family Bathtub!!" from *The Chicago Sunday Tribune*, May 6, 1906
Commercial lithograph, 23⅜ x 17¹³⁄₁₆ in. (59.4 x 45.3 cm)
The Museum of Modern Art, New York; gift of the artist 260.1944.2
(fig. 20)

The Kin-der-Kids, "Relief-Expedition Slams into a Steeple, with Results," from *The Chicago Sunday Tribune*, July 1, 1906
Commercial lithograph, 23⅜ x 17¹³⁄₁₆ in. (59.4 x 45.3 cm)
The Museum of Modern Art, New York; gift of the artist 260.1944.9
(not illustrated)

The Kin-der-Kids, "Piemouth is Rescued by Kind-Hearted Pat," from *The Chicago Sunday Tribune*, September 9, 1906
Commercial lithograph, 23⅜ x 17¹³⁄₁₆ in. (59.4 x 45.3 cm)
The Museum of Modern Art, New York; gift of the artist 260.1944.19
(fig. 21)

Wee Willie Winkie's World, from *The Chicago Sunday Tribune*, August 26, 1906
Commercial lithograph, 23½ x 17¹³⁄₁₆ in. (59.7 x 45.2 cm)
The Museum of Modern Art, New York; gift of the artist 261.1944.1
(not illustrated)

Wee Willie Winkie's World, from *The Chicago Sunday Tribune*, September 16, 1906
Commercial lithograph, 23½ x 17¹³⁄₁₆ in. (59.7 x 45.2 cm)
The Museum of Modern Art, New York; gift of the artist 61.1944.4
(fig. 22)

Wee Willie Winkie's World, from *The Chicago Sunday Tribune*, September 30, 1906
Commercial lithograph, 23½ x 17¹³⁄₁₆ in. (59.7 x 45.2 cm)
The Museum of Modern Art, New York; gift of the artist 261.1944.6
(fig. 23)

Wee Willie Winkie's World, from *The Chicago Sunday Tribune*, November 25, 1906
Commercial lithograph, 23½ x 17¹³⁄₁₆ in. (59.7 x 45.2 cm)
The Museum of Modern Art, New York; gift of the artist 261.1944.9
(fig. 24)

"The Dutch House of Orange" ("Die kaiserliche Oranierie"), *Lustige Blätter*, XXII, no. 11, 1907
Commercial lithograph, 12⅛ x 9⅜ in. (31.1 x 24 cm)
Lyonel-Feininger-Galerie, Quedlinburg
(fig. 17)

The White Man, 1907
Oil on canvas, 26⅞ x 20⅝ in. (68.3 x 52.3 cm)
Collection of Carmen Thyssen-Bornemisza
(fig. 32)

Carnival, 1908
Oil on canvas, 27 x 21¼ in. (68.5 x 54 cm)
Nationalgalerie, Staatliche Museen, Berlin
(fig. 34)

Jesuits I, 1908
Oil on canvas, 23¾ x 21½ in. (60.2 x 54.6 cm)
Private collection
Whitney only
(fig. 38)

Carnival in Gelmeroda II, 1908
Oil on canvas, 27¼ x 21⅜ in. (69.2 x 54.3 cm)
Private collection
Whitney only
(fig. 35)

Street Types (Strassentypen II), 1908
Watercolor and ink on paper, 9⅞ x 7½ in. (25.1 x 19 cm)
Private collection
(fig. 36)

Diabolo Players I, 1909
Oil on canvas, 15½ x 26 in. (39 x 66.5 cm)
Private collection; courtesy Moeller Fine Art,
New York and Berlin
Whitney only
(fig. 39)

Figures, Dusk, 1909
Oil on canvas, 16⅜ x 14⅜ in. (41.4 x 36.3 cm)
Private collection
(fig. 40)

Green Bridge, 1909
Oil on canvas, 39⅞ x 31⅞ in. (101.1 x 81 cm)
Private collection
Whitney only
(fig. 51)

The Green Bridge (Die Grüne Brücke), 1909
Watercolor and ink over pencil on paper, 9⅞ x 7⅞ in.
(25 x 20 cm)
Private collection
(fig. 45)

In a Village Near Paris (Street in Paris, Pink Sky), 1909
Oil on canvas, 39¾ x 32 in. (101 x 81.3 cm)
University of Iowa Museum of Art, Iowa City; gift of
Owen and Leone Elliott 1968.15
(frontispiece)

Newspaper Readers (Zeitungsleser), 1909
Oil on canvas, 19¾ x 24⅞ in. (50.3 x 63.2 cm)
Collection of Judy and John M. Angelo
Whitney only
(fig. 31)

Uprising (Aufruhr), 1909
Ink and charcoal on paper, 12½ x 9⅜ in.
(31.8 x 23.8 cm)
The Museum of Modern Art, New York; gift in memory
of Reverend Laurence Feininger 244.1976
(fig. 46)

Village, Dusk (Dämmerdorf), 1909
Oil on canvas, 31½ x 39⅜ in. (80 x 100 cm)
Nationalgalerie, Staatliche Museen, Berlin
(fig. 42)

*City at the Edge of the World (Die Stadt am Ende der
Welt)*, 1910
Ink and gouache on paper, 9¼ x 11⅝ in. (23.5 x
29.5 cm)
Private collection
Whitney only
(fig. 94)

Locomotive with the Big Wheel I, 1910
Oil on canvas, 21¾ x 39½ in. (55.2 x 100.3 cm)
Albertina Museum, Vienna; Batliner Collection
(fig. 43)

Sunday Morning (Sonntag früh), 1910
Watercolor and ink on paper, 9½ x 11⅛ in. (24.1 x
28.3 cm)
Private collection
Whitney only
(fig. 48)

Uprising (Émeute), 1910
Oil on canvas, 41⅛ x 37⅝ in. (104.4 x 95.4 cm)
The Museum of Modern Art, New York; gift of Julia
Feininger 257.1964
Montreal only
(fig. 47)

Velocipedists (Draisinenfahrer), 1910
Oil on canvas, 37⅞ x 33½ in. (96 x 84.6 cm)
Private collection; courtesy Eykyn Maclean LP
Whitney only
(fig. 44)

Carnival in Arcueil, 1911
Oil on canvas, 41¼ x 37¾ in. (104.8 x 95.9 cm)
The Art Institute of Chicago; Joseph Winterbotham
Collection 1990.119
Whitney only
(fig. 52)

"City at the End of the World" ("Die Stadt am Ende
der Welt"), *Licht und Schatten I*, no. 25, 1911
Commercial lithograph, 13⅞ x 11 in. (35.3 x 27.9 cm)
Lyonel-Feininger-Galerie, Quedlinburg
(not illustrated)

The Disparagers, 1911
Watercolor and ink on paper, 9⅜ x 12¼ in. (23.8 x
31.1 cm)
The Museum of Modern Art, New York; acquired
through the Lillie P. Bliss Bequest 477.1953
(fig. 50)

The Head Inquisitor, 1911
Ink on paper, 9⅜ x 12⅜ in. (23.9 x 31.5 cm)
Private collection
(fig. 37)

On the Quay, 1911
Ink and opaque watercolor on paper, 9½ x 12⅜ in.
(24.1 x 31.4 cm)
The Museum of Modern Art, New York; gift of Julia
Feininger 271.1964
(fig. 49)

Angler with Blue Fish II, 1912
Oil on canvas, 22½ x 29½ in. (56.9 x 74.9 cm)
Private collection
Whitney only
(fig. 58)

Bathers on the Beach I, 1912
Oil on canvas, 19⅞ x 25⅞ in. (50.5 x 65.7 cm)
Harvard Art Museums, Busch-Reisinger Museum,
Cambridge, Massachusetts; Association Fund
BR54.7
Montreal only
(fig. 59)

Bicycle Race (Die Radfahrer), 1912
Oil on canvas, 31⅝ x 39½ in. (80.3 x 100.3 cm)
National Gallery of Art, Washington, DC; collection
of Mr. and Mrs. Paul Mellon 1985.64.17
(fig. 64)

*The City at the Edge of the World (In der Stadt am
Ende der Welt)*, 1912
Ink and charcoal on paper, 12½ x 9½ in. (31.8 x
24.1 cm)
The Museum of Modern Art, New York; gift of Julia
Feininger 125.1966
(fig. 68)

Fisherfleet in Swell, 1912
Oil on canvas, 16⅜ x 19 in. (41.5 x 48.3 cm)
Sprengel Museum, Hannover
(fig. 62)

The Messenger (Der Bote), 1912
Oil on canvas, 19 x 15¾ in. (48.3 x 40 cm)
The Caroline and Stephen Adler Family
(fig. 63)

Pier (Landungsbrücke), 1912
Oil on canvas, 28½ x 32½ in. (72.4 x 82.6 cm)
Private collection
Montreal only
(fig. 30)

Study, On the Cliffs (Early Attempt at Cubist Form),
1912
Oil on canvas, 18 x 23¾ in. (45.7 x 60.2 cm)
Collection of A. Alfred Taubman
Whitney only
(fig. 60)

*Town Hall, Swinemünde (Rathaus von
Swinemünde)*, 1912
Oil on canvas, 28 x 23⅛ in. (71.1 x 58.9 cm)
Private collection
(fig. 65)

Trumpeters, 1912
Oil on canvas, 37 x 31½ in. (94.4 x 80.3 cm)
Private collection
Whitney only
(fig. 66)

High Houses II, 1913
Oil on canvas, 39½ x 32 in. (100.3 x 81.3 cm)
Neuberger Museum of Art, Purchase College, State
University of New York; gift of Roy R. Neuberger
1974.22.09
(fig. 55)

Gelmeroda II, 1913
Oil on canvas, 39⅞ x 31½ in. (100.3 x 80.3 cm)
Private collection; courtesy Neue Galerie, New York
Whitney only
(fig. 70)

Jesuits II, 1913
Oil on canvas, 28¾ x 23⅝ in. (73 x 60 cm)
Saint Louis Art Museum; bequest of Morton D. May
886:1983
Whitney only
(fig. 77)

On the Beach (Am Strande), 1913
Oil on canvas, 15¾ x 19⅛ in. (40 x 48.5 cm)
Musée National d'Art Moderne, Centre Georges
Pompidou, Paris
Whitney only
(fig. 72)

The Side-wheeler II (Raddampfer II), 1913
Oil on canvas,¾ x 39⅝ in. (80.6 x 100.6 cm)
Detroit Institute of Arts; City of Detroit Purchase
21.208
Whitney only
(fig. 71)

Train cars, c. 1913–14, buildings, c. 1925–55
Painted wood, overall dimensions variable
The Museum of Modern Art, New York; Julia
Feininger Bequest SC704.1971.1–37
(fig. 95)

Avenue of Trees (Allée), 1915
Oil on canvas, 31¹¹⁄₁₆ x 39⁹⁄₁₆ in. (80.5 x 100.5 cm)
Harvard Art Museums, Busch-Reisinger Museum,
Cambridge, Massachusetts; bequest of William S.
Lieberman BR2007.17
(fig. 81)

The Fleet (Schlachtflotte), 1915
Ink and watercolor on paper, 8⁵⁄₁₆ x 10 in. (21.1 x
25.4 cm)
Private collection
(fig. 83)

Gelmeroda IV, 1915
Oil on canvas, 39½ x 31⅜ in. (100 x 79.7 cm)
Solomon R. Guggenheim Museum, New York 54.1410
(fig. 88)

Jesuits III, 1915
Oil on canvas, 29½ x 23 3/6 in. (74.9 x 59.9 cm)
Private collection
(fig. 78)

Rainy Day, 1915
Oil on canvas, 39⅜ x 31½ in. (100 x 80 cm)
Private collection; courtesy Moeller Fine Art,
New York and Berlin
Whitney only
(fig. 84)

Self-Portrait (Selbstbildnis), 1915
Oil on canvas, 39½ x 31½ in. (100.3 x 80 cm)
Sarah Campbell Blaffer Foundation, Houston
BF.1979.15
(fig. 80)

Trumpeter in the Village, 1915
Oil on canvas, 25¾ x 29½ in. (65.4 x 74.9 cm)
Private collection
(fig. 85)

Untitled (Deserted Child), 1915
Watercolor and ink on paper, 12⅜ x 9¼ in. (31.5 x
23.5 cm)
Private collection; courtesy Moeller Fine Art, New
York and Berlin
Whitney only
(fig. 74)

Untitled (The Red Fiddler), 1915
Graphite, ink, and watercolor on paper, 12⅝ x
9¼ in. (32 x 23.4 cm)
Private collection
(fig. 145)

*Woman's Head with Green Eyes (Frauenkopf mit
grünen Augen)*, 1915
Oil on canvas, 28 x 24½ in. (71.1 x 62.2 cm)
Saint Louis Art Museum; bequest of Morton D.
May 887:1983
Whitney only
(fig. 79)

The Green Bridge II (Grüne Brücke II), 1916
Oil on canvas, 49⅜ x 39½ in. (125.4 x 100.3 cm)
North Carolina Museum of Art, Raleigh; gift of
Mrs. Ferdinand Möller
(fig. 90)

Streetcleaners, 1916
Oil on canvas, 47⅝ x 59⅛ in. (120.8 x 150 cm)
Private collection
Whitney only
(fig. 86)

Zirchow V, 1916
Oil on canvas, 31⅞ x 39⅝ in. (81 x 100.6 cm)
The Brooklyn Museum; J. B. Woodward Memorial
Fund and Mr. and Mrs. Otto Spaeth 54.62
(fig. 82)

Bridge, figures, houses, train, and tree, c. 1916–45
Painted wood, overall dimensions variable
Private collection
(fig. 93)

High Houses III, 1917
Oil on canvas, 39½ x 31 in. (100.3 x 78.7 cm)
Robert McLaughlin Gallery, Oshawa, Ontario
Montreal only
(not illustrated)

Mill with Red Man, c. 1917
Oil on canvas, 19⅛ x 15⅞ in. (48.6 x 40.3 cm)
Private collection
(fig. 87)

Euphoric Victory (Siegesrausch), 1918
Watercolor and ink on paper, 13⅝ x 12⅛ in.
(34.6 x 30.6 cm)
The Museum of Modern Art, New York; gift of Julia
Feininger 130.1966
(fig. 102)

Houses in Paris (Häuser in Paris), 1918
Woodcut on paper, 24¾ x 19⁷⁄₁₆ in. (62.9 x
49.3 cm)
The Brooklyn Museum; Dick S. Ramsay Fund
62.59.2
(fig. 110)

Promenaders (Spaziergänger), 1918
Woodcut, 14⁹⁄₁₆ x 11½ in. (37 x 29.5 cm)
The Brooklyn Museum; Dick S. Ramsay Fund
62.59.3
(fig. 91)

Yellow Street II, 1918
Oil on canvas, 37½ x 33⅞ in. (95 x 86.1 cm)
Montreal Museum of Fine Arts; purchase, gift
of The Maxwell Cummings Family Foundation,
The Montreal Museum of Fine Arts' Volunteer
Association, John G. McConnell, C.B.E., Mr. and
Mrs. A. Murray Vaughan, Harold Lawson Bequest,
and Horsley and Annie Townsend Bequest
(fig. 89)

Zirchow VII, 1918
Oil on canvas, 31¾ x 39⅜ in. (80.7 x 100 cm)
National Gallery of Art, Washington, DC; gift of
Julia Feininger 1966.3.1
(fig. 108)

Bridge V (Brücke V), 1919
Oil on canvas, 31⅝ x 39½ in. (80.3 x 100.3 cm)
Philadelphia Museum of Art; purchased with the
Bloomfield Moore Fund, 1951
(fig. 109)

Cathedral (Kathedrale), 1919
Woodcut, 16⅛ x 12³⁄₁₆ in. (41 x 31 cm)
The Museum of Modern Art, New York; gift of Abby
Aldrich Rockefeller 156.1945
(fig. 101)

High Houses IV, 1919
Oil on canvas, 39⅞ x 31⅞ in. (101.1 x 81 cm)
Collection of Joseph Edelman and Pamela Keld
(fig. 111)

Railroad Viaduct, 1919
Woodcut, 13⅛ x 16⅞ in. (33.3 x 42.9 cm)
Private collection; courtesy Moeller Fine Art,
New York and Berlin
(fig. 75)

The Red Clown, 1919
Oil on canvas, 28½ x 24½ in. (72.4 x 62.2 cm)
Private collection
(fig. 115)

Church at Gelmeroda, c. 1920
Painted wood, 12¾ x 10⅛ x 3⅛ in. (32.3 x 25.5 x
7.8 cm)
The Museum of Modern Art, New York; Julia
Feininger Bequest SC209.1972
(fig. 69)

Battle Fleet, 1920
Oil on canvas, 16 x 19 in. (40.6 x 48.3 cm)
Private collection
Montreal only
(fig. 116)

Hopfgarten, 1920
Oil on canvas, 25 x 32¼ in. (63.5 x 81.9 cm)
Minneapolis Institute of Arts; given in memory of
Catharine Roberts Seybold by her family and friends
55.2
(fig. 117)

Viaduct, 1920
Oil on canvas, 39¾ x 33¾ in. (100.9 x 85.7 cm)
The Museum of Modern Art, New York; acquired
through the Lillie P. Bliss Bequest 259.1944
(fig. 112)

Bridge, figures, and houses, 1920s–40s
Painted wood, overall dimensions variable
Moeller Fine Art, New York and Berlin
(fig. 99)

Figures and houses, 1920s–40s
Painted wood, overall dimensions variable
The Cleveland Museum of Art; in memory
of Leona E. Prasse, Gift of Ada Prasse Bittel
1985.170
(fig. 76)

Figures and houses, 1920s–40s
Painted wood, overall dimensions variable
Private collection
(not illustrated)

Figures and houses, 1920s–40s
Painted wood, overall dimensions variable
Private collection
(not illustrated)

Figures, houses, and trees, 1920s–40s
Painted wood, overall dimensions variable
Private collection
(not illustrated)

Architecture II (The Man from Potin) (Architektur II),
1921
Oil on canvas, 39¾ x 31¾ in. (101 x 80.5 cm)
Museo Thyssen-Bornemisza, Madrid
Whitney only
(fig. 113)

Departing Skiff (Ausfahrende Barke), 1921
Watercolor and ink on paper, 10¾ x 13⅞ in.
(27.3 x 35 cm)
Sprengel Museum, Hannover
(fig. 114)

Gelmeroda VIII, 1921
Oil on canvas, 39¼ x 31¼ in. (99.7 x 79.4 cm)
Whitney Museum of American Art, New York;
purchase 53.38
(fig. 121)

Nighthawks (Nachtvögel), 1921
Oil on canvas, 23⅝ x 19¾ in. (60 x 50 cm)
Collection of Charles K. Williams II
Whitney only
(fig. 118)

Church of Heiligenhafen, 1922
Oil on canvas, 15¾ x 23¾ in. (40 x 60.3 cm)
Reynolda House Museum of American Art,
Winston-Salem, North Carolina 1966.2.12
(fig. 106)

Lady in Mauve, 1922
Oil on canvas, 39⅝ x 31½ in. (100.7 x 80 cm)
Museo Thyssen-Bornemisza, Madrid
Whitney only
(fig. 119)

The Island (Die Insel), 1923
Oil on canvas, 18⅛ x 29⅛ in. (46 x 74 cm)
Private collection; courtesy Moeller Fine Art,
New York and Berlin
(fig. 122)

Town Gate—Tower I (Torturm I), 1923–26
Oil on canvas, 24½ x 18½ in. (61 x 47.5 cm)
Kunstmuseum Basel; bequest of Richard Doetsch-
Benziger, Basel G1960.18
(fig. 125)

Benz, 1924
Oil on canvas, 15 x 18¾ in. (38 x 47.5 cm)
Private collection; courtesy Moeller Fine Art,
New York and Berlin
Whitney only
(fig. 124)

Blue Marine (Blaue Marine), 1924
Oil on canvas, 18¹⁵⁄₁₆ x 33³⁄₁₆ in. (48.1 x 84.3 cm)
Munson-Williams-Proctor Institute, Museum of Art,
Utica, New York 52.35
(fig. 123)

Gaberndorf II, 1924
Oil on canvas mounted on board, 39⅛ x 30½ in.
(99.4 x 77.5 cm)
The Nelson-Atkins Museum of Art, Kansas City,
Missouri; gift of a group of the Friends of Art
46-10
(fig. 120)

Old Gables in Lüneburg (Die Giebel in Lüneburg),
1924
Woodcut, 9¾ x 16 in. (24.8 x 40.7 cm)
The Museum of Modern Art, New York; gift of Julia
Feininger 172.1966
(fig. 104)

Gables I, Lüneburg, 1925
Oil on canvas, 37¾ x 28½ in. (95.9 x 72.4 cm)
Smith College Museum of Art; Northampton,
Massachusetts; gift of Nanette Harrison Meech
(Mrs. Charles B. Meech), class of 1939, in honor of
Julia Meech, class of 1963
Montreal only
(fig. 127)

*The Bird Cloud (Vogelwolke [Wolke nach dem
Sturm])*, 1926
Oil on canvas, 17¼ x 28 in. (43.8 x 71.1 cm)
Harvard Art Museums, Busch-Reisinger Museum,
Cambridge, Massachusetts; purchase in memory of
Eda K. Loeb BR50.414
Montreal only
(fig. 129)

Church of the Minorites II (Barfüsserkirche II), 1926
Oil on canvas, 42¾ x 36⅝ in. (108.6 x 93 cm)
Walker Art Center, Minneapolis; gift of the T.B. Walker
Foundation, Gilbert M. Walker Fund 1943.20
(fig. 138)

Broken Glass (Glasscherbenbild), 1927
Oil on canvas, 28½ x 27½ in. (72 x 70 cm)
Private collection; courtesy Moeller Fine Art, New
York and Berlin
(fig. 126)

The Steamer Odin, II, 1927
Oil on canvas, 26½ x 39½ in. (67.3 x 100.3 cm)
The Museum of Modern Art, New York; acquired
through the Lillie P. Bliss Bequest 751.1943
(fig. 134)

Edge of the Woods (Pine Woods), 1928
Oil on canvas, 23¾ x 29½ in. (60.3 x 74.9 cm)
Private collection
Montreal only
(not illustrated)

Bulwark (Bollwerk), 1929
Ink and watercolor on paper, 11¼ x 15¹⁵⁄₁₆ in.
(28.5 x 40.5 cm)
Fine Arts Museums of San Francisco; bequest of
Ruth Haas Lilienthal 1975.2.8
(fig. 70)

Calm at Sea III (Stiller Tag am Meer III), 1929
Oil on canvas, 19¼ x 14⅛ in. (49 x 36 cm)
Private collection; courtesy Moeller Fine Art,
New York and Berlin
(fig. 136)

Gelmeroda XII (Church at Gelmeroda, XII), 1929
Oil on canvas, 39⅝ x 31¾ in. (100.7 x 80.7 cm)
Museum of Art, Rhode Island School of Design,
Providence; gift of Mrs. Murray S. Danforth
(fig. 137)

Lighted Windows I (Beleuchtete Häuserzeile),
1929
Oil on canvas, 14¼ x 22 in. (36.2 x 55.9 cm)
Staatliche Kunstsammlungen Dresden
(fig. 221)

Untitled (Bauhaus, Dessau, balcony of the atelier
building, night), 1929
Gelatin silver print, 7 x 9⅝ in. (17.9 x 23.9 cm)
Bauhaus-Archiv, Berlin
(fig. 215)

Untitled (Bauhaus, Dessau, at night), 1929
Gelatin silver print, 7 x 9⅜ in. (17.8 x 23.8 cm)
Bauhaus-Archiv, Berlin
(fig. 220)

Untitled (A misty night in the Burgkühnauer Allee,
Dessau), 1929
Gelatin silver print, 7 x 9⁵⁄₁₆ in. (17.7 x 23.7 cm)
Houghton Library, Harvard College Library,
Harvard University, Cambridge, Massachusetts;
gift of T. Lux Feininger
(fig. 141)

Untitled (The Albers-Feininger house in a fog,
Dessau), 1929
Gelatin silver print, 7 x 9⁵⁄₁₆ in. (17.7 x 23.7 cm)
Houghton Library, Harvard College Library,
Harvard University, Cambridge, Massachusetts;
gift of T. Lux Feininger
(fig. 142)

Untitled (Stand of pinetrees in front of the house
occupied by the artist and his family, Dessau),
1929
Gelatin silver print, 7 x 9⁵⁄₁₆ in. (17.8 x 23.7 cm)
Houghton Library, Harvard College Library,
Harvard University, Cambridge, Massachusetts;
gift of T. Lux Feininger
(fig. 143)

X 54 (Sailboats), 1929
Oil on canvas, 17 x 28½ in. (43.2 x 72.4 cm)
Detroit Institute of Arts; gift of Robert H. Tannahill
69.305
(fig. 139)

*Burgkühnauer Allee 4, around 10 at night
(Burgkühnauer Allee 4, nachts um 10 Uhr)*,
c. 1929
Gelatin silver print, 5 x 7 in. (12.8 x 17.8 cm)
Bauhaus-Archiv, Berlin
(fig. 218)

Mouth of the Rega III (Regamündung III), 1929–30
Oil on canvas, 18⅞ x 30¼ in. (48 x 76.5 cm)
Hamburger Kunsthalle, on permanent loan from the
Foundation for the Hamburg Art Collections
(fig. 135)

Sunset at Deep (Sunset), 1930
Oil on canvas, 18⅞ x 30⅝ in. (47.9 x 77.8 cm)
Museum of Fine Arts, Boston; The Hayden
Collection—Charles Henry Hayden Fund 41.568
(fig. 140)

*Church of St. Mary at Night, Halle (Marienkirche
bei Nacht)*, 1931
Oil on canvas, 39⅜ x 32½ in. (100.5 x 80 cm)
Von der Heydt-Museum, Wuppertal, Germany
Whitney only
(fig. 224)

Deep, 1932
Watercolor, charcoal and ink on paper, 10⅝ x
17¼ in. (27 x 43.8 cm)
Fundación MAPFRE, Madrid; courtesy Moeller
Fine Art, New York and Berlin
(fig. 151)

Lüneburg II, 1933
Watercolor and ink on paper, 13⅞ x 7¼ in.
(43.6 x 35.1 cm)
Solomon R. Guggenheim Museum, New York;
estate of Karl Nierendorf, by purchase 48.1172.473
Whitney only
(fig. 149)

Glassy Sea, 1934
Watercolor and ink on paper, 13⅜ x 18⅞ in.
(34.1 x 38.1 cm)
The Museum of Modern Art, New York; given
anonymously (by exchange) 258.1944
(fig. 154)

The Red Fiddler (Der rote Geiger), 1934
Oil on canvas, 39½ x 31½ in. (101.3 x 80 cm)
Private collection
Whitney only
(fig. 146)

Ruin by the Sea, III (Ruine am Meer, III), 1934
Watercolor and ink on paper, 11 x 17½ in.
(28 x 44.5 cm)
Private collection; courtesy Moeller Fine Art,
New York and Berlin
Whitney only
(fig. 152)

In the Trade Wind (Im Passat II), 1935
Watercolor and ink on paper, 11⅞ x 19⅛ in.
(30.1 x 48.6 cm)
Hamburger Kunsthalle; gift of Julia Feininger
Whitney only
(fig. 153)

Gelmeroda XIII (Gelmeroda), 1936
Oil on canvas, 39½ x 31⅝ in. (100.3 x 80.3 cm)
The Metropolitan Museum of Art, New York;
George A. Hearn Fund 42.158
(fig. 168)

Spring, Vollersroda, 1936
Oil on canvas, 39⅜ x 31½ in. (100 x 80 cm)
Private collection, on permanent loan to the
Hamburger Kunsthalle
Whitney only
(fig. 150)

IV B (Manhattan), 1937
Watercolor and ink on paper, 12 x 9½ in.
(31.4 x 24 cm)
Private collection
(fig. 159)

Untitled (Manhattan at Night), 1937
Watercolor and ink on paper, 12⅜ x 9½ in.
(31.4 x 24.2 cm)
Collection of Renée Price
Whitney only
(fig. 169)

Cathedral of Cammin, 1938
Watercolor and ink on paper, 11⅜ x 17⅞ in.
(28.9 x 45.4 cm)
The Brooklyn Museum; bequest of Edith and Milton
Lowenthal 1992.11.8
(fig. 156)

Montmartre, Paris, 1938
Watercolor and ink on paper, 12³⁄₁₆ x 10 in.
(31 x 25.4 cm)
Private collection
(fig. 170)

Offshore, 1938
Watercolor and ink on paper, 6⁵⁄₁₆ x 24⅞ in.
(16 x 63.2 cm)
Private collection
(fig. 155)

Dunes and Breakwaters, 1939
Oil on canvas, 24 x 36 in. (60.9 x 91.4 cm)
Private collection
(fig. 174)

Storm Brewing, 1939
Oil on canvas, 19 x 30½ in. (48.2 x 77.5 cm)
National Gallery of Art, Washington, DC; gift of Julia
Feininger 1967.12.1
(fig. 167)

Manhattan I, 1940
Oil on canvas, 39⅝ x 31⅞ in. (100.5 x 80.9 cm)
The Museum of Modern Art, New York; gift of Julia
Feininger 259.1964
(fig. 176)

Manhattan, Night, 1940
Oil on canvas, 24 x 16⅞ in. (61 x 43 cm)
Private collection; courtesy Moeller Fine Art, New
York and Berlin
(fig. 175)

The Night Express, 1941
Oil on canvas, 14 x 17 in. (35.6 x 43.2 cm)
Private collection
(fig. 177)

Peaceful Navigation, 1941
Oil on canvas, 17 x 17 in. (43.2 x 43.2 cm)
The Caroline and Stephen Adler Family
(fig. 179)

The Anglers (Black Bridge), 1942
Oil on canvas, 17 x 23 in. (43 x 58 cm)
Private collection
(fig. 181)

Manhattan Skyscrapers, 1942
Ink and charcoal on paper, 22¹⁄₁₆ x 15⅝ in.
(56 x 39.7 cm)
Whitney Museum of American Art, New York;
exchange 53.54
(fig. 171)

Off the Coast, 1942
Watercolor and ink on paper 12¼ x 18⅞ in.
(31.1 x 47.9 cm)
Whitney Museum of American Art, New York;
purchase 42.35
(fig. 172)

Moonwake, 1945
Oil on canvas, 30 x 23 in. (76.2 x 58.4 cm)
Collection of Carol and Paul Miller
(fig. 182)

Clouds Over the Baltic, 1947
Watercolor on paper, 12⅜ x 18⅞ in. (31.5 x 48 cm)
The Brooklyn Museum; bequest of Mrs. Carl L.
Selden 1996.150.11
(fig. 183)

Courtyard III, 1949
Oil on canvas, 23½ x 18½ in. (59.7 x 47 cm)
The Metropolitan Museum of Art, New York;
bequest of Miss Adelaide Milton de Groot
67.187.161
(fig. 185)

The Cutting, 1949
Oil on canvas, 17 x 28 in. (43.2 x 71.1 cm)
Private collection
Whitney only
(fig. 187)

Figures and houses, c. 1949
Painted wood, overall dimensions variable
The Art Institute of Chicago; bequest of Maxine
Kunstadter 1978.411
Whitney only
(fig. 97)

Jagged Clouds, I, 1950
Watercolor and pen and ink on cream colored
paper, 12⁷⁄₁₆ x 18⅞ in. (31.6 x 48 cm)
The Brooklyn Museum; Carll H. De Silver Fund
51.90
(fig. 173)

Yachts, 1950
Oil on canvas, 21 x 36⅛ in. (53.3 x 91.8 cm)
National Gallery of Canada, Ottawa; gift of Dorothy
Meigs Eidlitz, St. Andrews, New Brunswick, 1968
Montreal only
(not illustrated)

The Spell, 1951
Oil on canvas, 30 x 24 in. (76.2 x 60.9 cm)
Collection of Geraldine S. Kunstadter; courtesy
Moeller Fine Art, New York and Berlin
(fig. 186)

Mid-Manhattan, 1952
Watercolor, charcoal, and ink on paper, 20¼ x
15⅝ in. (51.5 x 39.7 cm)
The Metropolitan Museum of Art, New York;
George A. Hearn Fund 53.176
(fig. 184)

Sunset Fires, 1953
Oil on canvas, 24 x 36 in. (61 x 91.4 cm)
Private collection
(fig. 188)

Fenris Wolf, 1954
Oil on canvas, 20 x 30 in. (50.8 x 76.2 cm)
Private collection, on permanent loan to the
Hamburger Kunsthalle
Whitney only
(fig. 190)

Marine, 1954
Watercolor on paper, 11⅞ x 18¼ in. (30.2 x
46.4 cm)
The Metropolitan Museum of Art, New York;
George A. Hearn Fund 56.74
(fig. 189)

As of March 1, 2011

Selected Bibliography

Achim Moeller Fine Art. *Lyonel Feininger: Figurative Drawings, 1908–1912*. Exhibition catalogue. New York: Achim Moeller Fine Art, 1990.

Achim Moeller Fine Art. *Lyonel Feininger, Visions of City and Sea II: A small retrospective exhibition of drawings and watercolors*. Exhibition catalogue. New York: Achim Moeller Fine Art, 1986.

Acquavella Galleries and the Phillips Collection. *Lyonel Feininger*. Exhibition catalogue. Essays by T. Lux Feininger and Ralph F. Colin. New York: Acquavella Galleries; Washington, DC: The Phillips Collection, 1985.

Associated American Artists. *Lyonel Feininger: Etchings, Lithographs, and Woodcuts from the Estate of the Artist*. Exhibition catalogue. New York: Associated American Artists, 1972.

Barnett, Vivian Endicott. *The Blue Four Collection at the Norton Simon Museum*. New Haven: Yale University Press in association with the Norton Simon Art Foundation, 2002.

Barnett, Vivian Endicott, and Josef Helfenstein, eds. *The Blue Four: Feininger, Jawlensky, Kandinsky, and Klee in the New World*. Exhibition catalogue. Essays by Vivian Endicott Barnett, Michael Baumgartner, Sara Campbell, Stefan Frey, Josef Helfenstein, Christina Houstian, Angelica Jawlensky, Maria Müller, Naomi Sawelson-Gorse, and Karin Zaugg. New Haven: Yale University Press; Cologne: DuMont, 1997.

Barr, Alfred H., Jr. *Lyonel Feininger/Marsden Hartley*. Exhibition catalogue. Essays by Alfred H. Barr, Jr., and Alois J. Schardt. New York: The Museum of Modern Art, 1944.

Blackbeard, Bill. *Lyonel Feininger: The Kin-der-Kids: The Complete Run of the Legendary Comic Strip in Full Color*. Essay by Maurice Horn. New York: Dover, 1980.

Blackbeard, Bill, ed. *The Comic Strip Art of Lyonel Feininger*. Northampton, MA: Kitchen Sink Press, 1994.

Bode, Ursula, ed. *Begegnungen: Max Ernst—Carl Wilhelm Kolbe d.Ä., Lyonel Feininger, Dieter Roth*. Exhibition catalogue. Essays by Wolfgang Büche and Ingrid Wernecke. Hannover: Niedersächsische Sparkassenstiftung, 1999.

Büche, Wolfgang. *Feininger: Arbeiten aus seiner Zeit in Weimar und Dessau*. Exhibition catalogue. Leipzig, Germany: Beck und Eggeling, 1994.

Büche, Wolfgang, ed. *Lyonel Feininger: Gelmeroda, Ein Maler und sein Motiv*. Exhibition catalogue. Essays by Wolfgang Büche, Stephan E. Hauser, Andreas Hüneke, and Karl Kreuzer. Stuttgart: Gerd Hatje, 1995.

Büche, Wolfgang, ed. *Lyonel Feininger: Halle-Bilder, Die Natur-Notizen*. Exhibition catalogue. Essays by Wolfgang Büche and Katja Schneider. Leipzig, Germany: Beck und Eggeling, 2000.

Büche, Wolfgang, ed. *Lyonel Feininger: Zurück in Amerika, 1937–1956*. Exhibition catalogue. Essays by Magdalena Dabrowski, Björn Egging, T. Lux Feininger, Stephan E. Hauser, and Andreas Hüneke. Munich: Hirmer, 2009.

Büche, Wolfgang, Andreas Hüneke, and Peter Romanus. *Lyonel Feininger: Die Halle-Bilder*. Exhibition catalogue. Munich: Prestel, 1991.

Buchholz Gallery and Willard Gallery. *Lyonel Feininger*. Exhibition catalogue. New York: Buchholz Gallery and Willard Gallery, 1941.

Curti-Feininger, Danilo, ed. *Lyonel Feininger: Opere dalle collezioni private italiane*. Exhibition catalogue. Essays by Wolfgang Büche, Danilo Curti-Feininger, Lyonel Feininger, T. Lux Feininger, and Alfred Knoblauch. Milan: Skira in association with Museo di Arte Moderna e Contemporanea di Trento e Rovereto, 2007.

Curti-Feininger, Danilo, ed. *Lyonel Feininger, Edward Thöny: Caricature Karikaturen*. Exhibition catalogue. Essays by Wolfgang Büche, Danilo Curti-Feininger, Brunamaria Dal Lago Veneri, Ines Janet Engelmann, and Michael Seeber. Bolzano, Italy: City of Bolzano, 2003.

Demetrion, James T. *Lyonel Feininger, 1871–1956: A Memorial Exhibition*. Exhibition catalogue. Alhambra, CA: Cunningham Press, 1966.

Deuchler, Florens. *Feininger in Paris: Lyonel Feininger the Paris Drawings, 1892–1911*. Exhibition catalogue. New York: Achim Moeller Fine Art, 1992.

Deuchler, Florens. *Lyonel Feininger: Lokomotiven und Eisenbahnlandschaften: 40 Zeichnungen und Skizzen, 1901–1913*. Exhibition catalogue. Baden, Germany: Stiftung Langmatt Sidney and Jenny Brown in collaboration with Achim Moeller Fine Art, 1991.

Deuchler, Florens. *Lyonel Feininger: Sein Weg zum Bauhaus-Meister*. Leipzig, Germany: Seemann, 1996.

Dylla, Sabine. *Lyonel Feininger: Begegnung und Erinnerung Lüneburger Motive, 1921–1954*. Exhibition catalogue. Lüneburg, Germany: Kulturforum Lüneburg, 1991.

Eckmann, Sabine, "The Loss of Homeland and Identity: Georg Grosz and Lyonel Feininger." In *Exiles and Émigrés: The Flight of European Artists from Hitler*, edited by Stephanie Barron, 296–303. Exhibition catalogue. Los Angeles: Los Angeles County Museum of Art, 1997.

Egging, Björn. *Feininger im Harz*. Exhibition catalogue. Bielefeld, Germany: Kerber, 2009.

Eisold, Norbert, ed. *Lyonel Feininger: Sailing Ship with Blue Angler—The Dr. Hermann Klumpp Collection in Quedlinburg; Graphic Art, Drawing, Painting, 1906–1937*. Exhibition catalogue. Essays by Wolfgang Büche, Norbert Eisold, and Andrea Hüneke. Quedlinburg, Germany: Lyonel-Feininger-Galerie, 2006.

Faass, Martin. *Im Hafen von Peppermint: Die Schiffe Lyonel Feiningers*. Exhibition catalogue. Bonn: VG Bild-Kunst, 1999.

Faass, Martin, ed. *Feininger im Weimarer Land*. Exhibition catalogue. Essays by Martin Faass, Christine Lieberknecht, Michael Muller, and Hans-Helmut Munchberg. Weimar: NDG, 1999.

Feininger, Laurence. *Das musikalische Werk Lyonel Feiningers*. Tutzing, Germany: H. Schneider, 1971.

Feininger, Lyonel. Letter to Paul Westheim, March 14, 1917. First published in *Das Kunstblatt*, no. 15, 1931, 215–20. English translation in June L. Ness, ed., *Lyonel Feininger*. New York: Praeger, 1974, 27–28.

Feininger, Lyonel. "Ont Collaboré a ce Numéro, Les Peintres, Sculpteurs, Graveurs: Lyonel Feininger, Régnault-Sarasin, H. Ymart, A.-H. Gorson, Czarnecki, A. Mérodack-Jeaneau." In *Les Tendances Nouvelles*, no. 56, 1912. Reprinted in *Les Tendances Nouvelles*, vol. IV. New York: Da Capo Press, 1980, 1339–40.

Feininger, Lyonel, and Alfred Vance Churchill. Correspondence. Archives of American Art, Washington, DC, and New York.

Feininger, Lyonel, and Julia Feininger. Correspondence. Lyonel Feininger papers, Houghton Library, Harvard College Library, Harvard University, Cambridge, MA.

Feininger, Lyonel, and Julia Feininger. "Comments by a Fellow Artist." In *Paintings by Mark Tobey*. Exhibition catalogue. Portland, OR: Portland Art Museum, 1945.

Feininger, Lyonel, and Julia Feininger. "Perception and Trust" (statement on Black Mountain College). *Design* 47, no. 8, 1946, 7.

Feininger, Lyonel, and Julia Feininger. "Personal Recollections of Paul Klee." In *Paul Klee*. Exhibition catalogue. New York: Buchholz Gallery, 1940, 6–8.

Feininger, Lyonel, and Julia Feininger. "Wassily Kandinsky." *Magazine of Art*, no. 38, 1945, p. 74.

Feininger, Lyonel, and Adolf Knoblauch. Correspondence. First published in *Der Sturm* 8, no. 6, 1917–18, 82–86. English translations published in June L. Ness, ed., *Lyonel Feininger*, New York and Washington, DC: Praeger, 1974, 28–33.

Feininger, Lyonel, and Francis Kortheuer. Correspondence. Collection of the late Horace Richter (originals); Archives of American Art, Washington, DC, and New York (copies).

Feininger, Lyonel, and Alfred Kubin. Correspondence. Hamburg: Kubin Archiv. English translations published in June L. Ness, ed., *Lyonel Feininger*, New York and Washington, DC: Praeger, 1974, 33–55.

Feininger, Lyonel, and Galka Scheyer. Correspondence. Blue Four–Galka Scheyer Collection Archives, Norton Simon Museum, Pasadena, CA, and Lyonel Feininger papers, Houghton Library, Harvard College Library, Harvard University, Cambridge, MA.

Feininger, Lyonel, and Fred Werner. Correspondence. Lyonel Feininger papers, Houghton Library, Harvard University, Cambridge, MA; Fred Werner papers, Art Gallery of New South Wales.

Feininger, T. Lux. *Lyonel Feininger: City at the Edge of the World*. New York: Praeger, 1965.

Finckh, Gerhard, ed. *Lyonel Feininger: Frühe Werke und Freunde*. Exhibition catalogue. Essays by Antje Birthälmer, Anja Breloh, Gerhard Finckh, Ernst-Gerhard Güse, Susanne Hecht, Ulrich Luckhardt, and Peter-Klaus Schuster. Wuppertal, Germany: Von der Heydt-Museum, 2006.

Firmenich, Andrea, and Ulrich Luckhardt, eds. *Lyonel Feininger: Natur-Notizen, Skizzen, und Zeichnungen aus dem Busch-Reisinger Museum, Harvard University*. Exhibition catalogue. Cologne: Wienand, 1993.

Francis, Henry S. *Lyonel Feininger Memorial Exhibition*. Exhibition catalogue. Essay by Hans Hess. Stuttgart: Union Druckerei, 1959.

Fromm, Andrea, ed. *Feininger und das Bauhaus: Weimar—Dessau—New York*. Exhibition catalogue. Essays by Martin Faas, Andrea Fromm, and Ulrich Luckhardt. Apolda, Germany: Kunsthaus Apolda Avantgarde, 2009.

Fulton, W. Joseph, ed. *The Blue Four. Feininger, Jawlensky, Kandinsky, Paul Klee: Galka E. Scheyer Collection*. Exhibition catalogue. Pasadena, CA: Pasadena Art Museum, 1956.

Gerhard Marcks Stiftung. *Feininger and Marcks: Traditiona aus dem Bauhaus*. Exhibition catalogue. Bremen: Gerhard Marcks Stiftung, 2011.

Gerlach-Laxner, Uta, and Ellen Schwinzer, eds. *Lyonel Feininger—Paul Klee: Malerfreunde am Bauhaus*. Exhibition catalogue. Essays by Uta Gerlach-Laxner, Anette Kruszynski, Andreas Vowinckel, Gertrud Vowinckel-Textor, and Christoph Wagner. Bonn: VG Bild-Kunst, 2009.

Gmurzynska-Bscher, Krystyna, Chrysanthi Kotrouzinis, and Mathias Rastorfer, eds. *Lyonel Feininger: Marine, Mellingen, Manhattan*. Exhibition catalogue. Essay by Horst Richter. Cologne: Galerie Gmurzynska, 1994.

Güse, Ernst-Gerhard, ed. *Lyonel Feininger in Weimar*. Exhibition catalogue. Essays by Ernst-Gerhard Güse, Michael Siebenbrodt, and Hartmut Sieckmann. Weimar: Klassik Stiftung Weimar; Bonn, VG Bild-Kunst, 2006.

Heller, Reinhold. *Lyonel Feininger: Awareness, Recollection, and Nostalgia*. Exhibition catalogue. Chicago: The David and Alfred Smart Museum of Art, the University of Chicago, 1992.

Hess, Hans. *Lyonel Feininger*. New York: Harry N. Abrams, 1961.

Hess, Hans, Lillie E. Hess, and Ingrid Krause, eds. *Lyonel Feininger: 1871–1956*. Exhibition catalogue. Munich: Haus der Kunst, 1973.

Hess, Thomas B. "Feininger Paints a Picture." *ArtNews*, summer 1949, 48, 50, 60–61.

Horn, Wolfgang, Joseph Helfrecht, John Butler-Ludwig, and Maren Knaupp, eds. *Lyonel Feininger: Städte und Küsten; Aquarelle, Zeichnungen und Druckgrafik*. Exhibition catalogue. Essays by Wolfgang Büche, Gunter Braunsberg, Magdalena Bushart, Sabine Dylla, T. Lux Feininger, Anton Wolfgang Gar von Faber Castell, Lucius Grisebach, Stephen E. Hauser, Andrea Hüneke, Ulrich Luckhardt, Roland März, Astrid Plato, Judith Oberhauser, Werner Timm, Wendy Weitman, and Frank Whitford. Marburg, Germany: Hitzeroth, 1992.

Institute of Contemporary Art, Boston. *Jacques Villon—Lyonel Feininger*. Exhibition catalogue. Essays by George Heard Hamilton, Thomas B. Hess, Jacques Villon, and Frederick S. Wight. Boston: Institute of Contemporary Art; New York: Chanticleer Press, 1949.

Jensen, Jens Christian, ed. *Lyonel Feininger: Gemälde, Aquarelle und Zeichnungen, Druckgraphik*. Exhibition catalogue. Essays by Jens Christian Jensen, Ulrich Luckhardt, Eberhard Roters, and Johann Schlick. Kiel, Germany: Die Kunsthalle, 1982.

Der Kunstverein and Die Kunstsammlungen. *Lyonel Feininger: 200 Holzschnitte aus Privatbesitz*. Exhibition catalogue. Essays by Andreas Feininger, T. Lux Feininger, Stephan E. Hauser, and Claudia Pohl. Ludwigsburg, Germany: Der Kunstverein; Chemnitz, Germany: Die Kunstsammlungen, 1996.

Langner, Johannes. *Lyonel Feininger—Segelschiffe*. Stuttgart: Phillip Reclaim Junior, 1962.

Liberman, Alexander. "Feininger: An eyewitness in the studio of a great American artist." *Vogue* 127, April 1956, 90–93.

Lieberman, William S., ed. *Lyonel Feininger: The Ruin by the Sea*. Exhibition catalogue. Essay by Eila Kokkinen. New York: The Museum of Modern Art, 1968.

Luckhardt, Ulrich. *Lyonel Feininger*. Munich: Prestel, 1989.

Luckhardt, Ulrich. *Lyonel Feininger: Karikaturen*. Cologne: DuMont, 1998.

Luckhardt, Ulrich. *Lyonel Feininger: Lustige Blätter aus einer Privatsammlung*. Exhibition catalogue. Bonn: VG Bild-Kunst, 2000.

Luckhardt, Ulrich. *Lyonel Feininger: Schiffe und Meer*. Exhibition catalogue. Bonn: VG Bild-Kunst, 2010.

Luckhardt, Ulrich. *Lyonel Feininger—Rieder Gallery*. Exhibition catalogue. Munich: Galerie Rieder, 2001.

Luckhardt, Ulrich, ed. *Die Stadt am Ende der Welt: das Spielzeug von Lyonel Feininger*. Exhibition catalogue. Cologne: DuMont, 1998.

Luckhardt, Ulrich, and Martin Faass, eds. *Lyonel Feininger: Die Zeichnungen und Aquarelle*. Exhibition catalogue. Essays Martin Faass and Ulrich Luckhardt. Hamburg: Hamburger Kunsthalle; Tübingen, Germany: Kunsthalle Tübingen, 1998.

Luckhardt, Ulrich, and Matthias Mühling, eds. *Lyonel*

Feininger: Menschenbilder, Eine unbekannte Welt. Exhibition catalogue. Essays by Ulrich Luckhardt, Matthias Mühling, Peter Nisbet, and Charlotte Teller. Hamburger Kunsthalle: Hamburg; Ostfildern-Ruit, Germany: Hatje Cantz, 2003.

Luckhardt, Ulrich, Martin Sonnabend, and Regine Timm. *Lyonel Feininger: Karikaturen, Comic Strips, Illustrationen, 1888–1915*. Exhibition catalogue. Hamburg: Museum für Kunst und Gewerbe; Hannover: Wilhelm Busch Museum, 1981.

Marlborough-Gerson Gallery, *Lyonel Feininger*. Exhibition catalogue. Essay by Peter Selz. New York: Marlborough-Gerson Gallery, 1969.

März, Roland. *Lyonel Feininger: Mit neunzehn farbigen Tafeln und fünfundfünfzig einfarbigen Abbildungen*. Berlin: Henschelverlag Kunst und Gesellschaft, 1981.

März, Roland, ed. *Lyonel Feininger: Von Gelmeroda nach Manhattan*. Exhibition catalogue. Essays by Wolfgang Büche, Martin Faass, Lux Feininger, Jörn Grabowski, Peter Hahn, Andreas Hüneke, Ruth Langenberg, Ulrich Luckhardt, Mario-Andreas von Lüttichau, Roland März, Karin von Maur, Reiner Niehoff, Matthias Schirren, Carla Schulz-Hoffmann, Peter-Klaus Schuster, Peter Selz, and Werner Timm. Berlin: G + H Verlag, 1998.

McCloskey, Barbara, "Lyonel Feininger." In *New Worlds: German and Austrian Art, 1890–1940*, edited by Renée Price, Pamela Kort, and Leslie Topp. Exhibition catalogue. New York: Neue Galerie, 2001.

Merkel, Ursula, ed. *Feininger. Eine Künstlerfamilie*. Exhibition catalogue. Essays by Angelika Beckmann, Wolfgang Büche, Martin Faass, Andreas Feininger, Lyonel Feininger, T. Lux Feininger, Heinz Fenrich, Ursula Merkel, and Erika Rödiger-Diruf. Ostfildern-Ruit, Germany: Hatje Cantz, 2001.

Moeller, Achim, ed. *Years of Friendship, 1944–1956: The Correspondence of Lyonel Feininger and Mark Tobey*. Essay by Peter Selz. Ostfildern-Ruit, Germany: Hatje Cantz, 2006.

Mössinger, Ingrid, and Kerstin Drechsel, eds. *Lyonel Feininger: Loebermann Collection, Drawings, Watercolors, Prints*. Exhibition catalogue. Essays by Kerstin Drechsel, Andreas Hüneke, Ingrid Mössinger, Christoph Peter, Peter Selz, Heinz Spielmann, and Klaus Weber. Munich: Prestel in association with Kunstsammlung Chemnitz, 2007.

Muir, Laura. *Lyonel Feininger: Photographs (1928–1939)*. Exhibition catalogue. Cambridge, MA: Harvard University Art Museums; Ostfildern-Ruit, Germany: Hatje Cantz, 2011.

Nachbaur, Wenzel. *Lyonel Feininger: Gemälde, Aquarelle, Zeichnungen, Graphik*. Auction catalogue. Lugano, Switzerland: R. N. Ketterer, 1965.

Ness, June L., ed. *Lyonel Feininger*. New York: Praeger, 1974.

Nisbet, Peter. *Lyonel Feininger: Drawings and Watercolors from the William S. Lieberman Bequest to the Busch-Reisinger Museum*. Exhibition catalogue. Cambridge, MA: Harvard Art Museum; Ostfildern-Ruit, Germany: Hatje Cantz, 2011.

Nisbet, Peter. "Lyonel Feininger's *The Green Bridge II*: Notes on War and Memory." *North Carolina Museum of Art Bulletin* 17, 1997, 56–69.

Norris, Emilie. *Lyonel Feininger in Germany, 1887–1937*. Exhibition brochure. Cambridge, MA: Harvard University Art Museums, 1996.

Prasse, Leona E. *Feininger: A Definitive Catalogue of his Graphic Work. Etchings, Lithographs, Woodcuts*. Cleveland: The Cleveland Museum of Art, 1972.

Prasse, Leona E., ed. *The Work of Lyonel Feininger*. Exhibition catalogue. Essay by Frederick S. Wight. Cleveland: The Print Club of Cleveland and The Cleveland Museum of Art, 1951.

Preetorius, Emil, and Alfred Hentzen. *Lyonel Feininger*. Exhibition catalogue. Hannover: Kestner-Gesellschaft, 1954.

Rodiek, Thorsten. *Lyonel Feininger: Aquarelle und Zeichnungen*. Exhibition catalogue. Kiel, Germany: Bestandskatalog Stiftung Pommern, Grapische Sammlung, 1991.

Schardt, Alois J. "Lyonel Feininger." *Feuer* 1, March 1920, 429–40.

Scheyer, Ernst. *Lyonel Feininger: Caricature and Fantasy*. Detroit: Wayne State University Press, 1964.

Scheyer, Ernst. *Lyonel Feininger: The Formative Years*. Exhibition catalogue. Detroit: Detroit Institute of Arts, 1964.

Schreyer, Lothar. *Lyonel Feininger: Dokumente und Visionen*. Munich: Albert Langen-Georg Müller Verlag, 1957.

Serge Sabarsky Gallery. *Lyonel Feininger: Drawings and Watercolors*. Exhibition catalogue. New York: Serge Sabarsky Gallery, 1979.

The Society of the Four Arts. *Lyonel Feininger: 1871–1956*. Exhibition catalogue. Palm Beach, FL: The Society of the Four Arts, 1976.

Spiegelman, Art. "The Comic Strip Art of Lyonel Feininger." *The New York Times Book Review* 99, October 2, 1994, 11.

Stedelijk Museum Amsterdam, *Lyonel Feininger*. Exhibition catalogue. Amsterdam: Stedelijk Museum Amsterdam, 1954.

Stolzmann, Rochus von. *Lyonel Feininger: 1871–1956*. Exhibition catalogue. Cologne: Galerie Gmurzynska, 1989.

Teller, Charlotte. "Feininger—Fantasist." *The International Studio* 63, no. 249, November 1917, xxv–xxx.

Timm, Werner. *Lyonel Feininger: Erlebnis und Vision die Reisen an die Ostsee, 1892–1935*. Exhibition catalogue. Regensburg, Germany: Museum Ostdeutsche Galerie Regensburg, 1992.

Tobien, Felicitas. *Lyonel Feininger*. Kirchdorf, Germany: Berghaus, 1989.

The Tokyo Shimbun. *Lyonel Feininger: Retrospective in Japan*. Exhibition catalogue. Essays by Hirotoshi Furuta, Fumiko Goto, Kiyomi Hinohara, Ulrich Luckhardt, Isaharu Nishimura, and Tetsuya Oshima. Tokyo: The Tokyo Shimbun, 2008.

von Berswordt-Wallrabe, Kornelia, ed. *Lyonel Feininger: Vom Sujet zum Bild*. Exhibition catalogue. Essays by Susanne Fiedler, Birte Frenssen, Kornelia Röder, and Kornelia von Berswordt-Wallrabe. Bonn: VG Bild-Kunst, 2007.

Walker, Brian, "Lyonel Feininger: Lightning at the Crossroads." In *Masters of American Comics*, edited by John Carlin, Paul Karasik, and Brian Walker. Exhibition catalogue. New Haven: Yale University Press, 2005.

Weber, Christiane. *Lyonel Feininger: Genial—Verfemt—Berühmt*. Weimar: Weimarer Taschenbuch, 2007.

Wernecke, Ingrid, and Norbert Eisold, eds. *Lyonel Feininger: Thüringen und die See, Druckgrafik, Aquarelle*. Exhibition catalogue. Essays by Roland März and Johannes Wend. Quedlinburg, Germany: Lyonel-Feininger-Galerie, 1987.

Wernecke, Ingrid, and Roland März. *Kristall: Metapher der Kunst, Geist und Natur von der Romantik zur Moderne*. Exhibition catalogue. Quedlinburg, Germany: Lyonel-Feininger-Galerie, 1997.

Willard Gallery. *Feininger: Oils and Watercolors, 1906–1955*. Exhibition catalogue. New York: Willard Gallery, 1964.

Wolfradt, Willi. "Lyonel Feininger." *Junge Kunst* 47, 1924.

Wünsche, Isabel, ed. *Galka E. Scheyer and The Blue Four: Correspondence 1924–1945*. Wabern/Bern, Switzerland: Benteli, 2006.

Selected

Exhibition History

Compiled by Katharine Josephson

1901
Berlin Secession
IV Kunstausstellung (group exhibition)
Exhibits again with the Secession in 1902,
1903, 1908–12, 1914

1911
Salon des Indépendants, Quai d'Orsay, Paris
La 27me Exposition 1911 (group exhibition)
Exhibits again at the Salon Indépendants in
1912

1912
Berlin-Photographic Gallery, New York
German Graphic Art (group exhibition)

1913
The Art Institute of Chicago
*Exhibition of Contemporary German
Graphic Art* (group exhibition)
Galerie der Sturm, Berlin
Erster Deutscher Herbstsalon (group
exhibition)

1914
Freie Secession, Berlin
Lyonel Feininger
Exhibits again with the Freie Secession in
1919

1916
Galerie der Sturm, Berlin
*Lyonel Feininger, Conrad Felixmüller,
Paul Kother* (group exhibition)

1917
Galerie der Sturm, Berlin
Lyonel Feininger

1918
Neue Kunst Hans Goltz, Munich
Lyonel Feininger

1919
Galerie Emil Richter, Dresden
*Lyonel Feininger: Sonder-Ausstellung seiner
Gemälde, Aquarelle, Zeichnunger,
Holzschnitte*
J. B. Neumann und Karl Nierendorf Galerie, Berlin
Lyonel Feininger
Kestner Gesellschaft, Hannover
*Paul Klee, Lyonel Feininger: Gemälde,
Graphik* (two-person exhibition)
M. Zingler's Kabinett, Frankfurt
Lyonel Feininger

1921
Angermuseum, Erfurt, Germany
Lyonel Feininger
Kunstverein, Erfurt, Germany
Alte und moderne Kunst (group exhibition)
Exhibits again in group exhibitions at
Kunstverein, Erfurt, in 1923–26, 1929, 1933
Landesmuseum, Weimar
Lyonel Feininger und Paul Klee

1922
Galerie Goldschmidt-Wallerstein, Berlin
Lyonel Feininger
German Pavilion, Venice
XIII Biennale (group exhibition)
Exhibits again at the German Pavilion in 1926,
1930
Kaiser Friedrich Museum, Magdeburg, Germany
Lyonel Feininger

1923
Anderson Galleries, New York
A Collection of Modern German Art (group
exhibition)

1924
Graphisches Kabinett, Munich
Lyonel Feininger und Marc Chagall (group
exhibition)
Neue Kunst Fides, Dresden
Lyonel Feininger
Exhibits again at Neue Kunst Fides in 1925,
1926

1925
Daniel Gallery, New York
*The Blue Four: Feininger, Kandinsky,
Jawlensky, Paul Klee* (group exhibition)

1926
Galerie Goldschmidt-Wallerstein, Berlin
Lyonel Feininger
Oakland Art Gallery, California
The Blue Four (group exhibition)
Traveled to Los Angeles Museum of History,
Science, and Art; University of California, Los
Angeles; California School of Fine Arts, San
Francisco (1927); Fine Arts Gallery, San Diego
(1927); Portland Art Association and the
Museum of Art, Oregon (1927); Spokane Art
Association, Grace Campbell Memorial
Building, Washington (1927)

1927
Angermuseum, Erfurt, Germany
Lyonel Feininger
Kunstverein, Erfurt, Germany
Lyonel Feininger
Kunstverein der Städtischen Galerie, Kassel,
Germany
Lyonel Feininger

1928
Neue Kunst Fides, Dresden
*Ausstellung Lyonel Feininger: Neue Gemälde/
Zeichnungen*
Schlesisches Museum, Breslau, Germany
Lyonel Feininger
Staatliche Galerie Moritzburg, Halle, Germany
Lyonel Feininger

1929
Altes Generalkommando-Gebäude, Breslau, Germany
Lyonel Feininger, Erich Heckel, Ewald Mataré
(group exhibition)
Anhaltische Staatsgalerie, Palais Reina, Dessau
Lyonel Feininger
Galerie Ferdinand Möller, Berlin
Die Blaue Vier (group exhibition)
Galerie Flechtheim, Dusseldorf
Lyonel Feininger und Paul Klee
Kunstverein, Erfurt, Germany
Lyonel Feininger
The Museum of Modern Art, New York
Paintings by 19 Living Americans (group
exhibition)
Oakland Art Gallery, California
Lyonel Feininger: Block Prints, Etchings

1930
Braxton Gallery, Los Angeles
Lyonel Feininger

1931
Museum Der Bildenden Kunste, Leipzig, Germany
Lyonel Feininger
Traveled to Nationalgalerie, Berlin
Neue Kunst Fides, Dresden
Lyonel Feininger zum 60 Geburtstag

1932
Kestner-Gesellschaft, Hannover
Lyonel Feininger
Kunstsammlunger der Stadt Konigsberg und
Kunstverein, Germany
Lyonel Feininger und Paul Klee (group exhibition)
Kunstverein, Hamburg
Lyonel Feininger

1935
Galerie Ferdinand Möller, Berlin
*Lyonel Feininger: Neue Aquarelle,
Kohlezeichnungen, Federzeichnungen*

1936
East River Gallery, New York
Lyonel Feininger: Aquarelles
Galerie Nierendorf, Berlin
Lyonel Feininger: Gemälde und Aquarelle
Mills College Art Gallery, Oakland, California
Exhibition Lyonel Feininger
Traveled to San Francisco Museum of Art;
Henry Art Gallery, University of Washington,
Seattle; Faulkner Memorial Art Gallery, Free
Public Library, Santa Barbara (1937); Detroit
Institute of Arts (1937); Nierendorf Gallery,
New York (1937)
The Museum of Modern Art, New York
Cubism and Abstract Art (group exhibition)

1937
Archäologisches Institut, Hofgarten Arcades, Munich
Entartete Kunst (Degenerate Art) (group
exhibition)
Traveled to Haus der Kunst, Belin (1938);
Grassi-Museum, Leipzig, Germany (1938);
Kunstpalast, Düsseldorf, Germany (1938);
Festspielhaus, Salzburg, Germany (1938);
Schulausstellungsgebäude, Hamburg (1938);
Landeshaus, Szczecin, Poland (1939);
Landesmuseum, Weimar, Germany (1939);
Künstlerhaus, Vienna (1939);
Kunstausstellungshaus, Frankfurt (1939);
Kaufmännisches Vereinshaus, Chemnitz,
Germany (1939); Gebäude der Kreisleitung
de NSDAP, Walbrzych, Poland (1941);
Landesanstalt für Volkheitskunde, Halle,
Germany (1941)
Mills College Art Gallery, Oakland, California
*2nd Feininger Exhibition: 35 New Paintings,
130 Drawings and Prints by Lyonel Feininger*
Traveled to the University Gallery, University
of Minnesota, Minneapolis (1938)
San Francisco Museum Art
Exhibition of the Work of Lyonel Feininger
Traveled to Portland Art Museum, Oregon

1938
Addison Gallery of American Art, Phillips Academy,
Andover, Massachusetts
*Paintings, Watercolors, Drawings and
Woodcuts by Lyonel Feininger*
East River Gallery, New York
Lyonel Feininger

Milwaukee Art Institute
Watercolors of Lyonel Feininger
Minneapolis University Gallery
*Presenting Lyonel Feininger: A Retrospective
at the University of Minnesota*
Mrs. Cornelius J. Sullivan and Karl Nierendorf
Galleries, New York
*Lyonel Feininger: Paintings and Watercolors,
1919–1938*
The Museum of Modern Art, New York
Bauhaus, 1919–1928 (group exhibition)
Speed Museum, Louisville, Kentucky
Lyonel Feininger: Watercolors and Woodcuts

1939
Carnegie Institute, Pittsburgh
*The Pittsburgh International Exhibition of
Contemporary Painting* (group exhibition)
Exhibits again in Pittsburgh Internationals in
1950, 1952, 1955, 1958
Nierendorf Gallery, New York
Lyonel Feininger
The Museum of Modern Art, New York
Art in Our Time: 10th Anniversary Exhibition
(group exhibition)

1940
Dalzell Hatfield Gallery, Los Angeles
Lyonel Feininger
Farnsworth Museum, Wellesley College, Wellesley,
Massachusetts
Exhibition of Paintings by Lyonel Feininger
San Francisco Museum of Art
Watercolors by Lyonel Feininger
Organized by Western Association of Art
Museum Directors
Traveled to Little Gallery, Sacramento; Mills
College Art Museum, Oakland, California
Stendahl Galleries, Los Angeles
Feininger Watercolors
United States Pavilion, Venice
XXII Biennale (group exhibition)
Exhibits again at U.S. Pavilions in 1948, 1956
Whitney Museum of American Art, New York
*Annual Exhibition of Contemporary American
Painting* (group exhibition)
Exhibits again in Whitney painting annuals in
1945, 1948, 1949, 1951

1941

Buchholz Gallery and Willard Gallery, New York
Lyonel Feininger
Traveled to Detroit Institute of Arts
Corcoran Gallery of Art, Washington, DC
*17th Biennial Exhibition of Contemporary
American Oil Paintings* (group exhibition)
Exhibits again in the Corcoran Gallery Biennials
in 1943, 1947, 1951, 1957
Katharine Kuh Gallery, Chicago
Lyonel Feininger
Tilden-Thurber Gallery, Providence, Rhode Island
Lyonel Feininger
Whitney Museum of American Art, New York
*Annual Exhibition of Contemporary American
Sculpture, Watercolors, Drawings and Prints*
(group exhibition)
Exhibits again in Whitney sculpture and works
on paper annuals in 1945–47, 1949, 1951; exhib-
its in Whitney contemporary art annuals in 1942,
1943

1942

The Metropolitan Museum of Art, New York
*Artists for Victory: An Exhibition of
Contemporary American Art* (group exhibition)

1943

Buchholz Gallery, New York
*Lyonel Feininger: Recent Paintings and
Watercolors*
The Museum of Modern Art, New York
Romantic Painting in America (group exhibition)
Nierendorf Gallery, New York
Feininger: Paintings, Watercolors, Drawings
San Francisco Museum of Art
Recent Watercolors by Lyonel Feininger
Willard Gallery, New York
Fantasy in Feininger

1944

Buchholz Gallery, New York
*Lyonel Feininger: Recent Watercolors and
Drawings*
Dalzell Hatfield Gallery, Los Angeles
Fantasy in Watercolor by Lyonel Feininger
The Museum of Modern Art, New York
Lyonel Feininger/Marsden Hartley (group
exhibition)
Lyonel Feininger portion traveled to Frances
Lehman Loeb Art Center, Vassar College,
Poughkeepsie, New York; Boston Symphony
Orchestra, Symphony Hall, Boston (1945); Mead
Art Museum, Amherst College, Massachusetts
(1945); San Francisco Museum of Art (1945);
City Art Museum of St. Louis (1945); St. Paul

Gallery and School of Art, St. Paul, Minnesota
(1945); Fort Worth Art Association, Fort
Worth, Texas (1945); Albright Art Gallery,
Buffalo (1946); Philbrook Art Center, Tulsa
(1946); Speed Museum, Louisville (1946)
The Renaissance Society, University of Chicago
*Lyonel Feininger: Retrospective Exhibition of
Watercolors and Drawings, 1909–1941*

1946

Buchholz Gallery, New York
*Lyonel Feininger: Recent Paintings,
Watercolors*
Willard Gallery, New York
Figures by Feininger

1947

Henry Art Gallery, University of Washington, Seattle
Lyonel Feininger: Watercolors and Drawings

1948

The Art Institute of Chicago
*Watercolor Exhibition: Morris Graves and
Lyonel Feininger* (group exhibition)
Buchholz Gallery, New York
Feininger: Recent Work, 1945–1947

1949

Bozeman State College, Bozeman, Montana
New Paintings by Lyonel Feininger
Organized by Western Association of Art
Museum Directors
Traveled to San Francisco Museum of
Modern Art; Portland Art Museum, Oregon
Henry Art Gallery, University of Washington, Seattle
Lyonel Feininger
Institute of Contemporary Art, Boston
Jacques Villon–Lyonel Feininger (group
exhibition)
Traveled to Phillips Gallery, Washington, DC;
Delaware Art Center, Wilmington

1950

Buchholz Gallery, New York
Lyonel Feininger
Galerie Rudolf Probst, Mannheim, Germany
*Neue Aquarelle und Graphiken von Lyonel
Feininger*
Hofstra University, Memorial Hall, Hempstead,
New York
Lyonel Feininger
Kestner-Gesellschaft, Hannover
Lyonel Feininger: Aquarelle
Traveled extensively in Germany, known ven-
ues include: Modern Galerie Otto Stangl,
Munich; Galerie Otto Ralfs, Brauschweig;

Galerie Rudolf Probst, Mannheim; Galerie
Alex Vömel, Düsseldorf; Galerie Rudolf
Hoffmann, Hamburg; Reitzenstein-Seel-
Kunsthandel, Berlin
Schaefer Galleries, New York
Lyonel Feininger: Drawings

1951

City of York Art Gallery, York, England
*Feininger: An Exhibition of Forty Watercolors
and Drawings*
Traveled to Arts Council's Exhibition Room,
Cambridge, England; AIA Gallery, London
The Cleveland Museum of Art
The Work of Lyonel Feininger
The Museum of Modern Art, New York
Abstract Painting and Sculpture in America
(group exhibition)
United States Pavilion (Museu de Arte Moderna),
São Paulo, Brazil
Bienal de São Paolo (group exhibition)

1952

Curt Valentin Gallery, New York
Lyonel Feininger
Palmer House Galleries, Chicago
Lyonel Feininger Watercolors

1954

Allen R. Hite Institute, University of Louisville,
Kentucky
The Feiningers of Louisville
Bayerische Akademie der Schonen Kunste,
Munich
Lyonel Feininger
Traveled to Kestner Gesellschaft, Hannover
Curt Valentin Gallery, New York
*Lyonel Feininger: Recent Paintings and
Watercolors (1951–1954)*

1955

Museum Fridericianum, Kassel, Germany
*Documenta: Kunst des XX Jahrhunderts
Internationale* (group exhibition)
The Museum of Modern Art, New York
*Three Modern Painters: Feininger—Hartley—
Beckmann*
Traveled to Brooks Art Gallery, Memphis;
Tulane University, New Orleans (1956);
Public Library of Winston-Salem (1956);
Southwestern University, Georgetown, Texas
(1956); J. B. Speed Art Museum, Louisville
(1956); Phillips Exeter Academy, Exeter,
New Hampshire (1956); Morse Gallery of
Art, Hollins College, Winter Park, Florida
(1956); Richmond Artists Association,

Richmond, (1957); Concordia College, Moorhead, Minnesota (1957); University of Florida, Gainesville (1957); Telfair Academy of Arts & Sciences, Savannah, Georgia (1957); Hunter Gallery of Art, Chattanooga (1957)

1956
Cambridge Art Association, Cambridge, Massachusetts
 Lyonel Feininger and T. Lux Feininger
Fort Worth Art Center, Texas
 Feininger: A Memorial Exhibition of His Work from Fort Worth Collections
Willard Gallery, New York
 Gables: A Comprehensive Exhibition of Work from 1921 to 1954 Based on One Theme by Lyonel Feininger
Willard Gallery, New York
 Lyonel Feininger: Exhibition Oil and Watercolors, 1940 to 1955

1958
Busch-Reisinger Museum, Harvard University, Cambridge, Massachusetts
 Lyonel Feininger: Paintings of Harbors, Ships, and the Sea
Curt Valentin Gallery, New York
 Lyonel Feininger
Sala Esposizioni dell'Azienda Autonoma di Soggiorno, Merano, Italy
 Mostra retrospettiva di Lyonel Feininger
 Traveled to the Universita Populare Trentina, Trento, Italy
Willard Gallery, New York
 Lyonel Feininger: An Exhibition of Twenty-Five Watercolors, 1939–1953
Willard Gallery, New York
 Lyonel Feininger

1959
San Francisco Museum of Art
 Lyonel Feininger: Memorial Exhibition
 Traveled to Minneapolis Institute of Arts (1960); The Cleveland Museum of Art (1960); Albright-Knox Art Gallery, Buffalo (1960); Museum of Fine Arts, Boston (1960); Art Council Gallery, London (1960); Kunstverein, Hamburg (1961); Museum Folkwang, Essen, Germany (1961); Staatliche Kunsthalle, Baden-Baden, Germany (1961)

1960
Willard Gallery, New York
 Lyonel Feininger: Watercolors, from the Collection of Mrs. Julia Feininger

1961
Kunstverein, Hamburg
 Lyonel Feininger
Willard Gallery, New York
 Lyonel Feininger: Architecture, Paris—New York

1962
Museum am Ostwall, Dortmund, Germany
 Lyonel Feininger Kleine Blätter

1963
Dallas Museum for Contemporary Arts
 Lyonel Feininger: A Retrospective
Kunstverein, Hamburg
 Lyonel Feininger: Karikaturen
The Museum of Modern Art, New York
 The Intimate World of Lyonel Feininger

1964
Associated American Artists, New York
 Feininger: Ships and Sea
Busch-Reisinger Museum, Harvard University, Cambridge, Massachusetts
 The Working Methods of Lyonel Feininger
Detroit Institute of Arts
 Lyonel Feininger: The Formative Years
Galleria del Levante, Milan
 Lyonel Feininger—acquarelli e disegni
Moderna Museet, Stockholm
 Lyonel Feininger, 1871–1956: Akvareller, Tecknigar, Grafik
 Traveled to Städtische Galerie, Biel, Switzerland; Kunsthalle, Bern
Whitney Museum of American Art, New York
 Between the Fairs: 25 Years of American Art, 1939–1964 (group exhibition)
Willard Gallery, New York
 Feininger: Oils and Watercolors, 1906–1955

1966
Associated American Artists, New York
 The Architecture of Lyonel Feininger: Second Retrospective Exhibition of Woodcuts, Etchings, and Lithographs in New York
Pasadena Art Museum, California
 Lyonel Feininger, 1871–1956: A Memorial Exhibition
 Traveled to Milwaukee Art Center; Baltimore Museum of Art

1967
The Museum of Modern Art, New York
 Lyonel Feininger: The Ruin by the Sea

1968
Galleria del Levante, Milan
 Lyonel Feininger
Marlborough Fine Art, London
 Lyonel Feininger, 1871–1956: Drawings and Watercolors
Pennsylvania Academy of the Fine Arts, Philadelphia
 Lyonel Feininger

1969
Marlborough-Gerson Gallery, New York
 Lyonel Feininger

1970
Watson Gallery, Wheaton College, Norton, Massachusetts
 Lyonel Feininger: Nature Notes

1972
Associated American Artists, New York
 Lyonel Feininger: Etchings, Lithographs, and Woodcuts from the Estate of the Artist
Serge Sabarsky Gallery, New York
 Lyonel Feininger: An Exhibition of Drawings and Watercolors

1973
Haus der Kunst, Munich
 Lyonel Feininger: 1871–1956
 Traveled to Kunsthaus, Zurich

1974
Allan Frumkin Gallery, Chicago
 Lyonel Feininger: Etchings, Drypoints, Lithographs, Drawings, 1902–1924
Associated American Artists, New York
 Lyonel Feininger: A Collection of Rare Proofs of Woodcuts used as Letterheads from the Estate of the Artist
Berggruen and Cie, Paris
 Lyonel Feininger: Huiles, Aquarelles et Dessins
Serge Sabarsky Gallery, New York
 Lyonel Feininger: An Exhibition of Drawings and Watercolors

1975
Achim Moeller, London
 Lyonel Feininger, Visions of City and Sea: Watercolors, Drawings, Paintings
Whitney Museum of American Art, New York
 American Abstract Art (group exhibition)
Whitney Museum of American Art, New York
 The Whitney Studio Club and American Art, 1900–1932 (group exhibition)

1976

The Society of the Four Arts, Palm Beach, Florida
Lyonel Feininger: 1871–1956

1977

Associated American Artists, New York
Lyonel Feininger: Rare Prints—100 Etchings and Woodcuts from the Artist's Estate
Serge Sabarsky Gallery, New York
Lyonel Feininger: Drawings and Watercolors
Whitney Museum of American Art, New York
New York on Paper (group exhibition)

1978

Galerie Nierendorf, Berlin
Lyonel Feininger: Aquarelle, Zeichnungen, Druckgraphiken
Thomas Levy, Hamburg
Feininger: Bilder, Aquarelle, Zeichnungen

1979

Serge Sabarsky Gallery, New York
Lyonel Feininger: Drawings and Watercolors
Whitney Museum of American Art, New York
Tradition and Modernism in American Art (group exhibition)

1981

Museum für Kunst und Gewerbe, Hamburg
Lyonel Feininger: Karikaturen, Comic Strips, Illustrationen, 1888–1915
Traveled to Wilhelm Busch Museum, Hannover
Whitney Museum of American Art, New York
American Prints: Process and Proofs (group exhibition)
Whitney Museum of American Art, New York
Decade of Transition: 1940–1950, Selections from the Permanent Collection (group exhibition)

1982

Associated American Artists, New York
Lyonel Feininger: Rare Woodcuts from the Estate of the Artist
Kunsthalle, Kiel, Germany
Lyonel Feininger: Gemälde, Aquarelle und Zeichnungen, Druckgraphik

1985

Achim Moeller Fine Art Limited, New York
Lyonel Feininger, Visions of City and Sea II: A Small Retrospective Exhibition of Drawings and Watercolors
Acquavella Galleries, New York
Lyonel Feininger
Traveled to the Phillips Collection, Washington, DC

1986

Lyonel-Feininger-Galerie, Quedlinburg, Germany
Lyonel Feininger—Ausstellung aus den Beständen der Sammlung

1987

Lyonel-Feininger-Galerie, Quedlinburg, Germany
Lyonel Feininger: Thüringen und die See, Druckgrafik, Aquarelle
Marlborough Fine Art, London
Lyonel Feininger: The Early Years, 1889–1919, Watercolours and Drawings

1989

Galerie Gmurzynska, Cologne
Lyonel Feininger, 1871–1956

1990

Achim Moeller Fine Art, New York
Lyonel Feininger: Figurative Drawings, 1908–1912
Staatliche Graphische Sammlung, Neue Pinakothek, Munich
Lyonel Feininger: Aquarelle, Zeichnungen, Druckgraphik

1991

Kulturforum Lüneberg, Lüneburg, Germany
Lyonel Feininger. Begegnung und Erinnerung. Luneburger Motive, 1921–1954
Lyonel-Feininger-Galerie, Quedlinburg, Germany
Lyonel Feininger und die Romantik
Staatliche Galerie Mortizburg, Halle, Germany
Lyonel Feininger: Die Halle-Bilder
Stiftung Langmatt Sidney und Jenny Brown, Baden, Switzerland
Lokomotiven und Eisenbahnlandschaften: 40 Zeichnungen und Skizzen, 1901–1913
Stiftung Pommern, Kiel, Germany
Lyonel Feininger: Aquarelle und Zeichnungen

1992

Achim Moeller Fine Art, New York
Feininger in Paris: Lyonel Feininger the Paris Drawings, 1892–1911
Traveled to Germanisches Nationalmuseum, Nuremburg; Biennale Internationale des Antiquaires, Grand Palais, Paris
The David and Alfred Smart Museum of Art, The University of Chicago
Lyonel Feininger: Awareness, Recollection, and Nostalgia
Galerie Thomas, Munich
Lyonel Feininger: Gemälde, Aquarelle, Graphiken

Josef Albers Museum Quadrat Bottrop, Germany
Lyonel Feininger. Bilder-Aquarelle-Zeichnungen
Kunsthalle, Nürenberg, Germany
Lyonel Feininger: Stadte und Kusten, Aquarelle, Zeichnunger, Druckgraphik
Museum Ostdeutsche Galerie, Regensburg, Germany
Lyonel Feininger: Erlebnis und Vision. Die Reisen an die Ostsee, 1892–1935
Traveled to Kunsthalle, Bremen

1993

Achim Moeller Fine Art, New York
Lyonel Feininger's Windmills, 1901–1921
Kunsthalle, Emden, Germany
Lyonel Feininger: Natur-Notizen, Skizzen, und Zeichnunger aus dem Busch-Reisinger Museum
Traveled to Museum Ludwig, Cologne

1994

Galerie Gmurzynska, Cologne
Lyonel Feininger: Marine, Mellingen, Manhattan
Galerie Beck und Eggeling, Leipzig, Germany
Feininger: Arbeiten aus seiner Zeit in Weimar und Dessau

1995

Kunstverein, Ludwigsburg, Germany
Lyonel Feininger: 200 Holzschnitte aus Privatbesitz
Traveled to Städtische Kunstsammlungen, Chemnitz, Germany
Staatliche Galerie Moritzburg, Halle, Germany
Lyonel Feininger: Gelmeroda. Ein Maler und sein Motiv

1996

Busch-Reisinger Museum, Harvard University, Cambridge, Massachusetts
Lyonel Feininger in Germany, 1887–1937
Sprengel Museum, Hannover
Lyonel Feininger: Originale auf Papier und Druckgraphik aus dem Besitz des Sprengel Museum Hannover

1997

Galerie Gmurzynska, Cologne
Hommagean Lyonel Feininger
Lyonel-Feininger-Galerie, Quedlinburg, Germany
Kristall—Metapher der Kunst, Geist und Natur von der Romantik zur Moderne (group exhibition)

1998

Hamburger Kunsthalle, Hamburg
Lyonel Feininger: Die Zeichnungen und Aquarelle
Traveled to Kunsthalle, Tubingen, Germany

Marlborough Fine Art, London
Lyonel Feininger: City and Sea, 1905–1955, Watercolours and Drawings

Neue Nationalgalerie, Staatliche Museen zu Berlin
Lyonel Feininger: Von Gelmeroda nach Manhattan
Traveled to Haus der Kunst, Munich

1999

Kunsthaus Apolda Avantgarde, Germany
Feininger im Weimarer Land

Lyonel-Feininger-Galerie, Quedlinburg, Germany
Max Ernst und Lyonel Feininger (two-person exhibition)

Museum der Stadt Wolgast, Germany
Im Hafen von Peppermint: Die Schiffe Lyonel Feiningers
Traveled to Schiffahrtsmuseum, Flensburg, Germany

2000

Staatliche Galerie Moritzburg, Halle, Germany
Lyonel Feininger: Halle-Bilder, Die Natur-Notizen

Von der Hedyt Museum, Wuppertal, Germany
Lyonel Feininger: Lustige Blätter aus einer Privatsammlung
Traveled to Stiftung Hermann F. Reemtsma, Ernst Barlach Haus, Hamburg; Lyonel-Feininger-Galerie, Quedlinburg, Germany

2001

Beck and Eggeling, Dusseldorf, Germany
Feininger und das Meer Aquarelle und Zeichnungen

Galerie Rieder, Munich
Lyonel Feininger

2003

Busch-Reisinger Museum, Harvard University, Cambridge, Massachusetts
Lyonel Feininger

Hamburger Kunsthalle, Hamburg
Lyonel Feininger: Menschenbilder. Eine unbekannte Welt

2004

Marlborough Gallery, New York
Lyonel Feininger: Works on Paper

2006

Bauhaus Museum, Weimar
Lyonel Feininger in Weimar

Kunstsammlung, Chemnitz, Germany
Lyonel Feininger, Sammlung Loebermann: Zeichnung, Aquarell, Druckgraphik

Lyonel-Feininger-Galerie, Quedlinburg, Germany
Lyonel Feininger: Segelschiff mit blauem Angler

Von der Heydt Museum, Wuppertal, Germany
Lyonel Feininger: Frühe Werke und Freunde

2007

Museo di Arte Moderna e Contemporanea di Trento e Rovereto, Italy
Lyonel Feininger: Opere dalle collezioni private italiane

Staatliches Museum, Schwerin, Germany
Lyonel Feininger: Vom Sujet zum Bild
Traveled to Pommersches Landesmuseum, Greifswald, Germany

2008

Lyonel-Feininger-Galerie, Quedlinburg, Germany
Lyonel Feininger: Die Gelmeroda-Holzschnitte

Yokosuka Museum of Art, Tokyo
Lyonel Feininger: Retrospective in Japan
Traveled to Aichi Prefectural Museum of Art, Nagoya, Japan; The Miyagi Museum of Art, Sendai, Japan

2009

Beck and Eggeling, Dusseldorf
Lyonel Feininger: Die Stille des Augenblicks

Kunsthaus Apolda Avantgarde, Germany
Feininger und das Bauhaus: Weimar—Dessau—New York

Lyonel-Feininger-Galerie, Quedlinburg, Germany
Feininger im Harz

Moeller Fine Art, Berlin
Your Uncle Feininger: Comics, Fairy Tales, and Toys

Stiftung Moritzburg, Kunstmuseum des Landes Sachsen-Anhalt, Halle, Germany
Lyonel Feininger: Zurück in Amerika, 1937–1956

2010

Lyonel-Feininger-Galerie, Quedlinburg, Germany
Lyonel Feininger: Aquarelle und Federzeichnungen aus der Sammlung Dr. Hermann Klumpp

Stiftung Ahlers Pro Arte/Kestner Pro Arte, Hannover
Lyonel Feininger: Schiffe und Meer

2011

J. Paul Getty Museum, Los Angeles
Lyonel Feininger: Photographs (1928–1939)
Organized by and traveled to the Sackler Museum, Harvard University, Cambridge, Massachusetts

Sackler Museum, Harvard University, Cambridge, Massachusetts
Lyonel Feininger: Drawings and Watercolors from the William S. Lieberman Bequest to Busch-Reisinger Museum

Staatliche Museen zu Berlin
Feininger aus Harvard: Zeichnungen, Aquarelle und Fotografien
Traveled to Pinakothek der Moderne, Munich

Acknowledgments

Barbara Haskell

All scholarly projects build on the previous research and expertise of many individuals. This one is no exception. In the case of Lyonel Feininger, I am fortunate to be following in the footsteps of his family members who devoted themselves to furthering recognition and understanding of his art. Foremost was his wife, Julia, who compiled the 1961 catalogue raisonné of his paintings (published in Hans Hess's monograph), assembled his archives, and transcribed portions of his voluminous correspondence into five volumes. After her death in 1970, Feininger's three sons, Andreas, Laurence, and T. Lux, assumed responsibility for maintaining his legacy. T. Lux, Feininger's youngest son, took over Julia's role as family historian, authoring numerous books and articles on his father's life and art, which form the bedrock upon which Feininger scholarship has depended. In recent years, Feininger's grandsons have assumed these responsibilities. I am deeply grateful for the steadfast support of T. Lux's sons Conrad, Lucas, and Charles and his wife Kate; Andreas's son, Tomas; and Laurence's adopted son, Danilo Curti-Feininger. The most important early Feininger scholarship outside the family was provided by Hans Hess, Ernst Scheyer, June Ness, and Leona Prasse. Of contemporary art historians, Ulrich Luckhardt's research, exhibitions, and publications have been at the forefront of enhancing the public's understanding of Feininger's life and career for more than twenty-five years. The graciousness and enthusiasm with which he participated in all aspects of this project, including contributing the essay that appears in this volume, have been extraordinary. I am deeply indebted to him as well as to Wolfgang Büche, Björn Egging, Andreas Hüneke, Roland Marz, and Peter Nisbet for their assistance and scholarship on Feininger's art. I would also like to acknowledge the family of the late Horace Richter for graciously lending me the Kortheuer/Feininger correspondence; Miani Johnson for sharing the Willard Gallery archives with me; and Leon Botstein for conversations that strengthened and clarified my thinking about Feininger and the world in which he lived.

My most special thanks go to Achim Moeller of Moeller Fine Art, who has exceeded in every way his responsibility as a primary overseer of Feininger's art and author of the forthcoming Feininger catalogue raisonné. Throughout the four years I have worked on this exhibition and monograph, he served as a key advisor, generously sharing his deep and broad knowledge of Feininger's work and career, facilitating loans of major works of art, and helping with the many technical, diplomatic, and scholarly aspects of this exhibition and publication. I am extremely grateful to him for his collegiality and collaboration and also for that of his assistants Patrick Monahan and Sebastian Ehlert.

My greatest fortune has been the team who worked with me on this project. Most crucial to the project's success was Sasha Nicholas, senior curatorial assistant, who contributed to every facet of the exhibition and publication, from the checklist selection and procurement of loans to the catalogue's design and contents, including her illuminating essay on Feininger's photography. She was joined by Jessica Hong, research assistant, whose agile and creative research, securing of photographs and provenance information, and endless typing of the manuscript were indispensable to the project.

Special thanks also go to Marieke Wolf for her research in German archives and to the able translators who facilitated my ability to delve into Feininger's correspondence and the extant German scholarship on his work: Dictlinde Hamburger, Max Prior, Elisabeth Turnauer, Irene Zealacher, and Andrea Baumann. I am grateful as well to the interns who assisted with the research and administrative tasks related to this project: Drew Bucilla, Rebecca Lee, Kaia Magnusen, Barbara Werther, and especially Katharine Josephson, who prepared the exhibition history that appears in this catalogue.

Completing the team were those who worked on the publication. Rachel de W. Wixom, head of the Whitney Museum publications department, guided the catalogue with impeccable discernment and expertise, working in concert with Patricia Fidler of Yale University Press. I am especially grateful to Beth Huseman, editor, for her patience and meticulous attention to the clarity of the manuscripts and the quality of the publication; David Updike for his insightful editing; Katy Homans for producing a thoughtful and elegant catalogue design; Mary Mayer for carefully overseeing the book's production; and Kate Zanzucchi for her support throughout the project. Finally, my heartfelt appreciation goes to John Carlin, Bryan Gilliam, Ulrich Luckhardt, and Sasha Nicholas, for contributing essays that so greatly enhance Feininger scholarship.

At the Whitney Museum, I have been fortunate from the start to receive the unwavering support of Adam D. Weinberg, Alice Pratt Brown Director, Donna De Salvo, chief curator and deputy director for programs, and John Stanley, deputy director. They were joined by an extraordinary staff at the Museum: Seth Fogelman, senior registrar, who deftly arranged the transportation of Feininger's work to New York from all over the world; Mark Steigelman and Cara Bonewitz, managers, design and construction, who designed a sensitive installation; Hillary Strong, director of foundations and government relations, Jessica Vodofsky, manager of foundation and government relations, and Mary Anne Talotta, senior major gifts officer, all of whom persuaded foundations and individuals to financially support the exhibition of a highly deserving but under-known artist; Christy Putnam, associate director for exhibitions and collections management; and Lynn Schatz, exhibitions coordinator, who skillfully negotiated the exhibition's tour and logistics. Other Whitney colleagues assisted in this exhibition as well, including Carol Mancusi-Ungaro, associate director for conservation and research; Matt Skopek, assistant conservator; Joshua Rosenblatt, head preparator; Anita Duquette, manager, rights and reproductions; Kiowa Hammons, rights and reproduction assistant; Brian Reese, publications assistant; Kathryn Potts, associate director, Helena Rubenstein Chair for Education; Jeffrey Levine, chief marketing and communications officer; Stephen Soba, communications officer; Rich Flood, marketing and community relations manager; Rebecca Gimenez, head, graphic design; Francesca Grassi, senior designer; Meg Forsyth, graphic designer; Nick Holmes, general counsel; Alexandra Wheeler, deputy director for development; Gina Rogak, director of special events; and John Balestrieri, director of security.

My colleagues at the Montreal Museum of Fine Arts—Nathalie Bondil, director

and chief curator, Anne Grace, curator of modern art, and Pascal Normandin, head of exhibitions management—have been exceptional partners in this project. Their enthusiasm about Feininger has made it possible to bring the first retrospective of the artist's work to Canada and to publish the first French-language monograph on the artist.

Other individuals and institutions graciously shared invaluable material and information: the Houghton Library at Harvard University; the Archives of American Art, Smithsonian Institution; Laura Muir and Joanna Wendel at the Busch-Reisinger Museum; Mal Barasch; and Emilie Norris. I would also like to thank the galleries and auction houses who helped facilitate loans and locate works of art: Andrea Crane at Gagosian Gallery, Raimond and Silke Thomas at Galerie Thomas, Harry Smith at Gurr Johns, Chris Eykyn at Eykyn Maclean, Angelika Kolomoisky at Galerie Artvera's, Armin Bienger at Marlborough Gallery, Eric Widing at Christie's, and Dara Mitchell at Sotheby's.

No book or exhibition of this scope is possible without financial support. My deepest thanks go to the Anna-Maria and Stephen Kellen Foundation, whose major sponsorship of this exhibition in memory of Stephen Kellen contributed significantly to the project's successful realization. I am also deeply grateful for the funding given to the project in its nascent stages by the Shen Family Foundation and Susan R. Malloy. Without their early encouragement, the successful realization of this project would have been uncertain. I am indebted to them, as well as to the Henry Luce Foundation, the Terra Foundation for American Art, the Dedalus Foundation, and Furthermore. Their generous support of scholarly projects devoted to twentieth-century American art is essential for the field's healthy survival. Finally, my heartfelt appreciation goes to the following private foundations and individuals for their steadfast support of the proposition that the fate of contemporary art is linked inextricably to our art-historical heritage: the Karen and Kevin Kennedy Foundation; Déborah, André and Dan Mayer; Carol and Paul Miller; Joseph Edelman and Pamela Keld; Geraldine S. Kunstadter; the Karen and Paul Levy Family Foundation; Marica and Jan Vilcek; the Consulate General of the Federal Republic of Germany; and several anonymous donors.

Last, but most essential, are the lenders to this exhibition. I am extremely grateful for their participation in this project. Without their generous understanding of its significance and their willingness to share their important works of art with the public, the full extent of Feininger's achievement might be lost to several generations of Americans.

Lenders to the Exhibition

The Caroline and Stephen Adler Family

Albertina Museum, Vienna

Judy and John M. Angelo

The Art Institute of Chicago

Bauhaus-Archiv, Berlin

The Brooklyn Museum

The Cleveland Museum of Art

Detroit Institute of Arts

Fine Arts Museums of San Francisco

Fundación MAPFRE, Madrid

Hamburger Kunsthalle

Harvard Art Museums, Busch-Reisinger Museum, Cambridge, Massachusetts

Houghton Library, Harvard College Library, Harvard University, Cambridge, Massachusetts

Joseph Edelman and Pamela Keld

Geraldine S. Kunstadter

Kunstmuseum Basel

Kunstmuseum Bern

Lyonel-Feininger-Galerie, Quedlinburg, Germany

The Metropolitan Museum of Art, New York

Carol and Paul Miller

Minneapolis Institute of Arts

Moeller Fine Art, New York and Berlin

The Montreal Museum of Fine Arts

Musée National d'Art Moderne, Centre Georges Pompidou, Paris

Museum of Art, Munson-Williams-Proctor Arts Institute, Utica, New York

Museum of Art, Rhode Island School of Design, Providence

Museum of Fine Arts, Boston

The Museum of Modern Art, New York

National Gallery of Art, Washington, DC

National Gallery of Canada, Ottawa

Nationalgalerie, Staatliche Museen, Berlin

The Nelson-Atkins Museum of Art, Kansas City

Neuberger Museum of Art, Purchase College, State University of New York

North Carolina Museum of Art, Raleigh

Philadelphia Museum of Art

Renée Price

Reynolda House Museum of American Art, Winston-Salem, North Carolina

Robert McLaughlin Gallery, Oshawa, Ontario

Saint Louis Art Museum

Sarah Campbell Blaffer Foundation, Houston

Smith College Museum of Art, Northampton, Massachusetts

Solomon R. Guggenheim Museum, New York

Sprengel Museum, Hannover

Staatliche Kunstsammlungen, Dresden

A. Alfred Taubman

Carmen Thyssen-Bornemisza

University of Iowa Museum of Art, Iowa City

Von der Heydt-Museum, Wuppertal

Walker Art Center, Minneapolis

Whitney Museum of American Art, New York

Charles K. Williams II

Private collections

Index

Numbers in *italics* refer to illustrations.

276

The Montreal Museum of Fine Arts

Nicole Albert
Stéphane Aquin
Danièle Archambault
Bertrand Arseneault
Pierre Marcelin Avé
Lorraine Basque
Lise Beaulieu
Jean-Sébastien
 Bélanger
Marthe Bélanger
Serge Bellemare
Jean-Yves Bergeron
Diane Bernard
André Bernier
Magdalena Berthet
Christine Blais
Danielle Blanchette
Charles Blouin
Nathalie Bondil
Mario Borgogno
Gaétan Bouchard
Réal Boucher
Sophie Boucher
Stéphanie Boucher
Nathalie Bourcier
Thérèse Bourgault
Gisèle Bourgeois
Marianne Brault
Rachelle Brown
Dominic Brunette
Marie Carpentier
Danielle Champagne
Blanche Charbonneau
Diane Charbonneau
Éric Charland
Anne-Marie Chevrier
Emmanuelle Christen
Chantal Cyr
Linda-Anne D'Anjou
Louise Dansereau
Michel Daras
Sabine De Villenoisy
Anne-Marie Deland
Bénédict Delvaux
Monique Dénommée
Alexandra Derome
Joanne Déry
Jacques Des Rochers
Mara Di Trapani
Chantal Doolub
Jacques Dragon
Caroline Drolet
Suzanne Drolet
Alain Drouin

Christian Ducharme
 Gauthier
Anne Eschapasse
Guy Favreau
Lise Fournier
Jeanne Frégault
Clara Gabriel
Sandra Gagné
Richard Gagnier
Normand Garand
Sonia Gaudreault
Louis-Philippe Gauthier
Louise L. Giroux
Michel Giroux
Hilliard Todd Goldfarb
Martine Goyette
Anne Grace
Christine Guest
Catherine Guex
Valérie Habra
Jo-Anne Hadley
Christine Hamel
Sébastien Hart
Gaétan Hénault
Jean Houle
Ioan Ioanovici
André Jalbert
Carline Javel
Danielle Jodoin
Bernard Labelle
Simon Labrie
Sylvie Labrosse
Sylvain Lacroix
Geneviève Lafaille
Isabelle Laisné
Marilyn Lajeunesse
Diane Lambert
Claude Landriault
Jasmine Landry
Jocelyne Laplante
Pierre Larivée
Jean-Christophe
 Larivée
Mario Laroche
Paul Lavallée
Claude Lavoie
Francine Lavoie
Marlène R. Lavoie
Daniel Lefebvre
Marcelo Leiva
Sacha-Marie Levay
Stéphane Léveillé
Marie-Claude Lizée
Johanne Loiselle
Thierry-Maxime Loriot
Francis Mailloux
Ginette Mailloux
Marcel Marcotte
Carmen Martel

Mireille Masse
Éric A. Ménard
Sabrina Merceron
Carole Michaud
Olivier Millot
Aline Montigny
Mario Morin
Eliza Moses
Claude Mousseau
Jean-Luc Murray
Ngoc-Tuong (James)
 Nguyen
Claudine Nicol
Pascal Normandin
Raynald O'Connell
Catherine O'Meara
Odile Ouellet
Sylvie Ouellet
Manon Pagé
Guy Parent
Richard Pelletier
Rosalind Pepall
Johanne Perron
Tan Phan Vu
Marilyne Pinheiro
Vincent Pitre
Pierre Poirier
Marie-Laure Rahli
Estelle Richard
Dany Rivest
Danielle Roberge
Lynn Rousseau
Denis Routhier
Richard Roy
Marie-Claude Saia
Yvon Sénécal
Raymond Sigouin
Lucille St-Laurent
Josée St-Louis
Michèle Staines
Michèle Sylvestre
Elaine Tolmatch
Manon Tremblay
Natalie Vanier
Carl R. Vessia

Photographic Credits

The copyright holders, photographers, and sources of visual material other than those indicated in the captions are as follows. Every effort has been made to credit the copyright holders, photographers, and sources; if there are errors or omissions, please contact Yale University Press so that corrections can be made in any subsequent edition.

All Lyonel Feininger images are © 2011 Artists Rights Society (ARS), New York/VG Bild-Kunst, Bonn

Photographs by Ron Amstutz (figs. 31, 111); photographs by Jörg P. Anders (figs. 34, 42); © 2011 Artists Rights Society (ARS), New York/VG Bild-Kunst, Bonn (fig. 216); photographs © The Art Institute of Chicago (figs. 41, 52, 97); FotostudioBartsch (fig. 57); Bauhaus-Archiv, Berlin (figs. 57, 103, 206, 208, 214, 215, 217, 218, 220, 238, 239); photograph by Junius Beebe, courtesy Harvard Art Museums (fig. 212); © BildarchivPreussischerKulturbesitz/ Art Resource, NY (figs. 11, 16, 107, 147, 205, 212, 230, 237); © bpK/Zentralarchiv, Staatliche Museen zu Berlin (fig. 230); image courtesy the Bridgeman Art Library (figs. 71, 139); photograph by Martin P. Bühler (fig. 125); CNAC/ MNAM/Dist. Réunion des MuséesNationaux/Art Resource, NY (fig. 72); Robert Delaunay © L&M Services B.V. The Hague 20110312 (fig. 53); © AndreasFeiningerArchive. com, c/o Zeppelin Museum Friedrichshafen (figs. 98, 232, 239); photographs courtesy The Lyonel Feininger Project LLC, New York and Berlin (figs. 1, 29, 33, 35, 39, 54, 56, 66, 74, 75, 84, 92, 99, 118, 122, 136, 151, 152, 163, 164, 165, 166, 174, 175, 234, 235, 240); photograph by Jim Frank (fig. 55); © 2011 Frank Lloyd Wright Foundation, Scottsdale, AZ/Artists Rights Society (ARS), NY (fig. 201); GalerieNeue Meister, Staatliche Kunstsammlungen, Dresden (fig. 221); photograph courtesy Galerie St. Etienne, New York (fig. 48); courtesy George Eastman House, International Museum of Photography and Film (fig. 216); photograph by Erik Gould, courtesy the Museum of Art, Rhode Island School of Design, Providence (fig. 137); © President and Fellows of Harvard College (figs. 59, 67, 81, 129, 141, 142–44, 158, 207, 209, 210, 223, 225, 227, 228, 229, 242, 243); Harvard Art Museums, Busch-Reisinger Museum, Cambridge, Massachusetts; gift of T. Lux Feininger BRLF.1006.213 (fig. 242); Harvard Art Museums, Busch-Reisinger Museum, Cambridge, Massachusetts; transfer from the Fogg Art Museum BR813.12 (fig. 243); photographs by Katya Kallsen (figs. 59, 81, 85, 87, 129, 177); photograph by Christoph Irrgang (fig. 153); photographs by Idra Labrie (figs. 188, 191, 236); photograph by Allan Macintyre (fig. 209); The Metropolitan Museum of Art/Art Resource, NY (figs. 168, 184, 185, 189, 198); © MuseoThyssen-Bornemisza, Madrid (figs. 113, 119); photographs © 2011 Museum of Fine Arts, Boston (figs. 140, 199); © The Museum of Modern Art/Licensed by SCALA/Art Resource, NY (figs. 19–24, 46, 47, 49, 50, 68, 69, 95, 102, 104, 112, 134, 154, 176, 178, 192, 196, 197, 213, 219); image courtesy National Gallery of Art, Washington, DC (figs. 64, 108, 167); collection of the NeueGalerie New York/Art Resource, NY (fig. 232); photographs by Bill Orcutt (figs. 2, 5, 6, 233); photograph by Diana Panuccio (fig. 4); Philadelphia Museum of Art/Art Resource, NY (fig. 109); photograph by Bertrand Prévost (fig. 72); © Private collection in the Hamburger Kunsthalle (figs. 150, 190); courtesy Reynolda House Museum of American Art, Winston-Salem, North Carolina (fig. 106); collection of the late Horace Richter (figs. 2, 5, 6, 233); photograph courtesy Queens Museum of Art; gift of unknown donor (fig. 157); © SHK/Hamburger Kunsthalle/bpk (figs. 135, 153); photograph courtesy Sotheby's (fig. 61); © Carmen Thyssen-Bornemisza (fig. 32); Time & Life Pictures/Getty Images (figs. 203, 244–247); photograph by Elke Walford (fig. 135); digital image © Whitney Museum of American Art, New York (figs. 121, 171, 172)

This catalogue was published on the occasion of the exhibition *Lyonel Feininger: At the Edge of the World,* curated by Barbara Haskell, with the assistance of Sasha Nicholas.

Whitney Museum of American Art, New York
June 30–October 16, 2011

The Montreal Museum of Fine Arts
Michal and Renata Hornstein Pavilion
January 20–May 13, 2012

This publication was produced by the publications department at the Whitney Museum of American Art, New York: Rachel de W. Wixom, head of publications; Beth A. Huseman, editor; Beth Turk, associate editor; Anita Duquette, manager, rights and reproductions; in association with Yale University Press: Patricia Fidler, publisher, art and architecture; Mary Mayer, production manager; and Kate Zanzucchi, senior production editor.

Edited by Beth A. Huseman and David Updike
Designed by Katy Homans
Research assistance by Jessica Hong and Katharine Josephson
Translations by Andrea Baumann, Leon Botstein, Dietlinde Hamburger, Max Prior, Ingrid Schaedtler, and Elisabeth Turnauer
Proofread by June Cuffner
Indexed by Cathy Dorsey

Set in Folio and Futura
Printed and bound in Italy by ContiTipocolor

Library of Congress Cataloging-in-Publication Data
Haskell, Barbara.
 Lyonel Feininger : at the edge of the world / Barbara Haskell ; with essays by John Carlin . . . [et al.].
 p. cm.
 Published on the occasion of an exhibition held at the Whitney Museum of American Art, New York, June 30–Oct. 16, 2011 and at the Montreal Museum of Fine Arts, Jan. 20–May 13, 2012.
 Includes bibliographical references and index.
 ISBN 978-0-300-16846-4 (United States)—ISBN 978-0-300-17730-5 (Canada)
 1. Feininger, Lyonel, 1871–1956—Exhibitions. I. Feininger, Lyonel, 1871–1956. II. Carlin, John, 1955– III. Title. IV. Title: At the edge of the world.
 N6537.F37A4 2011b
 709.2—dc22

2011011043

10 9 8 7 6 5 4 3 2 1